EVA HESSE

D1422262

NEW ENCOUNTERS
Arts, Cultures, Concepts

Published

Conceptual Odysseys: Passages to Cultural Analysis
ed. Griselda Pollock, 2007

The Sacred and the Feminine: Imagination and Sexual Difference
ed. Griselda Pollock and Victoria Turvey Sauron, 2007

Bluebeard's Legacy: Death and Secrets from Bartók to Hitchcock
ed. Griselda Pollock and Victoria Anderson, 2009

Digital and Other Virtualities: Renegotiating the Image
ed. Antony Bryant and Griselda Pollock, 2010

Forthcoming

The Visual Politics of Psychoanalysis: Art in a Post-Traumatic Era
ed. Griselda Pollock

New Encounters Monographs

Published

Helen Frankenthaler: Painting History, Writing Painting
Alison Rowley, 2007

Eva Hesse: Longing, Belonging and Displacement
Vanessa Corby, 2010

Forthcoming

Outfoxed: The Secret Life of a Fairy Tale
Victoria Anderson

Witnessing Abjection: Auschwitz and Afterimages
Nicholas Chare

EVA HESSE

Longing, Belonging and Displacement

Vanessa Corby

I.B. TAURIS
LONDON · NEW YORK

Published in 2010 by I.B.Tauris & Co Ltd
6 Salem Road, London, W2 4BU
175 Fifth Avenue, New York NY 10010
www.ibtauris.com

Distributed in the United States and Canada Exclusively by Palgrave Macmillan
175 Fifth Avenue, New York 10010

ISBN 978 1 84511 543 2 (HB)
ISBN 978 1 84511 544 9 (PB)

A full CIP record for this book is available from the British Library
A full CIP record is available from the Library of Congress

Library of Congress Catalog Card Number: available

Printed and bound in Great Britain by
CPI Antony Rowe, Chippenham
from camera-ready copy
edited and supplied by the author

CONTENTS

ILLUSTRATIONS

Figures

ACKNOWLEDGEMENTS

My first thanks must go to my friends; Elsa Chen, Kate Fletcher, Helen Friedrichsen, Jo Heath, Rebecca Land, Ben Owen, Mark Simms, Joanne Taylor, Michael Ward, Liz Watkins, Liz Wright and *Bilge Pump*. Over the course of the seemingly never ending stages of this text's production their encouragement and understanding has been invaluable to me. Since its earliest beginnings this project has had the unwavering support of the Estate of Eva Hesse. The extraordinary generosity and continued insight of Helen Hesse Charash, Barry Rosen and support of the Hesse family has been invaluable to this research. In New York my continued engagement with Hesse scholarship is also indebted to the kindness and friendship of Dorothy Levitt Beskind and Douglas Johns. I should like to thank Kitty Crone, Tom and Jane Doyle, Sam and Ruth Dunkell, Hannah Hess, Manfred and Gloria Kirchheimer, Victor Moscoso, Elisabeth Sussman and William Smith Wilson for their assistance in the early stages of this research. I should like to thank Alison Rowley for her response to Hesse's No title, 1960/1961 that began my engagement with Jacques–Louis David's *Marat Assassinated*, 1793. I am grateful to Anna O'Sullivan of Robert Miller New York, Sabine Sarwa and Sylvia Bandi of Hauser and Wirth, Zurich for their assistance in seeing Hesse's works on paper and providing images for publication. I would like to acknowledge the Shawlands Educational Trust in Barnsley and the University of Leeds scholarship that supported the early stages of this research and also the American Foundation at the University of Leeds that enabled my first research trip to New York. My thanks go to the Faculty of Arts Research Committee at York St John University whose grant supported the permissions costs of this publication. I should like to thank the National Gallery London, Nora Eccles Harrison Museum of Art and Bracha Lichtenberg Ettinger for the kind permission to reproduce

works in their collections. I should like to thank my commissioning editor, Susan Lawson at I.B Tauris for her encouragement and her successor Philippa Brewster who has been key to the completion of this manuscript. I should also like to thank Barb Bolt and Estelle Barrett for their comments on the manuscript in its final stages and Helen Lofthouse for the final proof reading of the manuscript. Finally I should like to thank Griselda Pollock, editor of the New Encounters series. My intuitive response to Hesse's practice was first nurtured and developed in the truly generous academic community that she created in the AHRC CentreCATH at the University of Leeds. Without that theoretical space and support this text would not have happened.

SERIES PREFACE

NEW ENCOUNTERS
Arts, Cultures, Concepts

Griselda Pollock

How do we think about visual art these days? What is happening to art history? Is visual culture taking its place? What is the status of cultural studies, in itself or in relation to its possible neighbours art, art history, visual studies? What is going on? What are the new directions? To what should we remain loyal?

New Encounters: Arts, Cultures, Concepts proposes some possible ways of thinking through these questions. Firstly, the series introduces and works with the concept of a *transdisciplinary initiative*. This is not a synonym for the interdisciplinary combination that has become de rigueur. It is related to a second concept: research as *encounter*. Together transdisciplinary and encounter mark the interaction between ways of thinking, doing and making in the arts and humanities that retain distinctive features associated with disciplinary practices and objects: art, history, culture, practice, and the new knowledge that is produced when these different ways of doing and thinking encounter one another across, and this is the third intervention, *concepts*, circulating between different intellectual or aesthetic cultures, inflecting them, finding common questions in distinctively articulated practices. The aim is to place these different practices in productive relation to one another mediated by the circulation of concepts.

We stand at several cross-roads at the moment in relation to the visual arts and cultures, historical, and contemporary, and to theories and methods of analysis. *Cultural Analysis, Theory and History* (CATH) is offered as one experiment in thinking about how to maintain the momentum of the momentous intellectual, cultural revolution in the arts and humanities that characterised the last quarter of the twentieth century while adjusting to the different field of analysis created by it.

In the 1970s–1990s, the necessity, or the intrusion, according to your position, was Theory: a mythic concept with a capital T that homogenised vastly different undertakings. Over those decades, research in the arts and humanities was undoubtedly reconfigured by the engagement with structuralist and poststructuralist theories of the sign, sociality, the text, the letter, the image, the subject, the postcolonial, and above all, difference. Old disciplines were deeply challenged and new interdisciplines – called studies – emerged to contest the academic field of knowledge production and include hitherto academically ignored constituencies. These changes were wrought through specific engagements with Marxist, feminist, deconstructionist, psychoanalytical, discourse and minority theory. Texts and authors were branded according to their theoretical engagements. Such mapping produced divisions between the proliferating theoretical models. (Could one be a Marxist, and feminist, and use psychoanalysis?) A deeper split, however, emerged between those who, in general, were theoretically oriented, and those who apparently did without theory: a position easily critiqued by the theoretically minded because being atheoretical is, of course, a theoretical position, just one that did not carry a novel identity associated with the intellectual shifts of the post1968 university.

The impact of 'the theoretical turn' has been creative; it has radically reshaped work in the arts and humanities in terms of what is studied (content, topics, groups, questions) and also how it is studied (theories and methods). Yet some scholars currently argue that work done under such overt theoretical rubrics now appears tired; theory constrains the creativity of the new generation of scholars familiar, perhaps too familiar, with the legacies of the preceding intellectual revolution that can too easily be reduced to Theory 101 slogans (the author is dead, the gaze is male, the subject is split, there is nothing but text, etc.). The enormity of the initial struggles – the paradigm shifting – to be able to speak of sexual difference, subjectivity, the image, representation, sexuality, power, the gaze, postcoloniality, textuality, difference, fades before a new phase of normalization in which every student seems to bandy around terms that were once, and in fact, still are, challengingly difficult and provocative.

Theory, of course, just means thinking about things, puzzling over what is going on, reflecting on the process of that puzzling and thinking. A reactive turn away from active engagement with theoretical developments in the arts and humanities is increasingly evident in our area of academe. It is, however, dangerous and misleading to talk of a post-theory moment, as if we can relax after so much intellectual gymnastics and once again become academic couch potatoes. The job of thinking critically is even more urgent as the issues we confront become ever more complex, and we now have extended means of analysis that make us appreciate ever more the complexity of language, subjectivity, symbolic practices, affects and aesthetics. So how to continue the creative and critical enterprise fostered by the theoretical turn of the late twentieth century beyond the initial engagement determined by specific theoretical paradigms? How does it translate into *a practice of analysis that can be consistently productive?*

This series argues that we can go forward, with and beyond, *by transdisciplinary encounters with and through concepts.* Concepts, as Mieke Bal has argued, are formed within specific theoretical projects.[1] But, Bal suggests, concepts can and have moved out of – *travel from* – their own originating site to become tools for thinking in the larger domain of cultural analysis their interplay produces, a domain that seeks to create a space of encounter between the many distinctive and even still disciplinary practices that constitute the arts and humanities: the fields of thought that puzzle over what we are and what it is that we do, think, feel, say, understand and live.

Our series takes up the idea of 'travelling concepts' from the work of Mieke Bal, the leading feminist narratologist and semiotician, who launched an inclusive, interdisciplinary project of cultural analysis in the 1990s with *The Point of Theory: Practices of Cultural Analysis* and *The Practice of Cultural Analysis: Exposing Interdisciplinary Interpretation.*[2] In founding the Amsterdam School of Cultural Analysis (ASCA), Bal turned the focus from our accumulating theoretical resources to the work – the practice of interpretation – we do on cultural practices, informed not only by major bodies of theory (that we still need to study and extend), but by the concepts generated within those theories that now travel across disciplines, creating an extended field of contemporary cultural thinking. Cultural analysis is theoretically informed, critically situated, ethically oriented to 'cultural memory in the present'.[3] Cultural analysis works with 'travelling concepts' to produce new readings of images, texts, objects, buildings, practices, gestures, actions.

In 2001, a Centre for Cultural Analysis, Theory and History was founded at the University of Leeds, with initial funding from the Arts and

Humanities Research Council, to undertake what it defines as a *trans-disciplinary* initiative to bring together and advance research in and between distinct but interrelating areas of fine art, histories of art and cultural studies: three areas that seem close and yet can be divided from one another through their distinguishing commitments to practice, history and theory respectively. CentreCATH was founded at a moment when emerging visual studies/visual culture was contesting its field of studies with art history, or inventing a new one, a moment of intense questioning about what constitutes the *historical* analysis of art practices, as a greater interest in the contemporary seemed to eclipse historical consciousness, a moment of puzzling over the nature of research through art practice, and a moment of reassessing the status of the now institutionalised, once new kid on the block, cultural studies. CentreCATH responded to Mieke Bal's ASCA with its own exploration of the relations between history, practice and theory through an exploration of transdisciplinary cultural analysis that also took its inspiration from the new appreciations of the unfinished project of *Kulturwissenschaft* proposed by Aby Warburg at the beginning of the twentieth century. Choosing five themes that are at the same time concepts: hospitality and social alienation, musicality/aurality/textuality, architecture of philosophy/philosophy of architecture, indexicality and virtuality, memory/amnesia/history, CentreCATH initiated a series of encounters (salons, seminars, conferences, events) between artists, art historians, musicologists, musicians, architects, writers, performers, psychoanalysts, philosophers, sociologists and cultural theorists. Each encounter was also required to explore a range of differences: feminist, Jewish, postcolonial, politico-geographical, ethnic, sexual, historical. (See <http://www.leeds.ac.uk/cath/ahrc/ index.html>)

Each book in this new series is the outcome of that research laboratory, exploring the creative possibilities of such a transdisciplinary forum. This is not proposing a new interdisciplinary entity. The transdisciplinary means that each author or artist enters the forum with and from their own specific sets of practices, resources and objectives whose own rigours provide the necessary basis for a specific practice of making or analysis. While each writer attends to a different archive: photography, literature, exhibitions, manuscripts, images, bodies, trauma, and so forth, they share a set of concerns that defy disciplinary definition: concerns with the production of meaning, with the production of subjectivities in relation to meanings, narratives, situations, with the questions of power and resistance. The form of the books in this series is itself a demonstration of such a transdisciplinary intellectual community at work. The reader becomes the

locus of the weaving of these linked but distinctive contributions to the analysis of culture(s). The form is also a response to teaching, taken up and processed by younger scholars, a teaching that itself is a creative translation and explication of a massive and challenging body of later twentieth century thought, which, transformed by the encounter, enables new scholars to produce their own innovatory and powerfully engaged readings of contemporary and historical cultural practices and systems of meaning. The model offered here is a creative covenant that utterly rejects the typically Oedipal, destructive relation between old and young, old and new, while equally resisting academic adulation. An ethics of intellectual respect – Spivak's critical intimacy is one of Bal's useful concepts – is actively performed in engagement between generations of scholars, all concerned with the challenge of reading the complexities of culture.

One of CentreCATH's research strands focused on the concepts of *Indexicality* and *Virtuality*. We aimed to register and bring into dialogue several different debates in contemporary cultural analysis about the impact and potentialities of new media, new technologies and their virtual realities and both their cultural significance and artistic implications. At the same time, we aimed to reflect the renewed interest in the Bergsonian concept of virtuality, paired not with reality or materiality but with actualization, reanimated notably by the philosophy of Gilles Deleuze, in which the term virtuality has radically different connotations, leading us to issues of movement, sensation, time and memory and particularly, theories of art 'beyond representation'.

Indexicality, known to a fairly restricted circle of students of American logician and philosopher C. S. Peirce's semiotic theory, in which Peirce categorises the sign as icon, index and symbol, re-emerged in cultural theory, notably around photography and cinema, precisely because of the shift from analogue to digital photographic technologies. The index is a sign by virtue of a relation to its object, grounding the signifying relation in existential or indicative relations to real processes or things, in contrast to the icon, which works by resemblance, and the symbol by convention or rule. While earlier theories of photography sought to dissipate the delusion of photography's unmediated reproduction of the real in order to stress the role of rhetorics of the image and ideological over determination of the 'truth' effect, faced with the dissolution of the indexical link between photograph and its object in the simple necessity of the two actually confronting one another at some point for the genesis of the image, theorists became interested in the politics of indexicality or its absence in contemporary image-making and theory. This shift invited, therefore, what

we might call archaeological reconsiderations of pre-digital technologies but also of theories of cinema and photography that had been deposed by the structuralist/post-structuralist rhetorical and semiotic turns, and which now assumed a renewed interest in relations to both a politics and an ethics of knowledge and its mediations.

What both re-orientations – towards virtuality and indexicality – have in common is the analysis of the relation between new modes, processes, practices and theories of representation and even non-representation on the one hand, and, on the other, both the grounds for knowledge of the world and ourselves and the conditions of thinking embodied human social and sensuous life in the changing conditions of the information era. Bringing together a range of engagements with these concepts across their differences and possible confusions is a gesture towards analysis of contemporary cultural configurations.

This book creates the transdisciplinary encounters necessitated by so complex and varied a theme. It brings together philosophers, literary theorists, cultural theorists, theorists of informatics, film theorists, film makers, artists, and art historians, none of whom merely represent different disciplinary approaches. Rather they have been assembled in order to indicate the manner in which these current, vital, necessary and stimulating concepts are circulating in the expanded field of the image. This field involves critical reflections on both the visible and the invisible, the seen and the overlooked, the unseeable and the over-spectacularised. At the same time, these writers ponder the emotional tone and affective processes of subjectivities generated and mediated by both new and future virtualities. Yet the increasing domain of the virtual in the image-world has generated a renewed interest in the Peircean concept of indexicality, as that which defined analogue photographic imagery, linking representation existentially to the social and material world. New questions arise here. Does indexicality acquire renewed significance and political pertinence in increasingly virtual image-worlds as a political-aesthetic issue? How is it related to our continuing struggle to pierce the illusions of the 'society of the spectacle' and to grasp, through critical representational interventions, our material, social and economic groundedness and embodiment, and our ever-shifting determinations and limitations?

Centre for Cultural Analysis, Theory and History
University of Leeds 2010

INTRODUCTION

The measure of Eva Hesse's significance as an artist of the twentieth century lies in her ability to compel others to respond to her practice. Forty years after her death fine artists continue to mine the outcomes of her too brief professional career as an impetus to their own work. For this audience Hesse's oeuvre is characterised by a timelessness that can be ascribed, in great part, to the creative procedures captured in the material presence of her finished pieces. This startling ability to excite the creativity of others transcends the limits of her artistic activity and the trope of 'Hesse as wound' that has dogged much of the writing about her.[1] If this retrospective, abject vision of the artist is put to one side her interviews and private journals may be revealed as a testimony to a life grasped with both hands. The commitment, determination, energy and sheer gusto with which Hesse approached her work is contagious not only for artists, but critics, curators and scholars alike. As a young art student the combination of Hesse's drawing and her affirmation of the potential for doing, for making, for bringing something beautiful hitherto unthought into being, had been intoxicating; like countless others she *made* me want to be an artist. Hesse remained a potent force throughout my education but her impact went on to exceed the processes of drawing and painting that I initially sought to grasp. As the years went by my encounters with Hesse's work pressed more and more upon my engagement with feminist art criticism and the history of art. This monograph is the result of that pressure.

Hesse's creative practice has generated an extensive discourse that has shaped the terms through which viewers continue to understand and respond to her work. What has perhaps become most marked about Hesse's use of materials in this body of criticism is her ability to blur the boundaries of drawing, painting and sculpture in the context of the pre-feminist, Anti-Form moment of 1960s sculpture. Within this critical framework the prominence given to 'line' and the fluid nature of Hesse's media has

positioned the artist's drawings as precursors to her later sculpture. It is possible to argue, however, for an unforeseen consequence of this affiliation of two and three-dimensional practices: a formalist hierarchy that 'reads' sculpture yet only 'describes' drawing in respect of that reading. In contrast, the form and content of this book has been directed by a painter's desire to engage with the historical specificity of Hesse's process in the medium of drawing. *Longing, Belonging and Displacement* is a trans-disciplinary response to Hesse's work and its body of criticism made via a scholarly enquiry that has been informed by insights born of practice.

Contrary to conventional art historical method this book does not offer a comprehensive survey of either the artist's oeuvre in general or her drawing practice in particular.[2] In order to say something new about the work of Eva Hesse, *Longing, Belonging and Displacement* presents a close reading of two small, unnamed works in ink and gouache made at the beginning of her professional career in 1960/61 and 1961 (plates 1 and 2). To select only two details of such an accomplished body of art practice is not to herald these works as exemplars of beauty, content or style but to acknowledge that such an intent analysis has the power to transform the territories in which Hesse's larger oeuvre may be understood. The primacy given to these two drawings marks their role here, to borrow from Mieke Bal, not as 'illustrations' that punctuate an intellectual argument but as the generative source of an enquiry that nuances the interplay of the particular, the general and the universal in the history, theory and practice of Hesse's art. I argue that to approach Hesse's drawings via a set of encounters enables this text to put the *work* of art first, to read anew the circumstances of each drawing's production, reception and circulation within the discourse written for this artist. This is a text, therefore, that attends not only to the surface of finished artworks but to the particularity of each drawing's processes and their creative function; what Robert Morris called in 1970 the 'submerged side of the iceberg'.[3]

The concept of encounter that makes this shift possible also underlines this text's refusal of the quasi-objectivity that isolates moments of art making within a so-called static past. As my engagement with practice makes clear, the points at which the following questions were posed were 'historically situated, inexorably, in the present [and] the present is historical too'.[4] Hesse, her unnamed drawings and the discourse written for them now inhabit the first decade of the twenty-first century. This cultural present facilitates a supplement to the early feminist theory that in the early 1970s perceived a specifically gendered vocabulary in the work of this artist. As artist and psychoanalyst Bracha Ettinger writes, the viewer/witness is not contained

within the 'after' of an artwork; a passive receiver of sensation 'expressed' by the artist/work.[5] Rather at an intersection of the production and reception of the work, the artist and the author/viewer are intertwined in a transformative process of making and remaking that renders the artwork forever in the process of becoming. This cognisance points to the conscious writing of this book *after* the Holocaust. In so doing it accords new historical and historiographical significance to what hitherto had been framed as 'biographical' data. In particular Hesse's experience as a German Jewish refugee in 1950s America and the impact of the therapeutic structures of American psychoanalysis upon her perception of her relationship with her mother, Ruth Marcus Hesse, are crucial to the reappraisal of these drawings. *Longing, Belonging and Displacement* thus begins as a shared space; inhabited by some trace of the subjectivity and history negotiated during the making of these artworks and that of a particular witness.

This book creates what Eric L. Santner called a new 'receiving context' for Hesse and her art practice in order to ask, what was it to live after the Holocaust? Eva Hesse was born on 11 January 1936 in the Israeli Krankenhaus, the Jewish hospital in Hamburg. The eagle and swastika emblem of the National Socialist local government authenticated her birth certificate, a document that is now part of the Eva Hesse Papers in the collection of the Allen Memorial Museum in Oberlin College, Ohio. This stamp left an indelible mark not only on that document but also on the life of the person whom it certified as the 'Aryan's' *Other.* The National Socialist state and its anti-Semitic doctrines irrevocably altered the course of the Hesse family's lives. After the boycotts and pogroms of the mid 1930s Hesse, her sister Helen (1933), their mother Ruth Marcus Hesse (1906–1946) and father Wilhelm Hesse (1901–1966) fled their homeland in the winter of 1938–39 as part of the last significant wave of German Jewish immigrants.[6] The loved ones that they had to leave behind eventually perished. The Hesse family journeyed separately to Holland and then on to England and America together, where they settled in the German Jewish community of Washington Heights. Ruth Marcus Hesse took her own life on 9 January 1946 two days before Hesse's tenth birthday. Hesse's therapy later framed this loss via an emphasis on feminine pathology and weakness. In *Three Artists (Three Women): Modernism and the Art of Hesse, Krasner and O'Keeffe*, Anne Wagner situated Hesse's belief in her 'own sickness' within this psychoanalytical framework to mark the beginnings of the artist's sense of cultural difference that came to fuel her identification with the myth of the artist as a social misfit.[7] From 1952–53 Hesse studied art at Pratt Institute, went on to Cooper Union between 1955 and 1957 and in 1959

received a Bachelor of Fine Arts from Yale University. After graduation she worked in New York, mainly in studios on the Bowery, except for a period from June 1964 to September 1965 when she returned to Germany with her husband Tom Doyle. Hesse died from a brain tumour on May 29 1970. Across these geographies, in a period that barely spanned eleven years, Hesse produced a stunning body of drawings, paintings and sculpture. Had Hesse not 'got out' of Europe in 1939, this life and its legacies undoubtedly would not have happened. Hesse was sensible of what might have been; that had she not escaped she would, like Anne Frank, have perished as one among 1.5 million Jewish children murdered by the Nazi killing machine.[8] To acknowledge this hitherto occluded history and its attendant trauma is not to stumble into the pit of woeful tales of pathology alternately dug and deconstructed by the writings about this artist. The notion of the 'wound' relies upon a discrete vision of the subject. In this book I take up Wagner's significant corrective to those texts that figured 'Hesse as wound' to argue for a historically situated understanding of Hesse's artworking as a testimony to survival.

Chapter 1 begins with my own encounter with Hesse's drawing in reproduction in 1993 prior to any knowledge of the artist or her practice. In so doing it highlights the very different position from which artists may look at art; the oblique connections they make between practices and the questions that arise from those juxtapositions. From this starting point the anachronisms that have sustained the formalist hierarchy that has dominated readings of Hesse's drawing and sculptural practices are deconstructed. To date Hesse's sculptural outputs have been organised within a standard chronology of early, middle and late artistic production whilst her drawing has been cast as a thread that connects these three periods. Drawing is thus fundamental to the illusory coherence of an oeuvre that in fact had been only the beginnings of Hesse's practice. To locate all of Hesse's creative output within the space of the 'early' is to recognise that the artistic, critical, and scholarly responses that her work elicits can be said to perform a work of mourning for what she would have gone on to do had she lived; her discourse defies the death of the artist to sustain her presence in contemporary cultural consciousness. Made in the shadow of Abstract Expressionism, the significance of Hesse's drawing in such texts often resides in their perceived ability to capture the artist's 'true' self. This book foregrounds the role given to drawing in Hesse's histories as a biographical index that constructs a discrete coherent subject outside history. To draw attention to the function and position of drawing in the critical and historical texts written for this artist is a necessary step that

acknowledges the forces that structure our viewing of works of art and their role in crafting our responses to it.

This groundwork is continued by Chapter 2 that tracks the historical specificity of, and necessity for, the production of the gendered readings of Hesse's practice in the 1970s. Attention to the current understanding of the sculpture *Addendum*, made by Hesse in 1966, elicits an examination of the role of 'expressionism' and 'autobiography' within the then burgeoning politics of the Women's Art Movement. The foundation and present direction of Hesse scholarship in the thirty years since the artist's death is, therefore, illuminated. This text owes a debt to that critical lineage. The need to recognise the mutual inflection of gender, ethnicity and trauma within Hesse's art practice has, however, demanded a new model with which to think Hesse's difference. The writing of psychoanalyst Bracha Ettinger, whose painting practice negotiates the legacies of Ha Shoah from the position of the Second Generation, facilitates just such a complex weave of heterogeneous subjectivity via the notion of a non-gendered feminine sexual difference.[9] The 'invisible difference' of women, the uterus and the inter-uterine encounter in late pregnancy between the foetus and mother, form the *basis* of Bracha Ettinger's theory of the Matrixial subject-ive stratum that emphasises that woman and the feminine are not the same.[10] This intervention in the field of psychoanalysis after Lacan widens the scope of difference beyond the foundation of phallic sexual difference that privileges the visual.[11] The phallic paradigm not only polarises the sexes on the axis of having or not having the phallus, but also bases all relationships between the stranger and 'I' on an acceptance of the same or rejection of an irreconcilable other. The first chapters of this book thus seek to formulate a space of heterogeneity without hierarchy or foreclusion that is fundamental to its later hypotheses. The importance of being a woman does not preclude or diminish the invisible difference of being a German Jewish refugee during and after the Shoah in America. Rather, the co-existence of these and other co-emerging, intersecting and mutually dependent dimensions becomes clear.

Chapter 3 reads for the cultural conditions of the post-war period that silenced Hesse's history as a German Jewish subject in the writings about her art practice. This chapter also acknowledges that those same conditions prevented the trauma of that experience being self-present to the artist. In so doing it differentiates the theory of trauma as a historically specific response and its complex psychic temporality from the introverted pathology of the wound that has dominated writings about Hesse. Chapter Four performs a similar task in respect of psychoanalysis in 1950s America

and the prevailing pathological configuration of Hesse's relationship to and mourning for her mother. Chapters 2 to 4 thus act as a threshold from which to begin to bear witness to some part of those experiences and elements at *work* in this artist's practice that Hesse could not. It will become clear that, as a traumatised subject, Hesse's inability to bear witness to her own story was augmented by the 'false witness' created by her psychotherapy.[12] I argue that the 'truths' peddled by the paradigms of contemporary psychoanalysis effected a stranglehold on Hesse's experience to deny any primary cognition of 'her story' or recognition of it in the narratives born from the condition known as 'Other'.[13]

Only after these preliminary moves have been completed does it become possible to turn to Hesse's unnamed drawings with which this book begins. Chapter 5 is structured by what Brian Massumi has named the 'part-connections' that can occur between artworks created in proximity.[14] Works of art made in a similar time frame with similar materials are normally unified, art historically, under the umbrella of the 'series.' The model of 'part-connection', however, lets the echoes between such works hold but does not silence their aesthetic and historical specificities. Thus a new model of close reading is enabled for Hesse's two unnamed artworks hitherto grouped as 'early drawings.' A supplementary analysis of Hesse's relationship to Ruth Marcus Hesse and the re-evaluation of their joint experience of Holocaust trauma may then impact upon the viewer's encounters with those drawings. I situate each artwork with-in the texture of both their creative and historical moments of production that intersect, modify and are modified by unconscious psychical processes. I address not only the cumulative losses of a historically situated mother, contextualised by reference to the events in Nazi Germany and Washington Heights, but also Hesse's desire for her return. Finally I propose that Hesse's reading of *The Diary of Anne Frank* and its release as a film in 1959 collide in 1960 with the capture of Adolf Eichmann to bring about a flood of affect for Hesse. This affect had been, I argue, *unknowingly* imprinted on Hesse's drawings in an act whose processes and procedures negotiated this trauma but nevertheless simultaneously functioned as an active part in and affirmation of the continued survival of the artist.

1

SKIPPING TEXT, READING PICTURES

A good reader is, first of all, a sensitive, curious, demanding reader. In reading, he follows his intuition. Intuition – or what could pass as such – lies, for example, in his unconscious refusal to enter any house directly through the main door, the one that by its dimensions, characteristics and location, offers itself proudly as the main entrance, the one designated and recognised both outside and inside as the sole threshold.

To take the wrong door means indeed to go against the order that presided over the plan of the house, over the layout of the rooms, over the beauty and rationality of the whole. *But what discoveries are made possible for the visitor! The new path permits him to see what no other than himself could have perceived from that angle.* All the more so because I am not sure that one can enter a written work without having forced one's own way in first. One needs to have wandered a lot, to have taken many paths, to realise, when all is said and done, that at no moment has one left one's own.

Edmond Jabès, *From the Book to the Book*[1]

My encounter with Hesse unwittingly began in spring 1993. At the time I was a fine art undergraduate in the North East of England studying painting. I had never heard of Hesse. I had not seen any of her work. Nor had I any concept of the critical and art-historical discourse that had developed around her and her work. I was introduced to her art practice by an art school pedagogy in which certain proper "beginnings" were considered necessary in the formative stages of my own art making.[2] My tutor, the painter Virginia Bodman, had directed me to look at drawings by Hesse as relevant to my own emerging practice several times before I actually went to the library to find the relevant books. The first that I picked up was the classic and only monograph, *Eva Hesse*, published in

1976 by Lucy Lippard, curator, feminist art critic and close friend of the artist.[3] I flicked through it, skipping the text to read the pictures, but put it down again. The small black-and-white reproductions gave no real sense of the artworks I was supposed to be studying, while the colour reproductions gave precedence to what seemed to be, on first glance, sculpture. Luckily the library had another book: an exhibition catalogue *Eva Hesse Gouaches 1960–1961* from 1991.[4] The hitherto casual interest I had given to the series of images by this "sculptor," when I was after all a "painter" in an art school, whose politics polarised those disciplines, was arrested when I reached page five. There I was struck by an inky black rectangle punctured by three loosely shaped broken white areas. It was a reproduction of an unnamed drawing in gouache, six by four in, from 1961. I recognised something in that drawing or rather the simulacrum in those catalogue pages that at twenty years of age I naively conflated with the original. Somehow it was peculiarly familiar.

With the benefit of hindsight it is easy to attribute part of the initial connection I had with this 1961 gouache to my own studio practice and an exhibition of another artist that I had seen recently at London's National Gallery. When painting I worked in layers: under-painting and glazing in oil, I drew with pencil and pooled with ink. As a student, I looked to what I then discovered in such works by Hesse, for possibilities and for permission, for a way out of an impasse that had been reached in my painting practice. Caught between being a young practitioner preoccupied with painterliness and the desire to make "pictures" that worked with some kind of figurational structure I was stuck. I turned to the making of hundreds of small drawings, abstract doodles in and about ink, gouache, watercolour and anything else that would come to hand. For me "doodling" was the means of doing something while I did not know what I was doing. I was quite happy, pottering away, drinking tea and drawing. I could just explore and be absorbed by the materiality that seemed to be the beginning and the end of their signification. Of course, at that time they could not be the be all and end all of an art practice. They had to lead to *something*; I had to have "ideas."

Just before I discovered Eva Hesse through her gouache drawings, I had seen a travelling show: *Rembrandt: the Master and His Workshop* (1992). Notebook in hand, I walked around the gallery and tried to unravel how Rembrandt's processes of underpainting, painting, and glazing could culminate in an eye, the flesh of a hand, or the arm of a sleeve. I had never been in the habit of reading the tablets of easily digestible gallery blurb pasted next to each work. In 1993, I was not interested in dates, sitters, or

art history and its labels. For my own selfish study of art making, I wanted to know how a passage of colour could hold a whole painting together. Among the works on display was *A Man Seated Reading at a Table in a Lofty Room* c.1620 attributed to a follower of Rembrandt (plate 3). This painting's use of light and architecture fascinated me. Like a good little student I purchased a postcard of it and pinned it to the wall of my studio space. Though recently devalued as the work of a somewhat 'heavy-handed' impostor the painterly language that I imbibed from this small painting, its *work* of art, was my first, if somewhat oblique, way into that 1961 gouache by Hesse. [5]

In *A Man Seated* and the 1991 reproduction of *no title* 1961, the gaze of the spectator is drawn along a journey from the right hand bottom corner to the top left and right corners by blocks of dark ink and paint permeated by passages of untouched paper. In Hesse's unnamed drawing the hard edge that traces the left white passage makes the darker portion of the drawing from the centre to the right appear as a block of solid colour and creates a tension between these elements. This effect is also present in the darkened interior composition of *A Man Seated* whose space, lit by a single source, had informed the compositions of my own painting at that time. No matter how they began, layer upon layer of pigment and glaze led my practice to a certain swarthy depth of colour. In its 1991 reproduction, the black of *no title* has sepia resonances that combine with the cream of the paper to create the vitality, depth and warmth that enable the viewer to wander within its interior landscape. The architecture set down by that follower of Rembrandt acted as an unconscious template that configured my response to *no title* 1961. The paleness of the window frame in *A Man Seated* results from the light that it catches that contrasts against the grey sky outside and the white of the illuminated wall. The form of this seventeenth century window configured a similar play of feature in the unnamed gouache, a frame and a window from which a shaft of cream light falls across the floor. To the right a pale shape, a dim light seemed to reflect on a wall from a source of light occurring outside the parameters of the drawing. The artist's initials intervene in this tenuous representational reading to puncture the picture plane, however. They call forth the remembrance of the drawing's making; its specificity as an unnamed drawing made by Hesse in 1961. Materially and historically it is a work quite different from *A Man Seated*.

Unlike *A Man Seated*, it is clear from the reproduction of *no title* 1961 that none of the pale areas are highlights; they are not the result of an application of a medium onto the paper or ink ground. It is not a 'light' that

gently filters onto surfaces within the image. This light has no energy; the darkness of the reproduction swallows it. Its dark fluidity seems almost unnatural; it glows and yet simultaneously collapses in on its self. The patches of light emerge from untouched blank paper. This lack of intervention on the paper does not create a simple question within the dynamics of absence versus presence however. It is not a gap in making or of the maker; there was a decision after the appearance of this white passage to leave it as it was. The artist was both there and not there.

In that art school library a moment of encounter took place. *A Man Seated* had made possible an impaired or imperfect connection with *no title* 1961. In between practices and subjectivities the beholder was not a spectator forever one step removed from the work by knowledge of the artist's biography or intention. The gaze that looked upon the gouache was at liberty to wander within it: to make of it what it willed. The purpose of such a gaze is not to attain intellectual ownership by means of a quasi-objectivity that desires "the key" to the work and its maker. Rather the purpose of such a gaze *is* the encounter, a trans-subjective dialogue that has been theorised by artist and psychoanalyst Bracha Ettinger and is summarised here by Alison Rowley as:

> The possible but always unforeseen, emergence of a psychic place, between artist and viewer, viewer and viewer, artist and artist, created in the processes of making and viewing a visual artwork, but experienced as primarily affective rather than visual. In this theorisation affect destabilises visuality, and transubjectivity decentres the modernist definition of art making and art viewing as fundamental sites for the realisation, conservation and reflection of a singular subjective existence.[6]

Drawing and (not) Sculpture

Even the most recalcitrant student can only skip the text for so long. The 'new' art history has been slow to impact on the education of art students in Britain. There is still a general feeling in the UK that 'creativity', to be 'good' with one's 'hands', is a practical compensation for a want of more academic talent. At art school in the early 1990s the 'old' art history seemed to do nothing to counter this perception. It appeared to resign itself to the stupidity of art students rather than question the power of its own modes of analysis and pedagogical practice to disengage them. The almost endless chronology of 'styles' and 'movements' sucked the lifeblood out of the objects it offered and succeeded only in its ability to bore its audience. The

partial and prejudiced threads of art historical knowledge that I had gleaned allowed me to knit together a simplistic understanding of Modernism grounded in the utter connectedness of 'natural' artistic expression and biography. On no steadier foundation than this had the desire to know more about Hesse and her drawings been born. In the early 1990s I thought that biography would enable me to name, understand and give permission to that which I was intuiting from that unnamed drawing.

Biography, as it turned out and will become clear later, has been fundamental to the meanings attributed to Hesse's art practice. It is crucial to Lippard's monograph. The first page of that text locates Hesse's early drawing practice as follows:

> The drawings from 1960–1961 are among the most beautiful in Hesse's oeuvre, and in retrospect it seems that, had circumstances been different, they might well have lead her directly into the mature sculpture which they so often resemble. She could always draw, even when she was having trouble with painting, and the drawings expressed her deepest feelings. They were mostly ink, brush, wash; mostly grays, blacks, and browns, with heavy but eccentric and whimsical shapes. Though Hesse had yet to make her first sculpture and had not considered the possibility of a "girl being a sculpture," she seemed to be forming a *vocabulary of shapes that longed to be independent of the page.* The origins of her sculpture are, again with hindsight, easily discovered. There are irregular rectangles, parabolas, trailing linear ends, circles bound or bulged out of symmetry, sometimes tangled balls. There are shapes painted out with black, the white forms negative and contained; there is an eye-like form framed twice in rectangles on a dense grey wash ground which could have been one of the 1969–70 Woodstock series…[7]

For Lippard visual resemblance enables the means of drawing and sculpture to cohere to signify the core of Hesse's creative self. Indexed to the expressive nature of 'art', Lippard's argument underpinned my own tentative questions. To return to *Eva Hesse: Gouaches 1960–61*, we find that the catalogue essay by Elizabeth Frank is clearly indebted to Lippard:

> It seems impossible, looking backwards from the mid-sixties sculpture to these early drawings, that [Eva Hesse] could ever have 'just painted;' every mark she makes has an almost solid presence [...] Absorbing, enigmatic, and moving in themselves, *these works are without*

a doubt are an encyclopedia of Hesse's future concerns as a sculptor, although this insight is only available to us in retrospect.

These early works on paper, then, are important and central to Hesse's achievement. For the first time she discovers what's truly hers, the images and forms that are inescapable and imperative for her. Of course it's fascinating to wonder why Hesse did not go right from these drawings to sculpture ...[8]

Hesse's artworks are plotted over a coherent time-line. The artist is understood to have progressed naturally from the original articulation of a kind of form wholly 'hers' that is then followed by a seamless transition from sculptural painting to painterly sculpture. The role of precursor that has been assigned to 'the drawings' indexes them to a three-dimensional practice made four years later, which is problematic. For in doing so nothing has been actually said about the gouaches beyond visually describing them and their usefulness as *primi penseri*. In part the significance of these drawings hails from their status as the first works that Hesse exhibited. These first thoughts signal the beginnings of Hesse's professional practice. In 1961 Hesse showed several gouaches as part of the Brooklyn Museum *21st International Watercolour Biennial*, between 10 April and 28 May. Several drawings also featured as one third of *Drawings: Three Young Americans*, held at the John Heller Gallery between 11 April and 2 May. It was this exhibition and its reviews that signalled Hesse's entry into the New York art scene. Furthermore the notion of 'the drawings' and their relationship to sculpture constructs these works as a 'series' with all its connotations of recurrence, sameness and sequential order. I would argue that there is more to be said about these drawings than this paradigm of affiliation will allow.

To loosen the knot that binds Hesse's drawings to her later sculptural work it is first necessary to turn to her role in shaping that discourse. The beginnings of Frank and Lippard's analysis can be easily elucidated by Hesse's own account of how these drawings relate to her later sculptural works and to her. Whilst writing in the early 1970s Lippard had access to the eighty-page, unabridged transcript of 'An Interview with Eva Hesse,' published as an article in *Artforum*, in May 1970 by Cindy Nemser. Two extracts in particular have been often quoted from that text:

Eva Hesse: In retrospect it's so clear. I think there was a time, when I met the man that I married, I shouldn't say I went backwards but I did because he was a more mature artist and was developed and I

would unconsciously be somewhat influenced and he would push me in his direction and of course when I met him I already had a drawing show which was much, much more me.

Cindy Nemser: When was this?

EH: I had a drawing show in 1961 at John Heller Gallery which became Amel Gallery, it was called Three Young Americans and the drawings then were incredibly related to what I'm doing now its very interesting to see.

CN: I want to talk to you about your relation of your drawing to your sculpture that will be another question that we will get into [...].[9]

CN: do you feel that you have broken with tradition – say the tradition of sculpture. Do you feel your art relates in any way to traditional sculpture?

EH: Well I don't know. Where does drawing begin and where does drawing end and painting begin. And I don't know if my own drawings now are – they are really paintings on paper but you know I call them drawings. But they really are not. There is no difference between that painting except that is smaller and on paper. *It's* a canvas *and* – a sculpture – No I don't feel like I'm doing traditional sculpture. The last piece that I did was like paintings that are hung from the ceiling and it could be hung against a wall.

CN: Well your art is more like painting?

EH: Well I don't even know that. That is again – that see I am not traditional. I don't know whether anything – really the drawings could be called paintings legitimately and a lot of my sculpture could be called paintings and a lot of it could be called nothing – a thing or an object or any new word you want to give it *because* they aren't *traditional.*[10]

If viewers set out to find visual crossovers that index the 'vocabulary of shapes', present in both Hesse's early drawings and later sculpture, then logical connections between two such works as *no title (Rope Piece)* (1970, figure 1) can easily be drawn. The scarcity and scattering of Hesse's work in museums and galleries in Australia, Europe, Israel and North America, coupled with the practical difficulties of making the work travel prove to be significant obstacles to seeing it in the flesh. Until the retrospective *Eva Hesse* at Tate Modern in 2003, the last major show of this artist's work in the UK was in 1979, curated by Nicholas Serota in the Whitechapel. Thus the only regular access to this artist's work in Britain has been through the

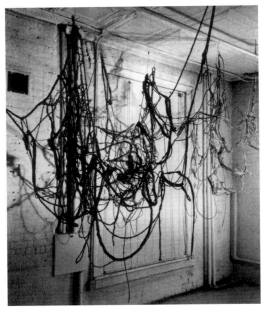

1 Eva Hesse, *No* title, 1970, Latex, rope, string, wire, 244 x 549 x 92 cm / 96 x 216
x 36 in (variable). Installation view at 435 West Broadway, New York 1970.
Whitney Museum of American Art, New York.

medium of reproduction; in exhibition catalogues, art magazines and art
history books. As Walter Benjamin suggests the reproduction of a
transparency that in turn reproduced the actual drawing permitted the work
to be seen independently of its position 'in time and space, its unique
existence in the place where it happens to be'.[11] Divorced from space this
medium of reproduction performs a transformation. Three-dimensional
sculptures, physical objects in space, become two-dimensional images and,
therefore, the similarities of visual style become more marked for the
viewer/reader. The medium of reproduction has therefore helped to
sustain this overlap of drawing and sculpture and thus shaped the
experience of Hesse's audience. What this two-dimensional medium often
renders obscure is the process inherent in the making and physicality of the
work. Within the Hesse-Nemser transcript there is, however, a not so well
known passage of conversation in which the artist discusses the relation
between her two and three-dimensional practices:

EH: I am interested in finding out through the working of the piece
some of the potential and unknown and not preconceived – I don't

think I've always felt this way – that changes ... the work itself can re-define or define the next step or it combined with some vague idea...'

CN: [an unnamed artist] feels now what he is doing – he is working it through so that it is a discovery except that each step that he takes sorted of ordered by the step he has taken before – a kind of working through. And *when I told* **him about your working out from drawing to sculpture, he got very excited**. Yes, yes that's it you know.

EH: What do you mean *from* drawing?

CN: Well I mean you did the drawing and how they evolved into three-dimensional pieces.

EH: Oh.

CN: In a way [*Hang Up*, (1965–66)] makes me think of Picasso's sculpture – his wire pieces which were really drawings. They were related to his *Cubist* work and he tried to three-dimensionalise them. Perhaps this was a similar impulse with you in the drawing.

EH: Yes. **But this was a long time after the drawings**. This was done the first year of being back in America. The drawings and the first series of sculptures were done a year or two before in Europe.

CN: Uh uh.

EH: But I was still using cord and rope, though about this time I started dropping it.

CN: I see.

EH: And I used it not that rigidly. I mean at first I used it ~~with attached lines~~ *rigidly like lines in a drawing*.

CN: But new ideas had been injected into it.

EH: Right.

CN: I think you said that this was one of the first times you had done a sketch. [Hesse is talking about *Contingent* (1969) and her drawings for it.]

EH: Yes. I did a whole group in one time like in one week or in two weeks. I think there were like 10 sketches and I think I worked them all out or they were being all worked out – everyone of them.

CN: That was very unusual for you.

EH: Yes

CN: Because previously the drawing –

EH: Yeah I never – no I always did drawings but they were *always* separate from the sculpture or the paintings. And I don't mean in a different style but weren't connected. *They* [are] *not* ~~you know~~ a

transfer sort of **they were related because they were mine but they weren't related in one completing the other.**
CN: Right EH: And these weren't either. They were just sketches like I tried something else and it worked.
CN: And then the piece –
EH: It is also not wanting to have such a definite plan. It is a sketch – it is just a quickie to develop [the sculpture] in the process rather than you know working out a whole model ~~and~~ *in small + following it – that doesn't interest me.*[12]

Hesse's drawing clearly had a role to play in the genesis of her sculptural practice. But she clearly differentiates between those 'sketches' produced in the preparation for works such as *Contingent* and her drawing *practice.* What her distinction draws out is the way in which tacit knowledge leads her making. Even where the line is visually analogous in such works as *Hang Up* and her 'machine' drawings she stresses each work's historical moment of production and the new challenges posed for her decision making processes by a shift from two to three dimensions. To go beyond the visual end product of 'art', to frame Hesse's work via the notion of practice, is to profoundly difference her work. To put it quite simply, to make a drawing, painting, or a sculpture requires different physical movements of the body that involve the lateral movement of the hand on the hinge formed by the wrist, elbow and shoulder. Like the 1960/1961 drawing, *Laocoön* (1966, figure 2) is marked by the persistent motif of a 'frame' traversed by 'trailing linear ends'. A visual resemblance can easily be perceived between these two works. As excerpts show from the film *Four Artists: Robert Ryman, Eva Hesse, Bruce Nauman, Susan Rothenberg*, the making of *Laocoön* involved the whole body in movements that navigated the work's materiality, not to mention the assistance of Ray Donarski, who helped Hesse with the construction of the plastic structure.[13] *Laocoön* does not elicit the fluid movement of a brush traced along paper but a labour intensive construction of something that has already been partially designed (figure 3). Stood on the floor reaching upwards or working on a ladder the almost monumental scale of this work made Hesse's whole upper torso bend and shift as her hands passed around and around the structure and wires as its lengths were followed by the cloth in which they were bound. The 'contrasting thin shiny pipes' and 'fuzzy ropes' of the piece were then painted light grey with acrylic to create coherence.[14] The recognition of movement in the media of drawing and sculpture thus breaches the concept of the repetition of a formal vocabulary of shapes as the recurrence

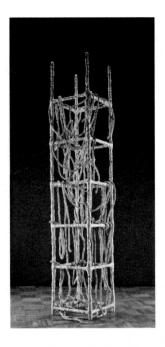

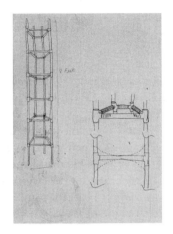

2 Eva Hesse, *Study for Laocoön,* pen and ink, pencil, 12 x 9 in.,
Collection of the Allen Memorial Art Museum, Oberlin College, Ohio.

3 Eva Hesse, *Laocoön,* 1966, acrylic paint, cloth-covered cord, wire, and papier
mâché over plastic plumber's pipe, 120 x 24 x 24 in (304.8 x 61 x 61 cm.),
Collection of the Allen Memorial Art Museum, Oberlin College, Ohio.

of the same. As Hesse did not make her first reliefs and sculptures until
1965, to state the obvious, they were not the motivating force behind the
production of those works of 1960/1961. Once these drawings have been
placed at a critical distance from Hesse's sculpture it is not my intention
assimilate them within the painting practice that was contemporary to
them.

Art history has not been a discipline about the mechanics of making. In
her essay 'The Teleology of Drawing', Deanna Petherbridge contrasts the
appreciation of drawing in its own right by the connoisseur or collector,
and the 'insistence by art historians that drawings are serially linked within a
causal chain ... devoted to the questions of attribution, affiliation, chrono-
logy and hierarchy'.[15] Art history's aim is not to consider the *work* of art but
those ideas that can be conveyed and brought together by finished
installations, paintings, photographs or sculptures. Traditionally, therefore,

drawing has been denigrated for its lack of value as the perceived record of the interim process of schematic preparation, a sketch. The value of drawings *for* art, not *as* art, is accorded by their connection to other works rather than for themselves alone. For art history it seems that if drawings are not made in direct preparation for a more monumental artwork then their elements can be read for similarities to it. Thus, they are still connoted as a sketch. It is something of a contradiction therefore that art criticism confined the emotive immediacy of drawing to the mediation of the sketch that the paradigm of expression denied. In this fashion *no title* 1961 by Hesse has been attached to those sculptures made four years later and more. It remains a paradox therefore that the mode by which Hesse and Lippard venerate the artist's drawings is the means by which their value as 'art' is denigrated.

Attention to the High-Modernist discourse of expression that framed Hesse's practice for her and the concomitant model of monographical biography that structured Lippard's text puts these paradigms under pressure. 'Writing on a text of the life', published in 1988 by J. R. R. Christie and Fred Orton, takes on board cultural theory's critique of monographical biography as an inherently problematic medium. For the purposes of this Chapter, I would like to draw attention to the authors' first point of focus 'The work of art as object', by Richard Wollheim. Wollheim understands the 'dominant theory' of 'mainstream' modern art practice as follows:

> The modern painter equates the picture (that which is on the surface) and the physical object (that which is the surface, the ground), and regards the manipulation of paint not as preliminary to making art but as the making of art.[16]

Without the language of representation to mediate between artist, medium and surface, artworks become intimately connected to the artist's being. Later, in Chapter Two of this book, I clarify the ways in which the texts written for Hesse understand her work within the artist's own Abstract Expressionist vocabulary. What Christie and Orton track that is significant at present is the connection between the spectator and a modern abstract artwork across 'two logically distinct notions of expression in art that in *Art and Its Objects* [had been] referred to as "natural expression" and "correspondence."'[17] Natural expression posits the work of art as a conscious or unconscious recording of the state of mind of the artist that remains available for all to read in its colour and surface. Correspondence is

the correlation between the feeling aroused in the spectator who views the marks on that surface and the state of mind of the artist at the moment of making; correspondence 'may also be good for reminding the spectator of that emotional condition or reviving it in him or her'.[18]

'The expressive fallacy', written by Hal Foster and 'Abstract Expression' by Art and Language, enable Christie and Orton to deconstruct the notion of 'natural expression'. Foster's writing demonstrates that rather than an historical style, Expressionism should be understood as a language that has been 'designed to look and is claimed to be "natural", "immediate", 'a language made to look as if it is not one'.[19] But this language of art practice is 'coded in so far as the traces and colours, as distinct from the subject matter, stand metaphorically as representative of the artist's inner self and of his or her inner necessity to express it'.[20] Christie and Orton continue their argument with reference to 'Abstract Expression' written by Art and Language to unravel the way in which the cause of the viewer's emotional response is anchored to the biography of the artist by the critic via a causal chain.

> Expression claims about the 'meaning', 'content', 'effect' or 'expressive quality' of the surface of a painting which have any chance of sticking must be made implicitly or openly, tacitly or not-so-tacitly, with reference to and by way of not the gloomy, suffering and sorrowful surface, but with reference to and by way of the biography of the artist because, though paintings cannot be caused to be gloomy, suffering and sorrowful, people can.[21]

In short, 'Writing on a text of the life' concludes that 'expression claims that stick emotions to paintings are claims inferred from what critics know or conjecture about the life of the person who made them'.[22] The role of 'expression claims' in the feminist art criticism of Hesse's practice is taken up in detail in Chapter Two. Such insights immediately pose questions, however, to Hesse's dismissal of her work from 1962–1964. For Christie and Orton's critique of expression is crucial to the vision of the self-generating, isolated, 'talent' at the heart of monographical biography. *The Invented Self: an Anti-biography, from documents of Thomas Edison*, by David E. Nye, on which they also draw, underscores the ways in which a particular vision of 'individual personality' defines the 'pulsating centre' of biography.[23] From this individual 'emanates the shaping forces that guide events, articulate doctrines, empower social movements, and generate art'.[24] The role of biography in this mode is to recreate such heroes and it is this

mode that characterises the figure of Eva Hesse in the histories written for her and her practice.

I would prefer to construct the kind of history for Hesse that Nye evokes for Edison. Nye argues that subjects within history are not individual personalities fixed from the beginning of their lives that can be recreated by an author's text. Rather they are the bearers of a subjectivity that is always in the process of becoming, indexed by and the product of shifting, cultural, genealogical, historical, and social intersections that cannot be mastered by historical knowledge. The biographer's faith in the objectivity of their own text and veracity of primary sources is misplaced. For the notion of the primary source, Nye tells us, is only another expression of the search for the lost 'single unitary presence' of the subject of the text that can never be regained.[25] The biographer's appeal to the primary source as a locus of truth is thwarted from the very beginning because language is never a neutral tool whose transparency enables the writer to perfectly recreate events, or even to tell them as they happen.[26] Language is always coded and generated, re-coded and regenerated by the historical moment of its happening and its writing, painting or sculpting. The 'meaning' that we imbibe from texts and artworks has its beginnings in the kind of questions we ask, and the historical and cultural moment in which we ask them. The meaning that artists draw from their own practice functions likewise. In *Writing and Difference*, Jacques Derrida elaborates the roots of the desire to articulate the origin, the first book, as put forward by Jabès. Derrida demonstrates that the repetition of the origin does not in fact reissue it. Instead a 'trace' of the origin, which is not the opposite of the origin, 'replaces a presence [of the origin] which has never been present'. The origin has never been 'invariable' or 'sheltered from play'.[27] In ways quite different from those early and contemporary discourses that engage with Hesse's work by putting her immediately in the frame, this text offers no extract, no *voice* of the artist either from her diaries or notebooks on which to centre a truth. Rather in congruence with the post-structuralist analyses of Barthes et al it seeks to read the language of Hesse's documents and art history's evaluation of them in order to situate each within their creative, social and historical particularity that is nevertheless indexed to the present.

Making, Materiality and Movement: 'Means of Transport'
I have suggested that Hesse's artworks demand to be understood beyond the concept of 'ideas' that are realised in the visual. I have also suggested that the paradigms of affiliation and expression are insufficient for an understanding of the historical production of Hesse's unnamed drawings

from 1960/1961 and 1961. The question arises, therefore, how then can these two drawings be approached? To distinguish the processes between two and three-dimensional art practice is to register the relationship between materials and bodily movement, the compulsion and satisfaction of certain repeated gestures that may contribute to the signifying potential of Hesse's art practice. The mark left on the paper is the trace of a movement, a residue. In the case of repetition the sensation of that movement, the satisfaction that it answers, may be crucial to how the work comes to mean for the artist and what compels its making. This train of thought is enabled by 'Eye and mind', written by Maurice Merleau-Ponty in 1961. His classic text performs a compelling critique of the Cartesian dualism of the thinking subject whose mind is wholly interior and split from the body. Much like a 'puppet' the body is dislocated; confined to the 'outside' of the external world.[28] What Merleau-Ponty proposes is a model of 'transubstantiation' that 'by lending his body to the world the artist changes the world into paintings'.[29] This process relies upon 'the working, actual body – not the body as a chunk of space or a bundle of functions but that body which is *an intertwining of vision and movement*':

> The eye is an instrument that moves itself, a means which invents its own ends; it is *that which* has been moved by some impact of the world, which it then restores to the visible through the traces of the hand.[30]

To cross the boundary of the mind body split is to set up a different economy of making. The 'restoration' of some impact of the world denies the isolation of the monographical subject. The historically specific register of the body goes against the grain of a hitherto introspective vision of psycho-biographical corporeality. Movement with-in art making is thus accorded further significance. In this paradigm moreover, the artist is not simply a master (mind) that acts upon materials that are wholly extraneous to them; a model of making akin to what Hesse called 'connectiveness' with materials is enabled. To intertwine vision and movement within the 'world' is to transform art making into a dialogical, responsive physical process between maker, materials and the social.

Merleau-Ponty's philosophy of painting is addressed to a subject that is conscious of its perception. Yet the connection between the eye and the hand/body that renders something visible can be thought at the level of memory, the unconscious and more particularly trauma. *Matrix Halal(a)-Lapsus: Notes on Painting*, are Bracha Ettinger's published work- journals that

4 Bracha Lichtenberg Ettinger, *Eurydice, n.17*, (1992–96), oil and photocopic dust
on paper mounted on canvas, 40 x 25.5 cm.

chronicle the beginnings of the co-emergence of her art practice and
interventions in psychoanalysis. These two spheres of theoretical work are
woven together via the author's reference to Merleau-Ponty's philosophy of
painting:[31]

> The line is also a *means of transport*. A superimposition that flattens
> consciousness in expansion, brain of the hand. And all that which
> does not come through the eyes, still perceived, from the interior or
> the exterior.
> The hand is another thought. Hearing or not hearing thoughts
> which the hand meets. The freedom of the hand and the thought of
> the hand; the freedom of the line and the grains; the thought of the
> lines and the grains. The hand-line is a thought of painting. The
> hand-grain too.[32]

As the daughter of survivors of Ha Shoah, Ettinger's writing has come
into being in a psychic space that exists forever before, after and beside the
terror of the Holocaust. Suspended beyond the limits of language at the
level of the Real it is an event that cannot be known or mastered. Within
Ettinger's painterly processes the hand-thought re-inscribes the tableau
with the impact of the Real, as a medium of thought the 'hand' may act out
or work through experience in art practice to restore to the visible some
trace of that which is denied psychic recognition. Thus Ettinger maps a
new means of imagining the work of art in its moment of historical

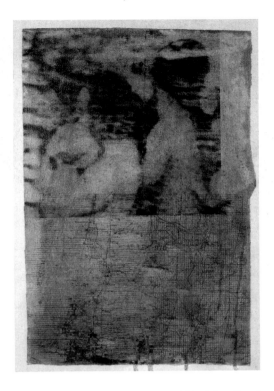

5 Bracha Lichtenberg Ettinger, *Eurydice, n.18*, (1992–96), oil and photocopic dust on paper mounted on canvas, 26 x 52 cm.

production that opens new possibilities for thinking about the processes and outcomes of Hesse's unnamed drawings. The hand thought is taken up in detail later in Chapter Five; my present focus must remain the discursive structures that regulate encounters with 'drawing'. For now, therefore, Ettinger's practice permits a further revision of the notion of repetition as the reoccurrence of the same. In 'Painting: The Voice of the Grain', Brian Massumi writes about the encounters between maker, making, media(s) and viewer(s), and the 'part-connections' between Ettinger's artworks. Again these concepts within Ettinger's art practice have co-emerged with and are thus shaped by her psychoanalytic theorisation of the Matrixial subjective stratum that will be elaborated in Chapter Two.[33] Massumi considers Ettinger's painting practice via the theorisation of the relation of 'seriation without filiation'.[34] In the case of the two drawing by Hesse, as in the *Eurydice* series by Ettinger (1992–96, figure 4 and figure 5), parts of paintings implicate each other within a connected whole. They 'call to each

other'. They 'come in crowds'.³⁵ Such connections do not frame these parts within a linear development that lead to a conclusion; to the 'finished' artwork. Ettinger works on several paintings at once and at intervals that can span several years. Close attention to Hesse's experimentation with the media of drawing and painting in the period between 1960 and 1961 shows a similar approach. In the painting *no title* (1960, plate 4) the overly fat oil that Hesse used would have necessitated drying times that exceeded several weeks. Thus, to work on more than one painting and quick drying drawings concurrently was simply practical. This studio methodology goes beyond common notions of a chronological creative progression. Rather this method of simultaneity, it can be suggested, can correspond to the non-linearity of psychic time. Between the drawings, paintings and sculptures that Hesse made the 'greater rhythm' that defines the whole, her oeuvre, may be distinguished. But this rhythm does not 'contradict the suspended isolation of each [work] icily alone,' each artwork's inner motion is free to be encountered by the viewer without bowing to a greater meaning.³⁶ With this insight in mind we may then appreciate the statement by Hesse quoted earlier:

> [...] I always did drawings but they were *always* separate from the sculpture or the painting. And I don't mean in a different style but weren't connected *they're not* ~~you know~~ a transfer sort of – they were related because they were mine but they weren't related in one completing the other. ³⁷

Encountering *no title* 1961

Six years separated that first glimpse of *no title* 1961 in reproduction and my encounter with the actual drawing. It was October 1999 and the gallery that was to show it to me was Robert Miller in New York's fashionable district of Chelsea. *No title* 1961 was propped up on a table piled high with the black slide and archive albums of the Estate of Eva Hesse. From a distance, I was struck by how small the actual drawing was. Even though the reproduction had been life size the pages of the *Eva Hesse Gouaches* catalogue had framed the drawing to make it appear larger. The real thing was window mounted in cream card and surrounded by a slim cream wooden frame. There it was. How strange, to be confronted with something you have known and yet not known for six years. I had expected the drawing to be a little different from the reproduction but in a way that would enrich the sense I already had. I was mistaken. Contrary to Benjamin's essay it was clear that the reproductive process had not brought

'out those aspects of the original that are unattainable to the naked eye yet accessible to the lens'.[38] The physicality of *no title* 1961 was all the more present for its execution on heavy water colour paper that had been neatly cropped to the edges of the drawing. As is so often the difficulty with dark works of art, its reproduction had heightened the contrast in the work at the expense of detail. In the catalogue the presence of one layer over another was only perceptible at the boundaries of the uppermost and left white passages of the drawing. Here, however, was a different drawing whose pronounced fluidity enabled the viewer to trace the making of its complex layers. Those seemingly still blocks of colour that in reproduction had a depth that invited the gaze of the viewer were unnatural after all; in the flesh they were less dense and had partially effaced another drawing beneath it, a palimpsest. The black ink of this drawing was not sepia but had a lilac tone and visible within it were fluid lines whose beginnings had hitherto only been visible in the right hand window in the image. The lines began in the space between the uppermost and right white passage. Part of their curved vertical divergent journeys to the bottom of the paper were made plainly visible by the left-hand passage that now extended across the middle of the work to the area below Hesse's initials. Further detail was revealed in the horizontal and vertical lines that intersected to separate the uppermost and right hand passages from the left of the drawing.

I peered at the drawing, as a painter, to discern the nature and order of those processes that had brought the work into being. On the borderline of this drawing's subcutaneous network of brushwork those marks visible in the uppermost white passage had emerged as water had been traced along the right side of a wet thin line of ink. In so doing a 'bleed' had been formed that marked the edge of the dry white paper. At the same time the direction of the stroke of a soft brush drawn on the paper can be seen by the greater presence of pigment at the bottom of the paper that had been trailed towards the top. The ease and steadiness of the line formed by the edge of this mark suggests that the paper might have been rotated during making. To make a downward or horizontal mark is far easier than an upward one. A further bleed traversed the white paper between the first line and that formed by the edge of this mark. The layers of wash that permeated the left and right-centre passage had dried before they were overlaid with lines. The drawing, therefore, began with a series of washes. It would seem that the flow of the materials and the artist's dialogue with them determined the image, rather than the work starting from a design. The lines that trailed off within the space of the right passage gave a clear indication that, as a left-handed person, Hesse repeatedly followed the

natural movement of her hand to form a slight curve. Two thirds of the
way up the drawing the natural horizontal flow of the hand shaped the lines
that intersect them. Some of these thin lines were subsequently worked on,
traced with the brush. Once they had dried a larger brush traced thicker
waving lines from the centre across them toward the bottom right of the
paper. The ink Hesse used was colourfast once dry and so these lines
remained permanent and visible as more concentrated colour was applied.
Around the three blank passages the ink is denser. To overlap two dark
layers around the right passage suggests a desire to create a contrast with
the areas Hesse wished to retain.

It was *no title* 1961 but I didn't recognise it. Did the 'authority' of this
'authentic' artwork disqualify all that I had intuited from the reproduction
that had authored a different image? The 'truth' of this 'original' artwork as
a *thing itself*, sheltered from the play of language and history, is an
impossibility that has been already acknowledged. Yet the validity of those
assumptions and perceptions made in 1993 may not arise from their having
been made in reference to the actual artwork, but because they formed the
conditions of the first meeting with *no title* 1961 in the flesh. The template
created by the reproduction heightened the actual affective experience of
the real drawing. What was crucial in 1999 was that the permeable darkness
repelled the wanderer; its trailing lines sent the viewer's gaze sliding off the
paper. Demoralised and apparently defeated I turned to the estate
catalogues on the desk and idly flicked through them. It was then that I first
saw the slide of *no title* 1960/1961.

Encountering *no title* 1960/1961 with *no title* 1961

No title 1960/1961 was produced in the same period, if not shortly before
no title 1961. Again this work was a visual and visceral shock. Whereas my
encounter with the reproduction of Hesse's *no title* 1961 had been marked
by ignorance my first sight of this earlier drawing (plate 1) felt all the weight
of too much knowledge. All I could see was the 'window.'[39] This motif in
Hesse scholarship is the production of a psycho-biographical reading that
indexes the artist's habit of creating a frame within her drawings to the then
current belief that Ruth Marcus Hesse, the artist's mother, had leapt to her
death from a window when Eva Hesse was a child. At that moment in the
Robert Miller Gallery the image gave an overwhelming impression of a
female figure with long flowing hair whose face was turned back to the
viewer, caught within a window frame a moment before departure.

A 'part-connection' may be drawn across the physicality of Hesse's two
drawings. The lines of each trail vertically down the centre and horizontally

cross the paper two thirds of the way up. Both employ a similar method moreover. On first glance it seemed that *no title* 1960/1961 began with the application of layers of wash on the paper. The form suggested by the first layer of brown wash was then traced as the paper was scored with the blunt end of a pencil or brush. The indent that resulted broke the surface of the paper to concentrate the fluid of the subsequent grey wash in lines. These etched line were then traced with significant pressure and supplemented by conté, soft pencil and charcoal that again indented the heavy paper. These marks were made on a small enough scale for the off-centre vertical lines to clearly follow the natural curve traced by the left hand. It is again possible, therefore, to argue that the figure in this drawing is not the product of a design recreated via a mastery of materials. This drawing had been produced in a dialogue with the artist. *No title* 1960/1961 emerged through an interplay of materials in which the artist listened to and connected with the forms suggested on and by the paper. Once Hesse recognised the figure that began to emerge on the paper she pursued it. Only then was the figure contained within the frame.

A space has been now cleared in Hesse's oeuvre in which her two unnamed drawings can be encountered for their own sake. I would argue, as yet however, that they still cannot be met on their own terms. Rather than immediately proceed to a direct engagement with *no title* 1960/1961 and *no title* 1961 the 'receiving context' of these works requires further inspection. To do so takes this text further along what began as an intuitive journey, in the lineage of Jabès, but has become a curious and demanding reading of the production of Hesse's histories and practice.

2

ADDENDUM: HEMISPHERES AND LOOSE ENDS

Action and acting are semi-illusory phenomena; they include not only the actor's hallucinations of mistaken identity but the inherent misapprehensions of their audiences.

> Harold Rosenberg, *The Act and the Actor: Making the Self*[1]

Addendum 1967, (plate 5) was first exhibited in *Serial Art* at Finch College in November 1967. It is the only sculpture made by Hesse currently in the collection of Tate Modern. On the wall beside it the gallery contextualises the piece with a caption that begins:

> This sculpture has a simple, serial organisation consistent with Hesse's belief that "the work exists only for itself." Though particularly spare, it has an organic informality that is characteristic of her work. The semi-circular forms from which the cords hang resemble breasts ...[2]

For the contemporary viewing public this work's painted papier-mâché hemispheres are thus framed by the visuality of sexual gendered forms and serial repetition. The literalness of the above reading would seem to leave little critical room to manoeuvre. This chapter argues, however, that there are ways that those 'semi-spheres' can be read beyond their resemblance to breasts. In order to do so the formal and theoretical genesis of the autobiographical programmes of the early Women's Art Movement that shaped the writings about this artist must be tracked. To locate the historical specificity of the gendered politics that still hold sway for Hesse's work is to create a supplementary critical space with which to consider the hitherto unexplored signifying potentialities of *Addendum* and other works by this artist.

'Hess' and Hesse

To begin I return to 1993 and my introduction not to the work of Eva Hesse but 'Eva Hess.' In the common pronunciation of her name, the final 'e' was silenced. Made mute by students and scholars alike it was not until the American feminist art historian Anna Chave lectured at the University of Leeds six years later that I heard of an artist called 'Hesse.'[3] The historical moment that we inhabit now and the enunciation of 'Hesse,' instead of 'Hess,' seem to signify, or at least coincide with, the beginnings of a change in the tide of Hesse's hitherto homogenised identity as an American Woman artist. The recognition of Hesse's ethnicity, as a supplement to the present focus on the question of sexual difference, is directed first and foremost by the Estate of Eva Hesse's support of new archival research and insistence upon the traditional pronunciation of the family name.[4] It is possible to situate the name Hesse within the particular history of German Jewishness. Prior to the Enlightenment Jews in Germanic territories were known only by a forename. This condition marked their social exclusion. The acquisition of citizenship in Germany and the attendant 'freedoms' that signalled the assimilation of Jews within society was thus dependent on the adoption of a surname. The drive to find a surname and stake a claim in the nation that now called them citizen and demonstrate their pride in it, led many Jewish families to take names from the towns and regions in which they lived.[5] The 'Hesse' region, in which the city of Frankfurt-Am-Main is located, may thus be a trace of both the geography and ethnicity of such assimilation. Under National Socialism the de-aryanisation of Jewish names became yet another tool of persecution. For German Jews therefore naming and the pronunciation of names is thus a freighted activity that bears a certain historical weight.

In response to an earlier version of this chapter the artist's friend William Smith Wilson told me that 'Hess' was in fact the way that Hesse pronounced her name in the 1960s. His generous and intelligent insights are, as always, instructive:

> My guess is that Eva, for whom authenticity was antinomy, apostasy, and autonomy, pronounced her name as her self-stylization, breaking rapport with Germany. She was born a baby without a country, why in hell should she pronounce her name in German? [...]
>
> In the meantime, as I understand Eva, herself constructing herself by making constructions, her birth-name would be raw material, like an art supply, for an expression of a meaning. That is, a change in her

name suggests her distance from Germany, her nearness to the United States.[6]

Indeed, the artist's friend Victor Moscoso confirms that when he first met Hesse at Cooper Union in 1954, at the age of 18, she already pronounced her name by silencing the final 'e.' He attributed the crafting of her name to her desire to mould her identity as an *American* artist.[7] Hesse, it could be argued, followed in her father's footsteps. Wilhelm Hesse Americanised his name by changing it to William when he began his immigrant life in New York in 1939. No matter how much we may consciously wish to, it must be acknowledged however, that a line between our (new) selves and our pasts cannot be drawn; our legacies travel with us. The 'identification' Hesse felt with Anne Frank, to be considered later, and an awareness of the fate she so narrowly avoided tells us that the artist knew this too.[8]

So is it Hesse or Hess? Further, beyond a respect for the Hesse family's wishes, does it really matter? What difference can such minutiae make to Hesse's audience? Isn't a text that splits hairs about pronunciation just another example of anal intellectualism? Surely how an artist's name is pronounced can only be incidental to the really important business of looking at 'the work'? I would suggest otherwise. I want to argue that as a part of the discourse created for and by Hesse this business of pronunciation is a crucial site for the production of meaning in her artworks.

'Character change and the drama,' written by American cultural critic Harold Rosenberg in 1932 offers a model with which to pursue this wider view.[9] The pronunciation of 'Hess' under which most scholars had laboured seems to me to be symptomatic of two things. First, it marks the line first drawn by Hesse between her 'American' self and her beginnings in Nazi Germany. Second, it is a sign of the dramatic 'character' built for Hesse in the historical moment of the 1970s upon the foundation of the artist's own 'construction.' The artist I am calling 'Eva Hess' was positioned as a universalised character that fulfilled a vital role for the Women's Art Movement and for subsequent generations of artists who were women, myself included. The insight afforded by Harold Rosenberg's essay, however, illuminates the way in which a 'poetical picture of a life' has come into play for Hesse due to gendered appropriation of 'events' that:

> Though seemingly related sequentially and causally, are chosen with reference to the application of specific laws leading to a judgement. The conventional coherence of these events, the suggestion to the

spectator that they have actually happened or are at least within the range of probability, is superficial, and far from determining the outcome of the action serves only to connect in the mind of the audience the natural world of causal determination with the dramatic world of judgement.[10]

The historical necessity for and inevitability of the shape, the gendered forms that the first generation's critical writings about Hesse took, must be acknowledged; they were products of the urgencies of the Woman's Art Movement in the 1970s. I do not intend to engage in an anti-essentialist, so-called post-feminist debate. The valuable insight of those early readings that recognised the differences brought to art practice by gender are not in question; they still need to be asserted in that nakedness. The focus on gender alone in the early texts written about Hesse has in many ways, however, exceeded its beginnings. It has been perpetuated by almost all of the subsequent discourse until the present day without due consideration being given to the impact of those early political agendas upon the readings they produced. Art history is at last becoming aware that, as Norman Kleeblatt tells us: 'Jewish ethnicity [is] a missing link in the discourse on diversity and difference.'[11] The historical moment of the late 1960s and early 1970s, when the first writings were produced for Hesse and secured what became the hegemonic discourse, precluded any recognition of either Jewish ethnicity or the impact of the events of/after the Holocaust as contributing factors in her art practice or, for that matter, that of any of her American contemporaries. Thus it is the structural origins of this lacuna as well as what has actually been omitted from the writings about Hesse that the following pages wish to explore.

First I wish to suggest that this gap may be analogous to what Evelyn Torton Beck identified in 'The Politics of Jewish Invisibility.' According to her analysis, much critical and feminist scholarship of the 1980s and 1990s did 'not yet recognise the presumption of a shared Christian (or non-Jewish) background as an equally unspoken norm within feminist theorising and within [its] own text[s].'[12] To draw Eric L. Santer's 'History beyond the pleasure principle' within the scope of Beck's argument, one must bear in mind that: 'The stories one tells about the past (and more specifically, about *how one came to be who one is or thinks one is*) are at some level determined by the present social, psychological, and political needs of the teller and his or her audience...'[13] Only when the limitations, what Beck would call the 'colonialist structure,' of the writing about Hesse and the methods she used to construct her 'identity' are acknowledged, will it be possible to '*proceed*

differently' to 'difference.' Only then can the artworks and utterances of Hesse be opened up to a more multi-layered and co-affecting cultural analysis that allows full recognition of sexual difference as one of *many* elements at play. Recognition of the Jewishness of Hesse's background *does not*, therefore, fulfil a desire to read her studio practice as the production of 'Jewish art' even though this is a burgeoning territory in art history today.[14] I do not want simply to exchange the identity of 'woman artist', for another, 'Jewish artist', or 'Jewish woman artist', or even 'German-Jewish-American woman artist.' As Alice Yaeger Kaplan remarks 'the way someone says hello, holds a pencil, wears a scarf—tells more about race, class, and gender than the dreary litany of categories ('I am white, female, middle-class heterosexual') that has come to pass in contemporary criticism for 'subject positioning'.'[15] Such a nuanced, expanded, inflected, and non-reductive analysis of how historical experience shapes a practice rather than finds expression in its content, can only begin with a close reading of the relation between Hesse and her two earliest critics, Cindy Nemser and Lucy Lippard who, in ensuring critical recognition for the artist, also shaped its exclusions.

'An Interview with Eva Hesse' appeared in *Artforum* in May 1970; a more extensive version was published in Nemser's book of conversations with women artists, *Art Talk*, in 1975.[16] Lippard's 'Eva Hesse: the circle' followed close behind Nemser's original *Artforum* article. Published by Lippard in *Art in America* in May-June 1971, it was the prelude to her monograph *Eva Hesse*.[17] Helen Hesse Charash, the artist's elder sister, was the driving force behind the publication of this book. Though Lippard finished writing the text in 1973 the editing, proofing, illustration, and design of the book meant it did not go into print until 1976.[18]

Both Lippard and Nemser's texts focus on Hesse's biography and its implication for her artworks. I do not believe as Jeff Perrone did in his 1977 book review in *Artforum*, that the sheer extent of the biographical detail of *Eva Hesse* was a testimony to Lippard's art historical impartiality. Rather I think that a significant part of the structure of that book can be attributed to the then novel autobiographical politics of the early Women's Art Movement. In the same year in which Lippard's monograph appeared "The circle" was republished by her in *From the Center: Feminist Essays on Art*. In that collection two further essays "'What is female imagery?'" (1973) and 'Changing since changing,' situate the politics of the texts Lippard wrote for Hesse's work.[19] These essays were not only fundamental to feminist art theory but also to the prevalent tropes of the subsequent texts written for 'Hess.' It is clear that the almost simultaneous writing and publication of

the works of Nemser and Lippard precipitated the critical discourse that surrounded Hesse and her work. Each text seamlessly confirmed and supported the other because their readings were 'objectively' grounded in the same remarkable primary source: the unpublished ninety page transcript of Nemser's interview.

Nemser recorded her interview with Hesse in 1969. At the time the artist had been in remission from her ultimately fatal brain tumour but its publication preceded her death by only a few weeks. In the New York art scene around 1965–69 both Hesse and Lippard had been accepted within the clique that the critics had named the 'Bowery Boys.'[20] Although Hesse's work was connected to the Minimalist and Process art world set in New York, it was fundamentally different from it. The first few paragraphs of 'An Interview with Eva Hesse' in *Artforum* articulate this difference. Carl Andre, said Hesse:

> Says you can't confuse life and art. But I think art is a total thing. A total person giving a contribution. It is an essence a soul, and that's what it's about ... In my inner soul art and life are inseparable. It becomes more absurd and less absurd to isolate a basically intuitive idea and then work up some calculated system and follow it through—that supposedly being the more intellectual approach— than precedence to soul or presence or what ever you want to call it ... I am interested in solving an unknown factor of art and an unknown factor of life. For me it's a total image that has to do with me and life. It can't be divorced as an idea or composition or form [...][21]

In the absence of possible female role models in the art world, the respect for Hesse's art practice and its apparent difference from the logicality of contemporary art by men was remarkable. Nemser recognised Hesse as a key figure for her own emerging project around the topic of women in the arts, of which this interview is part of a primary ethnography.

Nemser had embarked on a series of conversational style interviews with artists of both sexes in the late 1960s, and *Art in America* had subsequently offered to publish an article by her. It was during this period that Nemser 'became aware of the women's movement and discovered that it had great personal meaning...'[22] She outlined her desire to address the unsatisfactory isolation and derision under which women artists had to work in a letter she sent to Hesse dated January 6, 1969. To this letter Hesse responded by writing in its margins: 'excellence has no sex – the way to beat discrimination in art is by art'.[23] This typically Modernist statement negated

the possibility of Hesse giving conscious support to politicised individuals and groups that sought the title of 'women' artists. 'An Interview with Eva Hesse,' still succeeded as an extension of Nemser's forum project however, because the dialogue articulated one of the hitherto inaudible voices that would, in conjunction with the readings put forth by such texts as 'The circle' and *Eva Hesse*, empower subsequent women artists. 'My idea now,' Hesse said, 'is to counteract everything I've ever learned or been taught about [composition and form] – to find something that is inevitable that is my life, my feeling, my thought.'[24]

In 'The circle,' Lippard goes beyond the content of the Hesse-Nemser transcript to formulate her argument via the artist's journals and the reminiscences of old friends. Her text began, however, with an epigraph taken from the writings of Jean-Paul Sartre:

> Man is nothing else than his plan; he exists only to the extent that he fulfils himself; he is therefore, nothing more than the ensemble of his acts, nothing else than his life [...] When we say 'You are nothing else than your life,' that does not imply that the artist will be judged solely on the basis of his works of art; a thousand other things will contribute towards summing him up [...] When all is said and done, what we are accused of at bottom, is not our pessimism, but an optimistic toughness.[25]

Lippard takes her lead from the artist's belief in the inseparable nature of art and life to situate the ensemble of Hesse's acts, the collection of artworks left behind after her death, in relation to the 'thousand other things [that] will contribute to summing [her] up.' For Lippard these 'thousand other things' were the difficulties Hesse faced as a woman artist.

'Changing Since Changing,' Lippard's introduction to *From The Center*, retrospectively defines these difficulties. In that essay the critic recalled her familiarity with the 'professional-looking' studio spaces of artists that were men. To occupy such a space, away from the humdrum of everyday life, had the power to confirm the title 'artist.' The peace afforded by a studio was a significant aid to the audibility of the dialogue between maker, concept and materials. The privilege of a professional studio, Lippard believed, was thus critical to the 'air of self confidence' that the practice of men demonstrated. They were perfectly at home with 'jargon' and the 'articulation of formal problems, in other words, [they knew] what they were doing.'[26] When in the winter of 1970 Lippard began to visit the workspaces of artists that were women, however, she discovered a marked

contrast. She writes: 'I found women in corners of men's studios, in bedrooms and children's rooms, even in kitchens working away [...] I found some women were confused, unsure of themselves, much more vulnerable [...]'[27] 'The circle' may thus be read within Lippard's awareness of this gender specific linguistic and spatial displacement:

> A fundamental insecurity affected [Hesse's] personal life and her work, augmented by the fact that as an attractive young woman and wife of an older, more confident sculptor, she faced the disadvantages met by most woman artists. [28]

For Lippard Hesse's anxiety bore witness to the low self-esteem that arose from the vicissitudes of working as a woman; first as the wife of an older established artist and later within the 'rotten structure' of the New York art scene that perpetuated sexual discrimination. In the 1976 monograph Mel Bochner substantiated and helped Lippard cement this argument:

> In that heyday of "rigor" and "structure," Hesse seemed "very radical or very eccentric," Bochner recalls. "She was never afraid of that. She wasn't afraid of being old fashioned or of the work being about certain other issues, which right now looks very courageous, to go against public opinion like that." She kept her eyes and ears open. She was willing to learn, which may have appeared to be a lack of self confidence." Her isolation as a woman artist produced a certain internalisation, and there were times when her artist friends' attitudes toward her seemed rather patronising. She was a "beginner," and often, by choice, a "little girl." They admired her as much for working against the fashion as for the work she was actually making [...] [Sol] Lewitt, [Ruth] Vollmer, and Bochner all told her that Repetition Nineteen didn't work when she insisted on denting and manipulating the forms, although later they acknowledged that it was important piece. The preoccupations of her friends with aspects of art that were foreign to her occasionally intensified her insecurity: "Sometimes I feel there is something wrong with me. I don't have that kind of precise mind or I just don't feel that way. I feel very very strongly in the way that I feel, but I don't stand on a kind of system. Maybe mine is another kind of system...[My works are] much closer to soul or introspection, to inner feelings. They are not for architecture or sun, water or for the trees, and they have nothing to

do with colour or nature or making a nice sculpture garden. They are indoor things."[29]

In later years, made in the community of the Bowery Boys with the assistance of fabricators such as Doug Johns, Hesse's was without doubt a professional practice. Lippard nevertheless makes clear the difficult task of what Hilary Robinson describes as, 'negotiating the conflicting codes of 'woman' and 'artist,' in her life, in her work and in her concept and representation of self.'[30] With great acuity Lippard recognised that rather than enabling a quick fix panacea, the dissemination of artworks by women caught them and her writing within the problematic that has continued to perplex feminist historians of art since the 1970s. How can or should art by women be positioned in relation to the canon?[31] To profile the work of artists that were women, to undertake curatorial projects, to locate their displacement by the system was also to implicate them within it. To bring them to the critical attention of a mainstream of which they knew nothing was to draw them within the 'current rotten structure' that Lippard despised.[32]

In Hesse's case there was a further difficulty, however, one that Sartre's 'optimistic toughness' particularly answered. Lippard cites the artist's 'obsession' with the past; that her 'emotional soil was not of the present.'[33] The monograph dwells little on that past however. The critic had access to the complete Hesse-Nemser transcript yet her text did not situate the artist's 'fundamental insecurity' within the historical specificity of the traumas in Germany and New York that Hesse described in that dialogue. I suggest a more complex explanation of this omission later. At present, however, this decision must first be situated in Lippard's desire, as Wagner notes, to resist the burgeoning myth of a Hesse whose life was marked by tragedy. In the early 1970s to dwell on Hesse's beginnings in Germany would have only reinforced the romantic dramas being written for this young artist. Instead 'The circle' and Lippard's monograph were guided by Hesse's letter of 1965 to Ethelyn Honig:

I wonder if we are unique, I mean the minority we exemplify. The female struggle, not in generalities, but our specific struggles. To me insurmountable to achieve an ultimate expression, requires the complete dedication seemingly only man can attain. A singleness of purpose no obstructions allowed seems a man's prerogative. His domain. A woman is side tracked by all her feminine roles from menstrual periods to cleaning house to remaining pretty and 'young' and having babies. If she refuses to stop there she yet must cope with

them. She's at a disadvantage from the beginning ... she also lacks the conviction that she has the right to achievement. She also lacks the belief that her achievements are worthy. Therefore she has not the steadfastness necessary to carry ideas to the full developments. There are handfuls that succeed, but less when one separates the women from the women that assumed the masculine role. A strength is necessary and courage. I dwell on this all the time. My determination and will is strong but I am lacking so in self-esteem that I never seem to overcome. Also competing all the time with a man with self-confidence in his work and who is successful also.[34]

This passage has become Hesse's canonical statement on the inequalities of gender for artists. Lippard's insistence on the particularity of women's experience was crucial to the enabling of a feminist politics of art practice because it perceived the anxieties and disadvantages that they endured as a resource on which artists could creatively draw. Lippard's model of 'optimistic toughness' held out a promise that empowered women; they did not have to play the games on which the system depended. Rather than an obstacle the condition of being a woman, the exclusions and want of 'professional' studio space felt by so many, pressed the everyday upon their practice to the point at which it invaded their work and demanded an exploration of the self within it.[35] Writing in 'Changing Since Changing,' Lippard understood this liberation of personal and associative meaning to also go beyond the making of the work to shift the role of the audience. In a move that prefigures Ettinger's theorisation of the encounter Lippard reads the relation between artist, artwork and viewer as a 'sharing' of subjective experience. 'It is,' she wrote, 'no coincidence that the advent of behaviourist, autobiographical art coincided with the rise of the Women's Movement.[36] The 'optimistic toughness' that Lippard mobilised against the burgeoning Hesse myth nevertheless eased the artist's assimilation within an archetype. Hesse's biography came to embody a rite of passage fundamental to the emerging trope of the heroic woman artist determined to make art despite and against all the obstacles. This journey, it seemed in 1971, was readily available to anyone who took the time to look at Hesse's practice:

When a critic wrote in 1966 that the mood of Eva Hesse's work was 'both strong and vulnerable, tentative and expansive,' her stepmother said it sounded as though Eva herself were being described. In fact, the core of her art was the core of Eva's self; the two were inseparable

for her and for anyone who knew both the work and the artist. Those who did not come into personal contact with her know more about her than they realise, for to reach out to her work, or to be reached by it, was to be in touch with Eva's most profound aspirations. The tightly bound, imprisoned quality of so many pieces, the complementary structural strength supporting trailing linear elements can inevitably be connected with the truly anguished young woman who wanted to be a child again, and at the same time managed a disastrous life with such basic toughness and maturity that she triumphed through her work. [37]

For Lippard it was this basic toughness that led Hesse to triumph over the difficult isolation presented by her return to Germany in 1964: 'a country from which she had fled as a child, [in which] she was forced into a painful but fruitful confrontation with herself.'[38] Hesse's 1964 notes from *The Second Sex* by Simone de Beauvoir made whilst in Kettwig form the impetus for that 'confrontation':

What woman essentially lacks today for doing great things is forgetfulness of herself; but to forget oneself it is first of all necessary to be firmly assured that now and for the future one has found oneself.[39]

This period was a milestone in the artist's studio practice. Lippard translates Hesse's notations into concrete terms: 'the process [of finding oneself] began for Eva Hesse when she followed into three dimensions the organic machine like images of a group of drawings. The shapes were those with which she had always been obsessed – irregular rectangles, parabolas, trailing linear ends, curving forms, and circles bound or bulged out of symmetry; appear in her drawings from at least 1960.'[40] To find oneself in sculpture necessitated remembering the self in drawing. By the time the monograph was written in 1973 Lippard had honed her belief in the immediacy and expressivity at the core of Hesse's work:

Because of Hesse's total absorption of herself in her work one reads the work as one reads the person, not in a gossipy or personally associative so much as in an archetypal manner; in that sense this interpretation could be arrived at by someone who did not know the artist at all. In fact, those who had no personal contact with Hesse know more about her than they realise, for to reach out to her work or to be reached by it is to be in touch with her most profound aspirations.[41]

In *Three Artists* Wagner points out of course that 'knowing Eva Hesse meant knowing a version of her: the one the excerpt presents.'[42]

'What Is Female Imagery?'

Today it seems very clear that if a woman's experience in this society is entirely different from that of a man – biologically, socially, politically – and if 'art is an essence, a center,' as Hesse put it, coming from the inside of a person, then it would seem equally obvious that there are elements in women's art that are different from men's, not elements of quality but elements with esthetic results [...] Within a more recent context she might have been able to feel that the strength too was feminine, and to see the work, and herself, as a female entity. At the time, however, her respect for and insistence on a personal content made superficial specificity seem irrelevant. The fact remains that Hesse, like many more women than men, used circles and a central focus (especially in her earlier work), distorted geometry, layers, veiled and hidden forms. While her hemispheres are usually non-assertive, her vessels usually empty, their tangibility encourages a sensuous response; their evocativeness encourages a personal and associative response.[43]

It is no coincidence that autobiographical art practice emerged alongside the early texts written for Hesse. Indeed it is possible to argue that Lippard's pivotal role in each secured the co-emergence of inextricable discourses. In the forum 'What is female imagery?' held between contemporary women practitioners and critics Lippard outlined the prevailing motifs of 'female *sexual* imagery': 'circles, domes, eggs, spheres, boxes, biomorphic shapes, maybe a certain striation or layering.'[44] All of these formal qualities and methodologies have a sexual or gendered referent that was understood at that moment to be consistently evident in women's art. The similarity between them and Lippard's 1971 description of Hesse's formal vocabulary of 'trailing linear ends, curving forms, and circles bound or bulged out of symmetry' is so clear that the critic could easily have been describing Hesse's work.[45] Concomitant to this declaration of the politics of form 'What is female imagery?' made visible the newfound agency of women artists. The gathering was itself was revolutionary. It recorded the new communal consciousness that was geared towards a more collective creativity. Their dialogue had been a direct reaction against the isolation of women artists working before 1970. Alienated not only by the phallocentricism of the art historical canon they also had been displaced

from their own experiences as women and the experiences of other women artists. As part of this autobiographical agenda, feminist art theory in the early 1970's drew a clear boundary between the 'anti-linear,' anti-logical subjectively expressive approach of women artists and the logical non-subjective, intellectual opticality felt to be typical of contemporary work by men. This distinction can be discerned in 'What is female imagery?' in which Joan Snyder spoke of the symbiosis between herself and her work:

> If anybody was really looking at my work, I'd be very embarrassed because they'd know all about me. *My work is an open diary.* That's what I often miss in men's work an autobiographical or narrative aspect ... Men talk about art a lot and I don't think women talk about art so much as they talk about life.
>
> Lippard: You made this beautiful claim – which maybe all of us feel but are scared to make: that you can tell women's art from men's art. How?
>
> Snyder: It has to do with a kind of softness, layering, a certain colour sensibility, a more expressive work than any man is going to right now, and a repetitiousness – use of grids, obsessive in a way. When I look at women's art, I look for ideas and images that not only move me visually, but tell me something about who the artist is, what she is, what she trying to say. [...] In 1968 I did flock paintings, using flesh colours and sensuous, vagina-type shapes, stretching membranes, little seeds, floating objects. They were sensuous paintings and they were about me. [46]

In *On Abstract Art* Briony Fer cogently argued that the construction of a gender binary between the rationality of Minimalism and the irrationality of autobiographical practice by women may impose a restraint upon Hesse scholarship.[47] Lippard had feared a 'prescriptive' definition of 'female' form. Thus her resistance to the jargonistic articulations of formal problems had been not so much to do with their angular or 'phallic' results. Rather, she objected to what she perceived as the 'closed' nature of these forms and their making to enforce the boundaries of his work as 'things-in-the-world' separate from both maker and observer.[48] With subjectivity of the maker evacuated those 'thousand other things' were precluded from the practice of artist's that were men. For Lippard their work lacked the 'variety' that, in 1973, connected 'to fragmentation and to the autobiographical aspect...'[49] 'In the best detached minimal tone' Hesse described *Addendum* as:

A thing added or to be added. A title is after the fact. It is titled only because it is preferred to untitled. Explanations are also after the fact. The work exists only for itself. The work must then contain its own import.

The structure is five in high, nine feet eleven in long, and six in deep. A series of seventeen, five-inch diameter semi-spheres are placed at increasing intervals. The interval progression is as follows: 1/8, 3/8, 5/8, 7/8, 1 1/8, 1 3/8, 1 5/8, 1 7/8, etc. the semi-spheres are attached to the structure. They become united with the structure by means of the repetition of form, and progressive sequence of placement. Equally unifying factors are the surface texture and the rope pulled through the centre of each form. The three separate units are then made into one. The monochrome colour is a light neutral grey. The chosen nine foot eleven inch structure, the five-inch diameter semi-spheres and the long thin rope are as difference in shape as possible. The choice of extremely difference forms must reconcile themselves. To further jolt the equilibrium the top of the piece is hung seven feet high.

The cord is flexible. It is ten feet long, hanging loosely but in parallel lines. The cord opposes the regularity. When it reaches the floor it curls and sits irregularly. The juxtaposition and actual connecting cord realises the contradiction of the rational series of semi-spheres and irrational flow of lines on the floor. Series, serial, serial art, is another way of repeating absurdity.[50]

The use of repetition in works such as *Addendum* qualified Hesse's membership of the Bowery Boys.[51] This serial vocabulary of 'modular and serial frameworks' are transgressed however; for although *Addendum* 'first leans on its given support, it departs into the unexpected.'[52] 'Neater and better behaved' than *Ennead* 1966 (plate 6), it still 'reaches the floor only to coil in luxurious confusion.'[53] Hesse's 'intensely eccentric core' is still perceptible because its production had been enabled by the lack of a preconceived programme. Hesse's 'different type' of system had been guided by what she named the 'connectiveness' between maker and materials.[54] For Bochner it had been Hesse's 'way out of the mental blockhouse.'[55] For Lippard, writing in the early 70s, Hesse's consistent use of a hand-made methodology was her great *tour de force* for it tied her repetitive vocabulary of making to those chores that associated women with craft.[56] Patriarchal society had persistently directed women's creativity

towards such activities as 'tying, sewing, knotting, wrapping, binding, knitting, and so on.'[57] Thus Hesse's interest in 'finding out through the working of the piece some of the potential and unknown and not preconceived' enabled the 'openness' that, for Lippard, was instrumental to autobiographical practice.[58] The first page of the monograph *Eva Hesse* states that:

> In fact, [Hesse's] life and her art were so close that she did not concentrate on any specific content while she was making a piece: 'First when I work it's only the abstract qualities that I'm working with, which is the material, the form it's going to take, the size the scale, the positioning, where it comes from, the ceiling, the floor ... However I don't value the totality of the image on these abstract or esthetic points. For me, as I said before, art and life are inseparable. If I can name the content, then maybe on that level, it's the total absurdity of life.'[59]

Here, process suffuses the art object with narrative, with autobiography; it is the place where the person becomes the work and work becomes the person. Art and life become one under the rubric of a biographical collapse. Wagner's excellent explication of the value of the trope of the 'artist as social misfit' may be supplemented here via Rosenberg's concept of the 'Missing Person' in the early 60s.[60] The artist must retreat from society at large or, in Hesse's case, from the systematic projects of her own peer group. In exchange the artist is promised a discovery or recognition of the voice, 'soul' or 'essence' at the centre of the 'self.' Only then, as the notes that Hesse gleaned from Picasso tell us, without a programme or an 'image in the mind' with which to approach the canvas, the artist is able to 'simply express what was in us.'[61] The danger of such a paradigm is, to borrow from 'American Action Painting,' that the decision 'just TO PAINT' infuses the meaning of art with the pre-presence of the author; the surface becomes 'the same metaphysical substance as the artist's existence.'[62] As the articulation of an intransigent 'essence' Hesse's work is shielded form further hermeneutic intervention. Thus a tension may begin to be discerned between the lines of Lippard's feminist politics of shared experience and the patchwork of autobiographical and monographical paradigms that, via Hesse's understanding of her own practice, borrowed from Abstract Expressionism to refuse the solipsism of serial form. For the notion of a core creative 'self' calls forth a fixed truth that forecloses the possibility of a dynamic dialogue between artist, artwork and viewer. The interpretation of

an artwork becomes dependent on verifications that turn on the artist's awareness of self and thus as Christie and Orton have argued, inadvertently, fixes 'right' and 'wrong' readings. In spite of Hesse's enthusiasm for Abstract Expressionist modes of art making her own early writings and the Hesse-Nemser transcript question this framework. Art may have been an 'essence' and a 'centre' for Hesse but for her that did not outlaw the intuitive response of the viewer. Hesse believed that if 'preconceptions' were brought to her artworks they would foreclose the possibility of experiencing the 'unknown quality' that resides alongside and beneath the formal vocabulary of a work of art.[63]

Hesse's interest in the encounter between artwork and spectator can be traced to her studies at Yale. In her essay 'On Significant Form,' written for her philosophy of art class, Hesse examines the writing of Clive Bell. In it she considered the potential of significant form to enable the 'observer (listener) to experience aesthetic emotion.' As Hesse understands it this concept does not ask the spectator to read the representational elements of a work of art for its 'meaning'.[64] Although this is the work of Hesse the student, rather than the more 'mature' theorisations of a professional artist, its significance lies in her attraction to a mode of art history that recognises and emphasises the hitherto neglected transformative mechanisms that are active within making. Hesse's parenthetical reference to the intuitive 'listening' to a work of art is telling. Her argument demonstrates a burgeoning critique of the notion of a 'correct,' intellectual response. Instead she acknowledges that what the artist 'has dealt with and embodied with feeling has a meaning for him [...] the spectator might comprehend [it] differently, or, [...] he might have no awareness' of the artist's intention at all. For Hesse, therefore, if the discourse of art history was to 'yield satisfactory standards for analysis both perspectives must be considered.'[65]

Lippard's resistance to the modernism of Hesse's statements in general and of her understanding of *Addendum* in particular testify to the presence of two such 'perspectives'. Lippard retrospectively read Hesse's artworks from a cognisance that the artist could not possess. Her death before the advent of the Woman's Movement meant that her attitudes to gender in art practice were still characteristically modernist.[66] Hesse was, therefore, still blind to the impact of this dimension of her subjectivity and its possible outcome for her artworks. Critics such as Lippard have born witness to this blindness. Reference to Hesse's archive is thus not to re-invoke the pre-presence of the artist/author. Rather it is to illuminate the difficulty enacted by any project fuelled by a desire to fix the 'who' behind the making of a work of art. As a locus of 'self,' 'soul,' 'essence,' a 'centre' the work becomes at once caught

between the 'truth' bound paradigm of expressionism and the dialogue of encounter that is fundamental to a feminist politics of art's histories. In order to proceed beyond this impasse the model of an introspective gaze, a self at the core of Hesse's formal vocabulary, must be traversed.

Autobiography?

For Lippard the 'circle,' the 'empty vessel' and 'confusing,' illogical, non-symmetrical elements when combined with a craft-like methodology had a power that bespoke *the* condition of woman.[67] There is no doubt that Hesse's artwork has been interpreted and has functioned for her audience as an anti-structural, autobiographical, and therefore, anti-patriarchal, move ahead of its time. As a woman practitioner that appeared to write herself within her art practice through a heroic journey Hesse was rendered 'universally intelligible to all women.' To view autobiography in the early 1970s as an individualist articulation of sexual difference, a formal vocabulary anchored by biological fact would, however, be reductive and a mistake commonly made by the kind of criticism that has charged has sought to expose the 'essentialist' focus of art's engagement with sexual politics in the 1970s. In 'The Politics of Theory: Generations and Geographies in Feminist Theory and the Histories of Art Histories,' Griselda Pollock locates the significance of then new cultural, political and social theories of the 1950s and 1960s in the formation of contemporary feminism:

> The legacy of New Leftism and other political critiques deriving from civil rights movements, black power, anti-racist, anti-colonial struggles and student revolts gave new impetus to the study of ideological practices and cultural forms as being both privileged sites of *ideological* oppression and the place from which to mount *cultural* resistance. At the theoretical level, New Leftism challenged the idea of culture as Culture – truth, beauty, the best idea and values of civilisation – by proposing that culture is ordinary, a 'way of life,' a 'way of struggle,' the territory of social meaning and identities.[68]

In 'The body politic: female sexuality and women artists since 1970,' Lisa Tickner argued in 1978 that this blessing of greater social freedom that women had witnessed over the past twenty years had also become a 'curse'.[69] Women's bodies were a 'colonised territory [that] must be reclaimed from masculine fantasy' she argued.[70] Feminism was thus

compelled to intervene on the level of representation in order to find a cultural voice with which to express women's own sexuality.

The theorisation of the gaze and the fetishisation of the woman's body in the influential essay 'Visual pleasure and narrative cinema', published in 1975 by the theorist and filmmaker Laura Mulvey, has been fundamental to this struggle.[71] The author conceived of 'a political use of psychoanalysis' to show the way that vision can be used to confirm and help produce patriarchal power relations that subject women to an objectifying gaze. She argues that the visual pleasure of narrative cinema resolves the crisis of castration for the masculine viewing subject. The fetishization of the body of woman, the glamorisation in the case of film or the idealisation of the female figure who does not possess a look herself in the case of western art, enables the masculine subject to resolve the terror of castration by disavowing the existence of woman's 'lack'.[72]

In the 1970s artists who were women in the 1970s emphasised lack in the form of 'vaginal iconology' as part of a larger autobiographical project. This iconography sought to empower women by its refusal of patriarchy's need for fetishism and thus acted as a counter to the masculine fear of castration. This conscious emphasis on lack can be viewed in such classic works as *The Dinner Party* 1974–1978 by Judy Chicago. Further to this end 'an unconscious use of the 'centralised void' was perceived by Chicago and Schapiro in the work of artists that pre-dated the Women's Movement such as Georgia O'keefe, Barbara Hepworth and Lee Bontecou.[73] Such a strategy was not unproblematic. Tickner argued that in the late 1960s and 1970s, since women had no images available with which to express their own lived experience of their sexuality, they had to use those already available in the psychoanalytic and cultural public language that was to hand. Here, therefore, the often touted charge of essentialism levied at Chicago et al collapses. For as 'Border Crossings: Womanliness, Body, Representation,' written by Hilary Robinson, argued 'the specifics of female bodily experience are seen as cultural in origin.'[74] In 1996 Pollock elaborated the difficulties that had arisen from the project of the 1970s:

> At present, women's culture suffers unbearably from too much 'reading in.' Critics appear confident in their interpretations of artwork by women: it means this; she is saying that; it is feminist because she shows this ... Apparently, we already know what women are, feel, experience as women. The work remains tied in a loop of current ideological constructions of femininities. This denies the radical unknownness of the unconscious and the depth and

profundity of the alterity to which patriarchal cultures condemn those it calls 'woman.' Thus the feminine ceases to function as a radical rupture of patriarchy, and we produce an idealised femininity based on the identification of the good mother to the exclusion of female aggression and other sadistic impulses or the ambivalence at the heart of all subjectivity.[75]

Pollock looks to the writing of Ettinger as a means to evade this impasse. The artist and psychoanalyst proposes that 'women infuse the symbolic universe – already burdened with ideas concerning femininity – with other suggestions, in order to enrich the cultural historical 'text' concerning women and the feminine.[76]

Thus, although caught within ideas of what femininity was, in the 1970s women's autobiographical writing and art practice was seen as a significant 'defiance' that extricated feminine corporeality from the dominant cultural representation of woman as a passive vehicle of carnal and scopic pleasure in the classical stereotypical female nude.[77] Culture was re-presented with a de-eroticised female body, the 'challenge of its taboos and the celebration of its rhythms and pains, of fertility and childbirth', as Tickner said, that showed 'what it was to live in a female body, not look at it as a man'.[78] In the classic and still powerful feminist text, *The laugh of the medusa*, Hélène Cixous explained that:

> By writing herself, woman will return to the body which has become more than confiscated from her, which has been turned into an uncanny stranger on display ... censor the body and you censor the breath and speech at the same time. Write your self. Your body must be heard. Only then will the immense resources of the unconscious spring forth. Our naptha will spread, throughout the world, without dollars – black or gold – nonassessed values that will change the old rules of the old game.
>
> To write. An act which will not only 'realise' the decensored relation of woman to her sexuality, to her woman's being, giving her access to her native strength; it will give her back her goods, her pleasures, her organs, her immense bodily territories which have been kept under seal [...][79]

In 'Inscriptions in the feminine,' Pollock locates the arguments of Hélène Cixous within women's need to 'imagine new signifiers, to generate the signifying system that would allow a feminine imaginary and a feminine

symbolic to be an effective part of the culture that at present leaves women in exile, in dereliction, in the wilderness enforced by the blanked-out page.'[80]

What Pollock and Tickner et al make possible for a reading of Lippard's texts of the 1970s is a shift from the search for the externalisation of an interior coherent isolated 'who' or 'self' at the centre of Hesse's work. Art works are produced by subjects with-in culture/history/society. To borrow from Griselda Pollock's writing on Mary Kelly that, I believe, was informed by the writing of Ettinger:

> The artwork ceases to be a fetishised object, the deposit of a coherent, autonomous subject author. It is theorised as a text, a site of a working through culturally as well as personally freighted materials. Art practice, in addition to the meanings that the artist actively calculates and manufactures, registers traces of the processes of subjectivity that are always both conscious and unconscious at the level of a productive semiosis – a production of meaning via signs in which the culture of reception, the reader is vital as the process of producing.[81]

To acknowledge the 'what' of Hesse's art practice, the historical specificity of its production and reception, is to perpetuate this text's preferred model of scholarship that is predicated on layers and supplements rather than competing definitive answers. More to the point, however, in the case of Hesse the fallacy of autobiography as the conscious writing of one's life, the cause of so much contradiction and complexity in the texts written for this artist, can be elucidated. The classic text *What Does A Woman Want? Reading and Sexual Difference*, published by Shoshana Felman in 1993, formulates feminism itself as a practice of 'reading literature and theory with [your] own life – a life, however, that is not entirely in [your] conscious possession.'[82] In the case of women, Felman argues, '*none of us, as women, has yet, precisely, an autobiography.*'[83] Felman's insight can be tracked to her writings on psychic trauma and the difficulties of bearing witness to the Holocaust, published in *Testimony: Crises of Witnessing in Literature, Psychoanalysis, and History,* in 1992 with Dori Laub.[84] 'Because trauma cannot simply be remembered:'

> It cannot simply be 'confessed': it must be testified to, in a struggle shared between a speaker and a listener to recover something the speaking subject is not – and cannot be – in possession of. In so far

as any feminine existence is in fact a traumatised existence, feminine autobiography *cannot be* a confession. It can only be a testimony: To survival. And like other testimonies to survival, its struggle is to testify at once to life and to the death – the dying – the survival has entailed.[85]

Feminist art history has read for the testimony of Hesse's survival as a woman and an artist in a patriarchal age. And as a feminist practitioner and writer I am indebted to that intervention because it bore witness to what Hesse herself could not. But in *What Does A Woman Want?* Shoshana Felman cautions any writer or reader of the pitfalls in 'getting personal':

As educated women we are all unwittingly possessed by the 'male mind that has been implanted in us,' because though women we can quite easily and surreptitiously read literature as men, we can just as easily 'get personal' with a borrowed voice – and might not know from whom we borrowed that voice. [86]

The insights recorded by Lucy Lippard were invaluable. But due to their construction via the theoretical frameworks used by the artist and the early interventions of the Woman's Art Movement they could not help, in the 1970's, but be in the lineage of traditional art historical criticism. Hesse holds a special place in the esteem of many feminist art historians and practitioners. This esteem, attributable to the appeal of the myth of the heroic journey of the woman artist, hails not only from her art works themselves but also from her perceived resistance to male pedagogical figures, to the systems of her peers and the work of her husband Tom Doyle. In conversation with Nemser Hesse infamously described her marriage as a 'backwards' step, a detour from the vocabulary of form that was 'much more me' that had been evident in her 1960–61 drawings. In that transcript she also recalled her dislocation from the both the artistic and intellectual mainstream at Yale. She had been Josef Albers' favourite student in his colour course. Albers was also a German Jewish exile from Nazi Germany but Hesse leads us to believe that her 'Abstract Expressionist student approach' did not win her any allies among the teaching staff. 'Albers couldn't stand my painting' she said, it 'was not Albers, not really Rico Lebrun's nor Bernard Chaitin's approach either.'[87]

The resistance to Hesse's expressionist style at art school and her adherence to it as a professional artist again confirmed to Lippard that Hesse's art making was a natural extension of a feminine aesthetic sensibility.

In 2006 Catherine de Zegher made a compelling argument for the significance of the work of Anni Albers for Hesse.[88] Prior to this, however, inroads had been made into Hesse's account of her relationship with her tutor Josef Albers (1888–1976). 'Teaching Modernism: What Albers Learned at the Bauhaus and Taught to Rauschenberg, Noland and Hesse,' published in 1979 by Carl Goldstein confirms that Josef Albers 'abhorred' the expressionism that Hesse loved, and as a teacher he did indeed try to drive that philosophy out of all the New York students.[89] Yet this paper underlines a definite connection between Hesse's later drawings and sculptures and Albers' 'preferred elemental structures and rearrangements with grids and shifting structural elements of wire, thread and onion sack'.[90] De Zegher's analysis could throw light on the significance of Anni Alber's practice and pedagogy for her husband's teaching of Hesse at Yale. Hesse, it can be argued, did not abandon all of the lessons of her male tutors and despite his disapprobation Albers did not abandon Hesse. Goldstein, tells us, that four years after her graduation *The Interaction of Colour* published by Albers in 1963 included several of Hesse's colour studies from Yale.

As has been briefly noted Wagner executed a lucid critique of the mythic divide between Hesse and her art historical father(s). In the absence of role models in the feminine, Wagner underlines Hesse's significant identification with the myth of the artist as an outsider, as a locus of difference, from such sources as the *Letters of Van Gogh* and the *Journal of Eugene Delacroix*.[91] This pronouncement was perceived by some to be almost heretical. Wagner could not be a feminist and shrink from the disavowal of patriarchal role models. But this censure betrays the way that the discourse written for Hesse is cloaked within canonical and hence patriarchal practices of analysis. In this instance the heroic woman artist iterates the traditional myth of the great artist. Rather than subjecting herself to an over-identification with the figures of patriarchy, she triumphs over the obstacles presented by them, rebels against and (eventually) overthrows pernicious father figures.

In *Differencing the Canon: Feminist Desire and the Writings of Arts Histories*, Griselda Pollock employs Sarah Kofman's analysis of Sigmund Freud's aesthetics to throw light on the psychic mechanisms at work in canonical writings about art and artists within the history of art. This text illuminates how 'art appreciation can be informed by psychic structures that are characteristic of certain powerful moments of *archaic experience* in the history of the human subject which, in a sublimated form, are culturally perpetuated in social institutions and cultural practices such as religion and art.'[92] Through her reading of Sigmund Freud and Sarah Kofman, Griselda

Pollock directly implicates the Pre-Oedipal processes of idealisation of the father, and narcissistic identification with the hero who overthrows the father, in canonical writings about art. Since these psychic processes are not particular to one gender alone, Pollock reminds us that women historians are not immune to the lures of identification and idealisation. Thus it is possible to see that, via a 'bricolage of what phallocentric culture offers', those readings which readily offer the autobiographical meaning of Hesse's artworks to the viewer are indicative of the traditional model of art historical writing in which the artist is deemed to be self creating. As I shall suggest in Chapter Four, this model construes the artist, whatever their sex, in the figure of a man; they 'sustain a patriarchal legend.'[93]

This theoretical framework re-opens a path less trodden within Hesse scholarship: the formal relationship between the work of Hesse and Doyle. If the works of 1960–1961 were 'much much more me' as the artist implies it follows that other works, as Lippard would have us believe, such as the drawings and paintings from the period 1962–1964 (plate 7) were 'not me.' Though Lippard concedes that Hesse made 'good drawings' during this period their creative proximity to the practice of the artist's husband Tom Doyle (1928–) constructs these ill-fitting elements as alien. Lippard's research consulted Doyle extensively and situates the work that Hesse produced at this time as a product of a confusing conflict between the 'inner imagery of Gorky and de Kooning and the brash newness of pop.' Her text takes care to emphasise that the change in Hesse's work was in no way the result of a conscious desire on Doyle's part to mould his wife in his own image. Hesse remained estranged to herself by this 'up-to-date' less 'personal,' 'expressionist' and 'skilfully beautiful' work until the moment of that 'painful confrontation' that augmented her creative breakthrough.[94] An emphasis on the work of Marcel Duchamp as a resource for Hesse's practice, with whom Doyle's work had been engaged, has enabled criticism to successfully skirt this issue. In Germany Hesse's key encounter with Duchamp took place in October 1964 at the Kunsthalle in Bern. There the museum hosted a group show entitled 'Marcel Duchamp, Wassily Kandinsky, Kasimir Malewitsch' with two other solo exhibitions whose practices worked through the protocols of those earlier artists; one artist was Josef Albers, the other, as Lippard notes, was Tom Doyle. In recent years, most notably in the writing of Max Kozloff, Mignon Nixon and Sabine Folie, Hesse's 'machine' and other works made between 1962–1964 have begun to demand more and more critical attention. New scholarship has begun to place Hesse's own perception of her work under pressure. Though still married to Hesse upon her death Doyle made no claim on her

Estate as her legal next of kin and signed everything to her sister Helen
Hesse Charash. With Kofman's insights in mind it seems time to reconsider
the relationship between Hesse's use of colour and form and that employed
by Doyle in 1964–1965. In 'Drawing in Eva Hesse's Work,' written in 1982
Ellen Johnson goes beyond the usual history of the working relationship
between Doyle and Hesse during F. Arnhard Scheidt's patronage in
Germany. Like the other texts written for Hesse she acknowledges the
impact of the machine parts that Doyle salvaged from the disused factory
for both artists. Until recently this important essay has remained alone in its
insistence on the significance of the proximity of Hesse and Doyle's
practices in their Kettwig studio:

> Here Hesse was in much closer contact with [Doyle's] work than she
> had been in their Bowery location in New York, where his studio was
> across the street from hers, which was above their living quarters.
> Playful little forms begin to dance around her drawings and large flat
> shapes take on the crescent or plough configurations frequently
> present in Doyle's work.[95]

Here the means by which Doyle's significance for Hesse has been
negated is problematised. For Johnson indexes the creative moment at
which Hesse is said to have rediscovered herself to the practice of the
person deemed responsible for her original estrangement. Kirsten Swenson
has taken up this argument recently in her interview with Doyle for the
essay 'Machines and Marriage Eva Hesse and Tom Doyle in Germany
1964–65':

> Hesse's German reliefs were intertwined with the sculpture Doyle was
> producing, integrating Doyle's workmanship, enlisting his labor for
> their construction and his input for their quirky titles. Doyle
> emphasises the productive working relationship between himself and
> Hesse that existed in Germany despite their strained marriage, which
> would dissolve shortly after the couple returned to New York: "We
> always got along in the studio. Outside the studio was chaos. But in
> the studio, she helped me with my color, and I helped her with
> making things. She was Albers' favorite student. She knew her color
> business."
> Doyle turned to Hesse for advice on the coloration of his
> sculptures, and in turn she borrowed bottles of enamel from him and
> often used the same colors that she suggested for his sculptures to

paint her German reliefs. Doyle's sculpture *Joe Magarac* shares a palette with *Legs of a Walking Ball*. The limbs of *Joe Magarac* are cobbled from machine parts, and resemble the mechanical apparatuses depicted in the machine drawings made for *Legs of a Walking Ball*.[96]

Return to Germany

To lift the Ted Hughes-like shadow that has precluded any value for the work of Doyle in Hesse scholarship is to shift the territories of the artist's fruitful but painful 'confrontation with the self,' and craft a supplementary reading for the work she made at that time beyond the boundaries of sexual difference. As the 1960s progressed, and as Hesse read texts such as *The Second Sex*, she was no doubt able to read for the difficulties she faced because she was a woman. Identification always involves a cut however. On the one hand there is a resonance with the element with which we identify; in this case the oppression of an artist that was a woman. To situate her encounter with that text in Kettwig-am-Ruhr, Germany, on the other hand, is to gesture toward the pressures of a cumulative set of dimensions of displaced subjectivity that seemingly cohered under a singular, identifiable causality.

Hesse's return to Germany took place only nineteen years after the 'liberation' of the concentration camps. It was, as Lippard tells us in *Eva Hesse*, a 'return to the "fatherland" that had murdered many members of her family.'[97] Hesse's Omi and Oma, her grandmother and grandfather Erna and Moritz Marcus, her aunt and uncle, Nathi and Martha Hesse, that had helped secure the escape of Hesse and her sister from Germany to Holland all perished. A diary extract written shortly before she left for Germany in May 1964 communicates the far-reaching extent of those cumulative absences that forever changed the course of Hesse's life:

[It will be] a weird search like a secretive mission a new generation seeking a past. I know nothing of my family – my grandparents. Seeking out statistics, establishing losses encountered by the H. never knowing their lives, their knowing me, or mine...never having a grandma, grandpa life at all the gathering, house, encouragements, proudness.[98]

The production of Hesse's journals has been situated within both the therapeutic practice of her analysis and the lineage of the tagebücher kept by her father during her childhood.[99] These documents cannot be explained

away, therefore, as an aide-memoire or, as Helen Molesworth suggested, written with publication in mind.[100] For Hesse the writing of a journal had been an activity filled with historical weight; it functioned as a means of making sense of the world and one's place in it. Further to this it is possible to argue that her diaries continually confirmed the being of the writing subject as her pen authored her presence across the page.[101] Again Hesse's actions and texts may be read with the writing of Harold Rosenberg, in particular his review of *The Words*, Jean-Paul Sartre's 'negative autobiography':

> In real life, making himself present was not easy. It required unceasing struggle with the illusory egos that kept forming themselves in the gaps of his being.[102]

The death of Sartre's father when he was only a babe-in-arms 'failed,' Rosenberg believes, 'to leave him an inheritance which might have established between them the continuity of things. Sartre's identity was deprived of gravity and left bobbing on the air currents of other people's opinions of him.'[103] Rosenberg's insight permits an understanding of Hesse's pronunciation of 'Hess' that at once confirms and yet goes beyond the construction of an identity as an 'American artist' to testify to such a lack of 'gravity.' In Hesse's case a 'confrontation' with the self in Germany was a confrontation with the displacement that had precipitated the fragmentation of that self.

The production of Hesse's art practice can be considered in a similar vein. In the Hesse-Nemser transcript: 'I notice,' the critic said,' that you use [the circle] motif constantly. I notice that you use it in your drawings. Which were so effective. Can you talk about the circle, what it means to you?' Hesse replied:

> I think that there is a time element. I think that that was in the sequence of change and maturation. I think I'm less involved in it now. I guess if your going to *pick* a motif *you'd say* before I got sick I was working with squares and rectangles but I think at the time I really worked ... the last works I did which was just about a year ago, I was less interested in a specific form as the circle, or the square or rectangle and was really working, I think I mentioned this in the last tape, to get to non-anthropomorphic and non-geometric, non-non, like where you couldn't connote any reference as a circle, I'll try to get back to your question. I think the circle was very abstract, I could

make up stories of what the circle means to man but I don't know if it was that conscious, I think it was a form a vehicle, I don't think it had a sexual geometric atmosphere, it wasn't a circle representing life and eternity. I think that would be fake (maybe on an unconscious level) but that's so opposed to *use it as* an abstract life symbol or geometric *theory* there you have the two in opposition and I don't think I had ... one memory I have – I remember always working with contradictions and contradictory forms, which is my idea in life, the whole absurdity of life, everything for me has always been opposites, nothing has ever been in the middle. When I gave you my autobiography my life never had anything normal or in the centre.[104]

Hesse's response does not give a coherent, decisive account of her use of the circle. The disjointed nature of her reply can in part be attributed to the fatigue caused by her poor health, but also, I want to suggest, to her thinking through a question for which, in 1970, she did not yet have an answer. This lack of resolution is crucial for it is that which, I believe, compelled Hesse to redraw and remould the circle and other prevalent motifs. Hesse's move toward non-connotative practice implicates a psychology of the movement and physicality of making. The resurgence of the post art-school, 1960/1961 vocabulary of form evident in Hesse's drawings in Germany in 1965 can be ascribed not to the articulation of a fixed core of a coherent individual autobiographical or monobiographical subject but as the product of the desire to 'fix' a self: to frame, to encircle by a movement; an act of *centring something*.

Addendum: Feminine Sex Difference

In 'Character change and the drama,' Harold Rosenberg reads the figure of *Hamlet* in the beginning scenes of Shakespeare's play:

The argumentative, self-analytical Hamlet of 'non-action,' describing himself in every speech, and using speech as a substitute for deed, is very much the figure of a personality, of a being insufficient for, *because irrelevant to*, the dramatic role offered to him. Hamlet has all the qualities required for action; what he lacks is the identity structure which would fit him to be a character in a drama, a one-ness with his role originating and responding to the laws of his dramatic world. Thus he is contrasted or 'paralleled' with Laertes whose situation is similar to his,

For by the image of my cause, I see

The portraiture of his,
But who is characterised as identity by his readiness to act; and the
point is repeated in setting off his psychological diffusion against the
acting-craft of the visiting players. It is not a weakness of personality
that impedes his action but the fact that he is a personality.[105]

Hesse's identification with de Beauvoir's text fitted her for a particular
'one-ness' that transformed her from a person with a 'history' into a
character identity with a 'role' that had been appropriate to the emerging
dramatic plot of the Woman's Art Movement. As the theory of shared
sexual oppression 'built on itself' the narratives concerned with Hesse's
biography, to paraphrase Rosenberg, were constructed from information
that had been introduced and researched only because it was relevant to a
particular 'cause of action.'[106] It was a history in which:

Individuals are conceived as identities in systems whose subject
matter is action and the judgement of actions. In this realm the
multiple incidents in the life of an individual may be synthesised, by
the choice of the individual himself or by the decision of others into a
scheme that pivots on a single fact central to the individual's existence
and which, controlling his behaviour and deciding his fate, becomes
his visible definition. Here unity of the 'plot' becomes one with the
unity of being and through the fixity of identity change becomes
synonymous with revolution.[107]

For the 'constant' identity 'growth is excluded and change of character
occurs above the rigid substratum of the identifying fact.'[108] Eva 'Hess'
became a paradigm case for the writing of all women's lives through art
practice. The transparent 'counterparts' of Hesse's artworks became
embroiled within a position of 'abstract indeterminacy' that negates the
possibility of speaking of the differing dimensions of a 'personal historical
narrative.'[109] The identity of 'Hess' could not encompass the psychic
structure of trauma nor did it extend to the historically, temporally,
ethnically and gender specific dimensions of this artist's subjectivity. Before
their presentation to the reader/viewer, the artworks and dialogues of this
artist passed through a filter, whose action was analogous to canonisation.
This analysis of Hesse's art practice and biography is illuminated by the
insight of *Representing the Holocaust: History, Theory, Trauma*, in which
Dominick LaCapra explains that 'through canonisation texts are presumed
to serve certain hegemonic functions with reference to dominant values and

structure.'[110] To return to the words of Edmond Jabès, because 'painting,' and in this case sculpture, 'expresses you [...] you end up being nothing more than the expression of the painting, nothing more than the expression of the writing, which leads to something more universal.'[111]

How can, therefore, the methodological paradigm set by what I am naming the biographical collapse be resisted? Again the desire to proceed differently calls attention to the writings of Shoshana Felman and Dori Laub. In their introduction to *Testimony*, they too censure the pit-falls of representational 'mirror-games' between the biographies of artists and writers and the artefacts that they produce. Rather than interpret the object in question as reflective of a life, they feel it is far more challenging to discern the way that issues of biography and history are 're-inscribed, translated, radically rethought and fundamentally worked over by the text' or, we may add, artwork.[112]

> It is quite possible that many work-products carry subjective traces of their creators, but the specificity of works of art is that their materiality cannot be detached from ideas, perceptions, emotions, consciousness, cultural meaning, etc., and that being interpreted and reinterpreted is their cultural destiny.[113]

The implications of Ettinger's theorisation of the work of art for Hesse scholarship is that the binary between private self and cultural practice typical of monographical biography, evidenced in the division between 'Hess' and minimalism, is further dissolved.[114]

For Ettinger the production of meaning for works of art within the encounter between maker, art*work* and viewer is a process that exceeds the limits of the Symbolic in two ways. Artworks fulfil their 'cultural destiny' via what Ettinger calls 'trans-subjective encounters' that are modelled with-in the Matrixial stratum of subjectivity. Her intervention in the field of psychoanalysis after Lacan formulates a feminine sexual difference *beyond-the-phallus* that has implications for subjective traces imprinted in moments-with-in-making.

> The Matrix, whose primary meaning is womb/uterus, is not an organ but a symbol and a concept related to a feminine Real and to imaginary structure. Uterus/womb usually signifies a mythical area of archaic, undifferentiated sensations prior to subjectivity and outside the order of any possible symbolisation or even discovery.

The Matrix deals with the possibility of recognising the other in his/her otherness, difference, and unknown-ness. Matrixial acknowledgement of differences functions on both the psychological and the socio-political level. The *unknown not-I* corresponds to 1) the other unknown to the *I*, 2) to the unknown elements of the known *I*, and or, 3) to the unknown elements of the known other. we can recognise an unknown *not-I* in a matrixial way while he/she/it remains different, *neither assimilated nor rejected*. In other words, the Matrix is a composition of *I* and *not-I(s)*, of self and not-selves while they are unknown and anonymous. Some selves identify one another as *not-I* without abolishing difference and making the other a *same* in order to accept him/her, and without creating a phallic rejection so that only one of them can occupy the physical/mental space. They co-exist and change one another though neither dominates not submits in a recognised shared space.

The Matrix is a symbol for a more-than-one – subjects/elements + contact spaces – and a less-than-one – fragments and contact spaces – known and unknown. The model for a plural or fragmented subjectivity is the culturally and *individually* repressed prenatal state for both men and women and the repressed womb […]

The Phallus deals with symbols in relation to Oedipal subjectivity, whole objects, one-ness, sameness, all-ness, and symmetry. The Matrix deals with symbols in relation to prenatal strata of subjectivity, partial objects, differences that do not imply opposition, a-symmetry, more-than-one but not everything, less-than-one but not nothing. Subjects and elements can co-emerge in contradiction and not only in harmony, and yet take care of one another and provoke changes reciprocally. While the Phallus involves processes of metaphor and metonymy, the Matrix is related to Processes of metramorphosis on the edge of metaphor and metonymy. Metramorphosis is the process of change in borderlines and thresholds between being and absence, memory and oblivion, *I* and *not-I*, a process of transgression and fading away. The metramorphic consciousness has no centre, cannot hold a fixed gaze – or, if it has a centre, it constantly slides to the borderline, to the margins. Its gaze escapes the margins and returns to the margins. Through this process the limits, borderlines, and thresholds conceived are continually transgressed or dissolved, thus allowing the creation of new ones.[115]

As Ettinger notes, the socio-political meaning and consequences of the feminine difference of the Matrix provide another way for thinking about foreignness: 'the affinity between women and minority groups [might be] far richer and more complex than a simple identification or solidarity between culture and history's "underdogs."'[116]

The Matrix is not an exclusive term for the feminine or to be mistakenly thought of as a replacement for the Phallus. It draws on Lacan's late theorisation of 'feminine otherness [as] supplementary and not complementary to the Phallus.'[117] In this text, therefore, Ettinger illuminates the non-neutral model of Freudian and Lacanian psychoanalysis that leads her to the concept of a sedimented subjectivity:

> I think of the "complete" or "whole" subject as emerging after and from an already distinct and highly structured stratum rather than one that is undifferentiated. The Matrix is the term I have chosen to describe this distinct stratum of subjectivization and to account for the difference between the sexes from the point of view of feminine sexuality.[118]

In Freudian and Lacanian theories of psychoanalysis the human subject is formed by the 'symbolic process called castration.' The human subject passes from the Real to be structured in the Symbolic by the 'One/Other phallic binary mode.'[119] Bracha Ettinger states that the Phallus is the:

> "Code" chosen [by Lacan] to signify that which enables the child to separate from the mother's body. This separation takes place during each passage from the Real to the Symbolic. According to Lacan, this passage corresponds to each *reception of messages* from the Other by the subject.[120]

What Bracha Ettinger proposes are 'non-phallic passages to the symbolic network' for which the term castration is inappropriate. Thus she theorises a sedimented subjectivity that:

> Recognising the other as an *unknown non-I* differentiates the idea of the matrix from that of symbiosis. The matrixial stratum is prenatal and prior to symbiosis [...] for the moment it will be sufficient to say that symbiosis and matrixial modes of subjectivity – or strata of subjectivisation – can alternate, co-exist, and modify one another. *They both modify and are modified by the Oedipal stratum.* Symbiosis is operated by fusion or rejection, while the matrixial state is operated by

metramorphosis. The matrixial stratum of subjectivisation continues to operate alongside and subsequent to symbiosis, and it can be recognised by the human subject not only in regression but also by retroactive psychological moves.[121]

The formation of the subject does not lend itself to the developmental narrative of biography. Non-linear psychic time, theorised by Sigmund Freud in 'Screen memories,' (1899) and 'The unconscious,' (1915) for example, structures the porous nature of the strata of subjectivity: archaic phases effect later phases but later phases also effect earlier phases that may re-effect later ones. This theorisation can enlighten the way in which we think about what Griselda Pollock calls the 'generations and geographies' of feminist theory and past, present and future visions of the art practice of Eva Hesse.

I return at last to *Addendum*, therefore, because I want to ask the question 'how do these semi-spheres *resemble* breasts?' In Hesse's earlier work, *Ringaround Arosie*, (1965, plate 8) the *resemblance* between the central form and a breast is far clearer. Indeed, made from papier-mâché and painted concentric circles of cord, Lippard tells us that this is the work that, 'reminded [Hesse] of a "breast and penis," though in fact both rosy-nippled circles looked like breasts – a little one on top of a big one, forming a sort of doubly female figure.'[122] The piece was named for Hesse's friend who was pregnant; we might also suggest, therefore, that the larger of the two circles *resembles* the distended abdomen and navel of a pregnant woman. What is remarkable about *Ringaround Arosie* in the flesh, as it were, is the extent to which the nipples/penis/navels, call them what you will, breach the picture plane by four or five in to enter the space of the maker/viewer. What thus intrigues me about *Ringaround Arosie* is the actual act of *centring something, binding something* in a particular place, in Kettwig-am-Ruhr. In the case of *Addendum* the semi-spheres are hemispheres full stop. To state the obvious, such breasts of perfect symmetry, whose hemispheres jut out to meet the viewer call to mind male fantasy made flesh by silicone augmentation rather than the reality of women's bodies.[123] We are not presented with representations of breasts of phalluses per se but a perception of their symbolic equivalents; a culturally accepted sign of sexual difference. Though the work's 'unexpected' and 'confusing' elements have been understood to destabilise the minimal logical of artists who were men, the way in which the discourse does this is framed in such a way that it has no power to destabilise culture's notion of what the feminine is.

To gesture towards multiple, non-hierarchical possibilities for the reading of this artwork that do not cancel each other out is one way to begin to approach *Addendum* in the feminine. Some time ago I had noted that, in the conversation with Cindy Nemser in 1970, Hesse had said that Andy Warhol (1928–1987) had been, like Claus Oldenburg (1929–), 'high on my favourite list':

> CN: What is it about Warhol that you like?
> EH: Oh he is the most artist that you could be. I have what – if what I want to be is the most Eva can be as an artist or a person.[124]

When I think of Warhol via Hesse I arrive at works such as *Lavender Disaster* (1963, plate 9). What draws my eye is the dark loose trailing cable, that somehow comes out on the floor from behind the electric chair to lie in a semi-circle in front of it. This element of Warhol's screen print reminded me of the trailing cords of *Addendum*. If works of art can hold multiple traces of subjectivity that are historically and culturally specific, therefore might it not be possible to read *Addendum* for a co-emergent trans-subjective art practice? It is possible that as part of Hesse's liking for Warhol she had looked at these images and simply noted the way the cord fell and its repetition. Beneath an initial formal rapport between artists, Andy Warhol's artwork might, however, hold another significance. The tapering cord draws attention to a different significance for the hemisphere: the means of carrying electrical current and making contact with the human body. They are 'instruments of judicial murder.'[125] It might, just might, be interesting to pursue, alongside the dominant reading of sexual difference in *Addendum*, a place/space which acknowledges the importance of Andy Warhol's 1963–1967 *Electric Chair* silkscreen prints, part of the *Disaster* series made from found photographs. From my present position, after the emergence of a discourse about the Holocaust, I wonder if the affectivity of these powerful representations of the technological means by which the human subject is violated and dehumanised might have been of consequence for the artistic subject Eva Hesse.[126] As Robert Jay Lifton writes, 'we are haunted by the image of exterminating ourselves as a species by means of our own technology.'[127]

In 'Nichsapha: Yearning/Languishing The Immaterial Tuché of Colour in Painting After Painting After History,' Pollock describes the *Disaster series* as a:

> Provocatively neutral but still political gesture [that] breaches a taboo by making public this most hideous, and usually secreted, dimension

of the modern state and its legal system. Serial repetition, however, deflects any traumatic effect; literal repetition of this non-psychoanalytical kind pacifies the shock of the near-encounter with death via the image.'[128]

The catalogue *Andy Warhol Death and Disaster* introduces the electric chair series by telling us that the two last electrocutions were performed in New York State, at Sing Sing State Penitentiary in March and August 1963.[129] Griselda Pollock thus situates 'historically and politically' Warhol's paintings in American in the 1960s. Yet:

> While Warhol's work belongs to a forward thrust that initiated aspects of Pop Art and the disaffected postmodern attitude itself, art made now may allow is to read within it an unwitting anticipation of current preoccupations with the disaster and trauma of twentieth-century death. The work registered a freight that was not critically or theoretically spoken…the *Disaster series* may be read as yet another symptom of [modernity's] unfinished business.[130]

With the theory of nachträglichkeit Griselda Pollock argues for these works as a 'creative re-transcription' of the 'accumulated legacies' of the Holocaust that had been reactivated by 'fresh circumstance.' Andy Warhol's paintings, that come 'after' death, were 'transformed by [the] mass industrial murder of almost an entire people', a people to which Hesse belonged.[131]

3

CULTURAL MEMORY, TRAUMA AND ABSENTED HISTORY

By the early 1990s Lucy Lippard's efforts to forestall the 'Hesse Myth' had been overpowered by the momentum of a post-modern fascination with wound culture.[1] The overall absence of the Holocaust from the texts written for Hesse, an obvious resource for what Wagner named 'Hesse as wound' is therefore both puzzling and paradoxical. Chapter Two gave a first insight into those conditions that contributed to the exclusion of the Holocaust from the discourse written for this artist; namely that the autobiographical emphasis of the co-emergent Woman's Art Movement leant upon theories of expressivity and truth that fell short of the feminist politics of viewing that Lippard desired. In Chapter Three the fixed nature of the vocabulary of sexual difference that had informed those first readings is in part ascribed to the unwitting means by which this historical event and its specificity has been occluded via the mechanisms of what Santner has named a 'narrative fetish.' That is:

> A construction and deployment of a narrative consciously or unconsciously designed to expunge traces of the trauma or loss that caused the narrative to begin in the first place ... [it] is the way an inability or refusal to mourn emplots traumatic events; it is a strategy of undoing in fantasy, the need for mourning by simulating a condition of intactness, typically by situating the site of origin and loss elsewhere.[2]

Hesse's discourse demands that this 'inability' be critiqued further. This will take place in two ways but let it be understood that neither will proceed in the pursuit of blame. First, the tools of historiography and trauma theory are mobilised to uncover the complex methodology demanded by Hesse's

archive and the texts written for it. Second, American cultural memory is situated as a barrier that has precluded Holocaust experience as a signifier for Hesse's work. Only then may Hesse's outlook and practice begin to be situated within the specificity of refugee experience and thus read in reference to the ethos of the German Jewish community of Washington Heights.

Throughout the writing of this book I have been mindful of one question in particular: is it at all possible to speak in the same breath of Eva Hesse and the Holocaust, of separation, loss, exile and displacement without undoing Anne Wagner's significant corrective? I think it is. In order to do so Hesse scholarship must again turn its attention to the concepts and structures that continue to shape this artist's history. My point of departure must be the traditional linear narrative that currently characterises Hesse's biography. Within the histories written for artist's childhood is remarkable more often than not only as the point at which 'talent' emerges to be either supported or thwarted. The locus of these beginnings is the family. As the artist 'progresses' through their education, so the traditional model of social mobility goes, the seclusion and immediacy of the family becomes a distant background as art-school, 'influence,' and intellectual sophistication difference the becoming artist from these earlier connections and, eventually, take precedence. For 'mature' practice the relevance of the family and this beginning history is thus nominal. Such linearity supposes a substantial divide between Eva Hesse the three-year old refugee from Hamburg and Eva Hesse the New York artist. To this end, references to 'The Holocaust' as a general, background phenomenon need not be invested with any marked specificity beyond a historiographical desire for the names of people, places and dates. The significance of those early years wane as their memory fades and they pale in comparison to the constant difficulties presented by the negotiation of sexual difference in the competitive creative environment of New York.

On 13 May 1939, from the safety of London, Wilhelm Hesse noted in his youngest daughter's diary that she then aged three and a half, 'knows something about Hitler and talks about it.'[3] The family is never secluded or discrete. It is shaped by history, culture and the social: conditions that exceed the temporal framework of childhood and questions of memory to press up on the subject as it journeys from adolescence through adulthood. Rather than attempt to recover any historical truth or memory for the artist at this time it is sufficient to say that her reading of the tagebuch written for her had been fundamental to the artist's construction of self and thus crucial to the perpetuation of that history for Eva Hesse. The artist's

conversations with Nemser in 1970 testify to the means by which historical events act cumulatively and that traumatic experience is bound by a particular set of mechanisms within the psyche that differ from those of everyday narrative memory. Eva Hesse's Holocaust cannot remain consigned to the footnotes of her histories. Neither can traditional modes of historiography adequately sense the significance of Hesse's particularity for readings of her practice.

Historiography and Trauma: Notes on Analytical Method

The writing of David S Wyman provides a prelude to the wider historical framework that will be given to the psychoanalytic focus of this chapter. It does so via brief reference to the general attitude of non-Jewish Americans to a cultural or historiographical memory of the Holocaust in the late 1960s. In *The World Reacts to the Holocaust* he notes:

> In 1968 another *New York Times* reviewer, pondering two new books, Nora Levin's *The Holocaust* and Arthur Morse's *While Six Million Died*, asked:
>
> 'But another book on 'the Final Solution'? Who — we ask each other with a smile, a shrug, understanding that surpasses embarrassment, apology in eyes — who needs it?' This was written when Holocaust scholarship was in its earliest stages, when knowledge of many aspects of the Holocaust was very limited, and when the first great outburst of Holocaust writing was still a decade away.[4]

The *New York Times* greeted new publications that dealt with the Holocaust with fatigue. In 1968 the complex necessity for a dialogue between theory and history in the writing of traumatic events would be a long time coming. The conventional concept of historiography, as a factual record that would convey the truth of an event, could not comprehend the way in which the implications and the trauma of the Holocaust would echo across generation after generation. To some it would seem that the need for historical investigation of the events that took place between 1933 and 1945 was exhausted by the trial of Adolf Eichmann in 1961. Statistical knowledge, names, places, facts and figures were quite simply thought to be synonymous with the mastery of the past. Yet the Holocaust demanded 'a response from the reader that [could] not be confined to contextualisation or mastery through the accumulation of information.'[5] If the direct and indirect impact of the Holocaust in the history and practice of Eva Hesse is

to be read appropriately there must be, as Dominick LaCapra says, a sustained interchange of theory with historical research.[6]

Unclaimed Experience: Trauma, Narrative, and History, (1996) written by literary critic Cathy Caruth works in congruence with just such a programme. Her book notes the way in which Alain Resnais refused to make a documentary film about the violation of the Japanese people in the bombing of Hiroshima. In 1956 Resnais had completed *Nuit et Brouillard*, a documentary film that sought to witness the unspeakable horror of the *univers concentrationaire*. Caruth attributes the filmmaker's objection to making another such film about Hiroshima to the realisation that direct archival footage alone could not 'maintain the very specificity of the event.'[7] Thus *Hiroshima mon Amour,* the result of collaboration between Marguérite Duras and Resnais, was not about Hiroshima per se. Rather it is a fictional story that 'takes place at its site.' Historical specificity is conveyed by Resnais and Duras via the exploration of a faithful history made possible by 'the very indirectness of [its] telling.'[8] Although this text does not pursue Caruth's understanding of trauma, indirectness is fundamental to its theorisation as a psychoanalytic concept and forms the primary focus of LaCapra's desire to formulate a dialogical relationship between theory and history. Crucially in order to do so he refutes the notion of psychoanalysis as an introspective and internalising psychology of the individual. Instead he argues that the 'key psychoanalytic concepts (such as transference, denial, resistance, repression, acting-out, and working-through), are crucial to the elucidation of the relation between cultures that come into contact, as well as between the present (including the analyst) and the past.'[9]

For scholars and curators the theoretical demands of Hesse's archive has been made apparent by the 2006 Jewish Museum retrospective *Eva Hesse: Sculpture*. This carefully considered presentation of extensive research rightly situated Hesse's beginnings as a German Jewish, naturalised American in a way that no other exhibition has done. In so doing this retrospective drew attention to much unfinished business for Hesse scholarship. For it seems that 'Jewishness' and Hesse's experience of the Holocaust now inhabit a position akin to the predicament of women artists to the canon of Western art. How can or should this difference be positioned in relation to sexual difference and the canon? How may these conditions difference 'Hesse' and be read beyond inappropriate hierarchies, the common ground of culture's underdogs or heroic triumphs over adversity?

LaCapra outlines a two-fold strategy for the non-canonical reading of texts hitherto canonised by processes and desires that effaced the potential disruption presented by traumatic events.[10] The first mode reads for the

ways in which 'texts may resist or contest the canonical functions they are presumed to serve.' LaCapra outlines its concomitant method as the elucidation of those hitherto repressed or suppressed 'texts and artefacts that have not been simply bowdlerised but marginalised or altogether excluded with the effect that certain counter hegemonic traditions are effaced from the historical record.'[11] In the case of Eva Hesse hitherto marginalised artefacts inflected with ethnicity and sexual difference, have been and will continue to be the key to the creation of a discourse that resists hegemonic narrativisation.

I return to Hesse's often quoted commitment to art as 'an essence, a center […] a total image that has to do with me and life [that] can't be divorced as an idea or composition or form […]" that since 1970 has been central to the perception of her work.[12] Critics have employed this extract time and time again yet it is curious that the beginning of this passage is seldom referred to. A return to it, can shift the reading of those passages that have now such canonical authority. The *Artforum* interview opens with the question: "Do you identify with any particular school of painting?" Hesse's reply cites the significance of Arshile Gorky, Willem De Kooning, Yves Klein, Jackson Pollock, and Claus Oldenburg. As the theme of art and life is approached, Hesse concludes with Warhol:

His art and his statements and his person are so equivalent. He and his work are the same. It is what I want to be, the most Eva can be as an artist and a person ... I feel very close to the work of Carl Andre. I feel, let's say, emotionally connected to his work. It does something to my insides. His metal plates were the concentration camp for me.[13]

The unexpectedness of this last sentence jolts the reader. Its utterance is itself traumatic. In *Artforum,* Nemser then frames Hesse's direct reference to the Holocaust as follows:

CN: If Carl knew your response to his work what would be his reaction?
EH: I don't know! Maybe it would be repellent to him that I would say such a thing about his art. He says you can't confuse art and life. But I think it is a total thing. A total person giving a contribution ...[14]

Attention to the original transcript housed on microfilm at the Archives of American Art clarifies Nemser's editorial focus. The passage that confirms the power of Hesse's encounter with Andre's sculpture, such

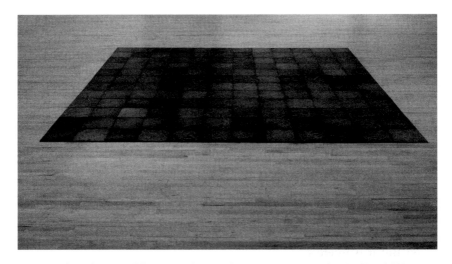

6 Carl Andre, *144 Magnesium Square* 1969, Magnesium, 10 x 3658 x 3658 cm, Collection Tate Modern.

as *144 Magnesium Square,* (1969, figure 6) for example, that did "something to [Hesse's] insides," is quoted from a separate part of the ninety-page interview:

> CN: What about minimal art—so called—or whatever name you want to give it.
> EH: Well I feel very close to one minimal artist—I mean who is really not a *minimalist.* He is really more a romantic and would *probably not* want to be called a *minimalist* and that is Carl Andre. I mean I like some of the other's very much too *but* I feel —let's say emotionally connected with his work. It does something to my insides […].[15]

This page, on which Hesse first connects the traumatic feeling she intuited from Andre's sculpture to the Holocaust, is particularly muddled and confusing. The typed transcript is supplemented in pencil by the following sentence; "*Carl Andre's work it was the concentration camp – it was those showers that put on gas + that's where to life.*" A pencilled arrow leads to this sentence from an ellipsis marked "inaudible." Hesse's pencilled and typed narration continues:

> In my own inner soul where art and life and I can't separate them and it becomes more absurd and less absurd, It's more absurd to isolate.

And then I worked up a calculated ... And ... I have confidence in understanding of formal esthetics so to paint and I don't want to be aware of it or make that as my problem that is not the problem. Those things are solvable I can solve them – I solve them beautifully. I am interested in solving an unknown factor of art and an unknown factor unknown of and sometimes unknown factor of life ... My Life and art have not been separated they have been together. This year of not knowing whether I was going to survive or not, not knowing whether I would ever do art ... was connected ... One of my first visions when I woke up from my operation is that I didn't have to be an artist to justify my existence. *That I had a right to live without being one.* And one of my second thoughts or third was that if I couldn't be an artist, I would make films. *Prior to sick saw weekend* and I loved it ... very much of my life.

CN: But it is interesting the response you had to Carl Andre's work and the funny part is that if you told him that response, what would be his reaction.

EH: I don't know. *It would be repellent to him that I would say such a thing about is art oh yes because that's not art.*

CN: Yes but that is why I had one answer ...

EH: You can't confuse life with art.

CN: Exactly. This whole attitude and *if you* wanted to know why people have stayed away from you. *certain critics.* That is probably one of the reasons.

You scare them. Sure you scare them. You know you talking like is terribly frightening. [16]

It is clear from the transcript that Nemser did want to pursue the questions Hesse raised in response to Andre's work. I want to suggest that it is possible to read the conjoining of the sentences, "I feel very close to the work of Carl Andre. I feel, let's say, emotionally connected to his work. It does something to my insides" and "his metal plates were the concentration camp for me," as a symptom of the historical moment in which they were edited. The legacy of the Holocaust for Hesse was entirely Other to the everyday experience of Nemser or Lippard. At that time there was no scholarly support that would facilitate a dialogue across the differences of these three women. The absence of an appropriate framework with which to guide Nemser's witnessing of the trauma of the Other led her line of questioning to a dead end. To situate Hesse's construction of a sense of self, in a different way, in America between the

1940s and 1970 is to argue that she was just as much a prisoner of that same historical moment as Nemser, perhaps even more so.

For Hesse the Holocaust is plotted with-in the silences that mark the point at which language fails. The historian's task thus becomes not only to uncover hitherto occluded archives but also to read for the cultural production of the conditions that silenced them. The psychoanalytic theory of trauma is crucial to an understanding of the repression and new articulation of Hesse's experience on the level of the subject and the social; that is within the context determined by the shifting positions of the Holocaust in cultural memory. To evoke this mode of analysis will, in the mind of some readers, instantly redraw Hesse within a paradigm of pathology. References to the theory of trauma have dwelt all too readily on its proximity to the concept of a physiological 'wound' derived from the Greek that takes its meaning from the verb to pierce.[17] Contemporary understandings of trauma within art and literary criticism have pursued this etymology to map trauma as a fixed historical, or 'veridical' truth made possible by a binary between the external world and interiority of the subject.[18] It is this model that interiorises and thus pathologises the response of the subject. The need to disentangle the common perception of trauma theory and thus the work of Eva Hesse, from an interiorised notion of pathology is of the utmost urgency. Several key texts written by Sigmund Freud's on the subject of trauma between 1895 and 1926 make clear that his use of terminology acts only a point of departure for his theory. Psychic trauma exceeds both the medical metaphor of the wound and the model of internal psychic reality punctured and scarred by the impact of an external event/force. What is clear from the use of psychoanalysis by current discourse is that potency of the external world struggles to be felt; it is quite literally extraneous. I make no apologies therefore for the great pains I take to explicate Freud's theorisation of trauma and thus its implications for Hesse's practice.[19]

To begin what I particularly wish to draw out is the relationship between the perception of the external world and timeless unconscious internal psychic processes that can occur across the interconnected forms of 'signal anxiety,' 'automatic anxiety' and *nachträglichkeit* (deferred action). For in addition to their value in understanding the means by which trauma acts upon the subject, these concepts also illuminate its impact upon culture and the social. Most significant for such an argument were the studies of trauma in three papers, the 'Project for a scientific psychology,' 'Beyond the pleasure principle' and 'Inhibitions, symptoms and anxiety,' written by Sigmund Freud in 1895, 1920 and 1926 respectively.[20] It was in 1920 that

Freud formulated his second topography, a move that led him to the conclusion that, in discussions of the mental apparatus, he would 'avoid a lack of clarity if we make our contrast not between the conscious and the unconscious but between the coherent *ego* and the *repressed*.'[21] Freud's further elaboration of the relation of psychic interiority and exteriority is pursued in the 'The ego and the id' from 1923 and thus throws retrospective light on 'Beyond the pleasure principle.'[22]

In order to forge an understanding of the human subject's response to a traumatic event in 1920, Freud modelled a simple 'living organism' for his reader: 'an undifferentiated vesicle of a substance that is susceptible to stimulation':

> The surface turned towards the external world will from its very situation be differentiated and will serve as an organ for receiving stimuli. [...] It would be easy to suppose, then, that as a result of the ceaseless impact of external stimuli on the surface of the vesicle, its substance to a certain depth may have become permanently modified, so that excitatory processes run a different course in it from what they run in the deeper layers.[23]

A 'crust' has been created, a 'protective shield against stimuli,' that preserves the vulnerable underlying layers by absorbing the chief intensity of the energy that assaults the organism. Thus it is only the remainder of this external energy that is passed on to these deeper layers:

> By its death, the outer layer has saved all the deeper ones from a similar fate – unless, that is to say, stimuli reach it which are so strong that they break through the protective shield. Protection *against* stimuli is an almost more important function for the living organism than *reception of* stimuli. The protective shield is supplied with its own store of energy and must above all endeavour to preserve the special modes of transformation of energy operating in it against the effects threatened by the enormous energies at work in the external world – effects which tend towards a levelling out of them and hence towards destruction. The main purpose of the *reception* of stimuli is to discover the direction and nature of the external stimuli; and for that it is enough to take small specimens of the external world, to sample it in small quantities.[24]

When the shield is 'breached' a 'flood' of free flowing excitation assaults the vulnerable underlying layers of the 'organism' that is felt as 'physical pain.' The mental apparatus must then attempt to master this excessive stimulus; that is to say to 'bind' it 'in the psychical sense so that it can be disposed of.' Trauma, Freud tells us in 1916, is thus to be understood in 'economic' terms because it 'presents the mind with an increase of stimulus too powerful to be dealt with or worked off in the normal way, and this may result in permanent disturbances of the manner in which energy operates.'[25]

Later this model of 'automatic anxiety,' the breaching of a protective shield, will prove crucial to the appearance of the Holocaust in American cultural memory in 1960/1961 suggested here. For between 1946 and 1959, and even as Wyman shows in 1968, the nature of those events could be described as in a state of cultural and historical repression.[26] In the meantime I should like to turn to the notion of timelessness, deferred action, displacement and symbol-formation.

In the 'Project for a scientific psychology,' Freud discusses the case of Emma Eckstein (1865–1924) whose treatment in 1895 enabled him to theorise the concept of hysterical repression.[27] Eckstein's significance for psychoanalysis hails from a neurosis that demonstrated the 'special psychical constellation in the sexual sphere' that would in turn throw light on 'hysterical compulsion' and enable the theorisation of displacement and nachträglichkeit.[28] This 'compulsion' manifest as an inhibition that prevented her from entering a shop unaccompanied. Eckstein had traced this symptom to a memory that post-dated the onset of puberty when she was just twelve years old:

> She went into a shop to buy something, saw the two shop-assistants (one of whom she can remember) laughing together, and ran away in some kind of *affect of fright*. In connection with this, she was led to recall that the two of them were laughing at her clothes and that one of them had pleased her sexually.[29]

Freud reasons that, by themselves, the 'relation of these fragments and the effect of the experience' in this first scene 'are alike unintelligible.' Analysis reveals, however, a second memory that Eckstein 'denies having in mind at the moment' of the first scene:

> On two occasions when [Eckstein] was a child of eight she had gone into a small shop to buy some sweets, and the shopkeeper had grabbed at her genitals through her clothes. In spite of the first

experience she had gone there a second time; after the second time she stopped away. She now reproached herself for having gone there a second time, as though she had wanted in that way to provoke an assault. In fact a state of 'oppressive bad conscience' is to be tracked back to this experience.

We now understand Scene I (shop-assistants) if we take Scene II (shopkeeper) along with it. we only need an associative link between the two. She herself pointed out that it was provided by the *laughing*: the laughing of the shop-assistants had reminded her of the grin with which the shopkeeper had accompanied his assault. The course of events can now be **reconstructed** as follows. In the shop the two assistants were *laughing*: this laughing aroused (unconsciously) the memory of the shopkeeper. Indeed, the situation had yet another similarity [to the earlier one]: she was once again in a shop alone. Together with the shopkeeper she remembered his grabbing through her clothes; but since then she had reached puberty. The memory aroused what it was certainly not able to at the time, a *sexual release*, which was transformed into anxiety. With this anxiety, she was afraid that the shop-assistants might repeat the assault, and she ran away.[30]

Freud reads the compulsion 'not to remain in the shop alone on account of the danger of assault' as a 'rational' outcome/symptom of these experiences. The memory had undergone a *displacement*, the processes of which the analyst had elaborated in the previous pages.[31] In consciousness the 'whole complex' was re-presented by the significance attached to clothes via a 'repression accompanied by a symbol-formation':

In our example, however, it is noticeable precisely that the element which enters consciousness is not the one that arouses interest (assault) but another one, as a symbol (clothes). If we ask ourselves what may be the cause of this interpolated pathological process, only one presents itself – the *sexual release*, of which there is also evidence in consciousness. This is linked to the memory of the assault; but it is highly noteworthy that it was not linked to the assault when this was experienced. Here we have the case of a memory arousing an affect which it did not arouse as an experience, because in the meantime the change in puberty had made possible a different understanding of what was remembered.

Now this case is typical of repression in hysteria. We invariably find that a memory is repressed which has only become a trauma by

deferred action [Nachträglichkeit]. The cause of this state of things is the retardation of puberty compared with the rest of the individual's development.[32]

The Language of Psychoanalysis, compiled by Jean Laplanche and J.-B. Pontalis caution readers of *The Standard Edition of the Complete Psychological Works of Sigmund Freud*, in which the 'Project' appears. They observe that its translation of nachträglich could be taken simply to imply a 'variable time-lapse due to some kind of storing procedure between stimuli and response.'[33] In the 'Project,' as Ruth Leys points out, trauma is constituted by the relationship between two events and is dependant upon a period of 'latency', revival and revision:

> Freud problematised the originary status of the traumatic event by arguing that it was not the experience itself that acted traumatically, but its delayed revival as a *memory* after the individual had entered sexual maturity and could grasp its sexual meaning.[34]

The theory of unconscious non-linear, non-progressive psychic temporality, which is fundamental to the notion of nachträglichkeit, is further clarified in 'Screen memories' (1899); Freud's thinly veiled self-analysis of his own 'dandelion fantasy.'[35] Here a seemingly unremarkable scene is revived as a memory of unusual clarity. What becomes clear from Freud's memory is that the details of an early childhood memory are inflected with meaning from two phantasies, one in late adolescence and another in early adulthood. A cover has been unconsciously constructed to enable other memories and feelings, otherwise held at bay by resistance, to enter consciousness. This cover is not, however, entirely invention, rather Freud supposes the existence of a 'memory-trace the content of which offered the phantasy a point of contact [that] comes, as it were, half way to meet it…the phantasy does not coincide completely with the childhood scene. It is only based on it at certain points. That argues in favor of the childhood memory being genuine.'[36]

Under the behest of nachträglichkeit a memory may undergo a deferred revision that bestows a new and possibly traumatic meaning upon an earlier event. This prior event had not been fully understood at the time because, in Eckstein's case and in Laplanche's words, the child did 'not yet possess the ideas necessary to comprehend it.'[37] Or, in the case of Screen memories, an 'innocent' memory may be enlisted by unconscious phantasy so that suppressed ideas might evade resistance and become conscious. It is

possible to argue, therefore, that both of these mnemonic transformations retain/work grains of historically specific perception.

In 1895 and 1899 Freud's psychoanalytic practice was still based on the possible recovery or 'reconstruction' of an original scene.[38] By the time he wrote 'Beyond the pleasure principle' in 1920 he had abandoned this earlier aim:

> The patient cannot remember the whole of what is repressed in him, and what he cannot remember may be precisely the essential part of it. Thus he acquires no sense of conviction of the correctness of the construction that has been communicated to him. He is obliged to *repeat* the repressed material as a contemporary experience instead of, as the physician would prefer to see, *remembering* it as something belonging to the past. These reproductions, which emerge with such unwished-for exactitude, always have as their subject some portion of infantile sexual life – of the Oedipus complex, that is, and its derivatives; and they are invariably acted out in the sphere of the transference, of the patient's relation to the physician. [39]

Though my reading of Hesse's history and art practice is at pains to suggest the possibility of grains of historical reality that, in a matrixial sense, co-exist and inform intrapsychic processes the aim of this text has never been to recover specific 'scenes' of psychical significance. The archive can only be employed to texture the history of this artist in a way that makes my hypothesis plausible. The reading of Hesse's drawings proposed in this manner also leans on a methodology of 'construction.' For, as Leys notes:

> The concept of *Nachträglichkeit* calls into question all the binary oppositions – inside versus outside, private versus public, fantasy versus reality, etc. – which largely govern contemporary understandings of trauma.[40]

It is Leys' insight that first substantiates a critique of the interiorisation of psychic trauma that has modelled Hesse as an artist at the mercy of her unconscious. The adherence to an overriding presence of the primary processes in the efficacy and timelessness of psychic trauma hails from 'Beyond the pleasure principle' written three years prior to the 'Ego and the Id.' [41] For whilst the protective shield of the ego is prepared for stimulus from 'without' there is no such protection from the excitation received

from within. Thus internal excitation is felt with greater intensity with the result that, Freud writes:

> The feelings of pleasure and unpleasure (which are an index to what is happening in the interior of the apparatus) predominate over all external stimuli. And, secondly, a particular way is adopted of dealing with any internal excitation which produce too great an increase of unpleasure: there is a tendency to treat them as though they were acting, not from the inside, but from the outside, so that it may be possible to bring the shield against stimuli into operation as a means of defence against them. This is the origin of projection, which is destined to play such a large part in the causation of pathological processes.[42]

Life and Death in Psychoanalysis, written by Laplanche in 1970, is instructive here for it's reading of Freud's early work on hysteria and trauma in the 1890s demonstrates the foundation of the widely held understanding of Freud's attitude to external excitation that is derived from passages such as that above.[43] What *Life and Death* demonstrates, and indeed what Leys picks up on, is the way in which the reception and processing of external events can be interpreted in such a way that completely 'interiorises' psychical trauma. Laplanche writes:

> Everything comes from without in Freudian theory, it might be maintained, but at the same time every effect – in its efficacy – comes from within, from an *isolated and encysted interior.*[44]

This mode of efficacy has been entirely suited to the expressive monad, to borrow from Frederic Jameson, of High Modernism.[45] And it is on these grounds that the social history of art and those histories written for artists that utilise the tools of psychoanalysis have parted company. Leys cites the above passage to critique the way that 'traumatic neuroses can be relegated to insignificance in this way [...] As if the external derived its force and efficacy entirely from internal psychical processes of elaboration, processes that were understood to be fundamentally shaped by earlier psychosexual desires, fantasies, and conflicts.'[46]

Though texts written for Hesse have long acknowledged the Freudian concept of a 'bodily ego' a close reading of 'The ego and the id' calls into question the reliance upon interiorisation still further.[47] Rather than a sharply differentiated mental apparatus that distances the conscious from

the unconscious, that would seem to iterate the binary of inside/outside, Freud's 1923 text proposes an understanding of the ebb and flow of psychical processes between the transitory state of consciousness and the descriptive and dynamic unconscious. He writes:

> We shall now look upon an individual as a psychical id, unknown and unconscious, upon whose surface rests the ego, developed from its nucleus the Pcpt. system [...] we may add that the ego does not completely envelope the id, but only does so to the extent to which the system Pcpt. forms its [the ego's] surface, more or less as the germinal disc rests upon the ovum. The ego is not sharply separated from the id; its lower portion merges into it.
>
> But the repressed merges into the id as well, and is merely a part of it. The repressed is only cut off sharply from the ego by the resistance of repression; it can communicate with the ego through the id. We at once realise that almost all of the lines demarcation we have drawn at the instigation of pathology relate only to the superficial strata of the mental apparatus [...][48]

For Freud the ego is an 'extension of the surface-differentiation'; that part of the id that has been 'modified by the direct influence of the external world.' Perhaps even more significant is the role played by the ego as it attempts to reign in the id by bringing the influence of the external world to bear upon it and its tendencies via the reality principle.[49]

In the special case of trauma Ruth Leys seeks to destabilise the binary of inside/outside further via Henry Krystal's writing about the survivors of · concentration camps. He urges a 'return to Freud's work on anxiety in order to reconceptualise both infantile and adult post-traumatic phenomenon.[50] In 'Inhibitions, symptoms and anxiety' Freud not only traces anxiety back to an 'expectation' of danger, but to the precise nature and meaning of the particular 'danger-situation.' Clearly, the 'danger-situation':

> Consists in the subject's estimation of his own strength compared to the magnitude of the danger and in his admission of helplessness in the face of it – physical helplessness if the danger is real and psychical helplessness if it is instinctual. Let us call helplessness of this kind that has been actually experienced a *traumatic situation*. We shall then have good grounds for distinguishing a traumatic situation from a danger situation.

The individual will have made an important advance in his capacity for self preservation if he can foresee and expect a traumatic situation of this kind which entails helplessness, instead of simply waiting for it to happen. Let us call a situation which contains the determinant for such an expectation a danger-situation. It is in this situation that the signal of anxiety is given. The signal announces: 'I am expecting a situation of helplessness to set in,' or: 'The present situation reminds me of one of the traumatic experiences I have had before. Therefore I will anticipate the trauma and behave as though it had already come, while there is yet time to turn aside.' Anxiety is therefore on the one hand an expectation of a trauma, and on the other hand a repetition of it in a mitigated form. Thus the two features of anxiety which we have noted have a different origin. Its connection with expectation belongs to the danger situation, whereas its indefiniteness and lack of object belong to the traumatic situation of helplessness – the situation which is anticipated in the danger-situation.[51]

The existing mnemic image of signal anxiety, Freud tells us, recalls 'affective states [that] have become incorporated in the mind as precipitates of *primaeval* traumatic experiences, and when a similar situation occurs they are revived like mnemic symbols.'[52]

Leys points to a correspondence between signal and automatic anxiety because the model of the breached protective shield 'defines the mechanism that Freud calls "primal repression" – the archaic or primal form of repression that comes before repression proper, and on which the latter depends […] and that can only be described in economic terms.' Leys therefore argues that:

Sigmund Freud characterises anxiety simultaneously as the ego's guard against future shocks *and* as what plunges it into disarray owing to the breach of the protective shield; anxiety is both *cure* and *cause* of psychic trauma. The result is that the opposition between the signal theory of anxiety and the automatic or economic theory of anxiety cannot be sustained.[53]

Leys analyses Freud's notion of 'signal anxiety' and 'automatic anxiety' in order to elucidate the 'mimetic' theory of trauma via 'primal repression' as the reactivated imprint of the 'emotional affective primary identification' formed by the not yet coherent subject.[54] Leys connects the situation of helplessness anticipated by signal anxiety with the unbinding of the ego and

primal repression 'due to an excess of stimulation that by traumatically breaching the boundary between inside and outside shatters the unity and identity of the ego.' Thus within the processes of 'binding' that seeks to master the influx of energy and that she 'aligns' with mimetic identification Leys perceives:

> An explicitly political meaning: by binding or bonding the individual with the other or outside in an emotional bond of identification that constitutes the homogeneous group or mass, individuals neutralise their lethal tendency to disband into a disorderly panic of all against all.[55]

Ley's text draws on the writing of Mikkel Borch-Jacobsen to elucidate this bond to the other, not in terms of libidinal desire for the other, but as a trace or model of 'an emotional bond of identification that is "*anterior* and even *interior* to any libidinal bond." Freud also calls that emotional bond of identification "feeling," a term that overlaps with a whole group of psychological concepts, such as sympathy and mental contagion, and implies an entire theory of *imitation*, or "mimesis."'[56]

This cogent study makes it possible for me to weave together the trauma of temporary separation in early childhood, an iteration of originary archaic trauma, and the final separation between mother and daughter caused by the death of Ruth Marcus Hesse. Both of these separations were can be situated in relation to the Holocaust. All of these experiences, moreover, felt the traumatic impact of, that is had been revived and revised by, what was for Eva Hesse, a hitherto latent history revealed by the cultural and historical events connected to the Holocaust that took place between 1959 and 1960. I only wish to follow the work of Leys so far. For its desire to solve the tendency to over interiorise trauma via the mechanism of mimetic identification, and thus to present a balance between internal modification and external experience presents another difficulty. Ruth Leys goes on to suggest that the human subject's inability to remember traumatic experience is due to its relation to the mnemic-trace of 'primary identification.'[57]

To write after the work of Bracha Ettinger is to discern how the binaric, assimilative phallic paradigm models contemporary theorisations of trauma and its relation to the external world upon such interpretations of the archaic encounter. Caruth and Bessel van der Kolk perceive trauma as a phenomenon that is a 'veridical' memory of an external event that possesses the subject. Their hypotheses are problematic for thinking about art because they propose a non-symbolic art practice, literally *history*

painting.[58] The subject absorbs and modifies external stimulus within an 'isolated and encysted interior' a model that brings us to back into the pitfalls of psychobiography since it interprets art practice as, what Griselda Pollock terms, the 'externalisation of what is inside a coherent and discrete subject.'[59] Ruth Leys has critiqued both these models. What remains problematic about the hypothesis of 'mimetic' trauma is that it is derived from an adherence to the Freudian identificatory model of the primordial encounter. This model cannot support the particular dynamic necessary to my reading of Hesse's drawings and her relationship to her mother Ruth. For the phallic paradigm, that has determined Hesse's writing and those texts written for her, has already fixed her identification with her mother not only as dangerous but as a pathological route to self-destruction that would have swallowed the artist in her own 'sickness.' In 'Matrix and metramorphosis,' Bracha Ettinger illuminates the non-neutral bias of Freudian and Lacanian psychoanalysis:

> I think of the "complete" or "whole" subject as emerging after and from an already distinct and highly structured stratum rather than one that is undifferentiated.[60] .

The point I wish to make is that Leys, following Freud's legacy, imposes a phallic structure on an archaic relation or 'rapport' in which that structure is irrelevant and forecloses its possibilities. Ruth Leys speaks of a 'homogeneous mass' that the subject may either reject (and becomes psychotic) or 'bind' itself to via an identification that assimilates it. The human subject still seems to have to give itself up to experience or incorporate it. This 'discrete' subject's relation to the social, and therefore maybe to history, is configured via the absorption of the very difference/particularity/multiplicity that is vital to my writing about Eva Hesse.

I would rather pursue the insights 'Traumatic Wit(h)ness-Thing and Matrixial Co/in-habituating.'[61] In this 1999 essay Ettinger theorises the 'archaic encounter' as the 'prototype of trans-subjective knowledge,' that, Alison Rowley suggests, 'might be read as another theorisation of the potential of painting, and more broadly the potential of art, for 'place making.'[62] I want to suggest that Bracha Ettinger's model of the matrixial archaic encounter between I and non-I as 'partners-in-difference,' makes possible grains of several historical realities which co-exist, modify and thus co-emerge and are co-poetic with subjectivity. Thus the matrixial stratum of subjectivity configures another relation between trauma and several, partial human subjects:

Painting captures in producing, or produces in capturing knowledge of the with(h)ness-Thing. A possibility of ethically acknowledging the Real emerges in transferential wit(h)ness-Thing, when someone else apprehends in place of the subject the subject's own non-conscious matrixial sites. Suddenly, in metramorphosing with the artwork, you might find yourself in proximity to a possible trauma, as if you have always been potentially sliding on its margin. You are threatened by its potential proximity and yet also compelled by a mysterious 'promise of happiness' (Nietzsche's expression concerning beauty), a promise to re-find in jointness what faded away and got dispersed, on condition of matrixially encountering the *non-I*, since your own desire is the effect of others' trauma no less than of your own. By such an effect of beauty, the feminine borderlinking doesn't qualify as dwelling beyond a barrier, a frontier. Rather, in-between pure absence and pure sensibility, it is embedded with-in co-affection and makes sense as a transformation on the level of a limit. The artwork extricates the trauma of the matrixial other out of 'pure absence' or 'pure sensibility,' out of its time-less-ness into lines of time, and the effect of beauty is to all wit(h)nessing with non-visible events of encounter to emerge inside the field of vision and affect you.[63]

Putting the Holocaust in the Picture:
A Note on America and Anti-Semitism 1940–1970

To destabilise the primacy of internalised unconscious psychic processes is to finally make felt the significance of the complex temporal interplay between 'outside' events and psychic experience. This external world exceeds the limits of the group of New York artists with which Hesse has been chiefly associated to encompass those conditions with which Holocaust experience was negated and excluded for refugees living in the US. I begin from the widest possible viewpoint, the general presence of Anti-Semitism in America. This foundation proceeds to a narrower focus on the community of Washington Heights in which Hesse grew up and the critical debate that surrounds concepts of 'survival' and 'survivors' in the case of children.

In a 1944 poll one third of the returnees said that they were sympathetic to or would join an anti-Semitic political campaign in America.[64] Those who had wished to keep America out of the European conflict had censured American Jews, Jewish immigrants and refugees as 'warmongers'.[65] It is incomprehensible that, after the Allied victory and the newsreel footage of the concentration camps that had been screened across

America, the immigration of Jewish and other refugees to America was still resisted. [66] In *A Time For Healing: American Jewry since World War II*, Edward S. Shapiro tersely comments: 'evidently during the cold war the American public could be concerned with only one totalitarian power at a time. The threat from the Soviet Union pre-empted interest in the horrors of Nazi Germany, while the status of Germany as an American ally made Americans reluctant to embarrass Germans by drawing attention to their recent past.'[67] The American media's reluctance to draw the American public's attention to *Nuit et Brouillard*, by Alan Resnais, may indeed be attributed to this wish not to embarrass Germany. The film had been scheduled for the Cannes film festival of 1956. Although the festival itself featured in the Jewish owned *New York Times*, no mention had been made of the film. This was all the more peculiar in light of the fierce debate that the film caused. The Federal German government objected to the inclusion of the film in the festival. The governing body at Cannes decided that, in the probability of the film 'wounding national sentiments', it should be removed from the official competition and be discreetly screened. Once the news had broken *The Times* in Great Britain and *Le Monde* in France were outraged, but in the *New York Times*, no comment was made.[68] The shift of America's political allegiance discussed in *The Holocaust in American Life*, by Peter Novick, provides cogent reasons why *Nuit et Brouillard* would be so ignored.[69] In his fifth chapter "That is Past, and We Must Deal with the Facts Today" Novick describes the Holocaust as 'something of an embarrassment' to American public life in the late 1940s and 1950s. His detailed analysis begins by proposing a post 1945 'ideological retooling' in the United States that accompanied a shift from the perception of Germany as the World War II enemy, 'the apotheosis of human evil and depravity,' while the Russians and Americans were allied with the other 'good guys.' 'Russians,' Peter Novick observes:

> Were transformed from indispensable allies to implacable foes, the Germans from implacable foes to indispensable allies. American forces had pounded Berlin into rubble; in 1948, Americans organised the Airlift to defend 'gallant Berliners' from soviet threat. The apotheosis of evil – the epitome of limitless depravity – had been relocated, and public opinion had to be mobilised to accept the new worldview. Symbols that reinforced the old view were not longer functional. Indeed, they were now seriously dysfunctional, reminding Americans of how recently our new allies had been regarded as monsters.[70]

The author posits the category of 'totalitarianism' as that which 'smoothed' this shift. Totalitarianism was perceived to be the common denominator of Nazism and Communism.[71] Whatever the theory's analytic merits, in the 1940s and 1950s it performed admirable ideological service in denying what to the untutored eye was a dramatic reversal of alliances. It only *seemed* this way, the theory asserted, in fact the Cold War was, from the standpoint of the West, a continuation of the World War II: a struggle against the transcendent enemy, totalitarianism, first incarnated in National Socialism, then in the form of the new Soviet Socialist Republic.

In the early years of the Cold War "totalitarian" was a powerful rhetorical weapon in deflecting the abhorrence felt toward Nazism onto the new Soviet enemy. Anticipating what some time later became a common theme, within a month of the liberation of the concentration camps, *Time* magazine was warning against viewing their horrors as a German crime. Rather, they were the product of totalitarianism, and its victims' deaths would be meaningful only if readers drew the appropriate anti-Soviet moral.[72]

This change of political allegiance brings us to the tight post-war American immigration policies that hampered the release of those trapped within the displaced persons camps. Many of these survivors were believed to be procommunist and therefore a threat to the security of the nation. As Shapiro noted, this was a 'curious charge since none of them wished to settle in Communist states behind the Iron Curtain.'[73] The belief that connected Jewish survivors to communism was augmented between 1950 and 1953, however, by the arrest, trial and execution of Ethel and Julius Rosenberg, Harry Gold and David Greenglass on charges of supplying classified information to the Soviet Union about the atomic bomb. 'Never', writes Shapiro, 'in American history was the hoary anti-Semitic association of Jews with communism more believable than in the early 1950s.'[74]

Slowly, very slowly, the credibility of Jewish people in America improved. Figures such as the baseball player and military hero Hank Greenberg and Bess Meyerson, the first Jewish Miss America crowned in 1945, provided both positive role models for Jews in America and also countered the prevalent anti-Semitic stereotypes. As the decades passed the acceptance of open anti-Semitism abated. But in the 1970s and 1980s many of the old prejudices remained.[75]

A New Life Awaits You: Silenced Histories

Within this post-war era, the suffering of those who had survived the event that would eventually be named Ha Shoah was firmly consigned by

those who had not endured it to a masterable past. When the issue of concentration camp survival was addressed in popular culture, its history was consistently refashioned in accordance with the new lives of the survivors. In so doing those that had stood by for too long appeared redeemed. *While America Watches: Televising the Holocaust*, published by Jeffrey Shandler in 1999, tracks how the narrative of survivor testimony was represented and structured by the medium of television. One an episode of the prime-time show *This Is Your Life*, hosted by Ralph Edwards, had been of particular interest to Shandler. On 27 May 1953 the programme focused on the life of Hanna Bloch Kohner. Born in Teplitz-Schönau, Czechoslovakia in 1919, Kohner had survived Auschwitz and Mauthausen.[76] Aided by the covert co-operation of her family, Kohner's history was carefully scripted and rehearsed to coincide with several emotional reunions with old friends. The programme interwove the particularity of her story with incidental music provided by an in house orchestra, general historical film footage, and photographs. At the climax of the show, Hanna Bloch Kohner's brother, whom she had not seen since their imprisonment in Auschwitz and who now lived in Israel, joined her on stage.

Instead of addressing the traumatic legacies of persecution, familial separation and loss *This Is Your Life* structured Hanna Block Kohner's history around romantic attachment, estrangement and reunion. In Germany before the war Hanna had planned to marry Walter Kohner. He had obtained a visa for the United States, but because of immigration quotas Hanna Bloch could not get out before Himmler closed all avenues of emigration in October 1941. Later, Hanna Bloch lived in Amsterdam and there she 'met and married Carl Benjamin, a young German Jewish refugee. They were arrested by Gestapo agents in the winter of 1943 and sent to the detention camp at Westerbork.'[77] Hanna Block Benjamin was to be an inmate of four concentration camps, and had to pass through her hometown in a cattle car on the way to Theresienstadt. 'Among the less fortunate,' in this narrative Shandler tells us, 'were Hanna's husband, father and mother who all died in Auschwitz.'[78] But like so many Hollywood movies, television had to have a happy ending. And if that happy ending could make America look good, in light of the fact that it was its immigration policies that had kept Hanna Block in danger in the first place, then so much the better. On 7 May 1945 Mauthausen was liberated by American troops. Hanna Block Benjamin was still alive and befriended by a Jewish GI who knew Hanna Bloch's former sweetheart Walter Kohner and wrote to him. The couple were reunited and married.

Thus, Ralph Edwards summarises, 'out of darkness, of terror and despair, a new life has been born in a new world for you, Hanna Kohner.'[79]

The redemptive conclusion of Hanna Block [Benjamin] Kohner's life story is very much structured by the post-war belief that survivors should forget about lives lived before and during the war and concentrate on a building a new future. 'Edwards employed this narrative structure,' Shandler states:

> To transform Hanna's experiences of rupture, loss, and displacement into a cohesive narrative of triumph over adversity. Most notably, the deaths of Hanna's parents and her first husband at Auschwitz were given the briefest mention, as they were subsumed by a narrative shaped by the course of her romance with Walter. Thus, *This Is Your Life* presented Hanna's life simultaneously as an exceptional tale of personal victory over genocidal evil and a conventional girl-meets-boy-girl-loses-boy-girl-gets-boy story.[80]

Likewise, the first major cinematic representation of the Holocaust, the adaptation of *The Diary of Anne Frank,* released in 1959, focused a significant part of the film on the romantic tension between the characters of Anne and Peter. The film ends optimistically. Doves fly from the window of the annex while Anne Frank stares out, leaving the audience with a voiceover drawn from the diaries, 'in spite of all, I still believe men are good.'[81] Judith E. Doneson points out that such an optimistic ending would have left little room for a European audience to recognise the reality of the *univers concentrationaire* and Nazi occupation. She continues: 'the ending indicates the need to fulfil the American expectations of an optimistic finish, and in so doing, encourage the [American] audience to identify with the film's characters.'[82] *The Diary of Anne Frank*, a film imbued with optimism synonymous with the American way of life to provide a model for refugees and survivors to approach their post war lives. The proffered belief that 'men are good' leads to the hope of better days to come, and an investment in the future.

The phenomenon that would seal survivors off from the lives they had lived before and during 1933–1945, that after the war would compel them towards a new future began even as the Nazi killing machine ruthlessly harvested the Jews of Europe. In *The Holocaust in American Life*, Novick makes a lucid and illuminating analysis of the potential for, and absence and presence of, Jewish American and Jewish Palestinian agency in aid of European Jewry.[83] Novick recognises the commonly acknowledged

pressure of wartime anti-Semitism in America.[84] In addition to this, however, he cites on the one hand the reverence of American Jewry for President Franklin Delano Roosevelt. The Jewish community wished to preserve the good relation it had with that administration and that meant, in their view, not unsettling it by pressing too hard on Jewish issues.[85] On the other hand, American and Palestinian Zionist organisations prioritised the establishment of the state of Israel above the rescue of European Jewry. Peter Novick's judicious account recognises that:

> The decision to give priority to post-war state-building over immediate rescue can easily be made to look appalling: ideological zealotry blind to desperate human need. But was it? One can criticise this or that choice, but overall the decision to 'write off' European Jewry and concentrate on building for the future was based on a thoughtful, if chilling, appraisal of what was and was not possible. It was based on the belief, shared by most Jewish leaders, Zionist and non-Zionist alike, that little could be done for the Jews caught in Hitler's net [...] Meanwhile, Zionists could take advantage of wartime sympathy for the plight of Europe's Jews, and the expected post-war political changes, to create what they believed to be a very different kind of 'final solution' to the Jewish question.[86]

Through 'displaced action' the unfulfilled desire to save European Jewry was 'channelled into working for the post-war and the long term.'[87] After the war many of those who had survived the *universe concentrationaire* were caught up in the Zionist drive for the State of Israel.[88]

Contrary to the political value of survivors *en masse*, one reads with dismay of the perfidious taxonomy applied to those individuals who had survived das Endlösung by sheer twists of fate. Novick defines a contrast between the perception of concentration camp survivors immediately after the war and present notions of the 'Holocaust Survivor' as an 'exemplar of courage, fortitude, and wisdom derived from their suffering.'[89] In the mind of Jews in America and Palestine in 1945, Novick informs us, the figure of the survivor conjured up an image of the devious petty criminal who had survived by their own ruthless cunning and selfishness.[90] Aside from the impolitic cruelty of such stereotypes, to identify those who had lived through such times as 'ex-ghetto elements' performed an act of Othering that distanced the speaker from the survivor: 'You are not (like) me,' 'I could not have been (like) you, in that place.' The stigma of the displaced

person, new American or survivor, who did not wish to be thought of as a criminal in their new life, silenced their experience.

The survivor was silenced again in part, and to an 'unknowable extent,' Novick tells us, in 'response to 'market' considerations: few were interested.' He repeats the advice given to a survivor by his aunt: 'if you want to have friends here in America, don't keep talking about your experiences. Nobody's interested and if you tell them, they're going to hear it once and then the next time they'll be afraid to come see you. Don't ever speak about it.'[91] We must understand that the experience of the survivor was 'Un–American.'

In *The Holocaust in American Film*, Judith E. Doneson tracks the transformation of *The Diary of Anne Frank* from its particularity as a European text, written by a young Jewish woman in 'hiding from the Nazis in Holland to a more Americanised, universal symbol.'[92] This transition is plotted alongside the rise of McCarthyism and quasi-liberalism in America after the war. To be affiliated to the Communist Party was of course, Doneson tells us, to be un–American. But, she continues, 'it was also un–American to be anti–Semitic or to prevent blacks from participating in the American dream.'[93] In this era, political equality meant sameness, the assimilation of difference. 'Socially,' Doneson continues, 'the trend was to accept the principle of equality for minority Americans.'[94] Survivorship was a signifier of difference *par excellence*. Survivors' experiences defined an unassimilable apartness from the American way of life that was the 'common religion' in the United States.[95] Thus the stasis of silence formed a veneer that overlaid both the difference of the survivor and the difference of the Jew from other new Americans.

In *C[lement] Hardesh [Greenberg] and Company* Margaret Olin argues that cultural anti–Semitism extended to the universalist foundations of Modernist art theory. The notion of universalised humanity, when combined with the purity of the material practices of formalism and abstraction, eliminated the subjective in art and thus assimilated ethnic, sexual and other forms of difference. Olin believes that in the world of art theory it was the 'self loathing' that characterised Clement Greenberg's Jewish identity that ultimately enabled Jewish artists 'to deny the reality of their oppression.'[96]

'Self-Hatred and Jewish Chauvinism: Some Reflections on "Positive Jewishness,' was first published in *Commentary* by Clement Greenberg in 1950.[97] In the context of a Jewish 'chauvinism' born out of tragedy, and likened to that of German Nationalism after 1918, he writes:

Those of us who are sick of Europe after Auschwitz and want to have nothing more to do with Gentiles have a right for the moment to indulge our feelings, if only to recover from the trauma. But humanity in general is still the highest value and not all Gentiles are anti-Semitic. Self-pity turned a good many Germans into swine, and it can do the same to others, regardless of how much their self pity is justified. No matter how necessary it may be to indulge our feelings about Auschwitz, we can do so only temporarily and privately; we certainly cannot let them determine Jewish policy either in Israel or outside it.[98]

In contrast to Olin's argument, Mark Godfrey's 1999 article 'Keeping watch over absent meaning: Morris Louis's *Charred Journal* series and the Holocaust,' argues that despite the beliefs of his mentor, Clement Greenberg, Morris Louis did publicly address the Holocaust in his paintings of 1951.[99] Godfrey believes that his participation in the 'debate' about 'Jewishness' evinces that that debate had 'now become a pressing question that *had* to be addressed by secular intellectuals.' The Holocaust had impacted on their history and sense of self. Jewishness was no longer simply 'an accident of birth' and their writing was symptomatic of the 'responsibility they felt had been imposed on them as a result of the destruction of the European communities.'[100]

Doneson draws on 'The Vanishing Jew of Our Popular Culture,' written by Henry Popkin in 1952 to show, however, that, under the rubric of liberal sameness, and the metaphor of the melting pot, the apparent decline of anti-Semitism after the war must be situated within the 'de-Semitization' that occurred across America. She reads the work of Albert Hackett and Frances Goodrich, the scriptwriters for *The Diary of Anne Frank*, within this desire for universal humanism. The diary had been published in American in 1952 and was widely read. The film, however, did not record any overtly Jewish elements of the diary, presenting instead a universalised notion of victimhood. Afraid of inciting or augmenting anti-Semitism by being too openly Jewish, John Stone of the Jewish Film Advisory Committee praised the film for its lack of specificity: 'You have given the story a more 'universal' meaning and appeal. It could very easily have been an outdated Jewish tragedy by less creative or emotional handling – even a Jewish 'wailing wall' and hence regarded as propaganda.'[101] As Doneson writes, 'out of misguided benevolence, 'Jewish characters, Jewish names, the word 'Jew" itself are expunged.'[102] It is this prism that may structure of reading of Hesse's account of her escape from Nazi Germany to Cindy Nemser. For at no point does the

artist make reference to the cause of her persecution, the fact that her family was Jewish.

It was the immediate aftermath of the war that placed survivors in an impossible position of silence. To speak of one's experience outside of the circle of co-survivors left one open to the censure of those who did not want or could not bear to hear. In *The War After: Living with the Holocaust*, Anne Karpf cites this myth as the 'justification for the silence that greeted Holocaust survivors in Britain.'[103] Clearly the repression and psychic numbing that had come into play to protect survivors could impede any articulation of those experiences after escape or release. Many did, however, wish to talk about their experiences; indeed the structure of trauma demanded it. Anne Karpf describes Primo Levi's nightmare of 'speaking and not being listened to, of finding liberty and remaining alone' as 'a wound almost as grievous as the original camp experiences, a second abandonment.'[104] Survivors needed someone to listen, to enable them to bear witness to a history that they were not fully in possession of. As Dori Laub tells us, 'survivors did not only need to survive so that they could tell their stories; they also needed to tell their stories in order to survive.'[105] The absence of such an 'empathetic listener' brought about the 'annihilation' of the story.[106] Those who had stood by and watched the genocide did not want, however, to bear witness to the scission of the twentieth century in which they too were culpable.

The myth of the silent survivor is fundamentally contradicted by the determined contribution to the tradition of Jewish historiography that had been made under the worst of possible circumstances. In spite of danger to the prisoners of the ghettos and the camps, fastidious records of the atrocities that were committed against the Jewish people were kept in secret. By far the most well known of these are the notes kept in the Warsaw ghetto by Emanuel Ringelblum, discovered after the war. Once it had become clear that in all likelihood the record keepers themselves would perish, measures were taken to ensure that the chronicles would tell their story after the war was over. In *The Holocaust and the Historians*, Lucy Dawidowicz maintains that 'the Jews were the quintessential people of history.' She traces the Jewish historiographic tradition evident in this time of persecution to the Five Books of Moses, that 'resound with the word *z'chor*, elaborating the concept of memory and remembrance, the stuff history is made of.'[107] The chroniclers empowered themselves in spite of the powerless position that their persecutors had placed them in. Dawidowicz cogently argues that a 'moral force' compelled the persecuted Jews of Europe to set down the events between 1933 and 1945 on paper in

the hope of combating subsequent anti-Semitism. Moreover, the chroniclers hoped that after the end of the war their records would help to bring the guilty to account, by accumulation a 'body of admissible evidence against the Third Reich'.[108] As early as 1945, inmates of the displaced person camps in 'Germany, Austria and Italy formed historical committees to collect testimonies, eyewitness accounts, memoirs, and other kinds of historical documentation.'[109]

Survivors were surrounded by a majority of Jews and non-Jews whose own understanding was so unaware of the incommensurability of those experiences they could not begin to meet the survivors halfway. Moreover, even in the 1960s, anti-Semitism categorically discouraged the possibility of an empathetic dialogue across the experiences of Jews and non-Jews. Those from the outside who attempted to traverse that boundary's experience through identification, fantasy or empathy were bombarded with criticism, as in the case of the poem *Daddy*, written by Sylvia Plath. One particular passage of *Daddy* incited fierce criticism:

And the language obscene
An engine, an engine
Chuffing me off like a Jew
A Jew to Dachau, Auschwitz, Belsen
I began to talk like a Jew
I think I may well be a Jew ...[110]

Jacqueline Rose cites Wieseltier's criticism of the poem as an abuse of:

The most arresting of all metaphors for extremity ... Whatever [Sylvia Plath's] father did to her, it could not have been what the German's did to the Jews ... Familiarity with the Hellish subject must be earned, not presupposed ... Plath did not earn it, that she did not respect the real incommensurability to her own experiences of what took place.[111]

Here the outcry made in the name of 'incommensurability' cloaks the real objection to the piece. Jacqueline Rose points out that, above all else, Plath's attempt to touch the experience of persecuted Jews in Europe through her own experience was sanctioned because a non-Jew sought to put themselves in the shoes of a Jew.

The belatedness inherent to traumatic historical experience as it happens, in its immediate aftermath and even in its telling by those who had seen but not witnessed it, foreclosed the attempts to give a voice to this event during

the 1940s and 1950s. Under the veil created by the myth of silence, psychoanalytic help for survivors was not forthcoming. In *The War After Living with the Holocaust*, Anne Karpf, herself the child of survivors, was incensed by the lack of psychological care given to those who had lived through Ha Shoah. In her argument she points out that the British and American schools of psychiatry and psychoanalysis had not progressed much since the diagnosis of shell shock in the World War I. The traumatic effect of 'war neurosis,' 'war weariness,' 'neurotic behaviour after liberation,' had all been studied. 'But,' Anne Karpf writes 'on adult concentration camp survivors [there was]– nothing. Shell shock extended only to combatants: the victims of war weren't assumed to have suffered from it. In the absence of this understanding, no appropriate, culturally sensitive help could be offered to Holocaust survivors in those early days.'[112]

Another contributing factor to the lack of psychological aid was the inability of the therapists themselves to hear the experiences of the survivors. Again, this point is elaborated in *The War After:* 'as the distinguished training analyst Pearl King points out, 'quite a lot of the analysts were already refugees from the continent, so it was very difficult for them. Analysing survivors wasn't a high profile thing because people hardly dared think about it.'[113] In 'An Interview with Robert Jay Lifton,' he and Caruth discuss the phenomena of the 'false witness' that can pervert the abreactive potential of the analyst/analysand relationship. The therapist may misguidedly 'insist that the patient looks to his or her childhood, or early parental conflicts, when the patient feels overwhelmed by Auschwitz or other devastating forms of trauma.'[114] Under these conditions how then, we may ask, could therapists bring themselves to hear the testimony of children?[115] In *Too Young To Remember,* a collection of testimonies from female child survivors of the Holocaust compiled by Julie Heifetz, Naomi recalled that the cause of her emotional problems was persistently denied by the professionals to whom she turned for help. Naomi had persistently suffered from depression, but she remembered: 'they never wanted to deal with the issues I wanted to deal with, issues I felt were important, like the Holocaust. A lot of people knew about the Holocaust but their attitude was 'why does it have to bother you?' Let's talk about your toilet training.'[116] Robert Jay Lifton elaborates the difficulties faced by the analyst:

Auschwitz survivors – what people actually did, what the Nazis actually did, what it was like when you smelled, you know, the smells of the crematoria, or when you learned that your children or your parents had been killed. It is very hard, for anybody, but all the more

so as a therapist or as a researcher, to sit in your office and let the
details in to reconstitute them in one's own imaginary. And it's such a
temptation to push them away, leave them out; to take the patient or
client back to childhood is much more comfortable, and we're used to
that. Or anywhere but in that terrible, terrible traumatic situation.[117]

Washington Heights: Community and Ethnicity

The obligations of the US government and American Jewry to refugees and
survivors were understood to lie in the provision of economic and social
rehabilitation. As the material and physical needs of refugees and survivors
were planned for and met, it is inevitable that they were driven towards an
investment in their future in the New World. In the late 1930s a newly
evolving community of German-Jewish refugees was attracted to
Washington Heights, an area in the Northern Hills of Manhattan
surrounded by parkland on the bank of the river Hudson. In *We Were So
Beloved*, a documentary film about Washington Heights made in 1985, the
filmmaker Manfred Kirchheimer, a childhood friend of Helen and Eva
Hesse affectionately referred to as Manny K, remarked that the landscape
in that region is very much like the Rhine and the cultured cities of Europe.
Forced to leave Germany with only their clothes, a little furniture and ten
US dollars in their possession Jewish refugees were also attracted to the
area by the lure of cheap housing. In *Frankfurt on the Hudson: the German
Jewish Community of Washington Heights, 1933–1983*, Steven M. Lowenstein
remarks that, beside the geographical attractions of the area, a 'chain of
migration' began after the first German-Jewish settlers left Germany for
economic reasons after the World War One. More often than not these
early migrants supplied the affidavits of support necessary to those
members of their families who had previously remained in Germany but
were now desperate to escape Nazi persecution. Lowenstein tells us that
'once a core group had been attracted to a neighbourhood, their friends,
relatives and former townspeople followed to be near familiar faces.'[118]
What had been a small colony of German Jews in the upper West Side of
Manhattan Island was transformed into a community of refugees from the
moment of Reichskristallnacht, or Pogromnacht, on November 9 and 10
1938. The Hesse family was caught up in the flight of the German-Jews
from their homeland.

By 1940 the population of German-Jewish refugees in Washington
Heights had reached over twenty two thousand and included Alice
Oppenheimer, a German Jewish refugee who had arrived in New York in
1938 before pogromnacht with her husband. Their early departure enabled

them to take more of their possessions out of Germany than those who got out after Reichskristallnacht. In *We Were So Beloved* Alice Oppenheimer remembered that in 1938 there was still something missing from this newly evolving community in Washington Heights: 'The people really felt like strangers here, they didn't speak English, they didn't have money. My husband thought that if we, the former immigrants, founded a congregation and the German Jews had their own services, they would feel more at home. We thought maybe hardship gets easier if you carry it together.'[119] Within the community the role of the synagogue went beyond its function as a centre religious observance. For those displaced by the violence in Europe, the synagogue offered a place where refugees could cling to each other and the culture that they had loved but left behind. Lowenstein corroborates Alice Oppenheimer's account: 'congregations gave a cultural and social anchor to the immigrants at sea in a new cultural world; their purpose was to preserve the familiar, not destroy it. Those who wanted to turn their backs on the customs of the past could join American congregations or none at all.'[120] In addition to this, synagogues also played their part in the commemoration of those individuals who fell victim to the Nazi killing machine. Manfred Kirchheimer recalls that, within Rabbi Leiber's synagogue 'memorial inscriptions painted in gilt characters would appear on the tinted windows attesting to a relative's death. With the end of the war, one read with ever-increasing frequency the names of loved ones and, in ghastly apposition, the names of the concentration camps – Auschwitz, Dachau, Theresienstadt, Mauthausen, Bergen-Belsen – where they perished.'[121]

For the new immigrants their economic and cultural concerns were bound to the difficulties of learning American English. Twice a week Alice Oppenheimer conducted English lessons for thirty-five to forty people from her apartment with the help of two unpaid teachers. The lessons were given for free, and the students told 'if you can afford it, become a member of our synagogue.' [122] This congregation, one of nine refugee congregations by 1940, began a clothing distribution scheme. Alice Oppenheimer explains:

> At that time, people were still allowed to bring their good clothes with them from Germany and, of course, it was understandable that they brought only good clothes. But since they had to work on the lowest level in America, doing housework for example, they needed work clothes. So we established this office, a room where everyone would come on a Sunday morning and get clothing. We were lucky to find

people who had lived a long time in America and gave us this clothing. And everybody accepted it because it was necessary.[123]

Even in the early days of their refugee lives, a 'fundamentally optimistic' attitude prevailed among many German Jews. It enabled them to bear the degradation of working for thirty cents an hour in a menial job in order to make enough money to buy food and to rent accommodation until they could learn English and retrain for a new profession. William Hesse was not untypical of most professionals who arrived in the New World. Eva Hesse tells us that his qualifications were invalid in the United States, so his career as a criminal lawyer was abandoned and he retrained as an insurance broker. To make ends meet refugees like the Hesses also rented out rooms in their apartments.

Early in 1940, when he was ten years old, Max Frankel came to Washington Heights with his mother. As Polish Jews, they had been thrown out of Germany in October 1938. At the time of his interview he was the editorial page editor of the *New York Times* and subsequently became executive editor between 1986 and 1994. In conversation with his childhood friend and class mate Manfred Kirchheimer, Frankel recalled that, in his own case, surrounded as he was by his close knit German Jewish neighbourhood, 'a fundamental optimism was preserved in a group that nonetheless had its share of trauma and relocation ... they are hard-working people who feel that, by dint of their own efforts, a decent life can be staked out.'[124] In light of what he and the German Jews had escaped from, Frankel stated in a matter-of-fact manner 'it focuses the mind when, in the end, all that's important is that you have a chance to breathe freely and a chance to earn your daily bread.'[125] The imperatives of hard work and building a new life in America had an additional dimension, however. A sense of obligation to those who were left behind demanded from the refugee justification for their survival. Alice Oppenheimer recalled her husband saying many times "We were not saved to think only about ourselves. We are saved in order to think about others." That really was his motto. He said, "It is not right that people as good as ourselves had to die in concentration camps, and we were saved. We weren't better. So we have to do something."'[126]

It is this communal resolution and determination of purpose that readied a home for Eva Hesse within the myths and practices of making art. In *Three Artists (Three Women)*, Wagner's astute analysis recognises that Hesse's 'confidence' did not 'follow logically from the social and economic position of the majority of American women at this particular moment in

history.' Rather she believes that Hesse's 'exceptionalism' is to be *'accounted for by the precise terms of the intersection,* in this instance, between personal and historical circumstance:'

> These are conditions that include the accidents of birth and family history, and their various consequences; the ideology of artistic selfhood current at the time; the urgencies and priorities of contemporary art practice; and so on. Their conjunction, in Hesse's case, enabled the staking out of a position which, 'wrong' or not, was one of considerable strength.[127]

Wagner leans toward the compounding moments of her art education and practice in a bid to avoid the pitfalls of Hesse as wound that may be evoked by the perusal of those 'accidents of birth and family history.'[128] Thus Wagner concludes that Hesse's 'sense of entitlement concerned the protocols of modernism *above all.*'[129] The monadic structure of modernism is, however, implicit in the reduction of the specificity of trauma to the 'wound.' To step to one side from that model is to acknowledge the historical weight of Hesse's beginnings:

> I always – art being the most important thing for me other than like existing and staying alive – became connected to this, the other thing that was keeping me alive was just like going And I never really separated [art and life] although I learned art on that other side. And they became closer enmeshed and absurdity is the key word. It has been the key focus to my life unless you want to make it really sad and sentimental and romanticise about a pathetic kind of ... occurrences
> Sort of – remember like in Waiting for Godot [...] where the main thing ... yeah like these people are there and they are doing nothing and yet they go on living.
> They go on waiting and pushing and they keep saying it and doing nothing and And it really is a key – the key to understanding me and once only a few understand and could see and that my humour comes from there. My whole approach to living and the sad things come from there – even the piece we talked about in the Sidney Janis Show [Hang Up].[130]

Hesse's conversation with Nemser is suffused with a sense of purpose with which the artist justifies her existence to herself and others by making art. I am not suggesting that the Holocaust should be introduced as the

primum mobile of Hesse's character or art making. I would argue for greater significance and attention to its impact however. To split hairs and say that the historical circumstance of displacement and exile in a refugee community facilitated a greater cohesion with the protocols of modernism and, as we shall see, the identity of the artist, that Hesse encountered. Her resistance to any sentimentalisation of the past, her ambition and determination are without a doubt characteristic of a generation of high achievers who fled Germany and grew up in the close knit community in the Northern Hills of Manhattan. As well as her scholarship from the Agency for Jewish Girls, Hesse's college education was, like that of many of her friends in that community, paid for by the restitution money her family received from Germany in compensation for the loss of her relatives. Again Hesse's generation was driven toward the future by a compulsion to succeed. Perhaps the root of this force was not felt consciously. But who would not work hard when the money that privileged you was in compensation for the loss of those you loved. To fail would be to betray them; one had to feel worthy of that privilege. It seems clear that Hesse's wonder at people that 'are there and they are doing nothing and yet they go on living' derives from the ethic of the German Jewish community summed up by the Oppenheimers: 'It is not right that people as good as ourselves had to die in concentration camps, and we were saved. We weren't better. So we have to do something.'[131]

To continue to research the dynamic of Washington Heights and the larger American Jewish community is to further comprehend Hesse's construction of herself as an American. Such research does not contradict that construction but illuminates the cultural specificity of its conscious and unconscious exclusions and inclusions to concomitantly attribute an aetiology to the directions of Hesse scholarship. *Frankfurt on The Hudson* argues that German language and culture presented a significant barrier between the German Jewish refugees and American Jewry. American Jews construed the continued use of German as the first language of the German-Jewish refugees as an abhorrent identification with Germany and its murderous fascism. Thus German Jews came to perceive themselves through the caricatured stereotypes given to them by their American Jewish neighbours.[132]

The German Jews perceived themselves as Germans of the Jewish faith, or German first and Jewish second a position that was almost incomprehensible to American Jewry. The extent to which German-Jews had become assimilated into the politics and culture of Germany since the Enlightenment had blinded them to the possibility of genocide in Germany.

We Were So Beloved conveys the paradoxical relationship that this community had with its Germany origins. The film began its interviews at the gathering of family and friends for the four o'clock café, a tradition carried over from happier times in Germany. Many of the older generation in the community longed for the tastes, smells and goods of home. Stores in Washington Heights often catered to the demand for German produce after the war. In contrast, the younger generation of German Jewish refugees that did not share this longing for 'home' boycotted German goods like VW cars long after the war.

The longing for 'home' often felt by older refugees, coexisted with an enthusiasm for all things American as signifiers of goodness, democracy, free will and free speech that for them further cemented their loathing of the National Socialists and what they had done to Germany. Parents encouraged their children to embrace everything all-American, especially sports, thus severing the ties with Germany. In *We Were So Beloved,* Kirchheimer remembers that he was woken late one night by his father and told that Joe Louis, the American, the 'good guy', had beaten Max Schmeling, the German, the 'bad-guy.'[133] In their eyes, 1930's America had given German Jewish refugees the gift of life. America was still, for many refugees, a nation of good guys. As Kirchheimer notes, the new residents had yet to take stock of the immigration restrictions that needlessly took the lives of so many others like the Kirchheimers and the Hesses and the racial discrimination of that country. While in conversation with Kirchheimer he noted that the games that the refugee children played, including himself, Max Frankel, Eva and Helen Hesse, were 'all-American.' For boys baseball particularly paved the way for refugee children's partial assimilation into their new society through the adoption of American culture.[134] Schapiro too outlines the importance of such a nationally identified sport for the acculturation of American Jews. To embrace baseball was to embrace the American way of life.

Lowenstein's recognition of a 'threefold character' in the Washington Heights community, 'American, German, and Jewish' has a clear bearing on our understanding of Hesse's self-construction as Eva 'Hess'. On the one hand, older refugees retained much of the Germanic culture they had brought with them. But this kulture belonged to a Germany long gone. To learn English had been the means of earning a living day to day but also incorporated American culture into the refugee's lives. As a child Helen Hesse Charash remembers helping her father to learn English but like many, the Hesse family often still spoke German at home. As they grew older the divide between the younger Jewish refugees and the experience of

their parents and Germany widened as they naturally became preoccupied with the new phenomenon of being teenagers. As Kirchheimer recalls:

> We had a club, we were dancing every night, being introduced to new people, nothing [about the personal and historical tragedies in Europe] was spoken about, until the Schindler reunion twenty-five years ago no one talked about it.[135]

The Case of the Child Survivor

In *The War After*, Anne Karpf contrasts the lack of psychoanalytic care given to adult survivors against the studies made of children who had survived the Third Reich.[136] Yet in the case of child survivors there was a further prohibition that silenced their stories, besides those against adult survivors and the open articulations of Jewish identity. This silence not only permeated general psychoanalytic practice, the general American public and American Jewry but also the survivor community. The introduction to *Too Young To Remember* outlines the difficulties encountered by child survivors whose experience was inextricably bound to and measured by scales of suffering:

> Many had shied away from participating in Yom HaShoah commemorations and felt out of place with an older generation of survivors. They had been told too often that they could not possibly remember events that happened to them when they were so young. They lived with a special loneliness, continuing to feel discounted and alienated. Initially they spoke as though their parents and others of the older generation were the real survivors and more important, as though they were not entitled to their own pain and lessons from the past.[137]

The question of what constitutes survivorship of the Holocaust is a highly emotive subject fraught with difficulty. My own position is that, as ever, the desire to give a shorthand definition to an experience in order to communicate it to others actively incorporates, universalises and marginalises those who were subject to it. No one should underestimate the magnitude or impact of the experience of the concentration camps. Yet those who believe that the term Holocaust survivor should apply only to those who lived through the concentration camps are clearly in danger of negating the rights of those who suffered trauma in ways other than the *univers concentrationaire*. In *Too Young to Remember*, Heifetz tells how she had to persuade one of the contributors to her book, known only as Naomi, to

take part. The myth of the aphonic survivor and the concept of what constituted survivorship doubly silenced Naomi's history. Naomi remembered: 'I was eight or nine years old, one child of many who had been surrounded by the threat of physical danger, put into a new environment and told suddenly, 'Okay, now you shouldn't think about anything more than hamburgers and ABCs.' But I never would have even thought to complain. After all look how lucky I was compared to the children in Europe. I had my life, what was there to complain about.'[138] Hesse left Germany in 1938 but the impact of the Holocaust is not confined to her first two years of life. Heifetz defines a child survivor as a person who was:

> Under the age of thirteen between 1933 and 1945 who lived in Europe, who was an eyewitness to persecution, whose life was threatened directly or indirectly, and whose psychological, emotional, and physical life was altered in an essential way by the Holocaust, both during and after those years.[139]

Naomi only consented to feature in *Too Young To Remember*, 'out of respect for [Heifetz's] interest in her story ... she insisted that the word survivor did not apply to her; she did not suffer enough.'[140] Naomi, Heifetz tells us, 'is one of the lucky ones. She and her parents escaped from Germany without experiencing either camp or ghetto.' Heifetz cogently argues that Naomi's story needed to be included in the book, however, because it communicated to 'all the children who escaped the physical tortures of the ghettos and camps, but who grew up in an atmosphere that bred insecurity and confusion during the psychologically crucial years.'[141]

While in conversation with Helen Hesse Charash, I asked if she thought the definition of the child survivor presented by Heifetz applied to her sister and herself. Like Naomi, in previous years Helen Hesse Charash did not recognise herself as a survivor because she had not 'witnessed outright persecution or ghettos or concentration camps.' 'However,' she continues 'we grew up in exactly the unsure and unstable environment' outlined by Heifetz.[142] Of the six contributors to *Too Young To Remember*, the testimony of Naomi is particularly pertinent to the case of Helen and Eva Hesse. Like the Hesses, Naomi arrived with her parents in America in 1939, leaving her grandparents behind. But, as we shall see in more detail in Chapter Four and Five, geographical safety is not necessarily synonymous with a sense of security or stability.

To illuminate those factors that inhibited the analeptic process of

bearing witness to the events of the Holocaust is to facilitate a non-polemical return to those hitherto occluded elements in the history of Eva Hesse. To return to the decisions Nemser made whilst editing her conversation with Hesse and place them beside the testimony of Naomi, and even to question Helen Hesse Charash is not to stand put their voices in the stead of a history of Hesse that we cannot know. The framework provided by *Too Young To Remember*, the testimony of Naomi combined with the notion of historical repression and deferred action, may nevertheless enable us to gesture towards to cogently 'construct' some sense of Hesse's hitherto occluded experience.

It is here that I would like to propose a somewhat preliminarily hypothesis of Hesse's intuitive reaction to Carl Andre's sculpture. To posit her experience of this work within the framework of Ettinger's borderlinking of the non-assimilative, affective, trans-subjective encounter formulated as 'traumatic wit(h)nessing.'[143] The sufferer of a traumatic event may possess 'a non-cognitive model of knowledge' that may 'reveal itself' in what Ettinger terms '*transcription:*'

> Such a transcription is a dispersed subsymbolic and affective memory of event, paradoxically both forgotten and inoubliable, a memory charged with freight that a linear story can't transmit, a memory that carries dispersed signifiers to be elaborated, and affects as sense carriers. It is not the story inscribed for reminiscences that I carry in place of a *non-I*. Rather, fragmented traces of the event's complexity carry fractured and diffracted memory, memory of oblivion itself and of what could not be inscribed in others even though it 'belongs' to a memory which is theirs, but only transcribed for/from them in me.
>
> Traces circulate in a trans-subjective zone by matrixial affects and non-conscious threads, that disperse difference aspects of traumatic events between the *I*(s) and *non-I*(s). thus, as I cannot fully handle events that concern me profoundly, they are fading-in-transformation while my *non-I*(s) become wit(h)nesses to them.[144]

The necessity for a position from which the listener may become a 'wit(h)ness' able to cognise material unavailable to the speaking subject re-frames Hesse's unedited narration of her escape from Germany in the unpublished transcript of 1970:

> *It's not a little thing to have two brain tumours in 4 months at age of 33. Well* I was born in Hamburg, Germany. My father was a criminal lawyer. He

had two doctorates – my parents are dead. And I have like books and poetry ... And I have the most *unusual* beautiful mother in the world. *She looks like Ingrid Bergman*. She was a *manic depressive* and she studied art *lived* in Hamburg, and my sister was born in 1933 and [I] was born in 1936. And then in 1938 – I was two years old, *children's pogrom*, I was put on a train and we went to *Holland* and we were supposed to be picked up by my father's brother and wife *in Amsterdam, parents hidden somewhere in Germany, but* he couldn't do it *couldn't get us* so we went into a *catholic* children's home. And when I was *sick* I was put in the hospital, *was even with my sister* and my parents *were hidden – came to Amsterdam* and I had trouble getting *out – getting us out went to England* and my father's brother and his wife *all my grandparents* ended up in a concentration camp. *No one made it we did.* And we got to America via one of my father's cousins. They had an import-export firm and one was in America and one was in England and the one in England saved hundreds of kids. And *the one got us out – it was very very late – like last chance we came in* at the end of the summer of 1939 he was a captain in the American army and he got us into [America]. And when we first came here we lived across the street from the Nazi party. He got us a place to live and my father he got trained as an insurance broker and my mother was sick a long time.

CN: But they all got here?

EH: Yes but then we lived in different homes because my mother was in and out of hospitals and my father was studying to be an insurance broker and [he wasn't home at night, crossed out] *and my sister and I used to be alone at night and terrified,* and my mother was there and not there. *We shifted into different homes* [illegible] *different places than sister ...* and my mother was in and out of sanitoriums. *She had psychiatrist who told her to divorce* and my father ... *fell in love with her psychiatrist* and the last time I saw my mother *I was with her and psychiatrist* she was living with a doctor and his wife. My father remarried *a bitch* and her name was Eva Hesse who had a brain tumour *same doctor same hospital* and stayed in the hospital two years to the day – she got out of the hospital two years to the day that I went in. *Same hospital Same doctor.*

CN: That is incredible.

EH: The same hospital, the same doctor and the same surgeon.

CN: It is amazing. And she had the same name.

EH: Well she married my father.

CN: Well she has all kinds of things wrong with her. *But she's alright*

EH: She has ... [*illegible*] but I mean in ~~two~~ *three* years two people *in the same family* not related had the same ... my father – well the story goes on. It doesn't end there. My father ... *no longer alive* my father died and two ~~or three~~ *I've had two brain tumours three* years after his death ... *He was sick for 15 years* he was getting ... and he never survived it. Well the history of health. Well no one lived but my father – *was sick for 15 years but* he lived *to 65* – I mean he died two days after *65* birthday. *Sick for 15 years but* no one in my family admitted that – no one. I have one healthy sister. *and I said it to her once.* She just couldn't stay couldn't ~~stay~~ *stand it.* I think my family is like the Kennedy's. I mean we didn't have that extreme wealth *or fortune* but it has all been extremes. There is nothing normal in my life. Even my art – I never try to get into a gallery – I never *tried to get in a show.* Art's the easiest thing that has been in my life and that is ironic because I have worked so little on it. *It's* the only thing – that is why I ~~manage~~ *might be* so good because I have no fear. I could take risk. I have the most openness ~~in that~~ about art of art. And my attitude is most openness. *Total unconservative, its total* just the freedom and willing to work. I really would walk on the edge.
CN: Uh uh.
EH: ~~and you know~~ *but* if I haven't achieved it well that is where I want to go. But in my life – maybe because my life's ~~is~~ *been* so traumatic so absurd – there hasn't been even one normal, happy – even happy – and I'm the *most* easiest person to make happy and the easiest person to make sad too because I think I have gone through so much. I mean it never stops. And I could go on. That is just the beginning. I ~~lived~~ *grew up with* with a stepmother whom I could not stand. And I love people. I have no trouble with people but I hated her. She was terrible to ~~us~~ *me.* And my father was terribly sick. He ~~first started the~~ *had his first heart* attack when I was 13 and ~~then~~ [*illegible*] *coronary attacks* and she used to say ~~we~~ you can't tell him anything because it will make him die. And *he loved me with this almost incestuous* [*illegible*] *too father* and we were very close and very quiet and ~~we would~~ *it wasn't* talked about *discussed* ~~other things~~ because he was *terribly ill* and he was getting crippled and *so had to operate spine and danger of heart* and my stepmother was ... *though a bitch did one* [but if there was] one thing in her life, she loved my father. So when she got sick they went to Europe and he died. Just like that. *Which was good.* She brought back his body and she came back and *she put herself in hospital to be tested,* said for last three years ... *he was alive didn't want to go in knew something was wrong looked can't find anything. Finally came, said brain tumour tomorrow we*

operate. My sister and I really took care of her. Fortunately when I got mine and ... *she came to hospital all time* and I can't stand her. When I was very sick she was good to me but ~~since~~ *soon* I am better she is not.

CN: There are a lot of people with that syndrome.

EH: My mother was like that. In between it was like you know – in between it was pretty much hell. *I used to feel fooled by life – because world thought I was a cute smart kid and I hid it – at home terror* tremendous fears ... incredible fear and ... *I miserable I had my father tuck my blanket in tight in my German bed which had bars at side* and he would have to hold me and tell me that he would be there in the morning *and we wouldn't be robbed and poor and* he would take care of me. That was the ritual at night.

CN: this happened to you – in between.

EH: Oh from the day I was born. And especially in the first part of my life.?

CN: I mean we take back with us what is ours.

EH: so that gave me whatever ... *My whole character I've been a giant in my strength* and my works are strong but somewhere *I'm a terribly frightened person – somewhere incredible strength – been built up whole abandonment syndrome father had to leave us. Not* with my sister all the time ~~so I was close~~ *went from home to* home. *Abandonment.*

CN: Yeah

EH: Then my marriage split up which created another ~~terrible~~ *abandonment* trauma. And then my father died –

CN: Yeah

EH: I mean it is just a whole ~~it never two~~ *relatively happy*

CN: Yeah

EH: It never was – I think I had two relatively happy *years* – but *as* bad ~~are the things~~ *as the* [things] that have happened and maybe because of that I have tremendous ~~strength~~ *happiness*. Even this year – I mean it is a miracle that I have lived through this first operation. I had a few hours – *left to live so much pressure* I mean the whole brain was being tipped over *all intelligence in front* but the thing is that but I had ... *in my own inner soul where* ... inaudible ... *Carl Andre's work it was the concentration camp – it was those showers that put on gas and that where to life.*[145]

Hesse's narration presents us with a historical account of her escape from Germany as a Jewish child in the era of the Third Reich. Nemser's role as a biographer at this point in the dialogue focuses her attention on the

historical facts. But the cultural context that shapes both the speech of these utterances and Nemser's listening forecloses her position as a potential wit(h)ness to the 'subsymbolic' silences of Hesse's narrative. Moreover, Hesse intercepts and forestalls the empathy of her listening from the very beginning of her conversation. The flippant tone with which we read *'its not a little thing to have two brain tumours in 4 months at age of 33'* entreats the listener not to give the coming disclosure too much gravity. Like the analysand who tells her therapist of her serious distress with the outward appearance of cheerfulness and a smile on her face, Hesse's first sentences seem to belittle the significance of the following communication and to say 'please don't feel sorry for me, or take me seriously, because I couldn't bear it.'

By listening to her narrative Nemser is party to the processes that recognise the referential force of her escape from death in the slaughter of European Jewry and the loss of those who were and would have been dear to her. While this process is contained by the framework of historical reference Nemser is secure enough not only to proceed but her lack of historical pointers enables the narration to flow undirected. In 'Bearing Witness, or the Vicissitudes of Listening,' Dori Laub elaborates the dangers of too much direction in the analytic framework: 'what is important is the situation of discovery of knowledge – its evolution and its very happening.'[146]

Hesse's narration of her family's escape from Germany is an event in itself. The historical reality outlined in it paves the way for a kind of knowledge of that event. The affect and the referential force of her survival permeate other elements and encounters in her life. Although the events of the Holocaust for Hesse are chronologically framed, their telling and the subsequently edited interview testifies to the timelessness of her own experiences and the fate of her family. To escape Germany at such a young age does not efface but rather compounds the nature of trauma as a phenomenon that is not recalled as a memory of a past event.

In anticipation of my argument in Chapter Five, is it possible to propose that, in this beside time of trauma, the vergangenheitbewältigung (unmasterable past) co-creates Hesse's intuitive response that co-exists with and traverses the formal boundaries of the cold steel plates of Carl Andre's artwork? The feeling that Hesse imbibes from that work would not be a *known* re-presentation of those events to her that could then establish a belated closure. Rather, those 'floor plates' are what Ettinger has named 'transport station of trauma' for the affective residue of a plurality of still unknowable events between a daughter, her family and its history.[147] For one who has escaped the annihilation in which loved ones perished such affect might be a register of a returning trace of the sheer terror that had yet

to be truly addressed. Sheer terror that carried some recognition of what might have happened to her, but, and this I can only imagine, a horror about what did happen haunted by the forever unanswered questions raised by those that bravely tackled that horror such as Alain Resnais. Questions too freighted to be sustained by consciousness but whose affect circumvented repression by a subterfuge in Hesse's sense of Andre's work. How did this life in death feel, how was it experienced, not by some dehumanised or simply unknown other, but by *her* aunt and *her* uncle who helped to save her and her sister, and by *her* Opa and *her* Omi?

4

WIVES, DAUGHTERS AND OTHER(ED) DIFFERENCES

I will not let an hour pass, my dear sir, without acknowledging your kindness in sending me my dear mother's letters, the only relics of her that I have, and of more value to me than I can express, for *I have so often longed for some little thing that had once been hers or been touched by her. I think no one so unfortunate to be early motherless can enter into the craving one has after the lost mother* ... I have been brought up away from all those who knew my parents, and therefore those who come to me with a remembrance of them as an introduction seem to have a holy claim upon my regard.

The Letters of Elizabeth Gaskell [1]

In the meanings produced for the work of Eva Hesse the death of her mother, Ruth Marcus Hesse, figures heavily. In 'An Interview with Eva Hesse,' the artist told Cindy Nemser in 1970 that:

I have the most ~~unusual~~ *beautiful* mother in the world. *She looks like Ingrid Bergman* She ~~led~~...*was manic-depressive* and she studied art *lived* in Hamburg. My father he got trained as an insurance broker and my mother was sick a long time.
CN: But they all got here?
EH: Yes but then we lived in different homes because my mother was in and out of hospitals and my father was studying to be an insurance broker and ~~he wasn't home at night~~ *and my sister and I used to be alone at night and terrified,* and my mother was there and not there. *We shifted into different homes* [illegible] *different places than sister* ... and my mother was in and out of sanatoriums. *She had psychiatrist who told her to divorce* ~~and my~~ father ... *fell in love with her psychiatrist* and the last time I

saw my mother *I was with her and psychiatrist* she was living with a doctor and his wife. My mother was there but not there – there, but not there.[2]

This brief history, that begins as Hesse speaks of her mother in the *present tense*, forms the basis of the writings about Ruth Marcus Hesse. In the absence of a significant body of historical information, because she is literally 'there but not there,' Ruth Hesse's role in her daughter's life has been elucidated psychoanalytically via the artist's journals. The retrospection of those documents inevitably led Hesse scholarship to focus on the loss of Ruth Hesse by suicide. As Anne Wagner's cogent analysis in *Three Artists (Three Women)* makes clear the way in which 'choices made in letting Hesse "speak for herself" via the selective use of her diaries and notebooks lead the texts written for her to 'privilege an image of psychic distress.' What gets left out, she tells us, 'is context and explanatory detail – the kinds of information that might be used to ground and justify emotional response. Hesse may have fumed and worried but she kept her life afloat.'[3] In the case of those diary entries that feature Ruth Hesse, Wagner judiciously describes Hesse's practice of writing as 'sustained efforts to make a conscious settlement with her mother's illness and suicide.' This analysis makes available a reading of the 'window motif' in Hesse's drawings as a recurrence of an unresolved residue of this artist's mother-daughter relationship.[4] Across the methods of Hesse's art practice the author: 'likes to imagine a *return in representation to the scene of the suicide of Hesse's mother*: remember that she died after jumping from a window. From its earliest appearance Hesse's window imagery has two concerns: there is the issue of demarcating the frame and the problem of characterising (or refusing to characterise) what lies beyond [...].'[5] Since the publication of *Three Artists* it has become clear that Ruth Hesse's death did not occur in the way first supposed by Hesse scholarship. I take up this point again in more detail in Chapter Five. Indeed it is difficult to establish what Hesse believed herself. For me what is significant is not the details of her mother's death but Wagner's insistence on Hesse's desire to make a 'settlement' with the psychic and physical loss of Ruth Hesse. That settlement, for Wagner, inevitably entailed 'defending herself against the threat that identification with her mother (identification with her as a woman) presented.'[6] This belief is drawn from several diary extracts made over the course of 1966, the year that Hesse separated from her husband Tom Doyle and her father died:

I do now think that I am like my mother was and have the same sickness and will die just as she did. I always felt this.' (Spring 1966) 'My father and mother got divorced, she was sick. He let her go off by herself – without us her children – she killed herself.' (March 1966) Or 'shame of height is shame of incest – an obvious seen shame covering for a hidden shame. Tom's desertions was [sic] planned as thought [sic] father's desertion of mother for me. I [sic] shame for this must therefore repeat and lose. Punished for being bad. Therefore my use of bad, "Eva is bad again" (=Eva is sick again. I was sick and bad and therefore got father. Helen smart and good, not sick, lost. So if sick and helpless have father, for which I then must punish myself.' (Fall 1966).[7]

The Oedipal structure that shapes Hesse's perception in these notes is clear. Moreover the 'disconnected character' of these notations seems to stem from their recording key points of the artist's therapeutic sessions with Dr Sam Dunkell.[8] The author understands the way in which Hesse framed her feelings about her mother in her journals to:

Convey what Hesse was able to understand about her fears concerning her mother – fears that centred on the multiple risks she ran of re-enacting her mother's death as the inevitable result of her relationships with her husband and her father. The fear of incest could involve not just a fear of the daughter's having caused her mother's suicide by seducing the father; if she takes her mother's place with her father, she may thus confirm her destiny as the heir of her mother's sickness as well as her man. And similarly, for Hesse to admit the failure of her marriage was to admit her *likeness* to her mother and thus to catalyse the inevitable result.[9]

Wagner quite rightly bases her analysis on Hesse's perception of the events and the artist's responses to them. Hesse's sense of reality was imbedded in the ideological structures of her therapy. Those structures, therefore, cannot be ignored. While the 'threat' of Hesse's identification with her mother had been very real it is now time to turn attention to the Freudian modes of analysis and interpretation that has informed Hesse's therapy and the scholarship built on its foundations. This step is crucial to my own desire to transcend the pathological framework that has consistently pre-determined understandings of the creative working-through of this mother-daughter relationship. I argue that Hesse's

psychotherapy did not sufficiently recognise the trauma of mother loss. Not only that but it constructed an impossible history for Ruth Hesse that imposed an economy of forgetting upon Hesse's responses to the loss of her mother. To counter what I have called this phallic forgetting it is necessary to take up Wagner's project: to seek out 'context and explanatory detail – the kinds of information that might be used to ground and justify emotional response.' The archive provided by Hesse's papers demands a close reading in conjunction with key historical texts that will situate the complex relation between Ruth Marcus Hesse, her daughter and the trauma and anxiety of life in Nazi Germany and America. Only then can Bracha Ettinger's question 'what is a woman for a woman?' be posed. Through the prism of the Matrixial subjective stratum different, non-pathological, part-connections between becoming artist/daughter Eva Hesse and creative/mother Ruth Marcus Hesse, that exceed the structures of the artist's therapy, may be imagined. This supplementary perspective then opens a space, explored in Chapter Five, in which the other(ed) presences of Ruth Marcus Hesse with-in Hesse's art practice can be thought.

Phallic Forgetting

Eva Hesse began psychotherapy in January 1954 with Dr Helene Papanek.[10] Helen Hesse Charash cites the deep effect that the death of their mother had on her sister as the significant contributing factor to Hesse's entry into analysis. She notes that their stepmother, Eva Nathanson Hesse, had not 'had it in her' to give her stepdaughters the affection they needed either in 1945 when she married William Hesse or after the death of their mother.[11] It was, however, Eva Nathanson Hesse who encouraged Hesse to seek professional therapy. This caused heated arguments in the family. Helen Hesse Charash remembers that her father was adamant that his youngest daughter was not 'crazy.' Yet Eva Nathanson Hesse persevered until William Hesse found the money to pay for his daughter's treatment.[12]

The period leading up to Hesse's entry into analysis began had been permeated with excitement, disruption and upheaval. Hesse had attended the High School of Industrial Arts in downtown Manhattan. Helen Hesse Charash tells us that William Hesse was dubious about his youngest daughter being able to make a living from her burgeoning creative talent: he asked 'how can you be an artist?' Hesse's father thought that she should be prepared to take a steady part-time job and then 'do your art in the afternoons and evenings.' 'Out of love and concern' he sent the young Hesse to see Bert Kirchheimer, father of Manfred Kirchheimer, who had been a successful commercial artist and declared the young artist to be

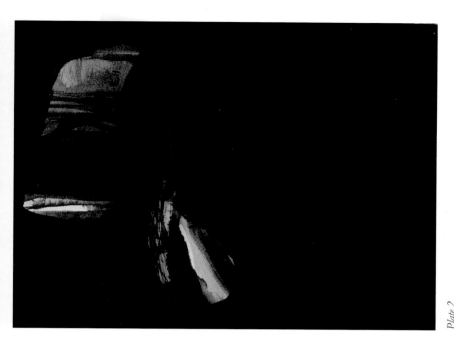

Plate 1
Eva Hesse, *No title*, 1960/61,
Gouache, ink and pencil on paper. 30.5 × 22.9 cm / 12 × 9 in.
© The Estate of Eva Hesse. Hauser and Wirth, Zürich and London.

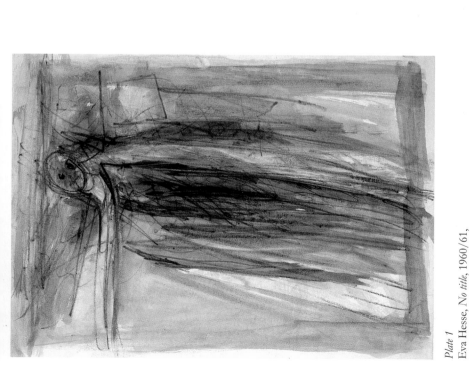

Plate 2
Eva Hesse, *No title*, 1961,
Ink on paper, 15.2 × 11.4 cm / 6 × 4½ in.
© The Estate of Eva Hesse. Hauser and Wirth, Zürich and London.

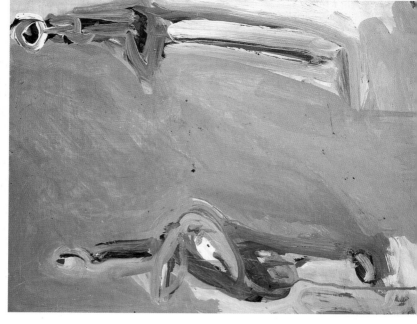

Plate 4
Eva Hesse, *no title,* 1960,
Oil on masonite, 15⅝ × 12 in.
Private Collection,

Plate 3
Follower of Rembrandt Van Rijn, *A Man Seated in A Lofty Room,* (c.1631–1650),
Oil on oak panel, 55.1 × 46.5 cm.
Collection of the National Gallery, London.

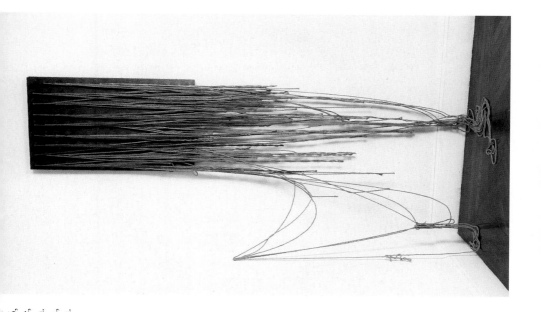

Eva Hesse, *Ennead*, 1966,
Acrylic, papier-mâché, plastic, plywood, string, Installation variable,
panel 91.4 × 55.9 × 3.8 cm / 36 × 22 × 1½ in.
Private Collection, Boston MA,

© The Estate of Eva Hesse. Hauser and Wirth, Zürich and London.

Plate 5
Eva Hesse, *Addendum*, 1967,
Painted papier-mâché, wood and cord, 12.4 × 302.9 × 20.6 cm.
Collection Tate Modern,

© The Estate of Eva Hesse. Hauser and Wirth, Zürich and London.

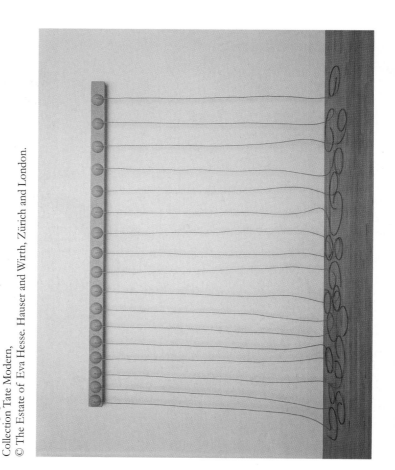

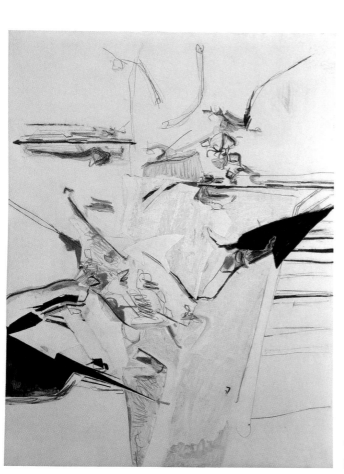

Plate 7
Eva Hesse, *no title*, 1963,
Watercolour, gouache, oil crayon, graphite and collage on paper, 55.9 × 76.2 cm / 22 × 30 in.
© The Estate of Eva Hesse. Hauser and Wirth, Zürich and London.

Plate 8
Eva Hesse, *Ringaround Arosie*, 1965,
Pencil, acetone, varnish, enamel, ink, and glued cloth-covered electrical
wire on papier-mâché and masonite, 67 × 41.9 × 11.4 cm.
New York, Museum of Modern Art.

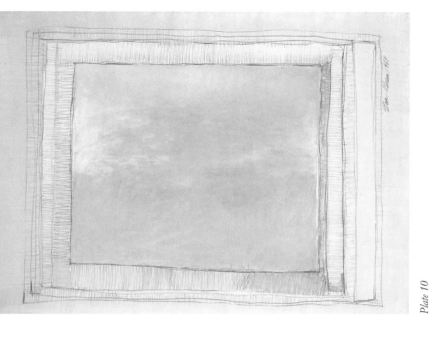

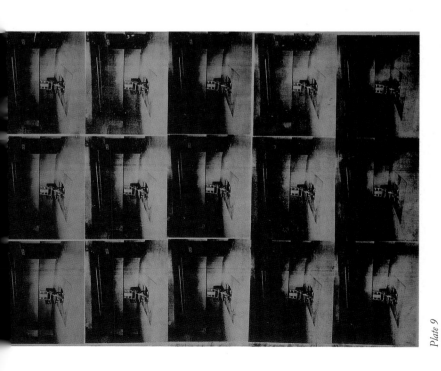

Plate 11
Eva Hesse, *No title (Oberlin)*, 1961,
Gouache and ink on paper, 20.9 × 30.5 cm.
© The Estate of Eva Hesse. Hauser and Wirth, Zürich and London.

Plate 12
Eva Hesse, *No title*, 1961,
Gouache and ink on paper, 11.4 × 15.2 cm / 4½ × 6 in.
Collection Deutsche Bank
© The Estate of Eva Hesse. Hauser and Wirth, Zürich and London.

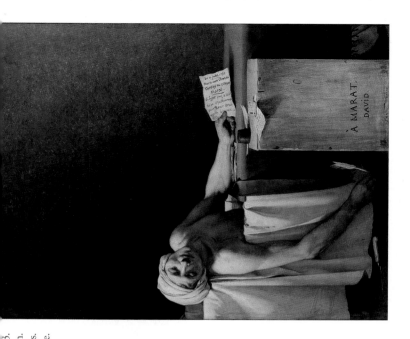

Jacques Louis David, *The Dead Marat*, 1793.
Oil on canvas, 65 × 50½ in / 165 × 128.3 cm.
Brussels, Musees Royaux des Beaux-Arts.
© Photo Scala, Florence.

Plate 13
Rico le Brun, *Floor of Buchenwald #2*, 1958, Rico Lebrun,
Ink and casein collage, 49.25 × 97.25 in.
© Charter Member Endowment, Nora Eccles Harrison Museum of Art, Utah State University.

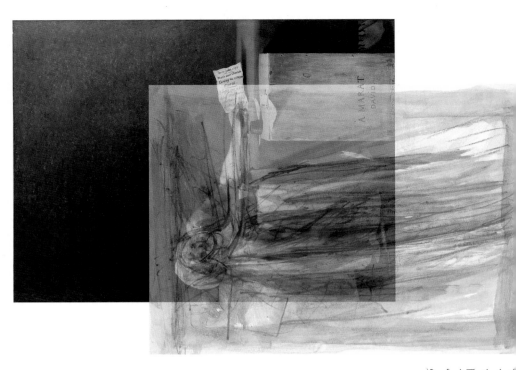

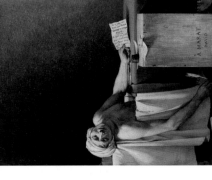

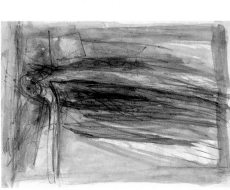

Plate 15
Eva Hesse, *no title*, 1960/61,
Gouache, ink and pencil on paper 30.5 × 22.9 cm / 12 × 9 in.
© The Estate of Eva Hesse. Hauser and Wirth, Zürich and London; and
Jacques Louis David, *The Dead Marat*, 1793.
Oil on canvas, 165 × 128.3cm / 65 × 50½ in.
Brussels, Musees Royaux des Beaux-Arts.
© Photo Scala, Florence.

Plate 16
Digital composite of Eva Hesse, *no title*, 1960/61,
Gouache, ink and pencil on paper, 30.5 × 22.9 cm / 12 × 9 in.
© The Estate of Eva Hesse. Hauser and Wirth, Zürich and London; and
Jacques Louis David, *The Dead Marat*, 1793.
Oil on canvas, 165 × 128.3cm / 65 × 50½ in.
Brussels. Musees Royaux des Beaux-Arts.

'gifted.'[13] Not long afterwards the article about Hesse and her artwork appeared in the 'It's All Yours,' article of *Seventeen Magazine*. After her graduation from the School of Industrial Arts Hesse's close friend Walter Erlebacher, a Jewish refugee from Frankfurt and fellow inhabitant of Washington Heights, encouraged her to enrol in the advertising design programme at Pratt Institute. When this course began she left home in the autumn of 1952, aged sixteen. Thus Hesse ventured away from her family circle and the refugee community of Washington Heights at a very early age. In December 1953 she abandoned her advertising design course at Pratt and waited to enrol at Cooper Union in September 1954.[14] In the meantime, she attended classes at the Art Students League. She moved back home into the community of Washington heights with her father and stepmother who told her to 'get a job.' She did just that, working for *Seventeen Magazine*. In addition to such articles as 'Posture Pointers to Make You Prettier' this magazine published the *Seventeen Magazine Books of Etiquette and Entertaining*, a text that the testimonies of *Motherless Daughters* referred to as an invaluable guide as to how to be feminine in social situations.[15] In June that year Helen Hesse married Murray Charash. Her departure from her father's house left Eva Hesse behind with her stepmother, whose jealousy Hesse blamed for forcing her father to abandon her.[16] In 1958, Papanek referred Hesse to psychotherapist Dr Samuel Dunkell and continued to see him until her death.

Freudian psychotherapy and its interpretation in America have had clear significance for reading Hesse's archive. In 1963 in her classic feminist text *The Feminine Mystique*, Betty Friedan addresses what she termed the 'sexual solipsism of Sigmund Freud' in late 1940s, 50s and 60s America.[17] Friedan's criticism focuses on the literalness with which American psychoanalysts applied Freud's theory of femininity and penis envy to women. Until the late 1960s a pseudo-contemporary model of femininity pervaded analytic settings and popular culture. Friedan argued that orthodox Freudians traced the origination of all forms of neurosis in women to repressed sexual memories or sexual trauma:

> Since they look for unconscious sexual memories in their patients, and translate what they hear into sexual symbols, they still managed to find what they are looking for.[18]

In her 1974 defence of Freud, *Psychoanalysis and Feminism*, Juliet Mitchell made clear that Freud's theorisations of femininity were not musings on the treatment of middle-class Viennese Victorian women: 'Feminine Sexuality'

was written in 1932. Despite taking Friedan to task, Juliet Mitchell is
sensible of the cogency of her account of the 'debased applications' of
'popularised Freudianism.'[19] Friedan writes that Women once were thought
again to be:

> Inferior, childish, with no possibility of happiness unless [they]
> adjusted to being man's passive object, – they wanted to help women
> get rid of their suppressed envy, their neurotic desire to be equal.
> [Freud's followers] wanted to help women find sexual fulfilment as
> women, by affirming their natural inferiority.[20]

The feminine identity desired by men for women in America in the
1950s understood 'Woman' and the mother-daughter relation to be
mediated by the heterosexual relation of women to men via the Castration
and Oedipal complexes. In 'The ego and the id' the little girl's Oedipus
complex is first formulated as 'precisely analogous' to that of the little
boy:[21]

> The outcome of the Oedipus attitude in a little girl may be an
> intensification of her identification with her mother *(or in the setting up
> of such an identification for the first time)* – a result which will fix the child's
> feminine character.
>
> These identifications are not what we should have expected, since
> they do not introduce the abandoned object to the ego [lost objects
> are not introjected]; but this alternative outcome may also occur, and
> is easier to observe in girls than in boys. Analysis very often shows
> that a little girl, after she has had to relinquish her father as a love-
> object, will bring her masculinity into prominence and identify herself
> with *her father (that is with the object that has been lost)*, instead of with her
> mother. This will clearly depend on whether the masculinity in her
> disposition – whatever it may consist in – is strong enough.[22]

In 'The dissolution of the Oedipus complex' and 'some psychical
consequences of the anatomical distinction between the sexes,' written in
1924 and 1925 respectively, Freud developed further his theory that the
outcome of the little girl's Oedipus complex would be either
maternal/feminine or paternal/masculine identification. The Oedipus
complex was no longer brought to a close by the threat of the castration
complex 'in little girls' as in the case of the male child. Rather the Oedipus
complex for little girls 'is made possible and led up to by the castration

complex.' From the very beginning the little girl perceives herself as a 'little man.'[23] In 'Femininity,' the pre-Oedipal attachment of a daughter to her mother is structured heterosexually; during this stage, Freud suggests, the daughter inhabits a 'masculine phase' that *properly* explains her feeling for her mother:[24]

> Almost everything that we find later in her relation to her father was already present in this earlier attachment and has been transferred subsequently on to her father.[25]

Once the question of sexual difference has been posed to the figure of the father, the mother becomes a figure of loathing. She has deprived her daughter of the valued organ and is herself castrated. The mother figure falls from grace because she is no longer the *phallic mother* with whom the little girl identified in the pre-Oedipal phase.[26] Ettinger's insight allows us to say that for Freud the pre-Oedipal phase is not a space of encounter between feminine, but bisexual, human subjects who are caught in the paradox that they must loose what they have never had. The lack projected onto the mother's body makes the daughter seek to disconnect from it; 'the attachment to the mother ends in hate.'[27]

Sigmund Freud's concept of the femininity of the mother plays only a subsidiary role in a daughter's psychogenesis in comparison to the significance of the father. The absence of the mother is made conspicuous in 'Fragment of an Analysis of A Case of Hysteria ('Dora'), Sigmund Freud's case history of Ida Bauer.

> I never made [Ida Bauer's] mother's acquaintance. From the accounts given me by the girl and her father I was led to imagine her as an uncultivated woman and above all as a foolish one, who had concentrated all her interests upon domestic affairs, especially since her husband's illness and the estrangement to which it led. She presented the picture, in fact, of what might be called the 'housewife's' psychosis.' She had no understanding of her children's more active interests, and was occupied all day long in cleaning the house with its furniture and utensils and in keeping them clean – to such an extent as to make it almost impossible to enjoy them. This condition traces of which are to be found often enough in normal housewives, inevitably reminds one of forms of obsessional washing and other kinds of obsessional cleanliness. But such women (and this is applied to the patient's mother) are entirely without insight to their

illness, so that one essential characteristic of an 'obsessional neurosis' is lacking. The relation between the girl and the mother had been unfriendly for years. The daughter looked down on her mother and used to criticise her mercilessly, and she had withdrawn completely from her influence.[28]

In *Freud's Women*, Lisa Appignanesi and John Forrester contextualise Freud's decision to 'fall in with Ida's contemptuous dismissal of her mother, effectively ignoring any significance her mother might have had in her life.' They read it not as an uncharacteristic 'compliance' with a patient's view of 'reality', but as indicative of the pattern of the generally scant treatment given to the mother in the histories of his patients.[29] The veracity of their argument is born out by Sam Dunkell's claim *never* to have discussed Ruth Hesse with Eva Hesse.[30]

In Dora's case history Freud draws a relation between Ida Bauer and her mother, Katharina Bauer or Käthe on three points. First, as a footnote to the patterns of Katharina Bauer's 'pathological' behaviour, a connection is made between mother and daughter by the notion of hereditary hysteria.[31] Second, framed by the Oedipus scenario, Katharina Bauer is perceived to be her daughter's 'former rival' for the affection of Philipp Bauer, her father.[32] Ida Bauer's behaviour and feelings about Philipp Bauer's affair with Frau K., Frau Zellenka, was more fitted to that of 'a jealous wife – in a way which would have been comprehensible in her mother':

> By her ultimatum to her father ('either her or me'), by the scenes she used to made, and by the suicidal intentions she allowed to transpire, – by all this she was clearly putting herself in her mother's place.[33]

Thirdly, Ida Bauer had learned that her father had fallen ill because of the 'loose life' he had led before he was married. He was infected with syphilis and his daughter believed that he had passed on his bad health to her by 'heredity.' In Ida Bauer's unconscious, however, her reproaches to her father were played out in identifications with her mother 'by means of slight symptoms and peculiarities of manner, which gave her an opportunity for some really remarkable achievements in the direction of intolerable behaviour.'[34] Appignanesi and Forrester name this identification as the single major point of contact between the two women.[35] Katharina Bauer's symptoms, her daughter conjectured and Sigmund Freud agreed, was brought on by her infection by Philipp Bauer.[36]

The case history of 'Dora' is instructive for thinking about Hesse's treatment. There is a correlation between the two on several points: the notion of pathological heredity, the Oedipal rivalry between mother and daughter for the affection of the father and the lack of significance accorded to Ruth Hesse outside of the parameters of this scenario. It is possible that Hesse's account of her mother's illness was also taken at her word simply because, like Katharina Bauer, Hesse's own Freudian analysis was indicative of the want of structural significance given to the figure of the mother in this phallic paradigm.

For Freud the diminution of a daughter's affection for her mother, that ends in 'hate', begins with the question of sexual difference that is first of all put to the father and is followed by the desire for the missing penis. In 'Some Psychical Consequences of the Anatomical Distinction between the Sexes', Freud states:

> A third consequence of penis envy seems to be a loosening of the girl's affectionate relation with her maternal object. The situation as a whole is not very clear, but it can be seen that in the end that the girl's mother, who sent her into the world so insufficiently equipped, is almost always held responsible for her lack of a penis. The way in which this comes about historically is often that soon after the girl has discovered that her genitals are unsatisfactory she begins to show jealousy of another child on the ground that her mother is fonder of it than of her, which serves as a reason for her giving up her attachment to her mother.[37]

The next of these developmental stages sees the little girl try to find 'compensation for the renunciation of the penis'. The little girl 'slips – along the line of symbolic equation, one might say – from the penis to a baby. Her Oedipus complex culminates in a desire, which is long retained, to receive a baby from her father as a gift – to bear him a child.'[38] The mother's relationship to her child is thus mediated by the desire for the missing phallus. The child's identification with the mother figure is established through a necessary role model of femininity. The aim of this femininity is to solicit the father's desire. The mother, therefore, becomes an object of sexual rivalry and jealousy. Thus Freud reasons:

> The girl's Oedipus complex is much simpler than that of the small bearer of the penis; in my experience, it seldom goes beyond the

taking of her mother's place and adopting a feminine attitude towards her father.[39]

The little girl likes to regard herself as what her father loves above all else; but the time comes when she has to endure a harsh punishment from him and she is cast out of her fool's paradise.[40]

'Mourning and melancholia' may throw some light on some light on the identificatory process that may follow the daughter's realisation that she is not her father's only object. Freud states that from a *real slight* or *disappointment* coming from [a] loved person, the object relationship was shattered.'

> The result was not the normal one of a withdrawal of the libido from this object and a displacement of it on to a new one, but something different, for whose coming-about various conditions seem to be necessary. The object-cathexis proved to have little power of resistance and was brought to an end. But the free libido was not displaced on to another object; it was withdrawn into the ego. There, however, it was not employed in any unspecified way, but served to establish an identification of the ego with the abandoned object. Thus the shadow of the object fell upon the ego, and the latter could henceforth be judged by a special agency, as though it were an object, the forsaken object.[41]

Thus it is possible that the cathexis previously attached to the father by his daughter is not transferred to a new object. The cathexes of the little girl are withdrawn into her ego, and there they 'serve to establish an identification of the ego with the abandoned object;' the father. For Papanek and Dunkell this introjection and mimicry of the father as the lost object seemed to be the cause of their diagnosis of father identification in their treatment of Hesse.

Helene Papanek referred Hesse to Sam Dunkell because she thought her patient would benefit more if she received her treatment from a male analyst. Hesse received treatment for this diagnosis until its 'resolution' in 1961.[42] Her identification with the heroic figure of the artist was diagnosed as a sublimated symptom of that condition. Hesse's determination to make art, to ground herself within the identity of the artist and to carve out a history for herself was understood as a neurotic refusal to relinquish what Friedan defined as 'phallic activities.' A term whose meaning Friedan used to encompass all activity that was 'usually characteristic of the male.'[43]

In 1966 Hesse retrospectively traced the real 'disappointment or slight' that precipitated that identification. William Hesse's second marriage took place in November 1945 two months before the death of Ruth Marcus Hesse. After one therapy session in 1966 Hesse wrote:

Mother died, father rejected me and took a competent cold woman. Therefore I feel I am helpless and incompetent – so I am like my mother who was dependent, feminine and…sick.[44]

Hesse's account revises the chronology of the actual events. Nor does she say that it was Ruth Marcus Hesse who left her husband in 1944. This new order implies that William Hesse was unmarried when he 'rejected' his daughter, and indicates the culpability that she felt. Viewed though the Oedipal framework, William Hesse's choice of another woman cemented the representation of Ruth Hesse, any 'likeness' Hesse might have to her and concepts of the feminine, within notions of pathology and sexual rejection. Thus their failures are attributed to feminine weakness and dependency.

For Freudian theory the most significant consequence of Ruth Hesse's death would seem to be that it occurred before her daughter began the transition from girlhood to womanhood. Ruth Marcus Hesse's periods of depression made her an unsuitable role model. This, combined with the timing of her death, meant that the bond of common femininity that secondarily identifies the castrated mother with the daughter after the Oedipus Complex could not be set up. 'Girls,' writes Sigmund Freud, 'remain in [the Oedipus complex] for an indeterminate length of time; they demolish it late and, even so, incompletely.'[45] To her therapists Hesse was persistently missing from her femininity. After one session in May 1964 Hesse noted in her diary that in her 'relationship with Dr. "I am a [sic] asexual child." I do not relate to him as a woman.' The tasks before Sam Dunkell were first, to resolve the father identification that brought about the prominent masculinity that 'differenced' Hesse from her female contemporaries. Second, he had to connect Hesse to a sense of femininity while circumventing, as Wagner stated, 'the threat that identification with her mother (identification with her as a woman) presented.' I want to suggest that as she is presently framed Ruth Hesse *can be thought of in no other terms*. Within the binaries of identification or irreconcilable difference Ruth Marcus Hesse can only signify as a dangerous 'dysfunctional' figure that Hesse must 'fear.' It seems that the only course open to Hesse, if she was to preserve her own psychic well-being, was to forever sacrifice the 'likeness' and connections she had once had with her mother while she lived.

The structure of Hesse's therapy had not been able to comprehend or confirm what *Motherless Daughters* has since described as the 'magnitude' of a daughter's loss.[46] Within the dominant theory of psychoanalysis such a rupture seems to be softened because the daughter who identified herself with her father in the Castration and Oedipus complexes is understood to have already achieved a significant separation from the mother. As we have seen the daughter's heterosexual desire for the father posits him as the lost love-object. In that sense it is not mother loss that would be understood as a psychic catastrophe, rather it is the loss of the father that is traumatic. Thus, Hesse's unresolved mourning that reoccurred every January, her refusal to let her mother go would appear, in this phallic paradigm, all the more pathological, *all the more like her mother*.

This retrospective application of the Oedipal structure by the artist's therapy made its vision of her mother and father real for Hesse. As Friedan asked, how, in the 1940s, 50s and 1960s, could 'an American woman, who is not herself an analyst, presume to question a Freudian truth?'[47] In 1966 the guilt and fears that Hesse felt about her mother's death were not analysed impartially but were translated, as Friedan said, 'into sexual symbols' in an ideologically structured discourse.

I must therefore ask what dimensions of experience exceeded the understanding imposed by this discourse? We may begin by suggesting that to write within this lineage is to reproduce the standard biographical subjects of 'daughter', 'mother' and 'father' inherited from patriarchal culture. The reader learns nothing of those dimensions and the dynamics of the relationship that were not mediated by men and defined by the Phallus. On a structural level I must, therefore, again refer to that sphere beyond-the-phallus, posited by Jacques Lacan and theorised by Bracha Ettinger if I am to extricate Ruth Hesse's complex subjectivity from its sole representation as the mother figure of the Oedipus scenario. I wish to defer this step for a moment, however, and begin to put in place the other(ed) differences of the Hesse family.

The Hesses in Hamburg

To begin with the old rigmarole of childhood. In a country there was a shire, and in that shire there was a town, and in that town there was a house, and in that house there was a room, and in that room there was a bed, and in that bed there lay a little girl...

Wives and Daughters, Elizabeth Gaskell[48]

The absence of Ruth Marcus Hesse in the structure of Hesse's psychotherapy has implications for the way in which her real absence and presence has been written about. Though never openly stated as such, the moment Ruth Hesse departed from her family home in November 1944 seems to be interpreted as a total rupture that draws a retroactive line between her and her daughters. Within the polarity that ensues we see a desire for the 'before' as a space of problematic presence within the parameters of the family unit. In turn this is set against the rejection of the 'after,' that precedes Ruth Hesse's death on 9 January 1946, a dysfunctional non-space of occlusion and absence that casts the mother out of the family unit. There is no cross over or middle ground. In both instances an emphasis on ill heath and depression position Ruth Hesse outside the parameters of desired femininity.[49] The reader could be forgiven for thinking that Ruth Hesse played little part in child rearing or that, after she left her husband, she played no part in the life of her daughters. The therapeutic narrative appears to imply that depression consumed her entirely and that to her daughters it was as if she were already dead. Helen Hesse Charash and the archive she has made available to Hesse scholarship offers another perspective from which it is possible to supplement this representation by putting in place some of the difficulties of life in Germany in the 1930s.

'Building a childhood memory: the diaries of Eva Hesse's early years,' written by Fred Wasserman, co-curator of the Jewish Museum exhibition *Eva Hesse: Sculpture* in 2006, presents a detailed analysis of the artist's beginnings in Germany.[50] The final room of the exhibition screened Dorothy Levitt Beskind's 1968 film of Hesse in her studio alongside vitrines containing the tagebücher. This curatorial decision brought the past of the Holocaust into the present of the working artist. 'Building a childhood memory,' outlines the significance of the tagebücher, the diaries written for Hesse from 1936 until 1946. Wasserman supplements excerpts from these documents with key biographical information regarding Ruth and Wilhelm Hesse.

Ruth Marcus, an only child, was born to Jewish but not Orthodox parents who lived in Hameln. One of the tragedies of her early death is that only fragments of the life of this 'creative, refined, genteel, very charismatic' young woman or her parents can be uncovered. Little is known of Moritz Marcus, her father, who has been described as a somewhat autocratic figure.[51] Erna Marcus, her mother, appears often in her grandchildren's diaries and was an invaluable support to Ruth Marcus Hesse's own mothering. Helen Hesse Charash remembers Erna Marcus as a very warm,

loving woman, with whom she, her sister, her father and mother had a very strong bond.

Helen Hesse Charash tells us that Ruth Hesse attended the Bacharach finishing school in Hamburg where, among other subjects, she studied art. After William Hesse died in August 1966 Eva Nathanson Hesse moved to a smaller apartment in Washington Heights and gave Hesse and Helen Hesse Charash many of his personal possessions and his photographs. Among this extensive collection were pictures of their mother that they divided up between them. One was of Ruth Marcus Hesse sitting with a nurse in what appeared to be the grounds of a hospital, from which they conjectured that some time before her marriage she had suffered from depression.

Moritz and Erna Marcus owned a furniture store in Hameln that was Aryanised under Nazi edict. William Hesse pursued restitution for the loss of the Marcus business from the German government through a Hamburg Lawyer in the late 1950s to 1960. As Eva Hesse's diary of 1960 notes the compensation the Hesse family were awarded was given to her and her sister. Without documentation of the Marcus' experience it is possible to look to the survivor testimony others and historical documents to comprehend the conditions that led up to the compulsory annexation of Jewish businesses by the National Socialist state and so give texture to Eva and Ruth Hesse's history. In *We Were So Beloved*, Hilde Kracko tells how, after 1933 her husband's furniture store near Düsseldorf lost revenue due to the subsidies given to newly wed Aryan couples that enabled them to buy furniture, on condition that they did not patronise Jewish businesses.[52] The first months of Hitler's chancellery in 1933 were marked by what is described in *Hitler's Willing Executioners: Ordinary Germans and the Holocaust,'* by Daniel Goldhagen as 'almost instantaneous, yet sporadic, physical attacks on Jews, their property, burial sites and houses of worship, and the establishment of "wild" concentration camps for the them and for the political left.'[53]

The regime's and the public's highly injurious verbal attacks aside, the first 'large-scale and potentially symbolic organised assault upon German Jewry came just two months after Hitler's assumption to power. The nationwide boycott of Jewish businesses on April 1, 1933 was a signal event, announcing to all Germans that the Nazi's were resolute. The Jews would be treated in accordance with the oft-stated conception of them: as aliens within the German body social, inimical to its well-being.[54]

The extensive research compiled by the University of Hamburg outlines the events of the 'Judenboykott,' the 'Volksaktion,' in which the German 'people' took action to 'defend' the nation against the atrocity propaganda

abroad: 'Abwehrkampf gegen die jüdische Greulhetze im Ausland.'[55] The headlines of Hamburg newspapers announced 'Marching orders against the Jews!' ('Marschbefehl gegen die Juden!') a call to 'Boycott the Jews,' and 'Der Kampf is unvermeidlich' ('the fight is unavoidable').[56] A preliminary boycott of Jewish department stores in Hamburg took place on 12 March 1933, when Nazi pickets laid siege to Hermann Tietz, Karstadt, EPA and Woolworths. The *Hamburger Tagblatt*, published the April boycott guidelines written by Julius Streicher, founder of *Die Stürmer*, under the headline 'Die Judenboykott beginnt – Morgen Schlag 10 Uhr!' (The Jewish Boycott begins this morning at the stroke of 10!).[57] NSDAP and SA members were stationed outside shops to intimidate those who wished to enter and distribute propaganda leaflets. The 1 April fell on a Saturday, when the smaller Jewish shops in the Grindel quarter of Hamburg were closed due to the Sabbath but nevertheless they had been vandalised with anti-Semitic slogans and posters, while the larger department stores were open.

What Wilhelm Hesse's diaries makes clear is that the vicissitudes of the Hesse family's survival began in 1933. Wilhelm Hesse was born in 1901; he had one brother, Nathan, who was several years younger than. The Hesse family were middle-class Orthodox Jews who lived in Hamburg. He attended University where he gained his Doctoral degree and took up his profession of Geschäftsleiter Doktor der Rechtswissenschaften, Doctor of Jurisprudence.[58] On March 24 1933 Wilhelm Frick submitted the Law for the Restoration of the Professional Civil Service' to the Reichstag. *Nazi Germany and The Jews: the years of Persecution 1933–1939*, written by Saul Friedländer, states that by the end of March 1933 the 'physical molestation of Jewish jurists had spread throughout the Reich. In Dresden, Jewish judges and lawyers were dragged out of their offices and even out of courtrooms during proceedings, and, more often than not, beaten up.'[59] On either 31 March or 1 April, Friedländer continues, Adolf Hitler 'intervened to support the proposal [...] although the scope of the law was general, the anti-Jewish provision represented its very core.'[60] In the 'so-called Aryan paragraph' Jewish doctors, lawyers, judges, and civil servants, as 'non-Aryans' were dismissed or forced into early retirement.[61] The decree that expelled Jews from the Bar was confirmed and made public on 11 April 1933. The extreme nature of the violence committed against attorneys and judges had been indicative of the need to silence reasoned protest for fear of greater international censure.[62] At the time the Civil Service Law was implemented Wilhelm Hesse was only in his twenties. He therefore lost his profession on 25 April 1933, several months before

Helen Hesse was born, as a consequence of anti-Semitic law and not simply by the fact of immigration and invalid qualification.

Ruth Marcus Hesse and William Hesse kept tagebücher for both their daughters from their birth until the age of ten.[63] It is very difficult to think of these journals as documents within an historical archive because they are so personal and so very moving. As Wasserman notes 'after an initial poem by Wilhelm on Eva's birth, Ruth filled the next twelve pages with details of their baby's eating habits, weight and growth.' In May 1936, when Eva Hesse was four months old, however, Wasserman tells us that:

> Her father became the sole diarist and remained so for the next ten years. The situation appears to have been different with the couple's earlier child. Ruth and Wilhelm Hesse were jointly involved in documenting Helen Hesse's first eighteen months, alternating entries though-out, before the *mother bowed out* and the father continued alone. Although there are photographs of Ruth with the children and she is often mentioned in the tagebücher thereafter – as 'Mami' – Ruth's presence is faint compared to Wilhelm's. During Eva's first couple of years, while he was not working, he wrote fairly regularly (every month or so), but once in New York, working hard to learn a new profession, he typically did a round-up every few months.[64]

Wasserman's sensitive reading pays particular attention to the role of Wilhelm Hesse in his youngest daughter's life. Via her father's interest in photography and 'arranging' of the tagebücher Wasserman maps a lineage for Hesse's fascination with collage and compositional skill. More significantly for the Jewish Museum in which the exhibition had been housed, however, was the particular attention drawn to the history of the Holocaust made present by Wilhelm Hesse for his daughters.

In *Between Dignity and Despair: Jewish Life in Nazi Germany*, Marion A. Kaplan writes of the need to put in place the '"little picture" of Jewish daily life to cast new light on the big picture' of the persecution of German Jews.[65] Her invaluable book combines women's, Jewish and German history in order to illuminate the ways that Jews coped privately with deteriorating and barbarous circumstances.[66] Her extensive research has revealed the pressures placed upon Jewish women whose 'duty' it was to 'make things work in the family and household' as Germany became what Wilhelm Hesse called a 'nation of criminals.' After the anti-Semitic Nuremberg laws passed on 15 September 1935 the employment of Aryan servants by non-Aryans was prohibited in the defence of German

Honour.[67] Thus most middle-class Jewish women found themselves left 'entirely to their own devices in running a household wither greater problems, shopping for food in stores staffed by increasingly hostile personnel, and performing all these tasks with ever shrinking resources.'[68]

After the Nuremberg Laws took effect, articles in Jewish newspapers addressed overworked, overwrought mothers. Written in the language of the psychoanalytic discourse of the 1920s and reworked by Jews in the dismal 1930s, these articles focused on mother-child relationships. With titles like "Mommy, Do You Have Time for Me?" they pleaded with mothers not to neglect their small children in their overcrowded day. After cooking and cleaning, mothers ought to repair torn clothing or help their older children with schoolwork, the articles suggested. But no matter how little time was left over, mothers should not overlook their youngest. A half-year later, stories featured even more tension and strain. One article entitled "Mommy Is So Nervous!" depicted a tense housewife who scolded her small children for small misdemeanours, leaving them anxious and depressed. Her husband, also overtired and overworked, tried to smooth things out when he came home. Eventually she discussed her over reactions with him, and he suggested that she should try to "pull [herself] together if at all possible." This story concludes with forced cheeriness: "Although, she, like many of our mothers today has a huge amount of unaccustomed work to complete every day and actually has every reason to be nervous," she forced herself to make the necessary psychological accommodations. After a few weeks her appreciative child noted: "mother you haven't been sooooo nervous in a while." [69]

Kaplan states that Jewish women created what 'psychologists then called "temporary frames of security"' whose focus of housework, community work and the family facilitated the denial that helped to preserve 'personal and family stability.'[70] Socialised, as men were, to take on roles in the larger world, the deprivation of that role hit many Jewish men hard.

Kaplan cites the 1941 analysis made by a Harvard psychologist of the 'coping strategies used by ninety émigrés whose memoirs they had collected in an essay contest.' "Most dramatic" among their findings were "the many instances of return to the healing intimacy of the family after bitter experiences of persecution."' Kaplan builds on their research to argue that 'memoirs by men, too – which in normal times tend to focus on career and public activities, often to the exclusion of family matters – pay some

attention to the importance of family.'[71] I want to suggest that forced retirement and persecution could be contributing factors to the depth of Eva and Helen Hesse's childhood diaries. Through this prism their archive is an invaluable resource that gives texture to the persecution of Jews in Nazi Germany as its impact and suffering is felt in the day-to-day events of family life. The diaries hold the trace of a lost life, family, fortune, beloved mother, grandparents, aunts and uncles.

At the beginning of Eva Hesse's tagebücher Ruth Hesse records the birth of her second child as follows:

All our friends returned from their vacation, only nothing had changes for us yet. I had simply miscalculated. On Shabbes morning, January 11, I felt faint symptoms, but I didn't tell Willi about it. I let him go to the synagogue and went back to sleep. I awaited the end of Shabbat with great serenity, then quickly left. I was already in great pain, it couldn't take much longer. Papi was sent away immediately […] at 7.45 I was given some drops, at eight I heard the scream that I had been waiting for[…]I can see her and am glad that she is healthy. Dear Papi will be happy about his second girl. First a quick call, everything is ok! He can even attend the important D.K meeting! Papi still comes to see me, he is beaming. We are rich – two daughters […] What does she look like? The little head is nicely formed, large blue eyes, she has a small nose and especially pretty ears, close to the head, pretty, narrow hands. The little fingers even show the beginnings of a half-moon. These are the first observations important for me. More important for the little one: eating! The baby is put to the breast and already suckles eagerly […] At birth she weighed 3540 grams. During the first three days the weight went back to 3120 grams. The little thing didn't feel well, ran a high fever and was very restless for that reason; she was fed tea with Plasmon. Every diaper was dirty, no reason to worry. *Mother's milk will heal anything.* […] On the eight day Omi [grandma, Erna Marcus] came to visit unexpectedly. Great Joy on all sides. I hear her arrive and wait for her by the stairs.[72]

By the time Hesse was born on 11 January 1936 the Jewish hospital was in serious financial difficulty. The City of Hamburg demanded annual repayments to the 1,000,000 RM loan borrowed to finance the extension for the surgical department built between 1928–1931.[73] Although Wilhelm Hesse had lost his professions the family retained a Jewish nanny, Schwester Lily, as befit their social position. The detail with which Ruth

Marcus Hesse chronicles the routine of 'Evchen's' first months of life, her breastfeeding in particular and the connection between them is very touching. What is also clear is a mother's fascination with the emergence of her daughter's personality:

> Often, she already lies [in her basket], looking at me cheerfully with large, blue eyes; or I see her playing with her little hands, this is new, it has been going on for a week and how interesting it is. In the fifth week we discovered her first tear and then also came the first laughter, when speaking or singing to her [...] Evchen is looking forward to the bath and is kicking her legs; her favourite is to have her hair washed (her 3 ½ hairs). Helen always looks on, if she isn't in kindergarten, which had a good effect on her, now she doesn't cry any longer, when her hair is washed and being cut! – Even when Evchen wakes up before her time and starts crying, the moment I pick her up she is quiet and happy, that's how much such a little thing knows.[74]

Ruth Hesse's writing reveals a mother-child bond far removed from the kind of mother, described by Anna Freud, whose attachment to her child is based only on physical need and is thus wholly given over to the care of paid nurses.[75] 'The Concept of the Rejecting Mother,' written in 1954, is Anna Freud's significant corrective to the erroneous belief that conditions such as autism and psychotic development were the product of 'faulty or bad mothering.' Her paper focuses on the first year of the life of the infant and, for my purposes, what is most instructive is Anna Freud's insistence upon the impact of external factors on the mother-child relationship that can intersect with internal factors.[76] What a child can perceive as rejection may be the result of unavoidable circumstance. In the case of 'rejection by separation' Anna Freud writes:

> There are the mother-child relationships where a good beginning is made in every respect. The mother may be devoted, happy with her baby, accepting and responsive. The child may respond to her care and make the first steps toward emotional attachment. Then there follows rejection brought about by sudden separation of the couple. Such separations may be the mother's fault (when she leaves the child in the care of strangers for trivial reasons such as trips, visits), but they need not be. The mother may be ill [...] external conditions may interfere, as they did in wartime. [...]

Such separations act on the child irrespective of their causes. Since the infant cannot grasp the reason for the mother's disappearance, every separation equals for him desertion on her part. Before his sense of time develops, the pressure of his needs makes every period of waiting seem agonisingly long; therefore he does not distinguish between separations of short and long duration. Everybody's sympathy and understanding are automatically extended to the infant whose mother dies; if the mother is absent for merely a few weeks, we are less concerned. Wrongly so; *we* know that the mother will return the *child* does not. Separations between mother and infant are *rejections*, whether they are brought about for good or bad reasons, whether they are long or short. The infant who is torn from the partnership with his mother is emotionally orphaned, even though he may be an 'artificial' orphan with a living mother.[77]

In the first year of Hesse's life several separations from Ruth Marcus Hesse and Wilhelm Hesse took place. The first began on May 6 1936, when Hesse was almost four months old and continued until July 2 that year. During these weeks Ruth Marcus Hesse and Wilhelm Hesse were on a 'trip' that included a stay in Venice while Hesse stayed in the Jewish Hospital. Hesse's diary contains several letters from nurses, doctors and the girls' nanny who kept her parents up to date on her welfare; Rosi Strauss wrote to the Hesses 'Evchen is well taken care of and you can stay away reassured.'

I would not wish to align this 'vacation' with the 'needless trips' censured by Anna Freud. A trip of similar length was taken in the first year of Helen Hesse's life while her grandmother, Erna Marcus, cared for her. Ruth Hesse noted that after Hesse's birth 'mother and child are quite well, I am feeling much better than with Helen' and a little later in the year 'I have all of my self confidence back.' It is possible, Helen Hesse Charash and Hannah Moller, her mother's friend, conjectured, that post-partum depression, that may not show symptoms until six months after birth, might have played some part in Ruth Hesse's need for a break away from Germany.[78] The pressures faced by Jews in Germany in the 1930s and 1940s should also be taken into account. Lengthy vacations were common because they were an opportunity for German Jews to get out of Germany temporarily. In *Between Dignity and Despair* Kaplan suggests that such a holidays enabled wealthier German Jews to maintain an 'illusion of normalcy' alongside the horror and despair as the culture and justice of Germany deteriorated.[79]

Another separation between Ruth Marcus Hesse and her child took place between May to July 1937 when Hesse was in the care of her grandmother, Erna Marcus. Despite bouts of ill health the accounts given by all those who cared for this little girl all agreed that 'Evchen is a very cheerful baby.'[80] In August 1937 her parents wrote:

Evchen developed marvellously. She is a very cheerful child. She is much more cheerful, really, and so more affectionate than Helen [...] [Eva Hesse's] love for Helen is enormously great. But she also loves Mami, Papi, Opa, Oma and Lotte very much. She is still as happy as before, when she sees one of her chosen ones then she keeps on calling with great bliss the name over and over again, her entire face beaming.[81]

To commemorate Hesse's first and second Rosh Hashanah two short poems were written on her behalf by her parents. The first written for Rosh Hashanah 5697 (September 1936) reads:

Dear Parents,
I, Eva, cannot yet say a word,
cannot even complain how bad,
dark and gloomy are our times.
But once I shall be ready,
everything, I hope, will be better,
also more light and sunshine.
Just what happened this week, oh, these enormous dark clouds!
However, now I have received my shots!
Now I am, thank goodness, immune
Now nobody can harm me anymore!
That's why I shall not fear for my life,
G'd will see to my succeeding.
Today I wish all the very best
On the first day of Rosh Hashanah.

The second to commemorate Rosh Hashanah 5698 (6 September 1937) reads:

A difficult Year comes to an end
Much sorrow it brought us
Much sickness and worry there was

The sun rarely shone.
May it be your will…
A new year begins,
May things change for the better
May only happiness and bright sunshine
Be in store for us.
Avinu malkenu chadesh aleinu shanah tovah!
Our Father, our King, fill our hands with Your blessings!
We should all recover and be well
Then everything will be clear
And straighten out.
A happy, good year!'[82]

The humour and optimism of these two poems written in the face of day to day mortification give the reader a hint as to one reason why the Hesse family did not apply for emigration until summer 1938. From the archive cited in *Between Dignity and Despair:*

Jewish daily life also shows that, despite the abundant deprivations and humiliations, until November 1938 the majority of Jews attempted to adjust to the new circumstances. At home in Germany for many generations, they were aware of anti-Semitism but distinguished between its varieties and thought they understood its nuances. Even if their dreams of complete acceptance had never been fully realised, they were patriots who had entered German culture. They had achieved amazing success amid anti-Semitism and in spite of it. Thus, as they continued to maintain their families and communities, they clung to mixed signals from the government as well as from non-Jewish friends and strangers – a lull in anti-Semitic boycotts here, a friendly greeting there, they hoped that the regime would fall or its anti-Semitic policies would ease.[83]

Throughout the diaries written for Hesse between 1936 and 1938 there are countless references to 'dark' and 'gloomy' times that are countered with the hope of sunshine around the corner. The particularity of these times, however, is never elaborated and never attributed Nazi injustice. Wilhelm Hesse does not discuss his role as a member of the Board of the Henry Jonas Lodge, that was, Helen Hesse Charash believes, associated with the synagogue and the Jewish community. Neither do we learn what the 'D.K meeting' was about and for good reason. There were no safe

havens or hiding places from persecution. Even in America late in 1940 William Hesse still refrained from writing anything that might be construed as incriminating in his daughter's diary. He was obviously proud that, at the tender age of age of five, Hesse had a position on the Presidential election and 'knew an English satirical poem aimed at the campaign that is strongly in favour of Roosevelt and against Willeby.' But he said 'I'd rather not write it down. Even if it is allowed here!'[84]

During the years of Nazi occupation the writing of a diary by a Jew was not an enterprise to be entered into lightly. In *I Will Bear Witness 1933– 1941: A Diary of the Nazi Years*, Victor Klemperer wrote on Monday 19 June 1933:

On Saturday I read out my "Afterword" [to *The New German Image of France*]. Shock. How could I keep something like that in the house? Köhler advised: hide it behind a picture. – But what shall I do with my diaries?[85]

And then on Monday 9 October 1933:

Gusti [Wieghardt] also told us a great deal about several especially bad concentration camps. About the misery the now sixty-year-old Erich Mühsam is suffering. He had already been released when a diary he had kept during his imprisonment was found and he was fetched back. I myself am constantly being warned about keeping a diary. But then so far I am not suspected of anything.[86]

In the daily lives of German Jews between 1933–1938 Kaplan tells us that friendship became the life-blood of the Jewish community. But when 'groups of Jews gathered in private homes, they feared that they were being watched by suspicious neighbours or, worse, the Gestapo. All Jewish gatherings were suspect.'

Yet the strained circumstances affecting the entire Jewish community, tension hovered over social evenings: "When one met in Jewish company, it meant mostly that there was not the slightest relaxation, because every last person had either his own unpleasant experience or some sort of ill tidings to report from somewhere else." The topic of conversation inevitably turned to the situation for Jews, the emigration of friends and children, and details about visas, foreign lands, and foreign climates, "of an existence where they would no

longer be frightened to death when the doorbell rang in the morning, because they would be certain: it is only the milkman!"[87]

It must be remembered that both Helen and Eva Hesse lived their lives under Hitler until the end of 1938 and that day-to-day fear and anxiety would have appeared normal.[88] In *The Uprooted: A Hitler Legacy, Voices of those Who Escaped the "Final Solution,"* Dorit Bader Whiteman tells of Margaret Furst who had been a small child in the 1930s. She 'remembers that she used to see the strain on her mother's face but did not know that there was anything abnormal about that. She had no normal time to compare it to.'[89]

Entries were made in Hesse's diary on average once a month, sometimes more. In 1938 there was a gap in Hesse's diary; entries were made on 23 February and 3 May but nothing in between. This hiatus coincides with the event that would have entirely shattered the illusion of security within the home, a haven from the vicissitudes of the outside world. On April 19 1938 the Hesse family home was defiled and Wilhelm Hesse was arrested as an active member of the Jewish community. Wilhelm Hesse writes little of the event itself:

> I lost my profession on April 25, 1933 and April 1, was the first infamous day of Boycott. Then there were more hard years. The worst days began around Easter 1938. April 19 I was arrested in my capacity as a member of the Officer's Board of the Henry Jonas Lodge, but only for one day (three hours search of the house, cell in the police station, prisoner can, handcuffs, mug shots etc.) During the November action I was not arrested.

> It is neither possible nor necessary to enumerate all the terrible events, for by the time when our children will understand this, good books will have been written about it.[90]

I must take Wilhelm Hesse's advice and turn to the 'good books' that have since been written about such 'terrible events.' Lore Parker's father, who was a lawyer, was arrested twice and released. She remembers waking one night 'to see two Gestapo men searching my room for my father. From that moment on the horror was clear and ever present.'[91] We must presume that the search of the Hesse home for incriminating material was unsuccessful as Wilhelm Hesse was released.

Victor Klemperer was arrested for quite different reasons on 11 November 1938. From his diary it is, however, possible to glean some

sense of the violation, pettiness and terror of arrest. Two policemen and a 'resident of Dölzschen' arrived at Victor Klemperer's home and demanded to know if he had any weapons. Like many First World War veterans he had a sabre and his bayonet, mementoes from the conflict. There followed a search of the house that lasted for 'hours':

> At the beginning Eva [Klemperer] made the mistake of quite innocently telling one of the policeman he should not go through the clean linen cupboard without washing his hands. The man, considerably affronted, could hardly be calmed down. A second, younger policeman was more friendly, the civilian was the worst. Pigsty, etc. We said we had been without domestic help for months, many things were dusty and still unpacked. They rummaged through everything, chests and wooden constructions Eva had made were broken open with an axe.[92]

By 15 June 1938 1,500 Jews in Germany were interned in concentration camps. In response to the terrible scenes that followed the Anschluss, the annexation of Austria to Germany on March 12 1938, the Evian Conference was called in France by President Roosevelt in July of that year to address the world refugee problem. It proved to be, however, a 'dismal failure.' Mark Jonathan Harris and Deborah Oppenheimer write 'of the thirty-two countries that sent delegates not one said it could accept more than a tiny number of refugees. This was the background to the initiative to take children from Germany and Austria.'[93] The British Government was not willing to admit any more adult German Jewish refugees either to England or Palestine that was under its mandate.[94] After Wilhelm Hesse's arrest the necessity of emigration pressed upon the Hesse family. On August 2 1938 Hesse's diary reads:

> In the meantime much happened. This will change the future of the children drastically. We went though bad times and expect more of the same and know that we must relocate our home and this as soon as possible.[95]

On August 9 in Munich a synagogue had been set on fire, on August 10 another synagogue in Nuremberg was burned to the ground.[96] For the Hesse family the 'motif' of Rosh Hashanah 5699 was emigration:

The children know nothing about it, as yet. Helen only knows that her acquaintances are going to America, Africa, Holland, England, Palestine etc, and knows as much geography as much as older children used to know. Thank God, the children have no worries. Later on, they may well wonder how much their parents had to bear in these times. [97]

Hesse's third Rosh Hashanah poem reads:

Now I am big and already smart,
Already know what's going on!
And I'm already really with it
That our future happy may be
I wish from the bottom of my heart!
Let's quickly forget about the heavy things!
Let's only look ahead
And trust in God and more strength
Le Shanah tovah, until the next year with the grandparents![98]

The emigration process was long and drawn out. Each family had to apply for a quota number. The figures were determined in each year by the percentage of the present population that was already in America from the country of origin. The annual German quota to the United States was 25,957 per annum, but only approximately seven thousand were admitted, of which approximately two thousand were Christian.[99]

As their parents moved apartments (it is possible that their apartment might have been 'appropriated' by the Nazis) and sought papers, Eva and Helen Hesse spent six weeks in a children's home in Wohldorf-Deurenstadt followed by at least four weeks with Erna Marcus in Neustadt. Their parents visited them every Sunday 'Epi [Hesse's name for herself] was always very happy [to see us], raced towards us and always said goodbye without having to be asked: "Mami and Papi soon come again!"'[100]

'Die Kinder! Was machen wir mit den Kindern?'[101]

In conversation with Cindy Nemser, Hesse described her departure from Germany to The Hague on a 'children's train.' In the subsequent accounts of Hesse's early life this description is invariably invoked. Though some of the 'Kinder' clearly remember that they did feel, and indeed their parents encouraged them to feel, that their journey was an adventure, the reality of that experience was far from any train journey the girls had taken before.

Though the Hesses had already made their emigration applications, the immediate removal of the children from Germany was precipitated by pogromnacht on Thursday 9 and Friday 10 November 1938. Martin Gilbert tells us that:

In twenty-four hours of street violence, ninety-one Jews were killed. More than thirty thousand – one in ten of those who remained – were arrested and sent to concentration camps. Before most of them were released two to three months later, as many as a thousand had been murdered, 244 of them in Buchenwald. A further eight thousand Jews were evicted from Berlin: children from orphanages, patients from hospitals, old people from old peoples' homes. There were many suicides, ten at least in Nuremberg; but it was forbidden to publish death notices in the press.[102]

On the 3 December 1938 all Jewish businesses were compulsorily 'Aryanised.' After continuing atrocities and pogromnacht a concession was finally made for the provision of children deemed to be 'at risk' from National Socialism. In *Into the Arms of Strangers: Stories of the Kindertransport*, Mark Jonathan Harris and Deborah Oppenheimer state that the Jewish community in Great Britain 'promised to pay guarantees for the refugee children, emulating a successful proposal by Dutch refugee workers to the Dutch Government' that gave visas to children with relatives in Holland.'[103] Provision for the children had been understood to be temporary on the grounds that they would eventually emigrate to Palestine. The children had to be certified to be healthy, free of vermin, and under eighteen years of age. They came from Germany, Austria and Czechoslovakia. Ninety percent of those children were Jewish. Ninety percent of those Jewish children never saw their parents again.[104]

The British Kindertransports are well documented, the Dutch transports less so. Invaluable testimonies are to be found in *The Uprooted: A Hitler Legacy, Voices of those Who Escaped the "Final Solution,"* by Dorit Bader Whiteman, *Into the Arms of Strangers: Stories of the Kindertransport*, written by Mark Jonathan Harris and Deborah Oppenheimer to accompany their film of the same title, and the film *My Knees Were Jumping: Remembering the Kindertransports*, (1997) directed, written and produced by Melissa Hacker. To get the children out, the Jewish community not only had to liaise with the Dutch and British governments but also with the Nazi emigration authorities, headed by Adolf Eichmann.[105] In *The Uprooted* Whiteman recalls the role of Gertruida Wijsmuller, who worked with the Dutch refugee

organisation, in bringing about the Kindertransports. After the British government had pledged to receive 10,000 children Wijsmuller travelled to the central office for Jewish emigration in Vienna and 'demanded' an interview with Eichmann:

> Eichmann's attitude was disdainful. Why was she, an Aryan, bothering about Jewish children? She argued her case and in the end Eichmann gave permission. A train was made available for the first group, consisting of 600 children [...] but, of course, Eichmann made a stipulation. All of the 600 children would have to be out of the country within the next five days! If the time limit was not met, the deal was off.[106]

By working through the night the deadline was met and the other transports went ahead.

William Hesse's brother Nathan and sister-in-law Martha lived in Amsterdam. Originally the Hesse's plan seems to have been that their nieces would stay with them, but the Dutch Government decreed that no refugee children could be privately boarded. Eva and Helen Hesse parted from their parents on 7 December 1938. On the 11 December, after changing trains five times, the children arrived in The Hague. In Hesse's tagebücher her parents described the girls' departure:

> Devotedly holding on to Helen's hand Epi dragged her onto the platform at the Altona train station. We weren't allowed to come to the train. It was a sad good-bye. In particular for Omi! The children didn't quite understand the tragedy of it. But at least they are saved for now.[107]

Helen Hesse Charash, then six and a half years old, remembers nothing of her leave taking or her journey. Experiences did vary from city to city, transport to transport and child to child. There is no way to give a concrete account of Eva and Helen Hesse's journey through Germany to Holland. It is possible, however, to give texture to the sense of that departure by drawing on the testimonies of those who do remember. *The Uprooted* conveys the 'intimidating' atmosphere that menaced the departure of the kinder. It cites the experience of David Ross who tells us that the train station at Hamburg was 'heavily decorated with swastika flags and swarming with people in uniform.'[108] Gerda Feldsberg remembers:

Looking back on the scene today, it appears macabre. This cold and dark railway station, the long lines of silent children; then sitting, in the train not knowing where I was going, surrounded by hundreds of children. The little ones were crying, and the older ones quite silent. It is hard to explain the way I felt, but I cold and numb with fear. I did not cry, and I really believed that my parents would follow.[109]

Many trains departed at midnight, Whiteman believes, because the 'Gestapo did not like to parade the scenes of departing children before the public.' As parents were not allowed on the platform, Norbert Wollheim, the Kindertransport organiser in Berlin, arranged for a room to be set aside for the parents and children away from the public waiting room:

The leaving taking was the most dreaded moment of the whole procedure. A chair would be placed in the middle of the room for Wollheim to stand on. The children, standing close to their parents, wore large tags with numbers around their necks. Wollheim would call out each number. Parents would hug their children and watch them leave.[110]

In *My Knees Were Jumping* Franzi Danenberg's voice cracks as she tells of her heartrending experience as one of the Kindertransport organisers:

Once the children had been put on the train 'that's when the tragedy began. Until now we had only seen the laughing eyes of the children who were happy to be leaving the inferno. But now what we saw over and over again were the parents who found it difficult to tear themselves away from their children. They had no idea whether they would see their children again.[111]

In the same film Franzi Groszmann remembers taking her daughter Lore Segal to a train station crowded with 'many many children' close to midnight. 'I tried to remember,' she tells her daughter and Melissa Hacker, the film maker, 'what one felt and I can only say this is something one cannot express; this feeling of sending one's child away. At the moment then, *I don't think I felt anything. I was alive, I walked, I did but I don't think I felt.*[112] William Hesse imparts the terror of parting in his eldest daughter's tagebücher:

Then came the sad farewell from the children at the railway station at Altona. Will there be a reunion? Will we get murdered first? We were not allowed on the platform. Helen and Eva held hands and marched off to the train, accompanied by criminals, certified as customs officials and Gestapo.[113]

In a letter to Ruth Marcus Hesse dated 13 December 1938, Martha Hesse, her sister-in-law, wrote of the children's journey and safe arrival. Martha Hesse says that Helen Hesse had said that the 'trip was quite nice', other than the series of changes the girls had to make. Wilhelm Hesse wrote 'like a hunted criminal I made my way through Hamburg during those days and then stayed with an Aryan family who gave me shelter against the SS. Criminals.' In a later letter, written sometime before December 25, Martha Hesse tells Ruth Marcus Hesse of the 'special friend' the girls had made on the train. Mirjam Aron was sixteen, and came from Frankfurt but travelled from Hamburg and had 'taken it upon herself to take special care of the two girls, who let only her bathe them, dress them etc..' The girls were not allowed to wear their own clothes as, like all the other children, they were in quarantine for two weeks. Martha Hesse reported that they both ate well and 'wanted for nothing.' The home in which the children stayed was Catholic but sympathetic to the needs of its Jewish children, 'they even lit Chanukah candles' and wore dresses on Shabbat. The children were allowed to write postcards to their parents once a week and received cards and letters from their parents. 'Evchen' did, however, demonstrate some anger at being sent away for reasons that she could not yet understand. In a letter Martha Hesse tells of a postcard sent by Ruth Hesse to her daughters that had been torn up by Eva Hesse; 'where upon Helen said: "I am going to tell Papa when he comes that you are very naughty."' Mirjam Aron wrote to the Hesses on Eva Hesse's third birthday but gave no indication that their daughters had been separated because Hesse was in hospital with suspected diphtheria.[114] Such a removal from everything and everyone that is familiar must be regarded as highly traumatic for a child three years of age.[115]

In early February 1939 Ruth and Wilhelm Hesse were 'rescued' from the 'homeland' that had become a 'nation of criminals.' In Hesse's tagebücher her parents tell of 'enormous' but unexplained 'obstacles to overcome settling all the formalities, but finally, we fought to get our children back.'[116] They were reunited with their daughters in Holland and stayed in The Hague with their friends the Meyers for three weeks and on 25 February journeyed to London. On 16 April 1939 Wilhelm Hesse writes in his eldest

daughter's tagebücher 'for eight months I have written nothing into the diary. They were eight months we will never forget.' He sensed that Helen Hesse felt it was not 'normal' for her to be in the children's home in Holland and 'was aware of the difference between the stay during the summer in a kinderheim. There lived within her insecurity because of that, if whether and how soon this condition would end.'[117] In May Wilhelm Hesse noted that both his daughters were aware of their current situation. On May 13, Ruth Hesse's birthday, he wrote ' [Eva Hesse] knows something about Hitler and talks about it.' On the same date he notes in more detail that his elder daughter has begun to 'understand [the] matter about Hitler':

> "We must be glad that we are out of Germany. Hitler is a bad man."
> "The poor grandma and grandpa must stay in Germany." "What will Hitler do to them?" In this manner Helen talks very often and very much – even very clever – over this bad and mad dog! [...]
>
> Helen, you must be ever grateful to Uncle Ernst [Neuberger] and Aunt Lena [Goldberger Neuberger], that they saved us by giving us the possibility to leave Germany, the country of the robbers and murders.[118]

On 27 May 1938 the Hesse's finally received word that they would be granted visas and were eager to leave by June 16:

> I have to earn money (here in London I am not allowed to work paid or unpaid) and last but not least: the danger of war [...] We have got to be prepared! On every corner are posters with this advertisement. And that is a warning for us too. We have got to be prepared and soon we hope to be beyond dangerous Europe.[119]

Refugee Life

And now we have emigrated and have begun our refugee life. For the first time I may write the whole truth into this diary without the danger of losing my head because of it. As our children will study these diaries later on as their life's history, I have to add a few short remarks about the past...[120]

Once the Hesse's arrived in America the entries in Hesse's tagebücher became less frequent presumably as her parents time was taken up by the pressures of making a living and re-education. In Rabbi Leiber's synagogue, that both the Kirchheimer's and the Hesse's attended, speeches were made about the situation in Europe.[121] On 9 May 1941 Hesse's diary notes the

'main concern' of her parents to be their desperate attempt to secure affidavits of support and tickets for their loved ones who remained in Holland and Germany: 'Omi [Erna Marcus], Onkel Nathan [Hesse] and Tante Martha [Hesse].'[122] On 23 October 1941 Nazi law forbade Jewish emigration from German territory.[123]

While in London the Hesse's had received parcels, letters and phone calls from the Marcus'. In America they continued to receive letters from Erna Marcus until 1942. By and large Hesse's tagebücher at this time relates her desires for toys, her relationship with her parents, other people and children, her good progress at school, her participation in Hebrew school and her interest in religion. It often comments on the marked difference between her and her sister. The entry for the 3 of January 1942 is typical:

> Helen is as quiet as Eva is temperamental. She truly sparkles with fire and life. What ever she does, she does with enthusiasm: learning, playing, eating etc. She is swift, loves romping about with children and adults. She loves fun, but mostly, when she can have fun together with others. She has a sense of humour. She loves disguising herself. Whenever she laughs, she laughs so heartily that one has to laugh with her.[124]

On the 14 January all 'enemy aliens,' including German Jews, in the United States were ordered by President Roosevelt to register with the government.[125] On 20 January the Wansee conference was held outside Berlin. There 'das Endlösung,' the Final Solution, that had first been talked of in May 1941, implemented the organised 'resettlement' of Jews in the East into forced labour and mass murder. On June 30 of that year William Hesse writes:

> Evchen takes little interest in the events of the times. Thank goodness, she doesn't see the tragedies that are happening in Europe. All the same, she often speaks of Omi and Opa. Her experiences of the war are limited to the flurries of excitement related to blackouts and the lack of rubber balls.[126]

Unbeknown to Eva Hesse, Helen Hesse, Ruth Marcus Hesse and William Hesse, the first deportation transport left Hamburg for Theresienstadt concentration camp on 15 July 1942.[127] The *Gedenkbuch fur die judischen opfer des nationalsozialismus im Hamburg* shows it was one of the largest to leave Hamburg, the list of names of those taken spans thirteen

pages. Among them is 'Erna Marcus geb. Lehmann [no.] 3.6.83, Ahrendsburg'.[128]

Though Hesse, her sister and parents were safely in America it is clear from her conversation with Nemser in 1970 that she experienced anxiety and a desire for routine and security:

> I used to feel fooled by life – because world thought I was a cute smart kid and I hid it – at home terror tremendous fears ... incredible fear and ... I was miserable I had my father tuck my blanket in tight in my German bed which had bars at side and he would have to hold me and tell me that he would be there in the morning and we wouldn't be robbed and poor and he would take care of me. That was the ritual at night.
> CN: this happened to you – in between.
> EH: Oh from the day I was born. And especially in the first part of my life.[129]

Hesse's tagebücher in part confirms her memory of her bedtime ritual and her need to reassure herself of her parents affection:

> Evchen is very much Mami's daughter. Once she is alone with Mami, she doesn't budge from her side. If Mami makes an angry face, she must first have a kiss. Every morning and evening is the time of great good byes and welcome. And always the exact same words. However, in the past six months she changed a little. She says: "Good night, Mamilein, Sleep well. I'll also sleep well, if I can, that's all one can do. Give me a kiss on the face. Am I red? Am I a little treasure? Am I a sweet (sugar) child? And in the mornings in a similar vein. Sometimes she mixes up the text and then dies with laughter. She is very set in her ways in every respect. In the evening the blanket must be laid down exactly according to the rules; by the same token, ... with her clothes she is equally extravagantly fussy.[130]

Hesse's habit of constructing 'frames of security,' to borrow from Marion Kaplan's vocabulary, out of language seems to be in some part reminiscent of the case studies of Patrick by Dorothy Burlingham and Anna Freud.[131] That Hesse should require reassurance at bedtime is of marked significance. In his essay 'The Child's Needs and the Role of the Mother,' D. W. Winnicot pays particular attention to the psychogenesis of

children aged between two and five or seven years. He argues that small children have not sufficiently developed an objective perception of the world, and particularly at 'going to sleep and waking times' their 'subjective conception of the world' is particularly strong.[132] In *Moses and Monotheism* Sigmund Freud stated that:

> What children have experienced at the age of two and have not understood, need never be remembered by them, except in dreams [...] But at some later time it will break into their life with obsessional impulses, it will govern their actions. The precipitating cause, with its attendant perceptions and ideas, is forgotten. This, however, is not the end of the process: the instinct has either retained its forces, or collects them again, or is reawakened by some new precipitating cause ... at a weak spot ... [it] comes to light as a symptom, without the acquiescence of the ego, but also without its understanding. All the phenomena of the formation of symptoms may be justly described as the "return of the repressed."[133]

Into the Arms of Strangers: Stories of the Kindertransport tells of Mariam Cohen and her foster-son Kurt Fuchel, who at the age of eight had arrived in Norwich, England after his journey from Vienna on the Kindertransport. Cohen noted that 'every night when it was dark, Kurt would come down the stairs and he'd check that the door was locked' in order to get to sleep and stave of his 'frightful nightmares.'[134]

Helen Hesse Charash recalled a childhood incident in which she and Eva Hesse had been terrified by noise they had heard in their Washington Heights apartment when their parents had gone out for the evening. William Hesse had noted in his youngest daughter's tagebücher on 30 June 1942 'Evchen is not fearful, in contrast to Helen. If we go out in the evening and Helen is scared or even cries, Evchen must cheer her up [...] it's cute how she encourages Helen.'[135] For Helen Hesse Charash this common enough incident remains charged with special significance. For her it reveals the lack of security she and Eva Hesse felt at home. Unlike the experiences of other children their parents did not preside over them omnipresent all-powerful guardians. That childhood illusion had been breached by the outside world that had enforced separations upon the family, by the day-to-day anxiety and fear that permeated Jewish households across Germany and by Wilhelm Hesse's arrest. The entry before Wilhelm Hesse's arrest tells of the great strides Hesse had made in speaking, the songs she loved to sing and stories she would tell. In neither

the entry that preceded his arrest or that of 3 May that year, is any future or past stay away from home for the children mentioned. It is possible that Hesse and her sister Helen had been at home when their father was arrested and their apartment invaded by security forces; that Hesse's anxiety of separation and security intersected. One tagebücher entry in the summer of 1941 suggests that, as fears grew for Erna and Moritz Marcus and Martha and Nathan Hesse in Europe, Hesse's anxiety was either augmented or retroactively evoked. When at home 'Evchen is very relaxed' Ruth and William Hesse tell us. Yet they recount the story of a vacation their daughters took on a farm without them. Hesse 'cried every day,' she was entirely inconsolable either by the family she stayed with her or sister.

[Evchen] is very set in her ways and if things aren't the way she's used to, she starts crying. She cries very easily. Maybe she felt homesick. When she came back she was sobbing uncontrollably in my arms with joy and emotion. It seems, it was homesickness, after all. Next year we'll go to the beach together, that's her most ardent wish.[136]

Immediately following this episode Hesse 'suddenly started biting her nails,' whereupon the doctor told Hesse that her fingers had grown equally long and the only cure was to stop biting; 'he prescribed bandages' that first of all were to be 'hung as a warning on the window.'[137]

The Dead Mother Complex

Evchen is very much Mami's daughter. Once she is alone with Mami, she doesn't budge from her side.[138]

Ruth Marcus Hesse and Wilhelm Hesse

It is clear from Eva Hesse's tagebücher that she and her mother were very close in the artist's early childhood. In America Ruth Hesse cared for her daughters, made her own and her children's clothes and sewed leather goods to keep the family financially afloat. Hesse's tagebücher does not mention Ruth Hesse's depression per se, only occasional 'illness.' The first recorded instance is reported minimally in September 1943: 'when [Evchen's] Mami was ill, she was very sweet, considerate, and helped her a great deal.'[139]

As the war progressed and the Red Cross sent word to relatives that loved ones had been killed, the synagogue attended by the Hesses painted its windows with the names of those who had perished.[140] Helen Charash remembered that her mother's depression caused her to spend much of her time in bed. Ruth Hesse left the family home in autumn 1944 because she

could no longer care for her husband and children. By the time of his separation from his wife William Hesse had passed his examinations to become an independent insurance broker and took up a position affiliated to Hamlin and Co, based in the financial district of Manhattan. After Ruth Marcus Hesse left the family home this more stable financial position enabled the family to employ a housekeeper, Hilda Lowenstein, who cared for the children while William Hesse worked. Ruth Hesse took a position as a governess for two to three months with a family in Lyons Falls in New York State to care for a young child and its new sibling. In a letter written to Hesse during this time Ruth Marcus Hesse's love for her daughter, her interests in her friends in New York and the pain of what had been lost after their exile from Germany are clear: 'I love the country, it looks like Hameln.'[141]

Afterwards Ruth Hesse returned to Manhattan to work for a dentist on 96 Street between Amsterdam and Columbus Avenues where she received regular visits from her daughters. Ruth Marcus Hesse wrote to her daughters shortly before her death. Although she had been treated for pneumonia, she gave no indication of depression and was greatly concerned with their welfare. Ruth Marcus Hesse did see a psychiatrist occasionally but was not in therapy. That Ruth Marcus Hesse should take her own life had been entirely unexpected by her family.

At this point of this Chapter I would like to introduce into Hesse Scholarship the theorisation of what André Green has named the Dead Mother Complex.[142] In his essay entitled 'The dead mother,' written in 1980, Green distinguishes between the psychical consequences of the actual, physical death of the mother, and those, affectively experienced, of the temporary or permanent 'psychical death' of a mother who is still alive:

> An imago [is] created in the child's mind, following maternal depression, brutally transforming a living object, which was a source of vitality for the child, into a distant figure, toneless, practically inanimate, deeply impregnating the cathexes certain patients whom we have in analysis, and weighing on the destiny of their object-libidinal and narcissistic future.
>
> The essential characteristic of this depression is that it takes place in the presence of the object, which is itself absorbed by a bereavement. The mother, for one reason or another is depressed.[143]

It is helpful here to invoke the writing of D. W. Winnicott. In *Babies and their Mothers*, he stresses that a mother can in no way help the onset of

depression that colours what he has called the 'holding environment' and that considerations of its effect should be approached from the position of an 'aetiology of significance' and not of blame.[144] Green perceives the abrupt detachment of the mother as a 'catastrophe' for the child who has no conception of why this has happened. For such a child he notes there is such loss of love is accompanied by a loss of meaning. The child responds with an attempt to repair the mother. Its subsequent failure, however, leads it to feel all the 'measure of his impotence.'[145]

The child's ego, therefore, employs defences against this trauma. 'First and Foremost,' Green writes, 'is a unique movement with two aspects: *the decathexis of the maternal object and the unconscious identification with the dead mother*.'[146] This decathexis is accomplished without 'hatred' or 'instinctual destructiveness,' rather it constitutes a 'hole in the texture of object-relationship with the mother.' Therefore, Green explains, though the cathexis that surrounds the hole enables the mother to care for the child and love it and the child to love the mother, the child feels that for some reason the mother is unable to *truly* love them. As he puts it their 'heart isn't in it.'

> The dead mother complex had taken away with her, in the decathexis of which she had been the object, the major portion of the love with which she had been cathected before her bereavement: her look, the tone of her voice, her smell, the memory of her caress. The loss of physical contact carried with it the repression of the memory traces of her touch. She had been buried alive, but her tomb itself had disappeared. The hole that gaped in its place made solitude dreadful, as though the subject ran the risk of being sunk in it, body and possessions.[147]

In the beginning decathexis is conscious and only becomes unconscious later as the withdrawal of investment becomes retaliatory.[148] The 'loss of meaning' brought about by the mother's withdrawal can manifest itself in the 'release of secondary hatred,' in excessive 'auto-erotic excitation' and 'more particularly, *the quest for lost meaning [that] structures the early development of the fantasmatic and the intellectual capacities of the ego*.' Green describes a 'frantic need for play' founded on a *compulsion to think* and a *compulsion to imagine*. Through this prism, artistic creation and intellectual activity have therefore been theorised as one of the possible outcomes of the dead mother complex, as a 'patched breast,' via the process of sublimation.[149] For as Alfred H. Modell points out:

What is crucial for some individuals is the ability to construct alternative inner worlds of the imagination that will effectively remove them from the impingement of a traumatising relation with the mother.[150]

Modell forces me to ask a question. How can we theorise the desire to create an alternative world when the 'dead mother' from whom both a distance and yet a connection is desired had been creative when she was 'alive'? Could I propose for Hesse a hypothetical double move in the creative act? The desire to imagine creates an inner world as a defence against the dead mother, yet in the act of creativity an unconscious affective connection might be formed with the vitality of the creative mother before or between her periods of bereavement. I will return to this point again with the work of Bracha Ettinger later.

In 'The dead mother syndrome and trauma' Modell emphasises the differing 'resilience' of individual children to the trauma of the dead mother. The same trauma for one child might result in a pathological syndrome while for another it might result in a complex. Though Hesse's childhood diaries and own memories tell of anxiety and a need for assurance of her parents' love, Ruth Hesse and William Hesse consistently describe her playful, enthusiasm and energy; on more than one occasion they write 'there is a fire in her.' Her character could be consistent either with a playful little girl or, possibly, a child with a *need* for play; there is no way of knowing.

'The reality of loss,' Green writes however, 'its final and irrevocable nature, will have changed the former [mother-child] relationship in a decisive way.[151] The catastrophe of the real loss of the mother may stem from the mother-child relationship that existed before death. [152] With Green's work in mind I want to suggest that Ruth Hesse's suicide was an event that retroactively, by the rival and revision of deferred action, bestowed the full force of traumatic meaning to Hesse's memory of her mother's 'aliveness' as well as the memory of physical and psychical separation from her. The absence of those who had known Ruth Hesse when Hesse was a small child, or who could talk about her, contributed to the representation of her mother as someone with 'a permanent characterological deficit, rather than remembering her as having suffered time-limited depression.'[153] It is through this filter, combined with the post-Freudian applications of psychoanalysis in America in the 1950s, that I would wish to begin to read Hesse's often cited diary entries about her mother.

Matrixial Memory: Motherless Daughters

I would have been so different if I would have had had my mummy, a companion, security; an actual person who loved me, not in a purely selfish way and would have sincerely told me when I was wrong, would have counselled me with an example or explanation of the right way.

Eva Hesse, Friday 18 February 1955

In accordance with *Motherless Daughters: The Legacy of Loss*, written by Hope Edelman, I would like to recognise mother loss as one of 'the most determining, the most profound, the most influential events of [a daughter's] life.'[154] Ruth Hesse was a mother worth mourning and Hesse's mourning was one that followed a typical cyclical pattern; augmented by birthdays, the anniversary of her mother's death, and her own times of stress when she needed her mother. Hope Edelman understands mother loss as a rupture in what Naomi Lowinsky called the 'Motherline':

Without knowledge of her own experiences, and their relationship to her mother's, a daughter is snipped from the female cord that connects generations of women in her family, the feminine line of descent...

Motherline stories ground a motherless daughter in a gender, a family, and a feminine history. They transform the experiences of her female ancestors into maps she can refer to for warning or encouragement. And to make these connections, she needs to know her mother's stories. [155]

Hesse lost Ruth Marcus Hesse when she was still her 'mummy.' Their relationship was cut short before it could become a friendship between adults or could begin the story telling that makes sense of a daughter's past and helps her form a sense of identity.[156] Moreover, this absence could not be assuaged by stories about her mother told by her grandmother or family friends. There was no extended family to fill in the blanks of this once, what Ettinger calls, 'woman-becoming-mother.'[157]

In *Remembering to Forget: Holocaust Memory Through the Camera's Eye*, Barbie Zelizer tells us that from 9 April 1945 until the first week of May 1945 the American and British public 'were exposed to an explicit and on going photographic display that visually documented the atrocities' committed in Europe.[158] As Nazi Concentration Camps began to be 'liberated' by Allied troops their newsreels and photographs, made under the orders of General

Eisenhower, began to play a significant part in the necessity to bear witness to the horrors committed in Europe.[159] In *While America Watches* Jeffery Shandler states that 'During the first days of May 1945 all five of the nation's major newsreels devoted most of their reports to the exposure of 'Nazi atrocities" [...] this was an unprecedented phenomenon, and, though short lived, it has proved to have a lasting impact on American remembrance of the Holocaust.'[160] I cannot imagine how the Hesse family could face this reality, the unspeakable pain of looking upon these images with the question is *this* how my brother, my mother died? Sometime in 1945 William Hesse received notification from the Red Cross that Nathan and Martha Hesse had died in Bergen-Belsen. Ruth Hesse also received confirmation that her parents had also been brutally murdered in Theresienstadt. All hope was now gone. Helen Hesse believes that their loss was without doubt a contributing factor to her mother's despair and death.[161]

The nature of Ruth Hesse's death, and the events that surround it, give us a sense of the immense trauma Hesse suffered. *Motherless Daughters* explains:

> Losing a parent to suicide is one of the most difficult types of death a child can experience. It's sudden and usually unexpected; it often involves violence; and even daughters who understand the part mental illness and depression play still experience suicide as a clear cut and real rejection." To a child, parental suicide is a 'fuck you,'" Andrea Campbell explains. "It's an 'I can't live for you. I can't stay alive for you. You may hurt, but I hurt more.'"
>
> A mother's suicide leaves a daughter to contend with a complex array of emotions, including heightened anger, guilt and shame; lowered self-esteem; shattered self-worth; feelings of inadequacy, deficiency, and failure; fear of intimacy; and an eroded capacity to trust that this type of rejection won't happen again [...] Child survivors [...] may exhibit post-traumatic behaviours such as distortions of memory when asked to recall the death; the belief that they will die young; a collapse of earlier development skills; and a tendency to repeat the trauma through dreams, nightmares, and play. And all this takes place in a cultural milieu that typically projects shame and guilt onto the family members left behind, no matter how young.[162]

The very unexpected and sudden nature of suicide denies any preparation to those who will be left behind in a world that still goes on without that person. In *Motherless Daughters* Hope Edelman cites the work of Therese Rando:

> When somebody dies suddenly, you don't have time to gradually shift your expectations […] everything is gone all at once, and you cannot bend your mind around the idea that fast. There has been such an assault on the way you have conceptualised your world, which includes that person. And especially with your mother. Your mother is your *mother*. How can she not be here?[163]

Guided by his concern for his children and his own inability to 'deal' with the death of his ex-wife William Hesse tried to shield his children from her death. The two girls were sent to stay with Hannah Moeller, who was a close friend of their mother's, and Judith Stern, who was slightly younger than Ruth Hesse.

Helen and Eva Hesse were only told that their mother was seriously ill when in fact she had already died. Manfred Kirchheimer recalls that it was a secret.[164] They were still ignorant of Ruth Hesse's death when William Hesse attended her funeral. An article about their mother's death had appeared in the Washington Heights local newspaper. William Hesse had meant to protect the girls by delaying the news but once it was made public Hesse was the subject of cruel bullying at school that she had to bear as well as the grief for her lost mother to whom she had not been able to say goodbye. Eventually the taunting became so bad that she refused to go to school. William Hesse then intervened and bribed his youngest daughter to go to school with the promise of a new bicycle. Helen Hesse, who had steadfastly continued to attend school, wanted to know 'how come I don't get a bicycle?'[165] The exclusion of Eva and Helen Hesse from their father's remarriage and their mother's funeral made them what Edelman would call, 'bit-part players in the family drama' whose lack of involvement detached them from the reality of what had happened and thus the ability to properly grasp it.[166]

Much has been said about Hesse's guilt about her mother's death. Motherless Daughters has much to say about the guilt of a bereaved daughter, particularly one whose mother took her own life. Daughters in late childhood, from the ages of six to twelve, are believed by some therapists, Edelman tells us, to have the 'hardest time coping' with mother loss.[167] The psychologists Albert Cain and Irene Fast studied the effects of

parental suicide and found that children between the ages of four and fourteen who were left behind were predominantly affected by guilt, and frequently asked 'Why couldn't I save her?' and 'Did I cause her despair?' The author outlines the phenomenon of guilt within the parameters of 'magical thinking' that can be discerned in children as young as three and that is evident into womanhood:

> *Mothers leave because children are bad; parents die because their children want them to go away* – these are examples of 'magical thinking', which grows out of a child's egocentrism and cause-and-effect belief system...these daughters see a mother's death or absence as a result of something they did – or didn't – do.[168]

The depression from which Ruth Marcus Hesse suffered, that was by no means permanent, and her suicide augment the complexity of Hesse's case. Edelman states:

> When a mother leaves mentally, that child feels even more strongly than the child whose mother dies, 'I didn't deserve to have her with me. I must have done something bad. I'm not worthy of having mother stay. If I were loveable, she would have stayed.[169]

A non-oedipal reading of Hesse's guilt about her mother's death would not only take into account her age, and her inability to revive her mother and sustain her interest in life, but also the advice that she and her sister gave to their father in 1944. As their mother's ability to cope in the home worsened they said to him as they sat around the dinner table, 'why don't you get a divorce?'[170] Let us think again about Hesse's statement that her father let her mother 'go off by herself – without us her children – she killed herself.' In the light of magical thinking this passage could indicate that, had Hesse believed that *if* she had not said what she did and *if* she and her sister been with Ruth Hesse, the tragedy that followed might have been averted.

To return briefly to the issue of father identification, the tagebücher show both Helen and Eva Hesse had very strong and loving relationships with their father both before their mother left the family home and after her death. William Hesse offered his daughters a model of how *to be*. A highly intelligent man, he nurtured his daughters' academic pursuits. Without the 'traditional social and cultural roles' of the 'two-parent family' it was easier to feel the potential of her talent and the naturalness of pursuing it. Her father had had the foresight to get his family out of

Germany and start again in middle age. He had accepted that his prestigious qualifications were invalid, and by the dint of his own efforts, he had learned a new language, taken new professional qualifications and built up a client base in insurance. Like much of the Washington Heights community he, therefore, provided a model of what was possible if only one worked hard enough. Life should not be wasted; it had to be grasped by both hands and lived. To put it quite simply, that a daughter should cling to such a father after the loss of her mother is not unexpected.

When a mother dies, Edelman tells us, or in this instance we might add when a mother's care has been genuine but inconsistent:

> Instead of detaching from her lost mother, a daughter may try to quickly and directly transfer her feelings of dependency, her needs and expectations onto the nearest available adult. This may be her father, an older sibling or other close relative, a teacher, a neighbour, or a therapist. During adolescence, a boyfriend or an older female friend often serves the same purpose. While transference can be helpful when the child is too young to detach all her emotion from her caregiver, if she doesn't return later to pull away from the image of her mother enough to mourn the loss she will continue to search for her in the people she chooses as replacements. [171]

A motherless daughter, Edleman tells us, may often find herself thinking:

> So here I am: I look like a woman, act like a man, and underneath it all still feel like a child, constantly looking for someone to reassure me I'm competent enough, attractive enough, good enough as I am. [172]

Edelman states that 'without a living mother to refer to for comparison, a daughter invents much of her identity alone.'[173] The 'feeling of uniqueness' that sets motherless daughters apart from their peers throughout their lives is one of the key concerns of Edelman's book.

Motherless daughters understand the artist's isolation. They, too, are different from their peers. To avoid the shame that typically follows mother loss, a daughter may try to push this distinctness to an extreme. Instead of being different, she then can perceive herself as special – and give herself an identity other than "orphan." She is no longer a pariah among her classmates, no longer the object of their compassion or pity, if she

reinvents herself as a star. And if she succeeds, she gains power and attention she didn't have as a motherless child.[174]

With this insight in mind we may add another, highly significant dimension to Anne Wagner's analysis of Hesse's adoption of the identity of the artist as a social outsider. *Three Artists (Three Women)*, employs a short essay written by Hesse entitled 'An Autobiographical Sketch of A Nobody.' With that text Wagner cogently argues that when Hesse wrote to her father "'I am an artist…I guess I will always feel and want to be a little different from most people. That is why we're called artists," she had found both 'an identity and a name for her difference.'[175] Wagner unravels the sources of Hesse's 'key identification' from the young artist's reading lists and the socio-historical context of the myth of the estranged and neurotic artist in America in the 1950s. 'Hesse, it is clear,' Wagner writes, 'certainly believed in her own difference – and sometimes, indeed, in her sickness. That belief, I am claiming, was one requisite – if not, indeed, a prerequisite – of her adoption of the artist's identity.'[176] For Wagner, Hesse's bricolage of role models from the art historical canon was a means to construct a place of belonging for her own ungrounded sense of sexual difference. In such an act of self-creation Hesse might have gained a degree of mastery over but also resurrected and thus affiliated herself to her artistic forefathers.[177] Yet she also provided herself with a means of escape from the enervating stereotypes of contemporary American neo-Freudian femininity.[178]

Hesse's 'An Autobiographical Sketch of a No-body,' had been written about the time the young artist began her therapy in 1954. Its insights seem to be intended for but as yet untainted by the analytic setting, but we cannot guarantee that they were not touched by the popularised psychology of the time. The full text reads:

> I am not a writer; now might you say should I be that pretentious to write down my thoughts. An autobiographical sketch of a no-body. But it is … because I feel like a nobody, when I should be feeling like a somebody that I shall write. *It is precisely because I have felt for the majority of my life, in rather unpleasant ways, different, alone and apart from others* that my case would be of interest. If fiction is of interest to people for reasons of the life like qualities centred in the protagonists who participate in activities of every nature offered to man with their entire being, consciously aware of themselves, it can be of greater interest for one not to have to fictionalise a character but bring forth from reality such a one without any make believe. The joy and sorrow can

be experienced with deeper intensity since the conviction of its occurrences are real and not fabricated.

It is a story of one whom *from the outside* reveals a rather pretty picture. Attractive with a congenial smile, and an immediate, amiable personality. The stature is not that of a vogue model but preferable to those men who admire more flesh and less bone. At this time it is only important in so far as I want to impress on the reader that picture of a more than socially acceptable view of a young lady. Pretty face, pretty body, pretty dress, pretty ... *However, the person does not feel pretty inside.*

Further more, the nature of experiences in this young life have, *as I have recently been made aware of,* been extremely out of the ordinary. Now it is said that what befalls a youngster in his earlier states of development moulds and effects his development from then on. He is aware of being different and at one stage might even enjoy this fate and dwell on its special characteristics. He might confuse this 'differentness' with something very special in a positive or negative sense. By comparing himself with others he might attempt to distinguish qualities of his own with those of others. Occasionally they allude to his feeling superior or inferior, very seldom to a feeling of contentment and satisfaction and with it understanding.

To complicate the matters some, for the last year our friend has shown and developed talent as a painter, a good one at that. Here she confronted herself with the universal questions regarding the artist and his "special temperament." *Was it in her being and feeling estranged and different that she could claim the title of "painter".* The rebellion presently is a direct outcome of what for the time being she has accepted as the answer. That is the artist in society, *the true artist is also the true personal misfit. It is by his very nature of being different that he finds himself having the desire to create a piece of prose or a musical composition.* Now is not the time to discuss the question of the similarities or differences of the arts nor the philosophical or aesthetic questions involved. My view regarding this would admit musical composition and poetry but not the writer of prose or non-fiction. Briefly the reasons being that the former are involved with the same abstractions, the same unreal universals only indirectly affecting life and very far removed from actual experience for the creator. That is they are removed from the realities of life he would have to face as being part of the majority of society. The word majority cannot here be stressed enough.

There was a relatively short period of contentment or adjustment while said person was fully engrossed in his small world of paints and canvas. Artistically speaking this is the greater world, the world outside and above daily routine, enveloped into colors and forms selectively chosen by the mater. He too is not alone in that world but find companionship among the 'select' few who also find their worlds among the smell of pigments and turpentine. Some are fortunate enough to maintain and sustain themselves a lifetime within this small isolated society. They although expected to be the spokesmen, the communicators of reality to the majority, never do they claim this role for themselves. They do attempt communication among themselves but secretly deny and reject the world of their compatriots.[179]

In the light of Edelman's profound insight could Hesse's sense of difference and desire to construct a sense of who she was out of a bricolage of identities be, in part, a testimony to the presence of a mother's absence?

Creativity with-in the Feminine

One of the consequences of the presence of Ruth Hesse's absence has been the no-histories written for her. She is represented as always already a mother figure, albeit one that is depressive and dysfunctional; castrated from history she folds in on herself and thus has no creative legacy to bestow. In order to create works of art, in order to survive, the texts written for Hesse make the artist turn away from her mother to emphasise the sense of self she constructed. To represent Hesse as 'self-creating' is to easily transform the artist into a phoenix-like male figure set up as the 'self creating genius-Hero' as formulated by Bracha Ettinger in the essay *Weaving a Woman Artist With-in the Matrixial Encounter-event*:

The psychoanalytic basis for understanding the genius-male-hero complex: born from *no womb*, the artist-genius is in fact the idea of a God, now transformed into a man, created by itself and then holding the power of creation.[180]

Ettinger analyses the writing of Otto Rank to unravel the 'neutral-but-phallic' psychoanalytic theory that binds the mother to a diminished role in the different myths of the birth of the genius-Hero. In those myths, whose basis is the Oedipus complex, the mother figure is persistently represented as:

An object of desire caught between father son-rivalry or a nursing object, and sometimes either a copulating or a nourishing animal, and in either of these roles a woman can also occur as a Muse, the source of inspiration.[181]

To frame Hesse's art practice on a structural level within the *phallic subjectivising stratum* alone is to confine her mother's (re)appearance in a particular way. Ruth Hesse has been figured as the impetus behind the creative compulsion that seeks to empty the artist's self of 'feelings and visions' while simultaneously maintaining the separation from the 'danger' she presents.[182] Through the substitution of metaphor the *work* of art becomes the place where the relationship of the mother and daughter could be worked through in drawing and gouache. The daughter's rivalry with Ruth Marcus Hesse for the father's sexual desire, her articulations of anger, guilt and absence might be all played out in the medium. The artist's creativity, however, remains confined within the paradigm of father identification.

Ettinger discerns an 'evacuated possibility,' a 'void' in the dominant interpretation of the mother figure between 'copulating and nursing,' that 'holds the genius-Hero complex together and allows its appearance':

The lacking possibility is the gestating and birth giving, the begetter mother that I have named the archaic m/Other as poietic Event and Encounter. Only on condition of the disappearance of this third possible woman-becoming-mother figure, the hero-son-god – torn between rebellion, rivalry and admiration towards his father, his own ex-hero-father-god – can be born of and from itself and establish a male filiation in the same move…the birth giving mother is not killed and then symbolically resurrected, like the father. She is not even rejected as an abject. For the hero to be born from his self, the archaic becoming-mother must melt into obscurity and senselessness as a Thing of no human significance.[183]

In Sigmund Freud's theorisation of the *phallic subjectivising stratum* male sexuality becomes productive via the male child's neutral-but-phallic narcissism and its concomitant insistence on the denial of the womb.[184] With Ettinger's theorisation of the Matrix the womb 'moves from nature to culture.' It is proposed as a 'support for another dimension of meaning, for another meaning and for supplementary feminine difference as the human

potentiality for shareability and co-poiesis where *no 'hero' can become creative alone.*[185]

The model of the archaic Encounter/Event formulated by this artist/psychoanalyst opens two possibilities for analysis. First the concept of 'subjectivity-as-encounter' brings within the scope of the writings about Hesse the real of history that modified and had been modified by the 'difference-in-co-emergence' of the borderlinked partial subjects Eva Hesse and Ruth Hesse.[186] It makes visible the tears in the fabric of Ruth Marcus Hesse's own relation with Erna Marcus and the shades of grey of her depression and aliveness; rather than a life painted black. In the same vein Hesse's relation to her mother need not be perceived entirely within the phallic mode of differentiating, identification/assimilation or rejection by a subject who is an individual.[187] Rather the:

> Matrixial difference conceptualises the difference of what is both joint and alike and yet not "the same," and of what is uncognised yet recognisable with-in a shared trans-subjectivity.[188]

Second what I would like to suggest pertains to the function of creativity for Hesse. I want to read Hesse's identification with the heroic figure of the artist beyond its value as the symptom of father identification, the social misfit as a metaphor for sexual difference, and present absence endured by the motherless daughter. I shift, therefore, from a notion of 'The Artist' as simply an identity to the becoming artist Hesse for whom possibilities were opened by her potential to be a creative subject who *makes things*. It is here that I am brought back to the question that was posed by the text of Modell and the tentative hypothesis I made above in respect to creativity and the dead mother complex. André Green states that the decathexis of the love that had been for the mother is not drawn back into the ego or displaced on another object. The subject, he continues 'ignores that he has left behind, has alienated, his love for the object, which has fallen into the *oubliettes* of primary repression.'[189] Green's theorisation, whose primary structure is that of the Oedipus complex, retroactively casts the affect of the 'alive' mother, her caress, her voice, her gaze to the oblivion of that from which the phallically constituted subject is forever split and mourns. I have already suggested that for Ruth Marcus Hesse the memory of her 'aliveness' may be bound to memories of her creativity. If so, in this case, the compulsion to imagine that is a symptom of the desire to create an inner world as a defence against the 'traumatic relation' with the dead mother might also draw an unconscious connection to her aliveness. Yet

the prism of the Matrixial subjectivising stratum facilitates an awareness of the 'non-symbolisable,' 'unthought' imprints of trauma and jouissance of the archaic encounter. I wonder therefore if it would be possible to propose another part-connection via art work, as the imprisoned affect of touch, caress and gaze that resonate with those traces of an awareness of the non-I that may resist castration/repression and appear, by 'subterfuge,' in painting?

5

LONGING, BELONGING AND DISPLACEMENT

Eva Hesse's *Art-Working* 1960–1961

The painter's creative gesture does not originate in decision or will, but *concludes an internal stroke*, a stroke which also participates in regression, but, contrary to regression, it creates – in a backward movement, as in a reversal of the course of psychological time – *a stimulus* to which the gesture becomes a *reaction*.

The Matrixial Gaze, Bracha Ettinger[1]

This chapter returns to the drawings with which this book first began. Its structure recalls Ettinger's notion of 'seriation without filiation' in which historical differences between artworks are not precluded by their proximate co-emergence. The complex interplay of connection and disparity that marks the co-emergent production of *no title* 1960/1961 (plate 1) and *no title* 1961 (plate 2) is not unravelled but sustained; neither separated nor assimilated. This chapter is concerned with the 'work' of these drawings; process, materiality, performativity. In congruence with earlier interpretations of Hesse's practice I suggest readings that touch on psychoanalytic theories of mourning and trauma. These analyses return to and yet transcend the visual register of representation to suggest ways in which these psychoanalytic frameworks might impact on understandings of process for this artist's practice. In so doing this chapter situates Hesse's drawing practice within a complex relation of contemporary cultural and social forces, in conjunction with past historical events and those points of biography already outlined in the discourse written for this artist. In so doing I propose a different kind of functionality at the heart of her art making in the early 1960s.

This shift of focus takes place at a time of peculiar complexity in the history of Hesse's discourse. In conversation with Nemser in 1970 Hesse spoke of her 'window drawings' of 1968 (plate 10) In 1982 Ellen H. Johnson suggested that this trope had been a creative thread that had run throughout Hesse's short lived practice from their 'extraordinary fertile' beginnings in 1960–61. Johnson attributes the significant presence of the window in the artist's later work, in part, to the view of Tom Doyle's studio across the Bowery from Hesse's own apartment and workspace.[2] In the mid 1990s the window had been ascribed further biographical meaning as a working through of the loss of Ruth Marcus Hesse who, it was believed, had jumped to her death from a window. As noted earlier this reading framed my first encounter with *no title* (1960/61) in 1998 and featured in Griselda Pollock's introduction to our 2006 publication *Encountering Eva Hesse*. More recently that hypothesis would seem to have come under scrutiny due to the clarification of the circumstances of the death of Ruth Marcus Hesse. Helen Hesse Charash has confirmed that on 8 January 1946 Ruth Marcus Hesse leapt from the roof of the Eldorado Apartments at 300 Central Park West.[3] Art history's account of Hesse's picture making as an index of mother loss thus finds itself in an interesting predicament. If it is not possible to assert what Hesse herself believed it may seem prudent to abandon the window motif. Rather than entirely renounce this hypothesis I still agree with Anne Wagner's belief that Hesse's relationship with her mother had been negotiated with-in her work. I prefer to view the conundrum brought about by this revision of events as an opportunity for feminist analyses of art making to consider the uses to which psychoanalysis has and can be put. To this purpose we must return to the earlier hypothesis of the window motif and the metaphoric and metonymic paradigms of symbol formation that are at the heart of this interpretation. To this end the knowledge that Ruth Marcus Hesse actually took her own life by jumping from the roof of the Eldorado apartments is temporarily suspended so that the means by which Hesse's work is theoretically framed may be considered. The value of such an analysis is not to render this artist's practice an illustration to an argument about art historical criticality and methodology. Rather, to attend to the work of art in this discursive context is to draw attention to the powerful potential of the kinds of enquiry born of practice to contribute to the meanings produced for art and intervene in the production of criticism and theory.

Anteriority, Representation and Loss

Three Artists (Three Women), in agreement with Johnson's earlier article, cites the prevalence of the window motif across a range of examples from Hesse's oeuvre.[4] Wagner is fascinated by the unconscious creative procedures at work in Hesse's practice. At an intersection of 'legibly artistic protocols' and a Freudian vocabulary Wagner argues for the ways in which Hesse's 'imagery' repeatedly configured a 'repository of desires, prohibitions, and fears' that concerned her mother 'above all.' Across the methods of Eva Hesse's art practice the author:

From its earliest appearance Hesse's window imagery has two concerns: there is the issue of demarcating the frame and the problem of characterising (or refusing to characterise) what lies beyond [...] The frame can be a simple, regular line of wash, which makes it seem co-extensive with the edge of the paper, or it can bristle with the marks of a pen, and thus become an object on or in a field. Sometimes the edge has the appearance of being wrapped, in a way reminiscent of her eventual treatment of the framing edge of *Hang Up*. Particularly in the later drawings [the window] can be summoned up complete with sill, moldings, and the like, and its presence is emphasised by a back and forth hatching that is sometimes repeated till it has a barbed sharp-edged density. What appears within the frame is equally varied: sometimes in the earlier drawings there are dark, vaguely humanoid shapes with round heads (on two different sheets is grouped a small family of such figures – four in all, just as in Hesse's family). Sometimes the frame holds an orb with a spiraling or concentric centre. Sometimes (again, particularly in the earlier drawings) it is filled with smaller compartments that in turn contain their own quasi-organic, mysterious shapes. Or the compartments – by 1964 Hesse had named them *boxes* – may be empty. In the later series, by contrast, the space within the frame is most often given over to the effects of light and air, or their utter absence. The illusion of luminosity and atmosphere suggest some space beyond the frame, while dark opacity revokes it completely.

The effects of these pictures encompass the desire to see beyond the frame, and the fear of so doing. They alternatively indulge that desire and prohibit it. They offer up the experience as either full or empty.[5]

This evocative passage reads an iconography of the frame across several images as the locus of an alternate play of loss either as the vehicle to her mother's absence or the desire and fear of her presence. Her formal description organises Hesse's mark making within a representational logic specific to the history of art. The acknowledgement of the specificity of this position leaves scope to supplement the astute observations Wagner offers us. For 'practice,' as Barbara Bolt makes clear in *Art Beyond Representation,* should be comprehended as the relation between the artist, the complex of practical knowledges, the materials of practice and the novel situation of the body in studio.[6] What I would wish to pursue in these works is the potential of making as repository of meaning. It is possible to turn the tables: for the image to be the register, a trace of a process and encounter in which all of these elements are co-responsible for the emergence of art?

I begin with Hesse's processes of 'demarcation.' As was first noted in Chapter One the construction of Hesse's small early drawings make clear that the paper is not an impassive ground on which the artist simply acts. Rather than the consistent setting of a boundary, the emergence of Hesse's 'frames' in earlier works might be more connected to the different recurrences of a tense relation between elements of the drawing to, or in spite of, the edge and plane of paper. In Hesse's drawings of this period marks are anchored to or escape the edge, *no title* 1960–61, (plate 11), or else they float on a plane above the paper, *no title* 1961, (plate 12), unless weighted down by a wash that creates a different picture plane to that of the paper, *no title* 1960/1961, (plate 1). To awaken students to the potentiality and limitations provided by the edge of a piece of paper or canvas is one of the earliest aims of an education in art. To make a frame after an image has emerged on the paper is one way to skirt a fundamental problem of composition in two-dimensions; the paper is brought to the image. That is not to reduce Hesse's act of 'framing' to a simple exercise or question of technique. What it does do is draw attention to the ways in which paper is always already framed for Hesse both as artist and subject. Any mark made is always already in response to those boundaries. Repeatedly Hesse's practice negotiates, in the doing of it, and thus draws attention, in the looking at it, to the dilemma of the edge. These observations may only seem a hair's breath away from Wagner's earlier research, yet it is a crucial distance. The stimulus to the creative gesture is here transformed from an unconscious act that performs the will of the subject upon the artist's media. It can be argued that both the choice of the artist's materials and the work performed are caught by the 'hand-thought'; the conclusion of a response to an 'internal stroke' that, informed by

regression, provoked the creative subject into action. Art thus emerges in the artist's present within a dialogue of psychic cyclic temporality between creative stimulus and reaction performed with-in mark and surface.

In contradiction to a transparent working through of past trauma in the present a complexity of practice begins to emerge that resists what Bolt has named the transformation into intelligible data. Hesse's drawings begin to lead viewers into the realm of the 'fuzziness of practice.'[7] Hitherto the unaccountability of practice, beyond description, has been disguised or reigned in by narrative made present via symptomatic symbol formation in the service of representation. In the case of the window motif this methodology guides the theorisation of the 'unconscious motivation' behind the notion of a daughter's *return* in representation' to the scene of her mother's suicide. Such a hypothesis implies the existence of a memory-trace from which Hesse *reconstructs* the original singular *past site*. In many respects the 'visual work,' to draw on Mieke Bal analysis of anteriority in 'common narrative modes' of story telling, becomes an 'illustration' of a prior narrative to which it is 'subordinated.' The 'success' of visual work in this paradigm is thus 'measured in terms of the degree to which it matches the story.'[8]

It is at this point that questions begin to emerge about the means by which art history has constructed Hesse's picture making as an index of mother loss. It is possible to argue that the representational logic on which it is founded is actually at odds with Freudian theorisations of psychoanalysis. How can a 'restoration to the visible,' to borrow from Merleau-Ponty's vocabulary, of a scene occur at which Hesse was in no way, either physically or psychically, present? It is precisely because Hesse was not present at the death or official mourning of her mother that the loss of her did not belong to the past. Such unresolved loss has the power to inhabit a life as a traumatic 'present-day force' and thus possess the means to modify contemporary experience and yet be modified by the revival and revision of deferred action.[9] This special relation to time negates the possibility of 'reconstruction', of a return or revival of 'the' scene for both artist and author to instead point towards the tool of 'construction' employed in psychoanalytic practice.

In 'Constructions in Analysis' Freud defines the task of the analyst as 'making out what had been forgotten from the traces which [experience] has left behind, or more correctly, to construct it.'[10] The analyst works with 'raw material'; fragments of memory that recur via the distortion of dream work, ideas via free association that give up 'allusions to the repressed experience and derivatives of the suppressed affective experience', 'hints of repetitions

of the affects that belong to repressed material to be found in the actions performed by the patient.' These 'emotional connections,' moreover, return in the transferential relationship between analyst and analysand.[11]

To write about the artwork of Hesse and the archives that she left behind is also to work with such raw material. Although Wagner writes of the formation of the window motif at the 'edge of a legibly artistic protocol' she chiefly locates the importance of previous artists for Hesse in their writings, not their fine art practice.[12] The production of the window motif as a locus of mourning appears to be an externalisation on the part of a discrete individual, that gives no hint of the complex interplay between the present time of Hesse the young artist who lived and worked in New York in the 1960s. In *Differencing the Canon* Griselda Pollock cites the writing of Nanette Salomon to elucidate the relevance of gender when historiography employs biographical material. The biographical details of masculine subjects are a symptom of the universal condition of mankind. Whereas, in the case of the woman artist, Salomon states:

> The details of a woman's biography are used to underscore the idea that she is an exception; they apply only to make her an interesting case. Her art is reduced to a visual record of her personal and psychological make up.[13]

Pollock concedes that feminist art criticism has been far from exempt from this problematic application of theory. In particular she highlights Salomon's critique of those readings of Artemisia Gentileschi's artworks that reduce them to 'therapeutic expressions of her repressed fear, anger and or/desire for revenge. Her creative efforts are compromised, in traditional terms, as personal and relative.'[14] Pollock argues for the 'careful interrogation of archives that include materials on a lived life.'[15] To do so she recalls Karl Marx's 'famous dictum in *The Eighteenth Brumaire of Louis Napoleon* (1852):

> Women make their own history, but they do not make it just as they please; they do not make it under circumstances chosen by themselves, but under circumstances directly encountered, given and transmitted from the past.[16]

Differencing the Canon argues for art as a product that is 'literally Other' made by subjects that are in/of the social and subject to the contemporary and historical protocols of visual art.[17] On 8 August 1960 Hesse announced

in her diary that she had 'become a painter, working largely in isolation, constructively even productively.'[18] Though Eva Hesse worked in physical isolation, removed from other artists, mourning or trauma cannot be approached in seclusion. With this in mind I want to approach the 'contemporary and historical artistic protocols' and historical events, the 'raw material' that press upon the making of *no title* 1960/61 *no title* 1961.

Figuring Practice after Art School

Eva Hesse began to attend Cooper Union, two blocks from 10 Street, in September 1954. It was there that she met Victor Moscoso, who became her friend and long-term boyfriend. Hesse's art education in New York took place at the moment that 'Tenth Street: A Geography of Modern Art,' was published in *Art News* in 1954 by Harold Rosenberg. In that text he declared that the 'new American "abstract" art', whose community was centred around Tenth Street, was the first art movement in the United States in which immigrants and sons of immigrants have been leaders in creating and disseminating a style.'[19] 'Abstract Expressionism,' Moscoso said 'was happening around us' and what is more 'half of the good painters were women.' Artists such as Helen Frankenthaler (1928) made it clear to young artists who had been taught exclusively by men that, so long as they played the Modernist game long enough to get noticed, 'women could paint as good as a guy.'[20]

In 1956 Eva Hesse was granted a scholarship from the Educational Foundation of Jewish Girls and moved to New Haven to attend the Fine Art degree programme at Yale School of Art and Architecture. Josef Albers (1888–1976) had taught at Pratt Institute and Cooper Union, and his appointment at the Yale School of Art and Architecture, beginning in 1950, stipulated a special arrangement for graduates from Cooper to go to Yale. Hesse graduated in 1959. Albers had emigrated from Germany in 1933. The Bauhaus, where he taught, had been infamously forced to close by the Nazis when the Gestapo padlocked the doors in June that year. This and the wave of anti-Semitism that endangered Anni Albers cemented the couple's decision to leave Germany. The Albers had both been invited, on the recommendation of the Museum of Modern Art New York, to teach at the newly formed Black Mountain College in North Carolina.[21] He retired from his position of Chairman of the Department of Design at Yale in 1958 but remained a visiting Professor until 1960. In 1958 Rico Lebrun (1900–1964) had been appointed as visiting professor to the fine art programme and had an exhibition in the Yale University Gallery.[22] Moscoso recalls that the politics between the two professors that embroiled

both the students and department. Albers objected to Lebrun's appointment because from 1956 Lebrun, who was Catholic and Italian by birth, had made work about the Holocaust.[23] Lebrun somewhat bitterly recalled the 'difficulties' at Yale as 'too much snow, and too much Albers.'[24]

I would like to think about Eva Hesse as a becoming artist, aged only twenty-three, just out of art school and its particular politics, going back to New York. The first two years (at least) after graduation are a crucial time in which the entire direction and worth of an artist's work is questioned. The sudden absence of the supportive and critical environment of art school, of both peers and faculty, can leave young artists in limbo between their student practice and what they think they should be doing as professional artists. At this time Hesse also began seeing therapist Sam Dunkell who had, as noted in Chapter Four, diagnosed her as suffering from father identification. In 1970, the benefit of hindsight led Hesse to recall her time in New York after her return in 1959 and in 1960 as follows:

> I believe that the struggle between student and finding one's self is, even at the beginning level of finding maturity for yourself, I don't think it can be avoided, I don't know anyone who has avoided it, and mine was very difficult and very frustrating. I was conscious of it all the time and if I ever had any worry in my development, it was then in like *am* I finding myself, and my *am* I just staying with like a "father" figure and where is my development and is there a consistency, and am I going through stages and will I reach there, I was very cognisant of that and it was a very frustrating, difficult time, but I worked – I never had the trouble of not being able to work although there would be three months, say, where I would work all the time and then there would be a break and that would be very frustrating but after a while I knew I could always get back but it was a difficult time.[25]

In the summer of 1959, Hesse had applied to, but was turned down by, the graduate school at UCLA. Lippard noted that this disappointment forced her to return to New York and to take a job in a jewellery store on West 4 street.[26] Lippard continues to emphasise Hesse's determination to become part of the art world in New York despite the early frustrations that she encountered:

> The apartment at 82 Jane Street [Hesse] had inherited from Camille Norman was too small to work in, and she found studio space in a

garage in the neighbourhood; later she shared a space at 3 Ninth Avenue with artist Phyllis Yampolsky. The 'art world' had been very important to Hesse even when she was a student. While still at Yale, she had made an attempt to be included in the Museum of Modern Art's 'Sixteen Americans' exhibition; her friend Ellis Haizlip recalls […] her profound disappointment when she was turned down. An artist who was seeing her during 1950–60 remembers her making a conscious effort to become more professional and to enter the art world at that time.[27]

The significance of having a studio goes beyond a simple space in which to make artworks. It is a signifier of professionalism in which the artist claims a place for his or her self, where they can visit and be visited. These spaces are integral to the networks in which ideas are exchanged and communal support given. The value of being an artist can often be dismissed by an unsympathetic world that exists beyond the realm of art institutions, while the sense of being an artist is daily contradicted by the day-to-day necessities of making a living. Those concerns can often be registered in the kind of materials used. On a university programme, materials may be provided as part of the course free of charge or, at the very least, subsidised. I do not think that it was a whim that caused Hesse to make so many gouache and ink drawings on paper, or that these works seem less inhibited than her oil paintings of the same period. Of course we know that she loved drawing and had always been a highly accomplished draftsperson. It should be noted, however, that pencils, inks and paper, even good quality ink and paper, are cheap. Post-Bauhaus art education drilled all ideas of 'preciousness' out of its students. Yet the thought of wasting expensive materials on an artwork that might not work would be much more of a consideration when using oil, its mediums, canvas and its preparations.

As noted in Chapter One Hesse worked on drawings and on painting concurrently. In paintings like *no title* (1960, plate 4) Hesse mixed her pigments with an almost excessive amount of linseed oil. As a result the surface of this painting is sickly sweet. On one hand this could be attributed to a desire for or an attempt to achieve the fluidity present in her drawings. On the other hand, an excessive use of fattening mediums could also indicate the necessity of making expensive pigments go further and last longer. The surface of this painting would not have seemed so sickly had she adhered to the fat over lean rule that would have been even cheaper. Moreover, although Eva Hesse's paintings at Yale could never be called large, her paintings of 1959–1961 were on the whole significantly smaller.

Again I believe this signals a necessity for economy. Katherine D. Crone, then known as Kitty Cline, Hesse's roommate for two years at Yale and friend in the early 1960s recalled that 'none of us had any money then.'[28] Crone remembers that Hesse 'drew a lot at home. That was all she could do there. Her apartment on Jane Street was very small, so I speculate that if she couldn't get to her studio, she drew there. She had to have a day job.' In January 1960 Hesse took a position as a fabric designer in a textile factory. In late February 1960 she had been awarded restitution money for the Aryanisation of her Grandparents furniture store twenty-one years before. In a passage, edited by Helen A. Cooper, Hesse noted the event in her diary in an undated entry:

> Terrible excited! …Have been working hard! Feel good about work (my own). Stronger than ever before. sold another painting … received $1,300 from grandparents' stay in concentration camp. I will make use of the money wisely. I will go on my own soon, paint and get a show and be in a gallery. It is all going so much quicker than I anticipated. God I feel strong.[29]

In a post-art school environment such as this, historical and contemporary art practices may act as tools with which to develop and give permission to a young artist's work. In his review of the 1961 John Heller Gallery exhibition, *Drawings: Three Young Americans,* in which Eva Hesse took part, Donald Judd is sensible of this trait:

> With little guidance, with ideas forestalling guidance, and without clear communication, artists are forced into the expensive procedure of trying something of most styles over the course of their youth. This show is a portion of such experiments. Probably in a few years the work of none of the three artists will resemble that shown here. Eva Hesse is the most contemporary and proficient. Her small and capersome ink-and-wash drawings are a combination of the stroke (used both as sign and association) and of encompassing rectangles.[30]

In 'Thoughts on Eva Hesse's Early Work, 1959–1965' Renate Petzinger describes a shift in Eva Hesse's practice from 'works derived from the traditional Yale style of abstract landscape' to the 'human figure' in the spring of 1960.[31] Petzinger cites Hesse's life class studies from Cooper Union as her initial work with the figure. Thus the author configures paintings such as *no*

title (1960 plate 4) as a 'return' to an earlier engagement with the figure.[32] Life drawing is a rudimentary part of every student's art education and is the means through which basic skills of composition, observation and proportion are taught. Petzinger substantiates her point with the following extract from Eva Hesse's diary: 'my form comes from the figure whether it is the figure or not so why not do it for a while?'[33] To study anatomy in a life class is not, I would argue, the same as engaging with the figure in practice. I want to propose that the phenomenon of form that 'comes from the figure whether it is the figure or not' might again suggest the unconscious recurrence of a hand-thought.[34] A form can appear in spite of the resistance of the artist. The artist may actively set out not to create it by employing different materials but the persistence of a form can be so unrelenting that in the end the artist gives in and pursues it. In 1959 and 1960 in particular, it will be come apparent that, contemporary events had forced the dehumanised and slaughtered figure of European Jewry into contemporary consciousness in America. With the structure of trauma that I put in place in Chapter Four in mind, I argue for Hesse's receipt of reparation money for the loss of her grandparents' business as an impetus that revived the trauma of personal loss after a period of latency sustained by the absence of the Holocaust in American cultural memory. This revival of personal loss had then been subsequently revised and revived again by these larger cultural and historical events between 1959 and 1960. In this light it is possible to perceive the figure that pressed on Hesse's art practice within this historical moment not *knowingly* but in the form of a repetition compulsion.[35]

The figure had been present on the borderlines of Yale's focus on the abstract landscape painting in the work Rico Lebrun prior to her actively seeking it out in drawings such as *no title* 1961–1960. Carl Goldstein's analysis of the importance of Albers' pedagogical practice for Hesse contradicts the distinction that Hesse drew between her own art practice and that taught by Albers. In that same statement Hesse had also outlawed any connection between her own painting practice at Yale and that of Lebrun. Hesse's comments can be taken in the context of her psychotherapy that had pathologised the notion of overt father identification. In the transcript Hesse expressed concern about affiliating herself to 'father figures' in her practice; she asks 'where is *my* development?' I do not think it is a coincidence that Hesse wished to put the art practice of Albers and Lebrun and her relationship to them as a student at a distance. Both of them might be thought of as possible father figures for different reasons. Albers was significantly older than Lebrun and German with a Jewish wife. Lebrun had left Italy for America as a child and was six years older than the artist's father

William Hesse. Even without any consideration of Lebrun's age in relation to Eva Hesse or the direction of her therapy Lebrun's concentration camp works, such as *Buchenwald Floor #2*, (1957, plate 13), that seem to directly reference the photographs taken by American and British troops in 1945 posses a force from which even modern audiences recoil. In response to his one man show at the Yale University art gallery the *New Haven Register*, a local newspaper, carried an article in November 1958 entitled 'Concentration Camps and Religious Themes Mark New Lebrun Sketches.' In 1959 Lebrun exhibited work in the group show *New Images of Man* at the Museum of Modern Art, New York. Curated by Peter Selz, who had come to America as a refugee from Nazi Germany, the exhibition responded to what he and Paul Tillich perceived in the Preface to the exhibition catalogue as the continued 'dehumanisation' of art under Modernism. As Dennis Raverty notes the representation of the human figure in *The News Images of Man* acted, for Selz and Tillich, as a direct challenge to the formalism of Abstract Expressionism. Selz contrasted the 'exploration of the "reality of form" found in much modern art with the artists in his show, struggling with the "reality of man."'[36] The raw brutality of affect that these works brought within the realm of art, at a moment otherwise dominated by the decision 'just to paint', could be a reason why Lebrun's work was too close to home for Hesse. On the other hand Alber's objection to an outsider's attention to this subject matter could also have fuelled her conscious decision to distance herself from Lebrun. To acknowledge the legacies of this artist, as I will later in this chapter, is not to construct a position of synthesiser for Hesse within the canon of art history. Lebrun's obscurity since his death in 1964 is in part security against such a misinterpretation. To recognise the indiscriminate bricolage with which art practice is constructed, that can regard the practice of artists because of or in spite of gender, is not as some critics have mistakenly believed to go against the grain of feminist interventions in the history of art. To acknowledge the complex transformation of material, process, psychic and social 'sources' performed by the 'work' of art precludes the kind of indebtedness that has hitherto subordinated the practice of women artists under the conventions of 'influence.'

In Chapter One, through the part-connections I drew between *no title* 1961 and *Man Seated in a Lofty Room*, I spoke of the different ways in which artists look at paintings; not as art historians in search of an iconography but as art makers who look to passages of paint and qualities of drawing that offer possibilities and, again, give permission and impetus to their own processes of making.[37] Thus the artist's look weaves oblique connections between practices on offer. Lebrun's own practice actively sought out such

connections. In the exhibition catalogue *Rico Lebrun Drawings* the artist makes clear the way that his art making had been ethically marked by the twentieth century to impact upon the historical subject matter on which he worked; 'as events troubled the face of the earth, so did I feel now the need to trouble the plane of the picture.'[38] In 1957 this methodology led to Lebrun's reworking of *Disparate Matrimonial* c.1816–1828, by Francisco De Goya (1746–1828). 'It seems to me that,' Lebrun wrote:

> As in music, to take a theme already in existence and to write meaningful variations on this theme is one of the most challenging tasks an artist can face. Not mechanically and as a virtuoso manifestation of daring, but because there are certain themes in paint – or words, or notes – which lend themselves to fresh reading and consequent new discoveries. [39]

Lebrun's 'fresh readings' accentuate a model that Alison Rowley has since called 'artist's time.' The presence of this model in Hesse's education is perhaps evident in a group of drawings from 1958 'engendered,' Johnson noted, by the power of Da Vinci's *Deluge* series one of which Hesse 'faithfully inscribed "from Leonardo".'[40] When Rowley looked at no *title* 1960/1961 the model of artist's time enabled her to be 'reminded' of *Marat Assassinated* painted by Jacques Louis-David in 1793, (plate 14). The chronological gulf between these two artworks makes any concrete connection between them seem highly unlikely if not ludicrous. Nevertheless, made curious by Rowley's observation I proceeded to place these two works side-by-side (plate 15). The cogency of her insight immediately became clear via the rapport between these two artworks. The question as to whether this rapport had been actual, pursued by the artist, or imaginary, fabricated at the point of the viewer's encounter, necessitated some kind of pursuit of that relation. It was apparent that, perhaps even more remarkable, side-by-side I could not help but be struck by the way that the curvature of the figure, the lines that flow from it and the tilt of the head in Hesse's drawing appear in reverse, a mirror image of those present in David's painting. This observation prompted an experiment: digital reproductions of both images were reduced to the same size. Equally their opacity was minimised until sufficiently transparent to enable no *title* 1960/1961 to be transposed onto *Marat Assassinated* (plate 16). From the new image, key elements of Hesse's drawing seem to correspond to the proportions of David's painting. The quasi-rectangular shape of the letter in David's painting is the one point where these works do not correspond in

reverse. Significantly, however, the rectangle on the right of Hesse's drawing does correspond to *Marat Assassinated* in its original orientation. With Lebrun's model of 'meaningful variations' and Hesse's own decision to give in to the 'figure' in mind, I want to suggest that in the period of creative uncertainty after Yale Hesse looked to David's canonical painting as a beginning point for one of her own drawings.

These original observations were made via the medium of reproduction. Close inspection of Hesse's drawing in the flesh suggests that the reversed elements of *no title* 1960/61 are a testimony to the beginning of this work as tracing. This possibility is supported by the scored indentations on the paper; the first 'marks' made for *no title* 1960/61. The corresponding position of Hesse's rectangular letter-like form to that in David's painting could indicate the point at which Hesse's reference to his work shifted from tracing to free hand and the beginning of her 'own' drawing in earnest. Of course, if one looks for similarities between artworks or artists, nine times out of ten they can be found. I am not thinking about *stylistic* similarities, but rather artistic devices and vocabularies that work to create a certain effect or affect. The points of connection between two works produced almost two centuries apart are sufficiently compelling to make this argument entertaining if nothing else. It is a hypothesis that, since it's formulation in early 2001, has been made bold by the burgeoning discourse that considers the kind of knowledges born of practice. My method is not too far removed from David Hockney's *Secret Knowledge,* published with no little controversy in October 2001, that, as Barbara Bolt notes, devises a 'complex complex and idiosyncratic methodology that involved research through drawing to test his hunch that Ingres had in fact used a camera obscura to make some of his most detailed drawings.'[41] So I remain committed to my encounter with Hesse and David and the two interconnected questions that emerge from it; what was it that drew Eva Hesse the maker to this particular painting? And what was it that she brought to that painting that differenced it to make it her own? As Victor Moscoso said 'try to do Vermeer and you'll see how individual you are.'[42]

no title 1960/1961: Work as Symptom?

Let me begin by stating the obvious, *Marat Assassinated* is a painting of a post-death scene. Laden with pathos and affect this painting precisely contains all the ingredients needed to re-invoke the trope of 'Hesse as wound' and re-pathologise the work of this artist. If this is to be averted any relationship between these two artworks must be pursued with the utmost caution. If Eva Hesse did indeed look at this painting between

1960–1961 then she encountered with-in her own history. Whether this encounter was conscious or unconscious is open to conjecture but what can be said is that even before Hesse picked up her pencil and paper her viewing of this work had been transformative. The narrative of a death scene is central to the sense that Wagner makes of the 'window motif.' In this light, it is possible to argue, that *no title* 1960/1961 and its encounter and part connections with *Marat Assassinated* could be construed via Wagner's analysis as a *symptom* of the work of mourning played out in the artist's present. Freud outlines process of 'reality testing' crucial to the work of mourning. The cathexis of libido attached to the lost object is steadily reduced as again and again the subject is disappointed and reminded that that object no longer exists. Rather than share this 'fate' the ego gives itself over to the 'narcissistic satisfactions it derives from being alive' and resigns itself to the severance of its attachment to the object that has been 'abolished.'[43] This process still runs its course even if one has been present at the death of one's mother. The suddenness of Ruth Marcus Hesse's death and the pains taken to shield her children from it denied them the preliminary means with which to grasp some sense of the reality of that event. Ruth Marcus Hesse left the family home in 1944 and took only her most personal possessions, among other things leaving behind the furniture and dinner service that she had brought over from Germany. Eva Nathanson Hesse, the artist's stepmother, had already taken Ruth Marcus Hesse's place in the house before her death. In the day to day running of the household, therefore, there was no concrete sense or confirmation of the permanent absence of Ruth Marcus Hesse. It might be argued, therefore, that the circumstances that both preceded and followed Ruth Marcus Hesse's death inhibited the reality-testing that would signal its absolute finality. Indeed the recent revelation of the method by which Ruth Marcus Hesse took her own life seems indicative of this state of affairs. In the absence of a mnemic image then might not Hesse have had to unconsciously *construct* that scene in order to try to grasp the reality that her mother really was gone? Of all the works in Eva Hesse's oeuvre *no title* 1960/1961 would seem, at first glance, to invite the window motif as its modus operandi. But can the psychoanalytic concept of the symptom make sense of *no title* 1960/1961 or, as I suspect, does the apparent ease of its representational logic destabilise this hypothesis at a structural level? In 'Inhibitions, symptoms and anxiety,' Sigmund Freud defines a symptom as 'a sign of, and substitute for, an instinctual satisfaction which has remained in abeyance; it is a consequence of the process of repression.'[44]

In 1926 Freud ascribes 'symptom-formation' to a *defensive process* that is set in motion by anxiety brought about by the anticipation of a danger situation. Symptoms are created to 'remove the ego from a danger situation' the situation of helplessness and thus to 'minimise the amount of anxiety generated and to employ it only as a signal.'[45] What, therefore, is it to read an artwork as a symptom? By far the most lucid answer to this question can be found in *The Childhood of Art: An Interpretation of Freud's Aesthetics* written by Sarah Kofman. She explains how the results of art work can be read as a decipherable text, a enigmatic veil whose (trans)formation directly corresponds to that of the symptom. Meaning, Kofman says, 'is given only in distorted form through a chain of signifiers which always are already substitutive.' The method of the analyst or art historian is thus a process of 'unravelling' '(*Abpsinnen*)' or 'unmasking' '(*Entlarvtung*)' the 'lacunary' properties of the text.[46]

Fundamental to the formation of symptoms is the process of displacement dependent upon a 'compromise' expounded in Freud's essay on 'Screen memories' in which two psychical forces are believed to be at work:

> One of these forces takes the importance of the experience as a motive for seeking to remember it, while the other – a resistance – tries to prevent any such preference from being shown. These two opposing forces do not cancel each other out, nor does one of them (whether with or without loss to itself) overpower the other. Instead a compromise is brought about [...] what is recorded as a mnemic image is not the relevant experience itself – in this respect the resistance gets its way; what is recorded is another psychical element closely associated with the objectionable one – and in this respect the *first* principle shows its strength, the principle which endeavours to fix important impressions by establishing reproducible mnemic images. The result of the conflict is therefore, that instead of the mnemic image which would have been justified by the original event, another is produced which has been to some degree *displaced* from the former one. And since the elements of the experience which aroused objection were precisely the important ones, the substituted memory will necessarily lack those important elements and in consequence most probably strike us as trivial. It will seem incomprehensible to us because we are inclined to look for the reason for its retention in its own content, whereas in fact that retention is due to the relation holding between its own content and a different one which has been suppressed [...] The process which

we see here at work [...] conflict, repression, substitution involving a compromise – returns in all psychoneurotic symptoms and gives us the key to understanding their formation.'[47]

In light of Sarah Kofman's explanation it might not be too far off the mark to situate the methodology of previous analyses of Hesse's work within the practice of deciphering. The clarity of the window motif in the 1968–1969 drawings retroactively, to borrow from Naomi Schor, 'inflates' the details of the 1960/61 drawings with meaning; they are 'hypersemanticised details' that allow repressed material to 'evade' censorship and enter consciousness.[48] In this context, as Wagner suggests, framing may act as a substitute in the *'neighbourhood'* of repressed material because the figure of Ruth Marcus Hesse cannot be admitted by consciousness.

The archetypal scenario of mother loss that is the foundation of the theorisation of symbol formation could then explain the motive force behind this drawing. The 'fort-da' game recounted in 'Beyond the pleasure principle,' written by Sigmund Freud in 1920 lent a further dimension to the prism through which I first saw *no title* 1960/61. In his explanation of the game Freud's grandson, little Ernst, would throw objects away uttering a 'loud, long drawn out "o-o-o-o"[...] that represented the German word 'fort' [Gone].' Sigmund Freud realised that the object of this game for his grandson was to play 'gone' with his toys.[49] Through the unconscious process of metonymy the cotton reel is perceived as a substitute, a symbol of the mother.[50] Little Ernst plays 'gone' with the reel at the behest of a drive 'beyond the pleasure principle.' Satisfaction is sought via the mastery of excessive excitation by repeating the scenario in a mitigated form. This process of binding thus inhibits the flow of excitation. The Death Drive is thus formulated via the desire to restore 'stability' to the psychical apparatus; 'the instinct to return to the inanimate state.'[51] Thus *no title* 1960/1961 could be configured in this paradigm as the site in which the excitation brought about by the helplessness of loss is mastered but also sending the mother away carries out a retaliation. Thus, to cite 'Mourning and melancholia,' *no title* 1960/1961 could be read as a symptom of mourning that 'impels the ego to give up the object by declaring the object to be dead and offering the ego inducement to live.'[52]

Yet to propose a reading of *no title* 1960/1961 as a symptom-image is to immediately unravel the terms of this analysis.[53] This image does not, to borrow from Sarah Kofman, seem to be given in 'its difference, its deferral, its alteration, its transformation, as the variant of a type that is never present – an originary substitute, a translation devoid of an original

text.' [54] The circumstances of the death of Ruth Marcus Hesse and the 'image' of this drawing as they are interpreted by the dominant history of Eva Hesse as a discrete individual are too proximate to make sense of this drawing as a symptom-image. The ease with which such mirror games might be played with this image could explain its curious omission from exhibition catalogues and monographs about Eva Hesse. Might I ask, therefore, if I could make sense of *no title 1960/61* as 'work-as-symptom' in which repressed material evades censorship through subterfuge in the connections and disguises constructed with paintings like *Marat Assassinated?*[55] Possibly, but do I really want to?

I struggle with the symptom for two reasons, both of which are informed by Ettinger's theorisation of the Matrixial subjective stratum. First, a methodology of unravelling or unmasking seems to be a search for roots or even singular causes. Such a method does not or cannot pay attention to the complex weave, that is the fabric, of histories, genealogies and geographies of both making and the creative subject Hesse at work in these drawings or the role of the author in the construction in art historical texts. Secondly, 'Some-Thing, Some-Event and Some-Encounter between Sinthôme and Symptom,' published in 2000 by Ettinger, critiques the concept of symptom as that which is structured by the phallic psychoanalytic paradigm. Her cogent analysis has consequences for my attempt to theorise the psychical processes at work in a work of art made by a woman that is deemed to be about the loss of her mother. Perhaps the easiest way for me to begin to think with this complex text is to first of all put in place Sarah Kofman's 1970 analysis that posits the enigmatic character of the symptom and its details as feminine:

> If the enigma of the text is linked to a disruption, an originary repression, a castration, and the prohibition against contact, one can say that it refers to the enigma par excellence: femininity.
>
> "Throughout history people have knocked their heads against the riddle of the nature of femininity," Freud remarks in the *New Introductory Lecture* titled "Femininity." Woman is enigmatic because she lacks a penis. Freud reminds us that it is she who is weaving (*weben*) in order to veil her nudity; that is, to hide the fact that she has nothing to hide: to cover over a hole (*verdecken*). In Freud's view, the spider (Spinne) that weaves is a symbol of the phallic mother. Indeed the text is such a symbol only because it is tissue that hides, clothing that conceals, through fear of castration.[56]

Ettinger argues that the 'symptom makes sense in and by the symbolic.'[57] The phallic paradigm structures the very heart of the concepts of unconscious processes, that is the 'unconscious "structured like a language,"' deemed to be at work in symptom formation:

> Lacan's symptom, following Freudian guidelines, has two facets. One is that of the articulated message at the service of the symbolic Other. This was emphasised in his early theory. Here comes to light what the symptom 'says' to the Other where the subject cannot speak for itself. Under this aspect, if the symptom participates in creation it does so by way of the metaphor, by a displacement of whatever is already a compensation for a lack, a subjective split, a separation from one's own partial corpo-reality, and from one's own archaic mother. The second facet is that of jouissance, emphasised by Lacan in his late theory. Here comes to light the ways drives are satisfied by way of the symptom and the pleasure derived from an imaginary satisfaction of the desire of the Other. Under this aspect the symptom participates in creation by metonymy, repudiating signification by rejecting any recognition of lack.[58]

The symptom is formed within the ideological biases of the writing of Freud and Lacan. Ettinger throws light on the structure of the symptom as confined within the negatively constituted feminine foreclosed by castration/repression; the lacking hole that disrupts signification and the Death Drive's archaic trauma and foreclosed femininity.[59] In her earlier paper, 'Matrix and metramorphosis' Ettinger challenged 'the assumption that all unconscious processes are either metaphors or metonymies [that] reflect the way western culture is based on the repression of the feminine.'[60] In 'Sinthôme and Symptom' Ettinger develops this argument to make a crucial point:

> If the symbolic Other already contains all the clues for deciphering the message contained in the work-as-symptom, this work has no potentiality *to transform* this same Symbolic.[61]

If *no title* 1960/1961 were to be made sense of as a 'work-as-symptom', Ettinger's structural analysis illuminates the way in which the cut that the dominant psychoanalytic discourse posits as *the* passage to subjectivity would be iterated in such an interpretation; the 'decoding' constitutes a 'cleft' from the archaic woman becoming m/Other.[62] To read only for the

symptom of the loss of Ruth Marcus Hesse, I would suggest, confines her reappearance as that of 'the source of inspiration' as a dead figure forever unobtainable: imprisoned within the realm of a death-space, entering the Symbolic on that paradigm's terms. Moreover, if by any chance she is not dead already then the structure kills her; in order for the subject to live the object for which it mourns must be declared to be dead. To recall Ettinger 's 'Weaving A Woman Artist,' we see again that by the expulsion of the archaic becoming m/Other as a radical Other the woman artist figure is transformed into a male artist figure; creativity with-in the feminine cannot be theorised in this paradigm.

no title 1960/1961 and *no title* 1961 'Work-as-Sinthôme'

The structure of the phallic paradigm cannot be disavowed. Its violence remained a present force for Hesse through the structures imposed by her therapy and thus cannot be ruled out as a means of reading her art practice. Through the supplementary stratum proposed by Ettinger, however, I like to imagine more than one element at work in *no title* 1960/1961 that finds an echo in and weaves a 'part-connection' to *no title* 1961. And I'd like to begin to consider them by thinking with David's *Marat*. One of the most compelling effects of *no title* 1960/1961 is its flatness; its occupation and breach of the picture plane that *confront* the viewer in the encounter with it. In his essay 'Painting in the year two' T. J. Clark asserts that 'spatial and human closeness is insisted on with unique passion in David's painting.'[63] The author's analysis hinges on a close reading of the historical 'contingency' that pervades and underpins David's processes of painting and picturing. His text is far too complex and historically grounded to do any justice to it here but I think it would be instructive to draw from this author's intelligent observations about David's painting practice.

I take up Clark's text at the point at which he invites the reader 'to think about the specialness of illusionism in general' via objects that come forward of the boundary of the picture plane.[64] He notes the traditional pictorial device employed in *Saint Matthew*, 1602 by Caravaggio (1571–1610) (figure 7) in which 'an object seemingly escapes from the picture space to become part of ours.' In that painting the foot of Saint Matthew's stool leaves the space of the painting and presses upon the space of the Real. In the painting by David are two letters, one from Charlotte Corday and the other to her by Marat's own hand. Marat:

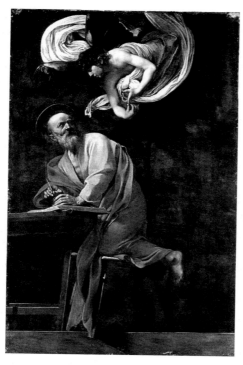

7 Michelangelo Merisi da Caravaggio, *Saint Matthew and the Angel,* Rome, Church of San Luigi dei Francesi. © Photo Scala, Florence.

Still has his pen in his hand. Another pen is ready when that one wears out. His left forearm rests on a pile of paper. And there, if we look, are his last words, put at the point in the picture where 'closeness' becomes positive cross-over from the space of illusion to the space of the Real – on top of the orange box's weather-beaten face (which already seems, by the looks of its lower reaches, hard up against the picture plane), and casting a shadow upon it.[65]

This traverse of Real and pictorial space is evoked in the writing of Rico Lebrun as he described his move away from linear drawing due to an 'impatience with the isolation of objects and figures divorced from surrounding space. Time and time again, in painting and drawing alike, I had found that figures and objects were not properly contained and extended in space.'[66] Again I am trying to think about the model that Lebrun made available to Hesse as her teacher and an artist. Clark argues that the illusion of breached reality in *Marat Assassinated* is, however,

significantly different from and more complex than the traditional uses of this device:

> The job of the painter, in his opinion, was to conjure Marat back from the realm of the dead, and make his body and attributes present. I have argued that the offer of presence on which the picture turns is a piece of writing, reaching forward into our space.[67]

The quasi-rectangle in *no title* 1960/1961, that corresponds to the position of Marat's letter in David's painting, combine with the trailing lines of the figure to force a similar breach of real space from this especially flat picture plane. In the last months of Ruth Marcus Hesse's life she wrote often to her daughters. The letters that she left behind marked her absent presence. Like the recto and verso of the same piece of paper I would like to suggest that, beside the need to grasp a point of departure that can be configured differently by the Matrixial Stratum, *no title* 1960/1961 also bears the mark of an unconscious fantasy of the *return* of Ruth Marcus Hesse.

To return to *Motherless Daughters* cited in the previous chapter, Edelman draws on the writing of Judith Mishne and Sigmund Freud's theory of the 'splitting of the ego' to show how, on the one hand, a child can accept that her mother has died, but, on the other hand, the fantasy that she will return co-exists with her acceptance of the finality of her mother's death.[68] If the mother's death occurs in later childhood, as it did in the case of Eva and Helen Hesse, the 'inner tension' between the coexisting denial and acceptance can be exacerbated 'when a girl receives minimal or false information about what she knows is a dramatic event.'[69] I want to suggest that the unconscious fantasy of return might have had a 'point of contact' in the mnemic images and affective mnemic residues of the prior returns that Ruth Marcus Hesse made after prolonged separations from her daughters.[70] Prior experience may have imprinted on the unconscious an expectation of return that was never fully annulled.

I would like to understand *no title* 1960/1961 as the result of art working caught *between* absence and presence. I begin with a sketch of Hesse's artworking via Ettinger's Matrixial theorisation of the 'relational dimension of the movement of Fort/Da' that she draws from the work of Pierre Fedida and Jean Francois Lyotard.[71] In 'An introduction to Ettinger's "Traumatic Wit(h)ness-Thing and Matrixial Co/in-habit(u)ating,"' Alison Rowley lucidly summarises the shift that Fedida and Lytoard make from Sigmund Freud's formulation of Fort/Da and its consequences for art practice:

Pierre Fedida's conception of the space or interval of the presence/absence rhythm of the repetition *as* the mother (rather, that is, than the reel alone as her substitute), where it is the rhythm of the intervals *between* presence and absence that are connected to the emergence of meaning, and Lyotard's repetition as "recurrent intermittence." Here (as Ettinger glosses) the subject finds itself in a "spasm…: where an appearance is bound up with disappearance in the one and the same movement." The artist's gesture produces a suspension of the 'spasm' and the artwork is a trace of that moment/space.[72]

The fantasy of return proposed as an active dimension within *no title* 1960/1961 grounded in mnemic-traces that post date the split between Hesse's "'emerging-self" versus *the mother/the world* can be approached in the field of the visual through the terms of Fedida's and Lyotard's theories.[73] The figure that appears/returns is never the same, marked as it is with the 'peril of disappearance in appearance.'[74] It is at this point that I wish to reintroduce the dilemma of the edge that is of paramount importance to Hesse's practice of drawing. Lippard's enthusiasm for the means by which Hesse's drawings 'longed for independence from the page' leads not only to the three-dimensional trajectory that the artist's work was to take. It also, with reference to Clark, draws attention to the journey of the mark off the paper into the space beyond. The movement of this creative gesture, at the behest of the symptom, could be construed as a performative working through of mother-loss beyond the representational confines of the window motif. The hand drawn down the page leaves the paper again and again and in so doing re-invokes a falling, a loss. Through this movement a leap from an 'existence' bound by the 'connectiveness' of materials within practice to the oblivion beyond the edge, appearance is forever bound with the peril of disappearance, is acted out again and again. This interpretation could account for some part of Hesse's artworking with respect to mother loss. Yet, I would argue, that to let this reading rest here, to view the relation of paper, mark/movement and beyond in only these terms is reductive. It centres its assumptions on the details of Ruth Marcus Hesse's death and so fails to capture, what I think, the complex weave of the means and material that Hesse negotiates in her processes of picturing. Even framing this 'leap' within the 'threshold' that Ettinger perceives within the suspension of the spasm that 'gives birth to the artwork's apparition' can only take us so far.[75] As Alison Rowley notes, 'both Fedida's and Lyotard's accounts remain ones of repetition and art as the response

of, (as the writer so movingly describes it) a 'celibate, individual psyche, split and mourning its separation.'[76] In Chapter Three, via the writing of Ruth Leys, I suggested that the theory of 'signal anxiety' facilitates an understanding of the separations that Eva Hesse endured as the stranglehold of Nazism tightened upon European Jewry. Her repeated removal from her parents and those dear to her enact historically specific echoes of 'primeval traumatic experience.' It is also possible to suggest the moments of return and togetherness were also historically specific events, woven with-in the fabric of the imprinted psychic traces that are the residue of encounters between I and non-I at 'the level of the *Thing* "before" it is emptied and erased by the symbolic Other, before the Other was empowered via the Phallus.'[77] Ettinger proposes that:

> Archaic prenatal affected encounter inaugurate a psychic co-formative space of transformation and differentiation in the link to a woman's corpo-real Thing. A feminine difference opens a unique time-and-space and is originary; it imprints psychic traces. The affected encounter generates and engraves passages and means of transport through which traces of joint events, shared trauma, and transmitted jouissance as well as reciprocal phantasmatic imprints are channelled.[78]

To attempt to construct *no title 1960/61* and *no title* 1961 as encounters with-in the Matrixial subjective stratum demands an awareness of an experience of those works in the 'here and now' that is not only framed but made possible by the prism of Ettinger 's writing. For as Rowley states Ettinger's matrixial prism opens the potential of art making as 'acts of co-making (co-poiesis)' in which subjectivities may be '"co-engendered" in a metramorphic relationship of distance in proximity between several *Is* and unknown *non Is*.'[79] In this paradigm neither the artist nor the writer has the last word on art. As Chapter One makes clear this book is plotted via several encounters with these artworks, through the Matrixially conceived possibility of 'inter-psychic trans-individual relations between the artist and the viewer with/through the artwork.'[80] The viewer does not come *after* the artist to passively imbibe sensation expressed by the artist/work. In a metramorphic non-symmetrical transferential borderlinking 'the artist and the viewer transform the artwork and are transformed by it in different times and places and to different degrees, in different-yet-connected ways. Each viewer gives the artwork new life, and what escapes the capture of the artist's awareness is the kernel of this process. Matrixial affects allow and accompany seeing with-in/through a work of art.'[81]

This new trans-subjective vision of Hesse's artworking emerges via Ettinger's critique of the 'creative artefact produced as a symptom' that can only make sense 'in and by the Symbolic.' In what I will abbreviate to 'Sinthôme and Symptom' Ettinger suggests that 'such a making-sense in and by the Symbolic, creative as it may be cannot be a measure of art.'[82] She takes up the work of Lyotard again to argue for the symptom as a reflection that constructs an illusory representation of traumatic events in a language to which it does not belong, bound by the laws of Symbolic and thus denuded of its transformative potential. Artworking, in a Matrixial sense, is 'traumatic' because it does something 'more' 'it makes the viewer's individual psychic limits more fragile':

> Matrixial artworking is tracing a spasm in/of/for the Other. It is therefore a co-spasming. If a *symbolic-imaginary articulation* of trauma and jouissance, a work of art is a *transport-station* of trauma-and-jouissance, where co-spasming is inseparable from sense-creating. This is a transport-station that more than a location in time and place is rather a dynamic space that allows for certain occasions for occurrence and for encounter, which will become the realisation of *borderlinking* and *borderspacing in yet another Matrixial space* by way of the encounter it initiates. The transport is expected in this station, and it is possible, but the transport-station does not promise that passage of remnants of trauma will actually take place in it; it only supplies the space for an occasion of encounter. [83]

To map Hesse's art practice within a formal vocabulary of sexual difference predicated on lack and a psychoanalytic structure that renders her mourning pathological is, to refer back to Lisa Tickner, to confine the artist's signifying potential to the codes 'already available in the psychoanalytic and cultural public language that was to hand.' The transportation of trauma is thus redirected, diverted to a sphere that shields the listener/viewer's fragile psychic limits where its 'symbologenic' potential is foreclosed. I am reminded here of the Hesse-Nemser transcript: '*if you* wanted to know why people have stayed away from you. *certain critics.* That is probably one of the reasons. You scare them. Sure you scare them. You know you talking like this is terribly frightening.' If I am going to say something new about *no title* 1960/1961 and *no title* 1961, that does not once more envelope Hesse within the psychosis of forecluded femininity her art needs to *work* as or create a supplementary sense-making that intervenes in the Symbolic in a way that is not deemed pathological. Such a reading must

be sustained by Ettinger's development of the Lacanian concept of the *sinthôme*.

In his introductory dictionary, Dylan Evans summarises Jacques Lacan's 1975-1976 seminar entitled the *Sinthôme* via the psychoanalyst's reading of James Joyce writing. This 'extended sinthôme' is:

> A fourth term whose addition to the Borromean knot of R [Real] S [Symbolic] I [Imaginary] allows the subject to cohere. Faced in his childhood by the radical non-function/absence (carence) of the Name-of-the-Father, Joyce managed to avoid psychosis by deploying his art as *suppléance*, as a supplementary cord in the subjective knot.[84]

One year prior to Lacan's seminar Julia Kristeva proposed that the signifying practices of the Joycean text bore the mark of what she named the semiotic Chora. In Joyce the rhythms of his revolutionary poetic language emerge from the 'pre' of the Symbolic to disrupt its linguistic structures.[85] The source of these interruptions is the 'organising principles' of the Chora on the 'path of destruction, aggressivity and death.'[86] Figured as the return of the repressed for the 'subject-in-process' the appearance of this archaic feminine can only mark the echo of a pathogenic force sublimated in the creative act. The laws of the symbolic not only mediate the post-oedipal encounters of mother and child but also retroactively colour archaic traces within its own prism. The mutual inflection of the Real, Imaginary and Symbolic via Lacan's use of the Borromean Knot is thus a radical psychoanalytic departure because it destabilises the rigid division of 'pre' and 'post.' For Lacan the Real, Symbolic and the Imaginary are woven together in a braid where 'interior and exterior may revert and be turned inside-out like a glove.'[87]

> If bodily traces of jouissance and of trauma (in the Real), their representations (in the Imaginary), and their significance (in the Symbolic) are woven in a braid around and within each psychic event, the knowledge of the Real marks the Symbolic with its sense and its thinking, no less than the Symbolic gives meaning to the Real via signification and concepts. We may therefore suppose a resonating significance between no-meaning and sign, intermingled with the fourth term that knits the three registers together: the sinthôme [...]
>
> If the Real, and not only the Symbolic, harbours already some knowledge, a feminine difference based on a bodily specificity does

not only occur as the always too early for knowledge and always too late for access, but can also make sense inside a sinthômatic weaving. When the Real, the Imaginary and the Symbolic intertwine around a feminine encounter according to the parameters of the Real, the knot "goes wrong," it appears as a "slip of the knot." The phallus fails, or this feminine-other-thinking fails the phallic order, and an-other sense, based in my view, on *originary* feminine difference, emerges. Is not this failure of the phallus in/by the feminine that Lacan calls a "sinthôme"?[88]

Inadvertently, Lacan opens the field for Ettinger's theorisation of the presence of the archaic feminine as the weave of the sinthôme. The diminution of the 'pre' and the 'post' in the weave of the knot lends itself to the non-linearity of psychic time. The lived experience of mother-child relationships may thus modify and be modified by revivals and revisions of the archaic feminine. Lacan's concept of the sinthôme, as a failure of the phallic order that yet 'allows the Symbolic, Imaginary, and the Real to go on holding together' is posited as the same for men and women; it 'represents what is a "woman" to a "man" as the phallically structured subject.'[89] The question that Ettinger poses through the prism of the Matrixial subjective stratum, that does not define 'woman' only by the failure of the phallic system, is 'what becomes a "woman" for a woman.'[90] How, after all, can a mother be a radical Other for a daughter whose look or voice bears her trace-in-difference? Rather than the precipitation of psychosis when women come into contact with their own difference Ettinger proposes that a woman's relation to a another woman must be that of a 'border-Other';

> She cannot be radically absent in subjectivity but *deabsent* or *abpresent*, and so her difference also locates a state of *preabsence*. However, in the no-place of the Thing in art, Lacan identifies via the sinthôme something of the dimension of the revelation of the "absent" feminine and of her "impossible" sexual rapport. I see in the sinthôme possibilities of sublimation in/from foreclosed aspects of the feminine, on condition that we give this notion a twist in light of the Matrixial difference in order to discover by what a "woman" can become in-difference for a woman.[91]

Ettinger's text theorises a '*Matrixial sinthôme*' through which it becomes possible to speak of a 'special kind of artworking' that traverses the 'art of

writing and the problematic to speak mainly on painting and the problematics of visual art.'[92]

> The work of art as Sinthôme [...] is a unique response that contains the enigma it co-responds to and that brings it about, an enigma that resonates a lacuna of quite a different status in the symbolic: it doesn't correspond to lacks defined by the phallic mechanism of castration but to whatever is not yet there, to what is yet to come, to what resists the Symbolic and to the mysterious and fascinating territory of that which is not yet even unconscious or to what is impossible to cognition.[93]

To return to the artwork of Eva Hesse I want to suggest that *no title* 1960/1961 and *no title* 1961, to paraphrase Ettinger, came to life and exercised effects as works of art on a level that, at least to begin with, exceeded the significance of the Symbolic; 'a level equivalent to the level of events that burst out on the Real.[94] What difference does my encounter in the twenty-first century make to *no title* 1960/1961? Ettinger's theorisation of the Matrixial sinthôme enables me to propose this drawing as a unique weaving that 'channels anew trauma(s) and jouissance(s) coming from the world and from non-I(s) that get linked to the artist who,' in the heat of practice, 'bifurcates, disperses, and rejoins their imprint-traces anew but in difference.[95] In this theoretical framework the making of Hesse's unnamed drawing can be mapped as a necessary passage to/creation of a space of/for sustaining affective residues that 'shed light on' on the archaic encounter of I [Eva Hesse] and non-I [Ruth Marcus Hesse] that 'hold together' both as a foundation for and are differenced by later encounters in togetherness, return and departure. These residues might be awakened further by and 'co-respond' to the unconscious affinity with the creative 'individual' Ruth Marcus Hesse.[96] I want to suggest that making operates as a part-connection to Ruth Marcus Hesse on different but connected levels. It is this affect of encounter that 'destabilises the visual' scene of *no title* 1960/1961 for a different non-I, in this case myself, to give another sense to the 'appearance bound up with the peril of disappearance.' This passage/residue exists beside the reality-testing that seeks to confirm the death of Ruth Marcus Hesse. It is an artwork that captures beauty and horror. *No title* 1960/1961 is not posited as a repository of suffering made by the artist as 'patient.'[97] Rather, as Ettinger writes:

The artwork is both the illness and the remedy enacting otherwise impossible rapports and realising the passage onto the screen of Vision of psychic traces from what is *otherwise* either absence (irredeemably lost) or potentially (not-yet-born).[98]

This feminine Matrixial sinthôme, whose appearance and processes are captured in the production of *no title* 1960/1961 and *no title* 1961, I suggest, allow Eva Hesse to go on holding together. If we read between the threads of the sinthôme's braid, woven in the feminine via creative protocols to sustain the subject, the interplay of partial-subjectivities with-in histories may engender a new sense of the world at the moment that these drawings were produced.

Once again this broader and yet more particular analysis of Hesse's practice refuses the compromise of the therapeutic expression of what may otherwise be deemed 'personal and the relative.' The Matrixial sinthôme forges a part-connection with-in Hesse's creative practice from which a cross over from *no title* 1960/1961 to *no title* 1961 may begin and Hesse's turn to the figure in 1960 may be considered. Chapter One paid attention to the central vertical and horizontal lines that occur two thirds of the way up the page of both unnamed drawings as a formal rapport. This part-connection can be found in other drawings from 1961 but *no title* 1960/1961 would appear to be one of if not the earliest instances. I would like to propose this formation of horizontal and vertical lines as a imprinted-trace of the encounter theorised with-in *no title* 1960/1961 that appears anew and keeps on 'holding together', as a 'habit' or a 'learned movement' in other works. In *The Phenomenology of Perception* Maurice Merleau-Ponty tells us that:

A movement is learned *when the body has understood it,* that it, when it has incorporated it into its 'world,' and to move one's body is to aim at things through it; it is to allow oneself to respond to their call, which is made upon it independently of any representation. Motility, then, is not, as it were, a handmaid of consciousness, transporting the body to that point in space of which we have formed a representation beforehand. In order that we may be able to move our body towards an object, the object must first exist for it, our body must not belong to the realm of the in-itself.[99]

This repetition, made by the body of a creative speaking subject with-in history, never returns in the same way. Something is calling on it. Some

pressure from the external world, I would suggest, evokes this need to 'hold together.' There is a binding of excitation at work, but Ettinger does not let such a 'tendency toward stability' cause a landslide into the realm of Death, dragging the feminine with it.[100] Rather it could be framed within the 'struggle with the angel of non-life-coming-into-life by a differential co-spasming within the Other and the world in the linkage to the feminine.'[101]

Picturing America 1959–1961

It is only now that the specificities of Eva Hesse's histories to which so much of this book is dedicated come to the foreground of my enquiry. For the events of the artist's past, the loss of her mother and the trauma of the Shoah, make sense of, and are revised by the potency of her present between 1959 and 1961. It is the mechanisms of deferred action that mark Hesse's early career with an intense pressure derived from the 'world' and its 'non-Is' hitherto unregistered. It is this pressure to which the Matrixial sinthôme in Hesse's artworking responds. In the texts written for Hesse, her position as a 'white' American woman de-politicised her life in the United States in the 1950s and 1960s. America appears as a neutral sphere that has no implications for art practice other than in the form of those creative communities in which Hesse worked and their participation in the Art for Peace Auctions of the 1960s. I would insist, as *Jews and Feminism: The Ambivalent Search For Home*, written by Laura Levitt does however, that it is 'crucial to theorise out of the contingent places we call home. Location matters.'[102] It is possible to sketch, for that is all I can do at the present time, another picture of life in the United States in those years. To gesture towards a complex intersection between the 'history' Hesse carried with her, the still unfolding events of the Holocaust that breached the 'safety' in which she now lived, and contemporary racial oppression in America.

I begin with Hesse's reading, as a teenager, of *The Diary of Anne Frank*, first published in the United States in 1952. *The Diary of Anne Frank* remained a potent cultural force throughout the 1950s in America; the Pulitzer Prize winning play opened on Broadway in October 1955 while George Stevens' Oscar winning film followed in 1959. Victor Moscoso cited Frank's text as the most important book Hesse had read at the time of their acquaintance in the 1950s and early 1960s. Hesse 'identified' with Anne Frank, he said, and the fate that, had the Hesses not been wealthy, would have been hers.[103] *The Diary of Anne Frank* seems is a document that, as Marion Kaplan notes, puts in place the '"little picture" of Jewish daily life [in order] to cast new light on the big picture' of the persecution of European Jewry.[104] The Frank Family moved from Frankfurt to

Amsterdam in 1933 to escape Nazi doctrine after Hitler came to power. Anne Frank writes:

> My father, the most adorable father I've ever seen, didn't marry my mother until he was thirty-six and she was twenty-five. My sister Margot was born in Frankfurt am Main in Germany in 1926. I was born on June 12, 1929. I lived in Frankfurt until I was four. Because we're Jewish, my father immigrated to Holland in 1933, when he became the Managing Director of the Dutch Opekta Company, which manufactures products used in making jam. My mother, Edith Holländer Frank, went with him to |Holland in September, while Margot and I were sent to Aachen to stay with our grandmother. Margot went to Holland in December, and I followed in February, when I was plunked down on the table as a birthday present for Margot. [...] Our lives were not without anxiety, since our relatives in Germany were suffering under Hitler's anti-Jewish laws. After the pogroms in 1938 my two uncles (my mother's brothers) fled Germany, finding safe refuge in North America. My elderly grandmother came to live with us. She was seventy-three years old at the time.[105]

Eva and Helen Hesse were sent to The Hague in December 1938 and were reunited with their parents after a struggle with the authorities in February 1939. German forces invaded the Netherlands on 10 May 1940, as Frank notes: 'the good times were [now] few and far between.' When the German's arrived the 'trouble started for the Jews':

> Our freedom was severely restricted by a series of anti-Jewish decrees: Jews were required to wear a yellow star; Jews were required to turn in their bicycles; Jews were forbidden to use streetcars; Jews were forbidden to ride in cars, even their own; Jews were required to do their shopping between 3 and 5 pm.; Jews were required to frequent only Jewish-owned barbershops and beauty parlours; Jews were forbidden to be out on the streets between 8pm. And 6am.; Jews were forbidden to attend theatres, movies or any other forms of entertainment; Jews were forbidden to use swimming pools, tennis courts, hockey fields or any other athletic fields; Jews were forbidden to go rowing; Jews were forbidden to take part in any form of athletic activity in public; Jews were forbidden to sit in their gardens or those of their friends after 8pm.; Jews were required to attend Jewish

schools, etc. You couldn't do this and you couldn't do that, but life went on. Jacque always said to me, "I don't dare do anything anymore, 'cause I'm afraid it's not allowed."[106]

The Frank Family hid in the secret-annex from 5 July 1942 until it was stormed and its occupants arrested on 4 August 1944 after which they had been first transported to Westerbork, and then to Auschwitz. Anne and Margot Frank were transported to Bergen-Belsen in October 1944 where they died of typhus in March 1945. The geography and fate of the Frank family could not but fail to evoke the sad loss of Hesse's own aunt and uncle who had secured the safety of her and her sister. Nathan and Martha Hesse lived in Amsterdam until their deportation to and death in Bergen-Belsen. Had they not aided her escape, Hesse's own life too, like Anne Frank's, would have been rendered only in documentation; in the tagebücher compiled by her mother and father. And like that of Anne Frank that documentation, for Hesse, would have been forever marked by the arrested potential of a creative subject. Rather than rest on the assimilative properties of 'identification' Hesse's responses to Anne Frank's writing opens a co-spasm of encounter that reveals the fragility of Hesse's psychic limits in the presence of the trauma of a partial-Other in the context of Ha Shoah. The loss of Frank's potential creativity is mourned in Hesse's self-awareness of a surviving creative potential: the realisation of creative acts, their appearance, is for Hesse, potentially bound up with the peril of disappearance. Again and again the hand of the artist falls from the page into oblivion.

Hesse discussed the diary of Anne Frank with Moscoso who, unaware of the tagebücher kept for Hesse and her sister, attributed Hesse's own diary writing to the importance of Anne Frank. Hesse mentions *The Diary of Anne Frank* in her own journal in the late 1950s. Speaking at the Eva Hesse Symposium at San Francisco MOMA in 2003 Helen Molesworth suggested that Hesse's diaries had been written from a position of a certain kind of narcissism that anticipates their reading. Her potency of her insight, with Frank's diary in mind, is clear. In the context of Frank's journal Hesse's own writing, as Moscoso intuited, acquires a greater psychic significance than the working through of Dunkell's therapy sessions or the anticipation of a wider readership. The journey of the hand across each page offers a statement of affirmation; I am still here, in the work of today I prepare for tomorrow. If Hesse did indeed desire a reader for her diary its production may thus index the need for a future witness to the creative force and energy of a lived life; the need to mark the surface of

the world's consciousness and in so doing to fulfil a potential saved from oblivion.

With this in mind it is instructive to return to the larger representation of Anne Frank in American 1950s popular culture. Judith E. Doneson cogently reads the end of the film of *The Diary of Anne Frank* within the framework of the House Committee on Un-American Activities that sought to root out communism in the 1950s through a system of informers. The Frank's secret-annex was discovered because of an informer. 'In that sense,' Doneson writes:

> *The Diary of Anne Frank* can be seen as a comment on racial discrimination against blacks and on the danger posed by the informer, its message is a liberal one. At the same time, the universalisation and Americanisation of its content fit into the prevailing mood – one that was simultaneously repressive and liberal – a time when being 'different' suggested either the wrong political attitude or the wrong social attitude.[107]

The author situates the universalisation of the Jewish elements within the film of *The Diary of Anne Frank* within the 'reflection of the general atmosphere in America, that encouraged the levelling of specific differences among its people.'[108] Anne Frank, she continues:

> As a symbol of the Holocaust becomes as well the affirmation of post-Holocaust *civilisation* because only she (and other victims) can forgive and hence allow man to live without guilt. Viewed in this way, the film is about universal forgiveness for the failure of a fundamental Christian belief.[109]

Frances Goodrich and Albert Hackett's screenplay of *The Diary of Anne Frank* begins with the return of Otto Frank to the secret-annex on a lorry from an unnamed concentration camp, to replay the events that led to that return through his reading of Anne Frank's diary; the mark of her present absence. It closes as German soldiers smash their way through the book case that has hidden the Frank family and those who hid with them for two years. Dust fills the secret-annex. Silent and motionless Edith, Margot and Otto Frank and Fritz Pfeffer (Dr. Dussel in the diary) become ghosts on film as the scene fades into a lightly clouded sky with circling sea-gulls that call as Anne Frank, played by Millie Perkins, is heard to say a quote from the diary; 'in spite of everything I still believe that people are really good at

heart.' The film's 'ambiguous' ending, Doneson writes, 'seeks to alleviate, via Anne Frank's forgiveness and hope, the guilt of the gentile world.'[110] Thus the film cannot end in Bergen-Belsen concentration camp as Anne and Margot Frank die of typhus. In 1959 the viewer is left to imagine Anne Frank's death rather than be confronted with its horror. This Post-Holocaust 'civilisation' might be taken as something of an oxymoron in view of the colonial structure that continued to underpin American liberalism after World War Two.[111]

The chronicles of the German Jewish community of Washington Heights, in which Eva Hesse grew up, clearly outline the contradictory nature of American life. In *We Were So Beloved*, Louis Kampf tells Manfred Kirchheimer of an incident in Washington Heights in 1942–43 when he was fourteen years old. His mother had sent him on an errand to a local delicatessen where a 'black man' had bought something 'but told the clerk that he had been short-changed by a nickel':

> The clerk insisted that no such thing had happened, and the black man said, "look, I need that nickel, it's important to me, I'm poor." Whereupon the guy said, "Ok, have your nickel."
> At that moment, two cops came storming in with brass knuckles on their hands and they just beat this guy into a living pulp. I mean there was blood all over the floor. They then dragged him out, bounced him up and down on the floor as they were dragging him, and his face had disappeared, it simply wasn't there anymore. And I stood wondering, isn't somebody going to say something about this? Isn't somebody going to say, "Stop, this is bad?"
> Well, nobody did, and I couldn't believe it. I went home and I told my parents. And they simply shrugged their shoulders. I guess maybe they assumed I was making it up since things like that don't happen in America, they only happen on the "other side."[112]

In *Post War America: 1945–1971*, Howard Zinn states that in 1954 the American Supreme Court ruled that racial segregation in schools was unconstitutional.[113] Six years after this declaration in November 1960 *Life Magazine* reported on the racist hatred that still impeded desegregation in the South of the country. The article describes the 'absurdity' of 12,666 white pupils prevented or refusing to attend schools because four '6-year-old Negro girls enrolled in two previously all white New Orleans schools.' The four girls had had to undergo seventeen tests to certify their 'mental, moral, psychological, economic and social fitness.' This first attempt to

enforce the 'minimal school integration plan' set off 'a state-wide rampage of hate and hysteria.' Segregationists 'passed a resolution praising mother's who turned out to jeer the Negro children or pulled their own out of school.'[114] This was far from an isolated incident. A fifteen year old girl remembers how in 1957 she was terrorised by a white mob as she approached the Little Rock Central High School in Arkansas. The crowd:

> Moved closer and closer. Somebody started yelling, "Lynch her! Lynch her!" I tried to see a friendly face somewhere in the mob – someone who maybe would help. I looked into the face of an old woman, it seemed a kind face, but when I looked at her again, she spat on me. Then I looked down the block and saw a bench at the bus stop. I though, "if I can only get there I will be safe..." when I finally got there, I don't think I could have gone another step. I sat down and the mob crowded up and began shouting all over again. Someone hollered, "Drag her over to this tree!" Let's take care of the nigger." Just then a white man sat down beside me, put his arm around me and patted my shoulder.[115]

In site of the political rhetoric of totalitarianism that distinguished the civil rights policy of America from the atrocities of the Second World War, how would it be possible to read *The Diary of Anne Frank* in America in the 1950s and not be dismayed and frightened by the parallels between segregationism and the oppression of Jews in Europe before the Final Solution? White supremacy was generous with its racial hatred; both 'Jews and blacks' conspired to take over the world.[116] In *International Politics and Civil Rights Policies in the United States 1941–1960* Azza Salama Layton writes that after World War Two the Allies could no longer endorse racist ideology after the genocide of the Third Reich:

> The rationalisation of racist oppression expressed in the United States and the racist ideology displayed in the South led civil rights advocates [in America] and abroad to compare racism in the United States to Hitlerism in Nazi Germany. These activists were able to point out the hypocrisy involved in fighting a world war against an enemy who preached a master race ideology, while supporting racial segregation and ideas of white supremacy at home. As Thomas Borstelmann put it, "explicit racial domination had lost its legitimacy in the gas chambers of the German Holocaust."[117]

Early in 1960 the Final Solution once again came under the scrutiny of
the American media but this time, unlike the film of Frank's diary, the
horror of those events was presented in an unmitigated form. On 12 May
1960 Israeli intelligence officers had captured SS Lieutenant Colonel Adolf
Otto Eichmann, who had been living in Buenos Aires under the assumed
name of Ricardo Klement. Eichmann had disappeared after the war.
Initially in charge of the forced emigration of Jews from German occupied
territory, once the borders were closed to Jews in 1941, he co-ordinated the
transportation of Jews to concentration camps and death marches as part
of Das Endlosung. In 1960 sensationalist tabloid-style biographies about
Eichmann began to appear and continued into 1961 and beyond. One such
example is *Eichmann The Man and His Crimes*, written by Comer Clarke in
1960. The book jacket described the author as a British correspondent who
had spent two years in Austria and Germany researching the book with
access to secret Nazi documents. Under chapter headings such as
'Streamlined Death and Wild Sex Orgies' he rebuts Eichmann's defence
that he was simply a 'cog in the wheel' of Nazi bureaucracy, proclaiming
that Eichmann was no 'desk-bound bureaucrat. He wanted to see his grisly
butchery through to the end.'[118]

On 28 November 1960, printed perhaps not unknowingly in the same
edition that featured '"Integration" in the South,' 'the editors of *Life*
present[ed] a major historical document: Adolf Eichmann tells his own
damning story. Part I: 'I transported them... to the butcher.' [119] The
following week, 2 December 1960, carried the concluding part of his
memoirs 'To sum it all up I regret nothing.' A Dutch-Nazi reporter had
recorded the manuscript of the Life Magazine article in a series of
interviews in Buenos Aries by the name of Wilhelm Sassen in 1955. When
Eichmann had let slip his real identity in a later interview Sassen contacted
the Time-Life correspondent in Buenos Aries about publishing the
manuscript. The memoirs were accompanied by documentary photographs
and serialised over two weeks, published on 28 November and 2 December
with extracts carried in *The New York Times* on the same days. On 2
December 1960 the newspaper of the German Jewish community in
Washington Heights, the *Aufbau*, where Eva Hesse's father still lived, also
responded to the *Life* publication. In contrast to *Eichmann The Man and His
Crimes* it is Eichmann's own disengaged matter-of-fact account of his part
played in the murder of so many that is so distressing to the reader. His
actions dealt only with units for transportation:

We managed after a struggle to get the deportations going. Trainloads of Jews were soon leaving from France and Holland. It was not for nothing that I made so many trips to Paris and The Hague. My interest here was only in the number of transport trains I had to provide. Whether they were bank directors or mental cases, the people who were loaded on these trains meant nothing to me. It was really none of my business.[120]

Eichmann asserted he was 'no anti-Semite': he had just been doing a job:

The area of my section's authority was those Jewish Matters within the competence of the Gestapo. Originally this centred on the problems of finding out whether a person was a Gentile or a Jew. If he turned out to be a Jew, we were the administrative authority which deprived him of his German citizenship and confiscated his property. Ultimately we declared him the enemy of the state. After the one-time German *Fuhrer* gave the order for the physical annihilation of the Jews, our duties shifted. We supervised Gestapo seizures of German Jews and the trains that took them to their final destination. And throughout German-occupied Europe my advisers from my office saw to it that the local governments turned their Jewish citizens over to the German Reich. For all this, of course, I will answer. I was not asleep during the war years.[121]

Eichmann offers an unconvincing separation of his 'political opposition' to the 'Jews because they were stealing the breath of life from us' and the anti-Semitic doctrine of National Socialism.[122] His testimony continues:

It was in the latter part of 1941 that I saw some of the first preparations for annihilating the Jews. General Heydrich ordered me to visit Maidanek, a Polish village near Lublin. A German police captain there showed me how they had managed to build airtight chambers disguised as ordinary Polish farmer's huts, seal them hermetically, then inject the exhaust gas from a Russian U-boat motor. I remember it all very exactly because I never thought that anything like that would be possible, technically speaking.
Not long afterward Heydrich had me carry an order to Major General Odilo Globonick, SS commander of the Lublin district. I cannot remember whether Heydrich gave me the actual message or whether I

had to draw it up. It ordered Globocnik to start liquidating a quarter million Polish Jews [...]

Muller had heard that Jews were being shot near Minsk, and he wanted a report. I went there and showed my orders to the local SS commander. "That's a fine coincidence, " he said. "Tomorrow 5,000 of them getting theirs."

When I rode out the next morning, they had already started, so I could see only the finish. Although I was wearing a leather coat which reached almost to my ankles, it was very cold. I watched the last group of Jews undress, down to their shirts. They walked the last 100 or 200 yards – they were not driven – then they jumped into the pit. It was impressive to see them all jumping into the pit without offering any resistance whatsoever. Then the men of the squad banged away into the pit with their rifles and machine pistols.

Why did that scene linger so long in my memory? Perhaps because I had children myself. And there were children in the pit. I saw a woman hold a child of a year or two into the air, pleading. At that moment all I wanted to say was, "Don't shoot, hand over the child..." Then the child was hit.

I was so close that later I found bits of brains splatters on my long leather coat. My driver helped me remove them. Then we returned to Berlin.[123]

The [Zionists] found ghettos a wonderful device for accustoming Jews to community living. Dr. Epstein from Berlin once said to me that Jewry was grateful for the chance I gave it to learn community life at the ghetto I founded at Theresienstadt, 40 miles from Prague.[124]

I remember clearly the first time [Hoess] guided me around [Auschwitz]. He showed me everything, and at the end he took me to a grave where the corpses of the gassed Jews lay piled on a strong iron grill. Hoess' men poured some inflammable liquid over them and set them on fire. The flesh stewed like stew meat. The sight made such an impression on that today, after a dozen, years I can still see that mountain of corpses in front of me.[125]

Fifty years after it was printed nothing prepares the reader for incommensurability of Eichmann's testimony. Reading it is an act fraught with the incomprehensibility of the events in which he participated and witnessed. How would Hesse have encountered such knowledge? There is no evidence that that Eva Hesse read the *Life* or *New York Times* articles or

any of the Eichmann literature. It might be more prudent to say that, to invoke Sigmund Freud again, perhaps she was 'more concerned with *not* thinking of it.'[126] There can be no doubt, however, that Eichmann's testimony ensured that camps, pits, shootings, gassing and the names of Theresienstadt, where Eva Hesse's Omi was murdered, and Bergen-Belsen, where Nathan and Martha Hesse met their deaths, were once again culturally present in post-war America. To receive restitution money for her Grandparents' business three months before the man who, as he put it, 'transported them to the butcher' and 'regretted nothing', was captured cannot be a circumstance that is overlooked.

My encounter with of *no title* 1961 brings to it and weaves it within this historical moment. Eva Hesse's diaries in November and December 1960 and January 1961 bear the trace of what seems to be an intense trauma.

November 16:

I must be totally engrossed in my own work, it is only thing that is permanent, matures and is lasting.

December 12:

I am in a bad way. Things have come to pass, so disturbing that the shell made of iron which has refused to be set ajar – will-must – at last open… Problems of my past, of my past sickness, of the scars of my early beginnings. The deeprooted insecurity which has made any relationship, meaningful one, impossible.

December 27:

Only painting can now see me though and I must see it through. It is totally interdependent with my entire being. It is [the] source of my goals, ambitions, satisfactions and frustrations. It is what I have found through which I can express my self, my growth – and channel my development. It affords the problems which I can think through, form ideas which I can work with and arrive at a statement. Within its scope, I can develop strength and conviction.

In January 1961 Eva Hesse was hospitalised for a 'lingering cold.' On 6 January she wrote:

Felt constant guilt in hospital, not really sick, no right to be taken care of. Unconsciously I feel 1 needed to be a child again, taken care of; totally dependent.[127]

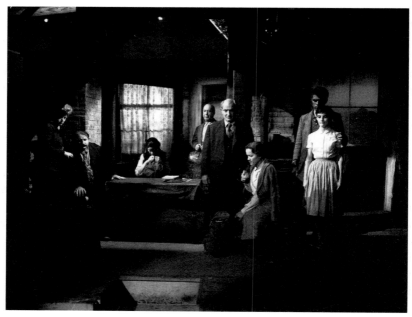

8 Film Still, *The Diary of Anne Frank,* 1959, directed by George Stevens, Twentieth Century Fox-Film Corporation.

I want to suggest that in 1959 the increased visibility of the figure of Anne Frank, due to the play and the film had heightened Eva Hesse's consciousness of her own survival. William Hesse must have begun legal action to gain restitution for his daughters against the loss of their grandparents' business in 1958 or 1959. This re-cognised loss of Erna and Moritz Marcus might therefore have lent further significance to this heightened sense of survival. Eichmann supplied a new graphic knowledge of the deaths of Jewish people in Europe that via the processes of nachträglichkeit revived and revised the loss of those who were dear to Eva Hesse in her early childhood and the meaning of that survival. This cognisance was augmented moreover by the continued racial persecution that gripped America to construct that nation not as a place of permanent safety but to borrow from Laura Levitt 'just a place on the map that seemed to be safe *for a while*.'[128]

Throughout the film of *The Diary of Anne Frank* the relation between the occupants of the secret annex and the promise of freedom in the outside world and its tyranny that presses upon them is figured through the windows of the secret-annex, (figure 8). The kitchen room window and the landing window, veiled by net curtains allow pale light to filter cast the

interior in semi darkness. Light falls on the attic floor from a square window devoid of glass, covered with tarpaulin to keep out the rain and snow. For those who had seen the film of *The Diary of Anne Frank*, we might also suggest that the world that lay beyond the windows of the secret-annex was refashioned to breach and menace that space and the ending of the film with hitherto ungrasped traumatic meaning. With the light of those windows there also shone darkness.

How does this weave of history, horror and loss contribute to a reading of *no title* 1961 as a work-as-sinthôme? Not an expression of a response, but the response itself that 'channels anew trauma(s) and jouissance(s) coming from the world and from non-I(s) that get linked to the artist who bifurcates, disperses, and rejoins their imprint-traces anew but in difference'?[129] The making of *no title* 1961 began with the horizontal and vertical lines that draw a part-connection with *no title* 1961. With-in *no title* 1960/1961 those marks emerged into a figure. If I imagine those marks as the emerging form of the figure in *no title* 1961 then it is possible to suggest that this figure was arrested in its becoming. It is dramatically obscured in *no title* 1961 like in no other drawing made at this time. This effacement might have been a response to Hesse's dissatisfaction with that form's aesthetic. If so, why didn't the artist just throw the drawing away? It was after all a piece of paper six by four in. To lay black over the top might suggest the emergence of something that had been just too much. That act could therefore be theorised as an unconscious repression of that figure and its affect.

Black is not neutral, however, but I would argue a colour charged with Rico Lebrun's own attempt to address the death of the human figure in the genocide of European Jewry.[130] 'I love black, but the best blacks' Lebrun writes:

> With the most meaning can be done only in full light of day – noontime blacks. Dark vision demands its own clarity. I am never agitated in executing forms, but travel rather as if the terrain of the paper was land-mined. When this journey is completed, a drawing is born.[131]

For me the colour and affect registers something of the architecture of the secret-annex in *The Diary of Anne Frank*. As I discovered in my encounter with *no title* 1961 in the flesh the repression of that colour is not complete the lines the lay beneath it bestowed a deeper intensity to it, something does not obey this repression/castration. We might say it hails

from a 'psychic world' where the phallic structure that regulates the castration of repression is just 'irrelevant.'[132]

I can't help thinking that not only did Eva Hesse not throw this drawing away but she also signed it. She signed only a few drawings from this period but *no title* 1961 is the only one that is signed with her initials. Of course she could not have signed it on the black it would not have been legible. And so she signed it in a space that could be called a window. To place her initials there, rather than choosing not to sign it at all could be an indication of her satisfaction with the work. These marks, I wish to argue, act as an unconscious register of survival. An act that on the one hand shouts 'I made this' whilst on the other 'restores to the visible' a trace of the mnemic-image of the windows of the synagogue that Eva Hesse attended as a child in New York on which the names of those who had perished were written. In a double move the act of affirmation thus inscribes Hesse within the space of the lost, in what might, all too easily, have been. Could it be that via, what Ettinger calls, a 'feminine weaving' the drawing holds is together and reinvents these traumas?

Notes on 'Artist' and Artworking as Notions of Home

To read extracts from Eva Hesse's diary in 1960 is to observe that art making and writing about art making and its possibilities, at times knowingly sometimes unknowingly, seemed to be a resource of from which she drew strength.[133]

> February:
> Terrible excited! …Have been working hard! Feel good about work (my own). Stronger than ever before. sold another painting… received $1,300 from grandparents' stay in concentration camp. I will make use of the money wisely. I will go on my own soon, paint and get a show and be in a gallery. It is all going so much quicker than I anticipated. God I feel strong.[134]
> April 24:
> Fight to be a painter. Fight to be healthy. Fight to be strong.
> November 2:
> I have moved so rapidly. I feel so alive, I am almost too anxious for every moment, and every future moment. Optimism and hope – even confidence. It cannot be defined as happiness, very rarely am I actually happy. But that bugs me less, maybe I care not whether or not I am happy.
> November 7:

I cannot do what I wanted and I feel real frustration. I want to plunge further into all the paintings, achieve a depth I might yet be incapable of handling.

November 19:

One thing has changed of late, or developed – I want to feel I can and should sell paintings. What I am doing now might not be a peak of matured painting, but they are good, follow and idea – and they are the works of a young, active developing painter. Maybe the change lies in that I feel myself to be a painter, which is evidently recent.[135]

Within these passages I sense several threads that weave together a fabric of making and the identity of the artist within the terms of survival. First, these extracts from 1960 put me in mind of the comment Hesse made to Cindy Nemser in 1970. After Hesse awoke from an operation she remembered thinking that 'I didn't have to be an artist to justify my existence and I could live without it.'[136] What makes a person feel they *have* to justify their existence? It is possible to situate such a belief within the ethic of the Washington Heights community and the losses incurred by the Hesse family. As Alice Oppenheimer said, 'It is not right that people as good as ourselves had to die in concentration camps, and we were saved. We weren't better. So we have to do something.'[137] Within this framework art making may be understood as a defence against reawakened loss and a confrontation with Eva Hesse's own mortality.

In *The Broken Connection: On Death and the Continuity of Life*, Robert Jay Lifton explicates the human subject's *need* for a sense of immortality. He argues that the subject's requirement for a sense of 'life-continuity' is not an 'irrational' denial of death. Rather, the author argues, 'an appropriate symbolisation of our biological and historical connectedness.'[138] His text characterises five general modes of immortality, two of which are the 'biological' and the 'creative':

The biological mode of immortality is epitomised by family continuity, living on through – psychologically speaking, in one's sons and daughters and their sons and daughters, with imagery of an endless chain of biological attachment.[139]

The 'unlimited technological violence,' to borrow from *The Broken Connection*, of the Holocaust ripped through and demonstrated the fragility of the Hesse's family's sense of biological continuity. That text extends this sense of immortality into a 'biosocial' mode to encompass not only the

family but also the larger notion of one's people or nation.[140] Thus the
annihilation of European Jewry magnified this fragility. The transience of
life was then further illuminated by the death of Ruth Marcus Hesse. Hesse
had to find some means of establishing a sense of permanence for her own
life.

Anne Wagner notes the writing of André Malraux among Eva Hesse's
sources for her identification with the myth of the artist.[141] Lifton employs
the writing of Malraux to define the third mode of 'symbolic immortality,'
'creativity'.

> The artist has long been recognised as participating in this [creative]
> mode of immortality – either in his prophetic function or, as Malraux
> believed, through 'the continuity of artistic creation' by means of
> which 'not the individual, but man, human continuity reveals itself,' so
> that 'more than any other activity, art escapes death.'[142]

To believe in self-expression that imprints the self upon art is thus to
believe in the preservation of the self in that capture. But to insist on the
act of making, again through the phenomenonlogy of painting proposed by
Maurice Merleau-Ponty, I would say is to insist upon the 'body that sees
itself seeing; [that] touches itself touching; [that] is visible and sensitive for
itself.'[143] Thus the artwork co-emerges with and confirms this vision of the
creative artist in the same movement that is bound by a sense of
'connectiveness' with the materials. Thus art making is more than the
residue of one who has survived; the existential fact of living and breathing,
sitting down and making art. Rather, as I would wish to think about it, the
act of creativity, the desire to evoke state of fusion between artist and
materials in the intense 'heat of practice' is also about *feeling alive*, the search
for life in defiance of oblivion.[144]

The value of the 'identity of the artist' again exceeds the boundaries of a
label for difference. For it creates the place in which to feel alive. In that
sense I would like to think of the 'identity' of the artist as, to borrow from
Laura Levitt, 'a kind of home.'[145] With this in mind I would like return to
the last passage of 'An Autobiographical Sketch of a Nobody,' that I cited
in Chapter Four:

> There was a relatively short period of contentment or adjustment
> while said person was fully engrossed in his small world of paints and
> canvas. Artistically speaking this is the greater world, the world
> outside and above daily routine, enveloped into colours and forms

selectively chosen by the mater. He too is not alone in that world but find companionship among the 'select' few who also find their worlds among the smell of pigments and turpentine. Some are fortunate enough to maintain and sustain themselves a lifetime within this small isolated society. They although expected to be the spokesmen, the communicators of reality to the majority, never do they claim this role for themselves. They do attempt communication among themselves but secretly deny and reject the world of their compatriots.[146]

The process of studying to be an artist could be described as a process of acculturation that was both part of being/becoming American and thus distancing Hesse from Germany but also being/becoming different, that in the same move witnessed those beginnings and their legacy. It is via a Matrixial alliance, I would argue that this creativity does not declare the subject to be 'alive' at the cost of declaring those left behind, via a phallic cut, to be dead.

In 'Remembering Eva Hesse', published in the exhibition catalogue *In the Lineage of Eva Hesse*, Mel Bochner, who met Eva Hesse between 1965–1966, recalled that the artist 'was more as a model of what an artist could be. She had a very romantic vision of the artist's life. Walking into her studio was like stepping back in time into a kind of pre-WWII idea of Bohemia.'[147] I think that the timelessness of Eva Hesse's studio that Mel Bochner emphasises is highly significant. Her place of making was quite literally, because it included her apartment, and figuratively as part of her identity, the home she had constructed for herself. Dorothy Levitt Beskind record of Hesse's apartment and its connecting studio reveals that, in between the windows of Hesse's living space that featured so prominently in her drawings of that time, stood what Helen Hesse Charash identified as their mother's trunk that she had brought with her when they left Germany in 1938–39. The trunk is wooden about six feet wide, three and a half feet tall and deep. It is decorated with painted panels that featured the story of the Pied Piper of Hameln. Once again I would like invoke 'Eye and mind' by Maurice Merleau-Ponty:

> Things are an annex or prolongation of [the body]; they are incrusted in its flesh, they are parts of its full definition; the world is made of the very stuff of the body.[148]

Ruth Marcus Hesse's trunk wove her own absence within the place of making. Yet the trace of her life in that object, however, might also be

argued in a similar way to *no title* 1960/1961 to be that which held together
and made bearable in that space the loss of Hesse's aunts and uncles, her
grandparents and their business, the trauma of immigration and the exile
from a life in Germany before Hitler. I would not wish to confine this
'prolongation of the self' to Hesse's refusal to relinquish what should be
confined to the past.[149] Rather these artefacts make visible the fractures of
present absences. Practice, to recall Bolt, may be comprehended as the
relation between artist, the complex of practical knowledges, the materials
of practice and the novel situation of the body in the studio. Within that
studio and the acts of making that took place in it lay the mnemic traces of
a creative Ruth Marcus Hesse whose 'aliveness' was bound up in what her
daughter called her 'connectiveness' with materials on the other side of
oblivion. The home that Eva Hesse constructed with-in practice as identity
was thus via a 'feminine weaving' co-emergent and co-respondent with the
traces of these fractures via the peril of disappearance in appearance; the
artist 'co-emerging with the work and by the work' as 'doctor-and-
patient.'[150]

IN PLACE OF A CONCLUSION

"If no place is mine, where is my true place?"
"I am alive; I have to be somewhere," said a sage.
"Perhaps," he was told, "your true place is in the absence of all place?"
"The place, precisely, of this unacceptable absence?"
And the sage said: "Inhabitable infinite. For my race, a haven of grace."
Edmond Jabès, *A Foreigner Carrying in the Crook of His Arm a Tiny Book*

The final pages of this book open via a return to the writing of Edmond Jabès to underline the processes of displacement inscribed both within Hesse's practice of art making and this book's practice of writing. In Chapter One Jabès enabled me to set the scene for a reading against the grain of the hitherto instrumental value of Hesse's 'early' drawing. As he noted there is 'no thought without desire' and my decision to think about only two drawings signalled a journey that wilfully set out on the wrong foot: from the space of the studio and the oblique logic of artist's time. Once begun my wanderings within and between these two unnamed drawings questioned the very fabric of the discourse written for this artist. Displaced from their role as beautiful agents of coherence *no title 1960/61* and *no title 1961* departed from the taxonomies of the already known into the realm of the possible. Relieved from the structure of the oeuvre and the series these works posed questions about the historical specificity of art's production. Once their situation and the ethical imperatives particular to Hesse had been revealed these drawings could then return to make new sense. Yet this book does not claim that Hesse's drawings are *about* the Holocaust. Rather to argue for the production of *no title 1960/61* and *no title 1961* as contingent upon the creative transformation of particular cultural and historical events is to question *what it is to make art after the Holocaust?*

Implicit within the act of 'situating' Hesse's practice is, therefore, a process of destabilising it. To argue, as I have done, for the generative, symbologenic condition of Hesse's practice is to mark its sense making not

as Knowledge but as the production of questions. For if, as Ettinger argues, the logic of the Symbolic is exceeded by the workings of the Real and the Imaginary in art then the viewer's ability to make sense of that work is always a process of construction. It is thus the continued acts of construction, of wandering that take place within moments of trans-subjective encounter between viewers, artworks and artists that are privileged here. Ettinger's propositions bring me back to Jabès, to whom her work has been very much indebted. Jabès had been among the founding theorist of the deferral of meaning but its value for this project exceeds a last minute doffing of the postmodern cap. Rather his work holds the key to the double inscription of displacement at the point of the production and reception of Hesse's practice. For within his writing the displacement of Knowledge by an act of wandering with-in and between texts traces the Jewish Diaspora in a sublimated form. Writing about the work of Jabès, Richard Stamelman tells us that the question is:

> An errant word, expressive of exile, rupture, movement and uncertainty. The question follows a quest not for an answer but for a deeper and more difficult questions, although Jabès does acknowledge that "sometimes a question is the flash of an answer."[1]

For Jabès 'the writer is the foreigner par excellence. Denied domicile everywhere, he takes refuge in the book, from which the word will evict him. Every new book is his temporary salvation.'[2] To situate practice within the context of the Diaspora enables the wandering time of art making to further cohere as a construction of place, experienced by Hesse's as a 'salvation' of 'connectiveness.' In the expanded field of the 'moment of production', the space of the studio, its objects and modes of making co-operated to place Hess(e) as 'artist' subject; a name for difference and the means to sustain that difference within the context of an artistic community and its histories. Thus with each act of making, studio visit, and exhibition a temporary space of belonging was created. This 'answer' to Hesse's sense of displacement did not provide its resolution however. The still uncertain years of post-war America evoked the temporal logic of deferred action to demand that this constructed identity of 'artist' be tested and continually reaffirmed. Just as for Jabès the 'word' may 'hurt' but also 'strangely comfort,' for Hesse it is possible to configure the production of art as that which worked its raw materials in ways that could be traumatic and sustaining at different times and even at the same time.[3]

No title (1960/1961) and *no title* (1961) thus made sense of specific moments of revived and revised geographical displacement and genealogical trauma to hold together what could not be known. The form taken by those creative, material, performative negotiations and transformations, in ink, gouache and pencil on paper, are implicit to their content; they could not be thought in any other way. Likewise, without the mutual inflection of the practice of art and the practice of writing about art this book could not have been produced. I want to end with one final suggestion therefore; that the insights born of practice, generated by the work of Eva Hesse, are not limited to her practice alone. While I hope this text will elicit new questions for Hesse scholarship, I also hope it has emphasised the potential of making, when listened to, to evoke new questions about art and impact upon the methodologies that govern its histories.

NOTES

Series Preface

1 Mieke Bal, *Travelling Concepts in the Humanities: A Rough Guide* (Toronto, 2002).
2 Mieke Bal, *The Point of Theory: Practices of Cultural Analysis* (Amsterdam, 1994); Mieke Bal, *The Practice of Cultural Analysis: Exposing Interdisciplinary Interpretation* (Stanford, 1999).
3 Bal: *The Practice of Cultural Analysis* p.1.

Introduction

1 See Anne Middleton Wagner's significant corrective to this trope in *Three Artists (Three Women): Modernism and the Art of Hesse, Krasner and O'Keeffe* (Berkley, 1996).
2 I refer readers to the exhibition catalogue *Eva Hesse Drawing* (New York, 2006) edited by Catherine de Zegher whose essays present an excellent survey of the artist's drawing practice.
3 Morris, Robert 'Some notes on the phenomenology of making', *ArtForum*, April 1970, pp.62-66.
4 Bal, Mieke, 'Reading art?' in Griselda Pollock ed., *Geographies in the Visual Arts: Feminist Readings* (London, 1996), p.39.
5 Ettinger, Bracha, 'Some-thing, some-event and some-encounter between sinthôme and symptom,' in Catherine De Zegher ed., *The Drawing Centre's Drawing Papers 7. The Prinzhorn Collection: Traces Upon the Wunderblock* (Los Angeles, 2000). This paper was presented by Ettinger at a seminar on Aesthetics and Psychoanalysis at the University of Leeds, 10 May 2002, p.61.
6 Lowenstein, Steven M., *Frankfurt on the Hudson: The German-Jewish community of Washington Heights, 1933–1983* (Detroit, 1989)
7 Wagner: *Three Artists (Three Women)*, p.217.
8 The author in conversation with the artist's friend Victor Moscoso, 2 August 2002.
9 See Massumi, Brian ed,. *Bracha L. Ettinger The Matrixial Borderspace (Theory Out of Bounds)* (Minnesota, 2006).
10 Ettinger, Bracha, 'Matrix and metramorphosis', pp.176–208 in *Differences: A Journal of Feminist Cultural Studies*, 4/3, 1992, p.202. 'To begin with I would like to present two pictures: first that of the foetus in its mother's womb with some kind of awareness of *I* and unknown *not-I(s)*, nether rejected nor assimilated; secondly, that of the mother carrying a baby in her womb with a similar awareness of *I* and *not-I(s)*' p.178. 'The first level of feminine difficulties, in the pre-Oedipal stage, is followed by the classical Oedipal complex, when according to Freud, a girl discovers through observation of the other that she lacks *the* sex organ. Her phallic inferiority is thus based on the

visual and relates to biology. For both Freud and Lacan, there is only one symbol for sex, the Phallus, and it is at the disposal of both sexes. The masculine sex organ is thus the only representative for sexual difference; we may or may not have it. The woman does not have *the* unique sex organ. Paradoxically, difference has only one signifier…'p.185. In her later paper *Weaving A Woman Artist With-in the Matrixial Encounter-event*, given at University of Leeds 4–5 July 2000, Bracha Lichtenberg Ettinger elaborates Freud's belief in the necessity to deny the womb for the sake of the 'neutral (male) child's narcissism', pp.2–3.

11 See Heath, Stephen, 'Difference', *Screen*, Autumn 1978, 19/3, pp.53–54.

12 Caruth, Cathy, *Trauma: Explorations in Memory* (Baltimore, 1995) p.142.

13 Felman, Shoshana, *What Does A Woman Want: Writing and Sexual Difference* (Baltimore, 1993), p.17. 'I cannot write my story (I am mot in possession of my own autobiography), but I can read it in the Other.'

14 Massumi, Brian, 'Painting: The voice of the grain', in *Bracha Lichtenberg Ettinger: Artworking 1985–1999* (Brussels and Ludion, 2000), p.12.

Skipping Text, Reading Pictures

1 Jabès, Edmond *From the Book to the Book: An Edmond Jabès Reader*, translated by Rosemary Waldrop (Hanover and London, 1991), p.5.

2 I am indebted to Fred Orton for his insight into the concept of "beginnings" that recognises the necessarily eclectic mode of early art production as opposed to the notion of influence.

3 Lippard, Lucy R., *Eva Hesse* (New York, [1973] 1976).

4 Elizabeth Frank, *Eva Hesse: Gouaches 1960–1961* (New York and Paris, 1992).

5 In 'Drawing in Eva Hesse's Work' Ellen H. Johnson references the importance of Rembrandt's 'expressionism' among other 'northern' European artists for the work of Eva Hesse. 'In that respect, Eva Hesse was and remained German…' Ellen H. *Eva Hesse: A Retrospective of the Drawings* (Oberlin, 1982), pp.9–10.

6 Alison Rowley in 'An introduction to Bracha Ettinger's "Traumatic wit(h)ness-thing and matrixial co/in-habit(u)ating', in *Parallax*, 1999, 5/1, p.83. Since the writing of this text Ettinger has published her own reading of the work of Hesse in the essay 'Gaze-and-touching the not enough mother', in C. De Zegher ed., *Eva Hesse Drawing* (New Haven and New York, 2006), pp.183–213.

7 Lippard: *Eva Hesse*, p.15. My emphasis.

8 Frank: 'Notes toward a previous life', third, fourth and fifth page of unpaginated text. My emphasis.

9 EH-CN transcript, unpaginated section. The transcript has been microfilmed by the Archives of American Art with the Eva Hesse papers that were loaned from the Dudley Peter Allen Memorial Gallery, Oberlin College, Oberlin, Ohio in 1978. There are three sections of the transcript, an unpaginated section (25 pages), a Biography section (27 pages) and Side B (42 pages). The text of the transcript is typed text with pencil notations and corrections. In each citation the pencil notations appear in italics.

10 EH-CN transcript, Side B, p.10.

11 Benjamin, Walter, *Illuminations* (London, 1973, 1940), p.214.

12 EH-CN transcript, Side B pp.7–8, p.40 and p.32 my emphasis in bold.

13 This film excerpt can currently be view at evahesse.com

14 Lippard: *Eva Hesse*, p.58.

15 Petherbridge, Deanna, *The Primacy of Drawing: An Artist's View* (London, 1991), p.12.

16 Christie, J R. R. and Orton, F., 'Writing on a text of a life', in F. Orton and G. Pollock, *Avant-Gardes and Partisans Re-Viewed* (Manchester University Press, 1996), p.296. This attitude can be also clearly seen in Rosenberg, Harold, 'The American Action Painters', Art News, 51/8 December 1952, pp. 22–23, 48–50, reprinted in H. Rosenberg, *The Tradition of the New* (New York, 1994), pp.28–30.

17 Christie and Orton: 'Writing on a text of a life', p.296.

18 Christie and Orton: 'Writing on a text of a life', p.297.

19 Christie and Orton: 'Writing on a text of a life', p.300

20 Ibid.

21 Christie and Orton: 'Writing on a text of a life', p.303.

22 Ibid.

23 Nye, David E., The Invented Self: An Anti-biography, from documents of Thomas Edison (Odense, 1983), pp.16–17.

24 Nye: *The Invented Self*, p.17.

25 Nye: *The Invented Self*, p.18–19.

26 Nye: *The Invented Self*, 'Each work of history, rather than being a realistic narrative account of a knowable set of previous events, is a restructuring of earlier codifications of these events, and one might add, at times buttressed by material not previously used'. p.19.

27 Derrida, Jacques, *Writing and Difference* (Chicago, 1978), pp.295–296.

28 Merleau-Ponty, Maurice, 'Eye and mind', originally published as 'L'Oeil and L'Espirt', *Art de France* 1, no.1 (January 1961), Reprinted in G. A. Johnson (ed), *The Merleau-Ponty Aesthetics Reader: Philosophy and Painting* (Illinois, 1993), p.131.

29 Merleau-Ponty : 'Eye and mind', p.121.

30 Merleau-Ponty: 'Eye and mind', pp124-.127.

31 See Ettinger, Bracha 'Matrixial gaze and screen: other than phallic, Merleau-Ponty and the late Lacan', in '*ps*', 2/1, Summer 1999.

32 Ettinger, Bracha: *Matrix Halal(a)-Lapsus: Notes On Painting* (Oxford, 1993), p.22 and p.38.

33 Ettinger, Bracha: 'Matrix and metramorphosis', pp.176–208 in *Differences: A Journal of Feminist Cultural Studies*, 4/3, 1992.

34 Massumi: 'Painting: the voice of the grain', p.12–13.

35 Massumi: 'Painting: the voice of the grain', p.12.

36 Massumi: 'Painting: the voice of the grain', p.13.

37 EH-CN transcript, Side B. p.32

38 Benjamin, Illuminations, p.214.

39 The 'window' was first outlined as a motif in 'Drawing in Eva Hesse's work', by Ellen H. Johnson and again in Johnson, 'Order and chaos: from the diaries of Eva Hesse', *Art in America*, Summer, pp.110–118. Wagner: *Three Artists*, pp.252–273.

Addendum: Hemispheres and Loose Ends

1 Rosenberg, Harold, *The Act and The Actor: Making the Self* (New York, 1972), p. xxi.

2 Tate Modern, 11 October 2000. In the catalogue raisonné *Eva Hesse Sculpture* (New York, 1989), Bill Barrette describes *Addendum* as a shift away from the 'breast-and-cord motif' present in *Ishtar*,' p.130.

3 Chave, Anna C., 'Eva Hesse: "a girl being a sculpture,"' in H. A. Cooper (ed), *Eva Hesse: A Retrospective* (New Haven, 1992), pp.99–117.

4 See Sussman, Elisabeth, and Wasserman, Fred (eds), *Eva Hesse:* Sculpture (New Haven, 2006).

5 Bering, Dietz, *The Sigma of Names: Antisemitism in German Daily Life, 1812–1933*, trans., Neville Plaice (Cambridge, 1992) first published as *Der Name als Stigma* (1987), pp. 27–29, 32.

6 William Smith Wilson in conversation with the author 5 May 2002. The first version of this chapter was published as 'Don't look back: reading for the ellipses in the discourse of Eva Hess[e],' *Third Text*, issue 57, winter 2001–02. See also Wilson, W. S., 'Eva Hesse: on the threshold of illusions,' in De Zegher, Catherine (ed), *Inside the Visible: An Elliptical Traverse of Twentieth Century Art in/of and from the Feminine* (Kortrijk,1996).

7 Victor Moscoso in conversation with the author 2 August 2002.

8 Victor Moscoso in conversation with the author 2 August 2002.

9 Rosenberg, Harold, 'Character change and the drama,' in *The Symposium*, 3/3, July 1932, 348–69, reprinted in Rosenberg: *The Tradition of The New*.

10 Rosenberg: 'Character Change,' p.139.

11 Kleeblatt, Norman (ed), *Too Jewish? Challenging Traditional Identities* (New York, 1996), p.3.

12 Beck, Evelyn Torton, 'The politics of Jewish invisibility,' in *NWSA Journal*, 1/1, 1988, p.98. Here the concept of 'Jewishness' is drawn from Beck: ' "Jew" describes a variety of factors (including but not limited to the intersection of religious identification, historical, cultural, ethical, moral, and linguistic affinities),' p.101.

13 Santner, Eric L., 'History beyond the pleasure principle: some thoughts on the representation of trauma', in Saul Friedländer (ed), *Probing the Limits of Representation* (Massachusetts and London, 1992), p.144.

14 See Soussloff, Catherine M. (ed), *Jewish Identity in Modern Art History* (University of California Press, Berkley, Los Angeles and London, 1999).

15 Kaplan, Alice Yaeger, 'On language memoir,' in Angelika Bammer (ed), *Displacements: Cultural Identities in Question* (Bloomington and Indianapolis, 1994), p.60.

16 Nemser, Cindy, *Art Talk* (New York and London, [1975] 1995), contains the more extensive, though still abridged version of the transcript. (1975), p.1.

17 Lippard, Lucy, 'Eva Hesse: the circle,' *Art in America*, 59, No.3 (May–June 1971) reprinted in Lippard, *From the Center: Feminist Essays on Art* (New York, 1976).

18 Elisabeth Sussman, 'Lippard's project,' Eva Hesse Symposium, Museum Wiesbaden, 2002.

19 Lippard, Lucy R, 'What is female imagery?' *Ms.*, 3, No.11, 1973, reprinted in Lippard: *From the Center*.

20 Wagner: p.236.

21 Nemser: *Artforum,* p.59.

22 Nemser: *Art Talk*, p.1.

23 EH-CN transcript: p.1.

24 Nemser: *Artforum,* p.59.

25 Lippard: 'The circle,' p.155.

26 Lippard, Lucy, 'Changing since changing,' in Lippard, *From The Center: Feminist Essays on Art*, p.4.

27 Lippard: 'Changing since changing,' p.4.

28 Lippard: 'The circle,' p.155–156.

29 Lippard: *Eva Hesse*, p.199–200. In 'Serial art, systems, solipsism,' *Arts Magazine*, Summer 1967, reprinted in Gregory Battock, *Minimal Art: A Critical Anthology* (New York 1968) Mel Bochner defines systematic art as that which explored the possibilities of making on the basis of an 'application of rigorous governing logics rather than on personal decision making.' P.100.

30 Robinson, Hilary, 'Border crossings: womanliness, body, representation,' in Deepwell, Katy (ed), *New Feminist Art Criticism* (Manchester, 1995), p.140.

31 See the classic text Parker, Roszika and Pollock, Griselda, *Old Mistresses: Women, Art and Ideology* (London, 1981) and Pollock's *Differencing the Canon: Feminist Desire and the Writing of Art's Histories* (London, 1999)

32 Lippard: 'Female imagery,' p.86.

33 Lippard: *Eva Hesse*, p.6 and 24–25.

34 Lippard: *Eva Hesse*, p.205.

35 Lippard: 'Female imagery,' p.89.

36 Lippard: 'Changing since changing,' p.4–5.

37 Lippard: 'The circle,' p.161.

38 Lippard: 'The circle,' p.156. In *Eva Hesse*, Lippard develops this point; see note 35.

39 Lippard: *Eva Hesse*, p.25–26.

40 Lippard: *Eva Hesse*, p.156.

41 Lippard: *Eva Hesse*, p.17.

42 Wagner, *Three Artists*, p.225.

43 Lippard: *Eva Hesse*, p.205–206

44 Lippard: 'Female imagery,' p.81.

45 Lippard: 'The circle,' p. 156. This formal vocabulary was iterated in *Eva Hesse*, p.15. In 'What is female imagery?' Lippard feared, however, that her definition of female sexual imagery might be too prescriptive, she therefore adds: 'But that's too specific. It's more interesting to think about fragments, that imply a certain anti-logical, anti-linear approach also common to many women's work.' p.86.

46 Lippard: 'Female imagery,' P.86.

47 Fer, Briony, *On Abstract Art* (London and New Haven, 1997), p.113.

48 Bochner: (1968). p.100–101.

49 Lippard: 'Female imagery,' p.88.

50 Lippard: *Eva Hesse*, p.96.

51 Fer analyses Lippard's curatorial intention behind the 1966 exhibition *Eccentric Abstraction*, to identify the critic's search for 'something else' that underlay the formal structure of Minimalism that acts as a precursor to her reading of *Addendum*. *On Abstract Art*, p.113.

52 Lippard: 'The circle,' p.158–159. In *Eva Hesse*, Lucy Lippard published her first thoughts on the subject: 'Hesse used the grid as both a prison and a safeguard against letting an obsessive process or excessive sensitivity run away with her. Women frequently use rectilinear frameworks to contain organic shapes or mysterious rites of autobiographical content. An integral part of Eva Hesse's work is that certain pleasure in providing oneself against perfection, or subverting the order that runs the outside world by action in one's inside world, in despoiling neat edges and angles

with 'home made' or natural procedures that relate back to one's own body, one's own personal experience.'p.209.

53 Lippard: *Eva Hesse*, p.192.

54 The dialogical relationship between Hesse and her materials is taken up in de Zegher, Catherine, 'Drawing as Binding/Bandage/Bondage Or Eva Hesse Caught in the Triangle of Process/Content/Materiality,' in De Zegher, Catherine (ed), *Eva Hesse Drawing* (New York, 2006), pp. 59–115.

55 Mel Bochner, 'Remembering Eva Hesse,' in Elizabeth Hess and Mel Bochner, *In the Lineage of Eva Hesse* (Connecticut, 1994), p.11.

56 Lippard: *Eva Hesse*, p.209.

57 Lippard: *Eva Hesse*, p.209.

58 EH–CN transcript: Side B, p.7.

59 Lippard: *Eva Hesse*, p.5.

60 Rosenberg, Harold, 'Missing persons', Sunday New York Times, 1963, reprinted in Rosenberg: *Act and The Actor*.

61 During her studies at Yale Eva Hesse made notes from Picasso's writings from Robert Goldwater and Marco Treves' *Artists On Art from the XIV to the XX Century* (New York, 1945).

62 Rosenberg, Harold, 'The American Action Painters', *Art News,* 51/8 December 1952, p. 22–23, 48–50, reprinted in Rosenberg: *The Tradition of the New*, p.28–30.

63 EH–CN transcript: Side B, p.13. 'CN: Do you think in your work that the spectator has to bring more to it? Do you think it makes him more aware of himself?
EH: Well he might not have to – it depends more of himself [if he] drops some of his preconceptions of esthetics and art and what is right and wrong and correct and just not bring to it something else. Let me bring to him something else but that something else is what I am more concerned with.'

64 Hesse, Eva: 'On significant form,' unpublished essay, p.1. Eva Hesse notes that 'there has been a failure to recognise that the transformation of reality, by means of the artistic perception, is the essential result of all artistic endeavour. The value of transformation was minimised, often ignored, or considered a flaw in the capabilities of the artist as a craftsman and technician.'

65 Hesse: 'On significant form,' p.4.

66 Linda Norden names Hesse's work as a 'pre-feminist' practice in 'Getting to "Ick": To know what one is not', in Helen Cooper ed., *Eva Hesse: A Retrospective* (New Haven and London, 1992).

67 Lippard: *Eva Hesse*, p.206.

68 Pollock, Griselda, 'The politics of theory: generations and geographies in feminist theory and the histories of art's histories,' in Griselda Pollock ed., *Generations and Geographies in the Visual Arts: Feminist Readings* (London, 1996), p.4–5.

69 Tickner, Lisa, 'The body politic: female sexuality and women artists since 1970,' in *Art History,* June 1978, 1/2 pp.236–49, reprinted in R. Parker and G. Pollock, *Framing Feminism: Art and the Women's Movement 1970–1985* (London, 1987), p.265.

70 Tickner: 'Body politic,' p.266.

71 Mulvey, Laura, 'Visual pleasure in narrative cinema,' *Screen*, 16/3, 1975 reprinted in Mulvey, *Visual Pleasure and Narrative Cinema* (London, 1989), P.14.

72 Mulvey, *Visual Pleasure*, p.21.

73 Tickner: 'Body politic,' p.268.

74 Robinson: 'Border crossings,' p.138.

75 Pollock, 'Politics of theory,' p.75. Lack is one such signifier. See Ettinger: 'Matrix and Metramorphosis.'

76 Ettinger: 'Matrix and metramorphosis,' p.180.

77 Lippard: 'Female imagery,' p.88.

78 Tickner: 'Body politic,' p.266.

79 Cixous, Hélène, 'La rire de la méduse' (*L'arc*, 1975), p.36–54. Translated and reprinted as 'The laugh of the medusa,' in E. Marks and I. de Courtivron (eds), *New French Feminisms: An Anthology* (Brighton, 1981), p.250.

80 Pollock, Griselda, 'Inscriptions in the feminine,' in C. de Zegher (ed), *Inside the Visible: An Elliptical Traverse of 20th Century Art, in, of and from the feminine* (Massachusetts and London, 1996), p.75. Écriture was inevitably caught, as Pollock points out, within the language of the symbolic.

81 Pollock: 'Inscriptions in the feminine,' p.73.

82 Felman, Shoshana, *What Does A Woman Want? Reading and Sexual Difference* (Baltimore and London, 1993) p.13.

83 Felman: *What Does A Woman Want*, p.14.

84 Felman, Shoshana and Laub, Dori, *Testimony: Crises of Witnessing in Literature, Psychoanalysis, and History* (New York and London, 1992)

85 Felman: *What Does A Woman Want*, p.16.

86 Felman: *What Does A Woman Want*, p.13.

87 Nemser: *Art Talk*, p.178. In *Eva Hesse*, Lucy Lippard quotes Eva Hesse saying that Albers 'style minded position limited ... paradoxically weak but strong,' p.10.

88 De Zegher: *Eva Hesse Drawing*, pp. 59–115.

89 Goldstein, Carl, 'Teaching Modernism: what Albers learned at the Bauhaus and taught to Rauschenberg, Noland and Hesse', *Art in America*, liv/4, December 1979. More recently the significance of Alber's teaching has been taken up by Jeffrey Saletnik in Josef Albers, Eva 'Hesse, and the Imperative of Teaching,' (2007) http://www.tate.org.uk/research/tateresearch/tatepapers/07spring/saletnik.htm.

90 Goldstein: 'Teaching Modernism,' p.115.

91 Wagner: p.214–220.

92 Pollock, Griselda: *Differencing the Canon*, p.13 and 14.

93 Ettinger, Bracha, *Weaving a woman artist with-in the matrixial encounter-event*, unpublished paper given at University of Leeds 4th– 5th July 2000, p.4.

94 Lippard: *Eva Hesse*, p.20.

95 Johnson: *Eva Hesse*, p.14.

96 Swenson, Kirsten, 'Machines and Marriage Eva Hesse and Tom Doyle in Germany, 1964–65,' *Art in America*, June–July, 2006, http://findarticles.com/p/articles/mi_m1248/is_6_94/ai_n16533177/pg_1

97 Lippard: *Eva Hesse*, p.24.

98 Eva Hesse diary, circa May 1964, Cooper: *Eva Hesse: A Retrospective*, p. 27–28.

99 Wasserman 'Building a childhood memory,' p.101.

100 Helen Molesworth, Eva Hesse Symposium, San Francisco Museum of Modern Art, May 2002.

101 De Zegher has also developed this train of thought in 'Drawing as binding,' p.99.

102 Rosenberg, Harold 'From play acting to self,' first published in *The New Yorker* (1968) reprinted in Rosenberg: *Act and The Actor*, p.126–127.

103 Rosenberg: 'From play acting to self,' p.127.

104 EH-CN transcript: side a p.8–9.

105 Rosenberg: 'Character change and the drama,' p.146–147.

106 Rosenberg: 'Character change and the drama,' p.138.

107 Rosenberg: 'Character change and the drama,' p.152, quoted in Fred Orton, 'Action, revolution, and painting', *The Oxford Art Journal,* 14/2, 1991, p.9.

108 Rosenberg: 'Character change and the drama,' p.152.

109 Martin, Biddy, and Mohanty, Chandra Talpade, 'Feminist politics: what's home got to do with it?' in Teresa De Lauretis *Feminist Studies/ Critical Studies* (London, 1986), p.194.

110 LaCapra, Dominick, *Representing the Holocaust: History, Theory, Trauma* (Ithaca and London, 1994), p.20–21.

111 Jabès and Ettinger: 'A threshold where we are afraid,' p.9.

112 Felman and Laub: *Testimony*, p.xiv-xv.

113 Ettinger: 'Matrix and metramorphosis,' p.196.

114 Ettinger: 'Matrix and metramorphosis,' for Lacan the Symbolic is a 'chain of linguistic signifiers.' 'Since signifiers and their laws, located in the Other, are saturated with laws of society and established within history, what we believe to be our private unconscious and our private subjectivity are structured by society and history through language. In other words we are not masters of our subjectivity. Human beings are "born" into language and that language gives meaning to their perceptions: imaginary meaning through the signified, and symbolic meaning through signifiers and their interconnections.' p.182.

115 Ettinger: 'Matrix and metramorphosis,' p.200–201.

116 Ettinger: 'Matrix and metramorphosis,' p.200.

117 'This means that the sexual difference of women is partly measured by/against the Phallus and is partly what the Phallus and the Symbolic cannot account for (*séminar XX* 1968) [..] my proposition related to this opening in the theory. I will not replace the Phallus by the Matrix; neither will I propose it as its opposite. Matrix is a slight shift from the Phallus, a supplementary symbolic perspective.' Ettinger: 'Matrix and Metramorphosis,' p.194.

118 Ettinger: 'Matrix and metramorphosis,' p.176.

119 Rowley: 'An introduction to Bracha Lichtenberg Ettinger's "Traumatic wit(h)ness-thing and matrixial co/in-habit(u)ating,' p.84.

120 Ettinger: 'Matrix and metramorphosis,' p.189.

121 Ettinger: 'Matrix and metramorphosis,' p.199.

122 Lippard: *Eva Hesse,* p.38.

123 In the catalogue raisonné *Eva Hesse Sculpture* (1989), Bill Barrette, the artist's studio assistant from 1969 until her death, notes that *Addendum* is: 'is very far indeed from the sexually biased combination of the same elements in *Ishtar* (1965), p.130.

124 EH-CN transcript: p.42.

125 Pollock, Griselda, 'Nichsapha: yearning/languishing the immaterial tuché of colour in painting after painting after history,' in Ettinger et al., *Bracha Lichtenberg Ettinger Artworking 1985–1999* (Ludion, Ghent-Amsterdam, Palais Des Beaux-Arts, Brussels, 2000), p.48.

126 Alison Rowley discusses the electrocution of the Rosenbergs and Helen Frankenthaler's art practice in 'Painting in the Rosenberg Era' in *Helen Frankenthaler: Painting History, Writing Painting* I.B.Tauris (2007).

127 Lifton, Robert Jay, *The Broken Connection: On Death and the Continuity of Life* (New York, 1979, 1983), p.5.

128 Pollock: 'Nichsapha,' p.48.

129 Hopps, Walter, Printz, Neil, et al., *Andy Warhol: Death and Disasters* (Houston, 1989), p.82.

130 Pollock: 'Nichsapha,' p.50.

131 Pollock: 'Nichsapha,' p.48.

Cultural Memory, Trauma and Absented History

1 See Seltzer, Mark., 'Wound culture: trauma in the pathological sphere,' in *October*, 80, spring 1997.

2 Santner: 'History beyond', p.144. My italics.

3 Ruth Marcus Hesse and William Hesse Diaries, written for Eva Hesse (1936–1943), unpublished, unpaginated.

4 Wyman, David S., ed., *The World Reacts To The Holocaust* (The John Hopkins University Press, Baltimore and London, 1996), p.722.

5 LaCapra: p.5.

6 LaCapra: p.8.

7 Caruth, Cathy., *Unclaimed Experience: Trauma, Narrative, and History* (John Hopkins University Press, Baltimore and London,1996), p.27.

8 Caruth: p.27.

9 LaCapra: p.9.

10 LaCapra: 'In the case of traumatic events, canonization involves the mitigation or covering over of wounds and creating the impression that nothing disruptive has occurred.' p.23.

11 LaCapra (1994), p.21.

12 Lippard: *Eva Hesse*, p.5.

13 Nemser: *Artforum*, 59.

14 Nemser: *Artforum*, 59.

15 EH-CN Transcript: side B section, pp.11–12.

16 EH-CN Transcript: biography section, 9–10. Italicised text indicates those entries made in pencil.

17 Laplanche, J and Pontails, J-B., *The Language of Psychoanalysis* (Karnac Books, London, 1973, 1988), p.465.

18 In *Trauma: A Genealogy* (University of Chicago Press, Chicago and London, 2000), Ruth Leys, argues that this is the kind of trauma theory supported by Caruth in *Unclaimed Experience* (John Hopkins, 1995).

19 What Leys' study makes clear via *Life and Death in Psychoanalysis*, written by Jean Laplanche in 1976, is that to understand trauma as the impact of a singular causal external event on a passive subject that is inhabited by it, is insufficient to the complex theory formulated by Freud. Laplanche states 'the model of the physical trauma, as an effraction or breach of external origin, is quite insufficient in the case of a psychical trauma,' p.19. Moreover, Leys argues that the 'dichotomy held to exist between the external and internal inevitably reinforces gender stereotypes by

conceptualising the already-constituted female subject as a completely passive and helpless victim.' p. 38.

20 Freud, Sigmund., 'Project for a scientific psychology,' (1950[1895]) in *The Standard Edition of the Complete Psychological Works of Sigmund Freud*, 1 (1886–1899) (Hogarth Press and the Institute of Psycho-analysis, London, 1966).
Freud, Sigmund., 'Beyond the pleasure principle,' (1920) in *On Metapsychology: The Theory of Psychoanalysis*, Penguin Freud Library, no.11 (Penguin, London, 1991), p.289.
Freud, Sigmund., 'Inhibitions, symptoms and anxiety,' (1926[1925]) in *On Psychopathology: Inhibitions, Symptoms and Anxiety and Other Works*, Penguin Freud Library, no.10 (Penguin, London, 1993)

21 Freud: 'Beyond the pleasure principle', p.289.

22 Freud, Sigmund., 'The ego and the id' (1923) in *On Metapsychology: The Theory of Psychoanalysis, Penguin Freud Library,* 11 (Penguin, London, 1991).

23 Freud: 'Beyond the pleasure principle', p.297.

24 Freud: 'Beyond the pleasure principle', p.297–299. See also pp.281–282.

25 Leys: *Trauma,* p.23, quoting Sigmund Freud, *Introductory Lectures on Psycho-Analysis* (1915–17), *Standard Edition*, 16, p.275. She notes that this is the same economic definition given to the death drive.

26 Freud, Sigmund., 'Repression,' (1915) in Sigmund Freud, *On Metapsychology: The Theory of Psychoanalysis,* The Penguin Freud Library, 11 (Penguin, London, 1991). I think it is worth bearing in mind that 'the process of repression is not to be regarded as an event which takes place *once*, the results of which are permanent […] repression demands a persistent expenditure of force, and if this were to cease the success of the repression would be jeopardised, so that a fresh act of repression would be necessary.' p.151.

27 Appignanesi, Lisa and Forrester, John., *Freud's Women* (Virago, London, 1993), p.138.

28 Freud: 'Project', pp.352–353.

29 Freud: 'Project', pp.352–353.

30 Freud: 'Project', pp.353–354.

31 See Freud: 'Project', pp.350–352.

32 Freud: 'Project', pp.355–6.

33 Laplanche and Pontalis: *The Language of Psychoanalysis*, p.114.

34 Leys: *Trauma,* p.20.

35 Freud, Sigmund., 'Screen memories,' (1899) in *The Standard Edition of the Complete Psychological Works of Sigmund Freud*, 3 (1893–1899) (Hogarth Press and Institute of Psychoanalysis, London, 1958)p.309–322. In 'The unconscious' (1915), hereafter referred to as (1915b), Freud defines the timelessness of condensation and displacement that belongs to this system as exempt from 'ordered temporality, [they] are not altered by the passage of time; they have no reference to time at all. Reference to time is bound up, once again, with the work of the system Cs.' in Freud, Sigmund., *On Metapsychology: The Theory of Psychoanalysis,* The Penguin Freud Library, 11 (Penguin, London, 1991), p.191.

36 Freud: 'Screen memories', pp.318–319.

37 Laplanche: *Life and Death*, p.41.

38 Freud: 'Screen memories', pp.353–354.

39 Freud: 'Beyond the pleasure principle', p.288.

40 Leys: *Trauma,* p.21.

41 Freud: 'Beyond the pleasure principle', p.299. 'We have learnt that unconscious mental processes are in themselves "timeless."

42 Freud: 'Beyond the pleasure principle', p.300.

43 Laplanche: *Life and Death*, pp.31–44. That text pays particular attention to *Studies in Hysteria*, co-authored with Josef Breuer in 1893, 'The aetiology of hysteria,' (1896) and the 'Project for a scientific psychology.'

44 Laplanche: *Life and Death*, pp.42–3. My emphasis.

45 http://www.marxists.org/reference/subject/philosophy/works/us/jameson.htm

46 Leys: *Trauma*, p.21.

47 Freud: 'Ego and id', pp.362–4. 'Another factor, besides the influence of the system *Pcpt.* seems to have played a part in bringing about the formation of the ego and its differentiation from the id. A person's own body and above all its surface, is a place from which both external and internal perceptions may spring. It is *seen* like any other object, but to the *touch* it yields two kinds of sensations, one of which may be equivalent to an internal perception.'

48 Freud: 'Ego and id', p.364.

49 Freud: 'Ego and id', p.364.

50 Leys: *Trauma*, p.25.

51 Freud: 'Inhibitions, symptoms and anxiety', pp.326–327.

52 Freud: 'Inhibitions, symptoms and anxiety', pp.244–245.

53 Leys: *Trauma*, p.28.

54 Leys: *Trauma*, p.25. Leys argument first removes the seeming differences of 'signal anxiety' and 'automatic anxiety.' The economic definition of 'automatic anxiety,' that is the breach of the protective shield by excessive excitation, does not hold good for signal anxiety. Rather, Ruth Leys tells us that the author 'subordinates the economic dimension of anxiety in favour of an account that historicises it and narrativises it, by taking the danger that threatens the ego to be the reproduction of a prior situation that signal, indicate, and represent: the threat of the father (castration) or, more primordially, the danger of the loss of the mother, or her breast. On this model, anxiety serves the purpose of protecting the psyche's coherence by allowing the ego to represent and master a danger situation involving the threatened loss of an identifiable libidinal object. Freud would like to assimilate the traumatic neuroses to the same libidinal model.' (2000), p.27. Freud accomplishes this aim with reference to narcissism 'that libidinalises the ego and the instinct for self preservation…the unconscious knows nothing of death' thus the 'fear of death should be regarded as analogous to the fear of castration.' p.28.

55 Leys: *Trauma*, p.29.

56 Leys: *Trauma*, p.30.

57 Leys: *Trauma*, P.31-3. It is on the basis of 'primary identification' that Ruth Leys posits the theory of 'mimetic' trauma. She understands primary identification as that that 'can never be remembered by the subject precisely because it precedes the very distinction between self and other on which the possibility of representation and hence recollection depends. It follows that the origin is not present to the subject… what if – as Freud suggest – trauma is understood to consists in *imitative or mimetic identification itself*, which is to say in "the subject's *originary* 'invasion'" or alteration? This would attribute to the patient's lack of memory of the trauma not to the repression of the representation of the traumatic event, but to the vacancy of the

traumatised subject or ego in a hypnotic openness to impressions or identifications occurring prior to all self-representation and hence to all rememoration. So the victim of a trauma identifies with the aggressor, she does so not as a defence of the ego that represses the violent event into the unconscious, but on the basis of an unconscious imitation or mimesis that connotes an abyssal openness to all identification.' Thus trauma is not remembered as an event in the past but belongs to the present 'transferential' relationship as a 'hypnotic identification with another in the present…that is characterised by a profound amnesia or absence from the self. Trauma, is therefore redefined, not as an event but as a 'situation' or experience because it occurs to a subject that is yet to be 'fully coherent.' 'Trauma, Ruth Leys continues, 'is this imagines as involving not the shattering of a pregiven ego by the loss of an identifiable object or event but a dislocation or dissociation of the "subject" prior to an identity and any perceptual object.'

58 In *Trauma: A Genealogy*. Ruth Leys performs an illuminating seventy-page critique of Cathy Caruth's application of Sigmund Freud's theory of trauma (see pages 229–305). To briefly summarise: Ruth Leys makes clear that Cathy Caruth's psychoanalytic insight is dependent upon the literary critic's dialogue with the questionable scientific findings of physician Bessel van der Kolk who claims a 'veridical' core of traumatic dreams and flashbacks that exceeds 'verbal-linguistic-semantic representation' and distorts Sigmund Freud's notion of *Nachträglichkeit*. In 'Retrieval and Integration of Traumatic Memories within the 'Painting Cure,' in Bessel A. van der Kolk, *Psychological Trauma* (American Psychiatric Press, Washington D.C, 1987), Van der Kolk and co-author Mark S. Greenberg suggest that since the traumatised individual is possessed by images, bodily sensations, and emotions that are dissociated from all semantic-linguistic-verbal representation, such images or memories may not be retrievable by verbal methods of cure but only by therapies of a non-linguistic or 'iconic' kind. They therefore advocate the value of a 'painting cure' in which a trauma victim is encouraged "private iconic images" in the form of paintings, drawings and dream reports as literal reproductions of the repressed traumatic events in question. This hypothesis goes against the grain of the 'trans-subjective' encounter, proposed by Bracha Lichtenberg Ettinger, that is the foundation of this text, and her work in 'Some-thing, some-event'.

59 Pollock, Griselda., 'Inscriptions in the feminine,' in M. Catherine de Zegher ed., *Inside the Visible: An Elliptical Traverse of 20th Century Art, in, of and from the feminine* (MIT Press, Cambridge, Mass and London, 1996) , p.73.

60 Ettinger: 'Matrix and metramorphosis', p.176.

61 Ettinger, Bracha., 'Traumatic wit(h)ness-thing and matrixial co/in-habituating,' in *Parallax*, 5/1, 1999, p.92.

62 Rowley: 'An Introduction', p.81.

63 Ettinger: 'Matrix and metramorphosis', p.92.

64 Shapiro, Edward S., *A Time for Healing: American Jewry since World War II* (John Hopkins University Press, Baltimore and London, 1992), p.7. Edward S. Shapiro, states however, that when the American people were given the opportunity to do just that they declined, rejecting Gerald K. Smith's anti-Semitic presidential campaign in 1944.

65 Shapiro cites the speech 'Who are the war agitators? Given by Charles Lindbergh in 1941 before an American First Audience in Des Moines, Iowa. The speech accentuated the stereotype of the powerful American Jew. p.6.

66 Shandler, Jeffrey, *While America Watches: Televising the Holocaust* (Oxford University Press, New York and Oxford, 1999), pp.6–10.

67 Shapiro: *A Time for Healing*, p.4.

68 'Only amiable films need apply,' *The Times*, Friday April 20, 1956. 'Nuit et Brouillard,' *Le Monde*, May 2, 1956.

69 Novick, Peter., *The Holocaust in American Life* (Houghton Mifflin Company, Boston, New York, 1999, 2000) published as Peter Novick, *The Holocaust and Collective Memory: The American Experience* (Bloomsbury, London, 1999) in Great Britain.

70 Novick: *The Holocaust*, pp.85–86.

71 Novick: *The Holocaust*, p.86.

72 Novick: *The Holocaust*, p.86.

73 Shapiro: *Time for Healing*, p.5. Shapiro cites William Chapman Revercomb, a west Virginia Republican, 'one of the most influential and fervent senatorial opponents of immigration.

74 Shapiro: *Time for Healing*, p.36.

75 Shapiro: *Time for Healing*, p.45.'

76 Shandler: *While America*, p.31. Shandler tells us that as film footage of German soldiers marching through a city is shown and music plays Edwards, the host, recounts the story of the Anschluss and the invasion of the Sudetenland, 'a slow cross-fade back to Hanna superimposes her face on the footage. A bass drum beats heavily as Edwards mentions the Nazis' torching the local synagogue.' For Shandler's full reading of the Hanna Bloch Kohner episode of *This Is Your Life* see p.29–40.

77 Shandler: *While America*, p.33.

78 ibid.

79 ibid.

80 Shandler: *While America*, p.36.

81 Doneson, Judith E., *The Holocaust in American Film* (The Jewish Publication Society, Philadelphia, New York, Jerusalem, 1987), p.60.

82 Doneson: *The Holocaust*, p.76. Doneson describes the illusion of historical accuracy given to the narrative of the film by the voices over Anne Frank's character supposedly reads from the diary. Originally the scriptwriters devised another ending. Doneson tells us 'in a sneak preview in San Francisco, another ending was tried 'which showed the girl in a concentration camp uniform swaying in a numb, miasmic fog...' Apparently, this was too tough for the audience and went against Twentieth-Century Fox's desire to have the film considered 'hopeful despite all.' p.60.

83 Novick: *The Holocaust*, p.31.

84 Novick: *The Holocaust*, pp.40–41.

85 Novick: *The Holocaust* (1999), pp.41–42.

86 Novick: *The Holocaust*, pp.44–45.

87 Novick: *The Holocaust*, pp.45.

88 See Novick: *The Holocaust*, p.77–81 for an in depth analysis of the political role given to the survivors the Shoah in the creation of Israel.

89 Novick: *The Holocaust*, p.68.

90 Novick: *The Holocaust,* pp.68–69. Among his examples Peter Novick cites David Ben-Gurion's view that those who survived included 'people who would not have survived if they had not been what they were – hard, evil, and selfish people, and what they underwent there served to destroy what good qualities they had left.'

91 Novick: *The Holocaust,* p.83. 'Both in Israel and the United States survivors found listeners reluctant to hear of their ordeal. Jews in Palestine, according to Israel Gutman, listened to survivor's stories with a 'forced patience' that was soon exhausted.'

92 Doneson: *The Holocaust,* p.60.

93 ibid.

94 ibid.

95 Doneson: *The Holocaust,* p.65.

96 Olin, Magaret, *C[lement] Hardesh [Greenberg] and company,* in Norman Kleeblatt ed., *Too Jewish? Challenging Traditional Identities* (Jewish Museum and Rutgers University Press, New York 1996)p.46. See also Louis Kaplan, 'Reframing the Self-Criticism: Clement Greenberg's "Modernist painting" in light of Jewish identity,' in Catherine M. Soussloff ed., *Jewish Identity in Modern Art History* (University of California Press, Berkley, Los Angeles and London, 1999), p.180–199.

97 Reprinted in Clement Greenberg, *The Collected Essays and Criticism: Affirmations and Refusals, 1950–1956,* 3, ed., John O'Brian (University of Chicago Press, Chicago and London, 1993), p.44–58.

98 Greenberg: *Collected Essays,* p.51.

99 Godfrey, Mark., 'Keeping Watch over Absent Meaning: Morris Louis's *Charred Journal* series and the Holocaust,' in *The Jewish Quarterly,* Autumn 1999, p.17–22.

100 Godfrey: 'Keeping Watch', p.17.

101 Doneson: *The Holocaust,* p.72.

102 Doneson: *The Holocaust,* quoting Will Herberg (1987), p.65. Her text continues: 'According to Popkin, the attitude (perhaps unconscious) went as follows: 'If we pretend that the Jew does not exist, the reasoning goes, then he will not be noticed; the anti-Semite, unable to find his victim, will simply forget about him.' Those involved in the arts attempted to reflect the 'American' experience rather than a specifically Jewish one.'

103 Anne Karpf, *The War After: Living with the Holocaust* (Heinman, London, 1996), p.199–200.

104 Karpf: *The War After,* p.166–167. Karpf refers to Primo Levi's recurring dream in which his friends and family were indifferent to the camp experiences he narrated to them.' see Primo Levi, *If This is a Man* (Abacus, London, 1987)

105 Laub: 'Bearing Witness', p.63.

106 Laub: 'Bearing Witness', p.68.

107 Dawidowicz, Lucy, *The Holocaust and the Historians* (Cambridge Mass., and London, 1981), p.125.

108 Dawidowicz: *The Holocaust,* p.126.

109 Dawidowicz: *The Holocaust,* p.126.

110 Rose, Jacqueline, *The Haunting of Sylvia Plath* (Virago, London, 1991), p.205

111 Rose: *Haunting,* p.206.

112 Karpf: *War After,* p. 202–203.

113 Ibid.

114 Caruth: *Trauma*, p.142.

115 Heifetz, Julie, *Too Young To Remember* (Wayne State University Press, Detroit, 1989), p.18 In her later therapy, after the 1961, Sam Dunkell did address the Holocaust in Eva Hesse's therapy.

116 Heifetz: *Too Young*, p.106

117 Caruth: *Trauma*, p.144.

118 Lowenstein: *Frankfurt on the Hudson*, p.45.

119 Gloria DeVidas Kirchheimer and Manfred Kirchheimer, *We Were So Beloved: Autobiography of a German Jewish Community* (University of Pittsburgh Press, 1997) p.87.

120 Lowenstein: *Frankfurt on the Hudson*, pp.143–144.

121 Kirchheimer and Kirchheimer: *We Were So Beloved*, p.136.

122 Kirchheimer and Kirchheimer: *We Were So Beloved*, p.88.

123 Kirchheimer and Kirchheimer: *We Were So Beloved*, p.88–89.

124 Kirchheimer and Kirchheimer: *We Were So Beloved*, p.114.

125 Kirchheimer and Kirchheimer: *We Were So Beloved*, p.115.

126 Kirchheimer and Kirchheimer: *We Were So Beloved*, p.89.

127 Wagner: *Three* Artists, p.274.

128 Wagner: *Three Artists,* p.273–274.

129 Wagner: *Three* Artists, p.275. My italics.

130 EH-CN Transcript: side b p.27–28.

131 Kirchheimer and Kirchheimer: *We Were So Beloved*, p.89.

132 Lowenstein: *Frankfurt on the Hudson*, pp.245–246.

133 Kirchheimer and Kirchheimer: *We Were So Beloved*, p.1.

134 The author conversation with Manfred Kirchheimer April 16 2000.

135 Manfred Kirchheimer, in conversation with the author, April 16 2000.

136 Karpf: *War After*, p.201–202.

137 Heifetz: *Too Young*, p.19.

138 Heifetz: *Too Young*, p.103.

139 Heifetz: *Too Young*, p.19.

140 Heifetz: *Too Young*, p.93.

141 Ibid.

142 Helen Hesse Charash in conversation with the author, 7 January 2001.

143 Ettinger: 'Traumatic wit(h)ness-thing', p.91.

144 Ettinger 'Traumatic wit(h)ness-thing', pp.91–92.

145 EH-CN Transcript: biography section, p.4. The script that appears in pencil is shown in italics.

146 Laub: 'Bearing Witness,' p.62. A position no doubt informed by Freud's writing on 'Suggestion,' in the analytic scenario.

147 Ettinger theorises 'Art as the transport-station of trauma,' in Bracha Ettinger et al., *Artworking 1985–1999* (Ludion, Ghent-Amsterdam, Palais Des Beaux-Arts, Brussels, 2000) p.91–115.

Wives, Daughters and Other(ed) Differences

1 John Chapple, *Elizabeth Gaskell: The Early Years* (Manchester University Press, Manchester, 1999), p.154. My Italics. Quoted from *The Letters of Mrs Gaskell*, ed. John A. V. Chapple and Arthur Pollard (Manchester University Press, 1966), p.796–797.

2 EH-CN transcript: biography section, p.5.

3 Wagner: *Three Artists*, p.227.

4 Ibid.

5 Wagner: *Three Artists*, pp.264–268

6 Wagner: *Three Artists*, p.227 and pp.262–263.

7 Extracts reproduced as in Wagner: *Three Artists*, p.263.

8 'Some Aspects of Freudian Psychology,' written by Eva Hesse in 1956, when she had been in therapy for two years, demonstrates a clear preliminary understanding of the life and death instincts, the topographical aspects of the self, including the id, ego and super-ego and the major and minor economic mechanisms of the psyche.

9 Wagner: *Three Artists*, p.263. My emphasis.

10 Wagner: *Three Artists*, p.212.

11 The author in conversation with Helen Hesse Charash April 2000.

12 The author in conversation with Helen Hesse Charash, April 2000.

13 The author in conversation with Helen Hesse Charash and Manfred Kirchheimer, April 2000.

14 Lippard: 'Eva Hesse: The Circle', p.8.

15 Hope Edelman, *Motherless Daughters: The Legacy of Loss* (Hodder and Stoughton, London, 1994), p.179.

16 The author in conversation with Victor Moscoso, 2 August 2002.

17 Friedan, Betty, The Feminine Mystique (Dell Publishing, New York, 1964), p.95.

18 Friedan: *The Feminine Mystique*, p.98.

19 Mitchell, Juliet, *Psychoanalysis and Feminism: A Radical Reassessment of Freudian Psycho-analysis* (Penguin Books, London, 1990, 1974), p.317. Mitchell concedes that in a sense Freud was culture-bound but, she writes, in a sense that was the 'diametric opposite of that deduced by Friedan.'

20 Friedan: *The Feminine Mystique*, p.110.

21 Freud: 'Ego and the id', p.371.

22 Freud: 'Ego and the id', P.371–372.My italics.

23 Freud, Sigmund, 'Femininity,' ([1932] 1933) in Sigmund Freud, New Introductory Lectures on Psychoanalysis, Penguin Freud Library, no.2 (Penguin London, 1973, 1991), p.151.

24 Freud: 'Femininity', p.152.

25 Freud: 'Femininity', p.153.

26 Freud: 'Femininity', p.160.

27 Freud: 'Femininity', p.155.

28 Freud, Sigmund, 'Fragment of an analysis of a case of hysteria ('Dora') (1905 [1901]), in *Case Histories I 'Dora' and 'Little Hans,'* Penguin Freud Library, 8 (Penguin, London, 1990), p.49–50.

29 Appignanesi and Forrester: *Freud's Women*, p.148.

30 The author in conversation with Elisabeth Sussman, September 1 2002.

31 Freud: 'Fragment of an analysis', p.50. Ida Bauer's predisposition to hysteria was also a consequence, Freud writes, of a father infected with venereal disease.

32 Freud: 'Fragment of an analysis', p.105.

33 Freud: 'Fragment of an analysis', p.90. Sigmund Freud also reads such an identification with Frau K. as the woman that her father currently loved, of course disavowing Ida Bauer's actual feelings for Frau K.

34 Freud: 'Fragment of an analysis', p.111–112. The analyst traces, through the accusation against the father via a symptomatic identification with the mother, a 'self-accusation' that her own illness had arisen from childhood masturbation.

35 Appignanesi and Forrester: *Freud's Women*, p.148.

36 Freud: 'Fragment of an analysis', p.111–112. The analyst traces, through the accusation against the father via a symptomatic identification with the mother, a 'self-accusation' that her own illness had arisen from childhood mastsurbation.

37 Freud, Sigmund, 'Some psychical consequences of the anatomical distinction between the Sexes' (1925), in Sigmund Freud, On Sexuality: Three Essays on the Theory of Sexuality and Other Works, Penguin Freud Library no.7 (Penguin, London, 1977, 1991) p.338.

38 Freud, Sigmund, 'The dissolution of the Oedipus complex' (1924), in Sigmund Freud, On Sexuality: *Three Essays on the Theory of Sexuality and Other Works*, Penguin Freud Library, 7 (Penguin, London, 1977, 1991), p.321.

39 Freud: 'The dissolution', p.321.

40 Freud: 'The dissolution', p.315.

41 Freud, Sigmund, 'Mourning and melancholia (1917[1915]) in Sigmund Freud, *On Metapsychology: The Theory of Psychoanalysis,* the Penguin Freud Library, 11 (Penguin, London, 1991), p.257–258. In 'Ego and the id,' Freud describes this introjection as follows:

'When the ego assumes the features of the object, it is forcing itself, so to speak, upon the id as a love-object and is trying to make good the id's loss by saying: "Look, you can love me too – I am so like the object."' p.369

42 The author in conversation with Sam Dunkell 13 September 2000. Sam Dunkell remarked that Hesse's father identification was resolved around 1960 and it was this that enabled her to marry Tom Doyle in November 1961. Eva Hesse's treatment 'succeeded' because it repressed her active impulses in exchange for the father's and ultimately the husband's penis as the source of all life and creativity. In her dialogue with Nemser Hesse recalled the moment of her marriage as the point at which her art practice began to go 'backwards'. If we are to read Eva Hesse's work produced between 1962 and 1964 as a backward step at all, it should at least be located historically. If read through the analytical prism of The Feminine Mystique, the immediate legacy of the resolution of Eva Hesse's father complex would have been the oppression of her creativity in deference to the judgement of her husband. She would then be able to take up her place within the normalised gender roles of the time. Her therapy demands that her identification with the myth of the artist as an empowering site of difference and agency must be given up. Thus the conclusion of Hesse's therapeutic treatment connected her to the desired notion of contemporary femininity that she was felt to be missing and that would normally have been inherited from the mother. But this connection to femininity must not be misconstrued as a re-connection to Ruth Marcus Hesse.

43 Friedan: *The Feminine Mystique*, p.107.

44 Eva Hesse (1966), quoted in Wagner: *Three Artists*, p.211.

45 Freud: 'Femininity', p.163.

46 Edelman, Hope, *Motherless Daughters: The Legacy of Loss* (Hodder and Stoughton, London, 1988, 1994), p.xxiii.

47 Friedan: *The Feminine Mystique*, p.113.

48 Gaskell, Elisabeth, *Wives and Daughters* (Penguin, London, 1999,1866), p.5.

49 Wagner: *Three Artists*, p.207.

50 Fred Wasserman, 'Building a childhood memory: the diaries of Eva Hesse's early years,' in Elisabeth Sussman and Fred Wasserman eds., *Eva Hesse: Sculpture* (Jewish Musem New York, Yale University Press, New Haven, 2006).

51 The author in conversation with Elisabeth Sussman, 15.04.2000.

52 Kirchheimer and Kirchheimer: *We Were So Beloved*, p.65.

53 Goldhagen, Daniel Jonah, *Hitler's Willing Executioners: Ordinary Germans and the Holocaust* (Abacus, London, 1996), p.90.

54 Goldhagen: *Hitler's Willing Executioners*, p.90.

55 See the University of Hamburg website http://www.rrz.uni-hamburg.de.

56 Judenboykott" of 1 April 1933,' http://www.rrz.uni-hamburg.de.

57 *The "JudenBoykott" of 1 April 1933*, http://www.rrz.uni-hamburg.de. Julius Streicher (1885–1946) edited *Die Stürmer* until the fall of the Nazis, and was sentenced to death by the war crimes tribunal at Nuremberg.

58 His mother Helene Goldberger Hesse, after whom Helen was named, died at the age of fifty-two of cardiovascular disease. His father also died young sometime before 1933. Both parents were buried in the Jewish cemetery in Hamburg and, therefore, did not die in concentration camps as Hesse's testimony implied in 1970.

59 Friedländer, Saul, *Nazi Germany and The Jews: the years of Persecution 1933–1939* (Weidenfeld and Nicolson, London, 1997), p.29. The decree that expelled Jews from the Bar, with the exceptions of World War I veterans and their relatives, and longevity in practice, as under the Civil Service Law, was made pubic on April 11 1933. Hesse, as a criminal lawyer, was one of the first to be dismissed. 'Of the 4,585 Jewish Lawyers practising in Germany, 3,167 (or almost 70%) were allowed to continue their work,' Friedländer continues to say however, 'though still allowed to practice, Jewish lawyers were excluded from the national association of lawyers and listed not in its annual directory but in a separate guide; all in all, notwithstanding the support of some Aryan institutions and individuals, they worked under a "boycott by fear."'

60 Friedländer: *Nazi Germany*, p.28.

61 Kaplan, Marion A., *Between Dignity and Despair: Jewish Life in Nazi Germany* (Oxford University Press, New York and Oxford, 1998), p.24.

62 On Wednesday April 12 Victor Klemperer noted in his diary, 'and every day new abominations. A Jewish lawyer in Chemnitz kidnapped and shot. "Provocateurs in SA uniform, common criminals."' Victor Klemperer, *I Will Bear Witness: 1933–1941 A Diary of the Nazi Years* (The Modern Library, New York, 1999), p.13.

63 Sussman, Elisabeth, *Lippard's Project*, a paper presented at the Eva Hesse Symposium, Museum Wiesbaden, 1 September 2002.

64 Wasserman: 'Building Childhood Memory', p.102.64

65 Kaplan: *Between Dignity and Despair*, p.4. Holocaust literature she argues has emphasised 'killers, on Nazi Policies towards the Jews, and, to a lesser extent, on Jewish organizational responses.' See also Anderson Mark M., ed., *Hitler's Exiles: Personal Stories of the Flight from Nazi Germany to America* (The new Press, New York (1998).

66 Ibid.

67 Gilbert, Martin, *The Holocaust: A Jewish Tragedy* (Fontana, London, 1986), pp.47–48.

68 Kaplan: *Between Dignity and Despair*, p.55.

69 Kaplan: *Between Dignity and Despair*, p.56–57.

70 Kaplan: *Between Dignity and Despair*, p.58.

71 Kaplan: *Between Dignity and Despair*, p.51.

72 Ruth Marcus Hesse and William Hesse unpublished tagebücher of Eva Hesse, January 1936. Translation courtesy of Helen Hesse Charash.

73 Hamburg University, History of Jews in Hamburg, http://www.rrz.uni-hamburg.de The City of Hamburg would not permit delays or reductions of the amount repaid so the Jewish community funded the 200,000 annual sum until 1939 when the hospital was closed. Medical insurance companies would no longer make payments to Jewish patients or Jewish hospitals.

74 Ruth Marcus Hesse and William Hesse, January 1936.

75 Freud, Anna, 'The concept of the rejecting mother,' (1954), in Anna Freud, *Selected Writings by Anna Freud*, Eds., Richard Ekins and Ruth Freeman (Penguin, London, 1998), p.86.

76 Freud: 'The concept of the rejecting mother,' p.85.

77 Freud: 'The concept of the rejecting mother,' p.85.

78 The author in conversation with Helen Hesse Charash 3 September 2001. The Royal College of Psychiatrists states that among the known causes of post-partum depression are a 'history of depression' and an 'accumulation of misfortunes' that stem from the external world. The Royal College of Psychiatrists,
 http://www.rcpsych.ac.uk/info/help/pndep/

79 Kaplan: *Between Dignity and Despair*, p.52.

80 Ruth Marcus Hesse and William Hesse, 7 January 1937, p.12.

81 Ruth Marcus Hesse and William Hesse, September 1936. P.15–15.

82 Ruth Marcus Hesse and William Hesse, September 1936. P.7–8 and p.16.

83 Kaplan: *Between Dignity and Despair*, p.5.

84 Ruth Marcus Hesse and William Hesse, January 1941. P.22.

85 Klemperer: *I Will Bear Witness*, p.20.

86 Klemperer: *I Will Bear Witness*, p.36–37.

87 Kaplan: *Between Dignity and Despair*, p.51–52.

88 Whiteman, Dorit Bader, *The Uprooted: A Hitler Legacy, Voices of those Who Escaped the "Final Solution,"* (Insight Books, Plenum Press, New York and London, 1993), p.130.

89 Whiteman: *The Uprooted*, p.130–131.

90 Wilhelm Hesse, Helen Hesse Tagebücher, unpaginated, 16 April 1939.

91 Whiteman: *The Uprooted*, p.134.

92 Klemperer: *I Will Bear Witness*, p.275.

93 Harris, Mark Jonathan and Oppenheimer, Deborah, *Into the Arms of Strangers: Stories of the Kindertransport* (Bloomsbury, New York and London, 2000), p.9. On May 27 in Helen Hesse's tagebücher Wilhelm Hesse tells of the difficult they had in securing their visas. 'We had a terrible time, even worse than in Germany. We did not get our visa and did not know the reason. Finally we found out the reason. The important letter of the Hamburg American Consul to the London American Consul which had to confirm the London Consul that he can give us a visa in the beginning of April has gone astray. And now after a very hard struggle we were informed today that a cable was sent to the Hamburg Consul to the London Consul that we will get our visa in the beginning of June.'

94 The British government reduced Jewish immigration to Palestine in 1937, thus as Mark M. Anderson tells us, 'closing down one of the chief escape routes for German refugees. Anderson: *Hitler's Exiles*, p.13.

95 Ruth Marcus Hesse and William Hesse, September 1936. P.22.

96 Friedländer: *Nazi Germany*, p.270.

97 Ruth Marcus Hesse and William Hesse, September 1936. P.26.

98 Ruth Marcus Hesse and William Hesse, September 1936. P.24.

99 Linda M. Woolf, *The Holocaust, Anti-Semitism, and the United States and some parallels to Kosovo* http://csf.colorado.edu/forums/peace/may99/msg00032.html

100 Ruth Marcus Hesse and William Hesse, September 1936. P.22.

101 'The Children! What will we do with the children?'

102 Gilbert: *The Holocaust*, p.69–70. For a detailed account of Pogrom nacht and the events that preceded and followed it see Saul Friedländer (1997), p.269–305.

103 Harris and Oppenheimer: *Into the Arms of Strangers*, p.10. See Sophie Yaari's testimony on http://sorrel.humboldt.edu/~rescuers/book/Pinkhof/yaari/sophie1.html In early 1939 legislation was proposed to admit 20,000 children into America as refugees (Child Refugee Bill) but this plan was defeated by Congress.

104 Hacker, Melissa, *My Knees Were Jumping: Remembering the Kindertransports* (1997).

105 The Jewish effort was co-ordinated by Otto Hirsch, head of the central orgainisation of Jews in Germany and Norbert Wollenheim. Harris and Openheimer: *Into the* Arms of Strangers.

106 Whiteman: *The Uprooted*, p. 141. Gertruida Wijsmuller gave testimony at the trail of Adolf Eichmann in 1961. See *The trial of Adolf Eichmann : record of proceedings in the District Court of Jerusalem* (Trust for the Publication of the Proceedings of the Eichmann Trial, in co-operation with the Israel State Archives and Yad Vashem, the Holocaust Martyrs' and Heroes' Remembrance Authority, Jerusalem, 1992–1995) and www.uni-essen.de/Ev–Theologie/courses/ course-stuff/kinderD5.htm

107 Ruth Marcus Hesse and William Hesse, December 27th 1938.

108 Whiteman: *The Uprooted*, p.151.

109 Whiteman: *The Uprooted*, p.151.

110 Whiteman: *The Uprooted*, p.151.

111 Franzi Danenberg, speaking to Melissa Hacker, in *My Knees Were Jumping*.

112 Franzi Groszman speaking to Melissa Hacker, *My Knees Were Jumping*.

113 Wilhelm Hesse, Helen Hesse's Tagebücher, April 16 1939.

114 Ruth Marcus Hesse and William Hesse unpublished tagebücher of Eva Hesse, April 1939. Translation courtesy of Helen Hesse Charash.

115 Freud: 'Inhibitions, symptoms and anxiety,' pp.329–333, addresses the anxiety that signals the possible loss of the object. Anna Freud and Dorothy Burlingham's clinical experience suggests that children up to three years old reactions to the loss of the mother are violent: 'the child feels suddenly deserted by all the known persons in its world to who it has learned to attach importance. Its new ability to love finds itself deprived of the accustomed objects, and its greed for affection remains unsatisfied. Its longing for its mother becomes intolerable and throws it into states of despair which are very similar to the despair and distress shown by babies who are hungry and whose food does not appear at the accustomed time. For several hours, or even a day or two, this psychological craving of the child, the 'hunger' for its mother may

over-ride all bodily sensations. Quoted in Bowlby, John, 'Grief and mourning in infancy,' *The Psychoanalytic Study of the Child*, 1960, 15, p.30–31.

116 Ruth Marcus Hesse and William Hesse unpublished tagebücher of Eva Hesse, April 1938, p.25

117 Ruth Marcus Hesse and William Hesse unpublished tagebücher of Helen Hesse, April-May 1939 Unpaginated.

118 Ruth Marcus Hesse and William Hesse unpublished tagebücher of Helen Hesse, April-May 1939 Unpaginated.

119 Ruth Marcus Hesse and William Hesse, May 1939. Unpaginated.

120 William Hesse, Helen Hesse's tagebücher, 16 April 1939.

121 Manfred and Gloria Devidas Kirchheimer, in conversation with the author and Helen Hesse Charash, April 16 2000.

122 Ruth Marcus Hesse and William Hesse unpublished tagebücher of Eva Hesse, 9 May 1941P.7

123 Anderson: *Hitler's Exiles*, p.17.

124 Ruth Marcus Hesse and William Hesse, 3 January 1942.

125 Anderson: *Hitler's Exiles* (1998), p.17.

126 Ruth Marcus Hesse and William Hesse, 30 June 1942.

127 Five transports had left Hamburg by that time, one to Litzmannstadt, two to Minsk, One to Riga and one, three days before, to Auschwitz.

128 Hamburg Senat, *Gedenkbuch fur die judischen opfer des nationalsozialismus im Hamburg*, 25 October 1965, p.63. Among these pages there is no listing for Mortiz Marcus though Helen Hesse Charash believes he too was deported to Thersienstadt. A 'Max Marcus' and a 'Moses Marcus' are both listed in the same transport as Erna Marcus but neither of them come from Ahrendsburg to which the Marcus' had moved in 1937. Mark Anderson tells us that by December 1942 almost four million Jews had been slaughtered in Europe (1998), p.17.

129 EH-CN Transcript: Biography section. unpaginated

130 Ruth Marcus Hesse and William Hesse, October 1940. p.3.

131 Freud. A and Burlingham quoted by Bowlby: 'Grief and Mourning in Early Childhood' p.22–23. It is in some way significant I think that Eva Hesse ritual took place within the home and in the presence of her mother.

132 Winnicot, D. W., 'The child's needs and the role of the mother in the early stages,' (1951), p. 14–23, in D. W. Winnicot, *The Child and the Outside World* (London, 1957), p.17.

133 Freud, Sigmund, 'Moses and monothesism,' (1939 [1934–1938]) in *The Standard Edition of the Complete Psychological Works of Sigmund Freud*, 23 (London, 1964).p.124. In 'The dead mother syndrome and trauma,' Arnold H. Modell makes clear the advances in the understanding of infantile amnesia. Investigations support the view that infantile amnesia is a problem of recall, not of registration. We know that infantile amnesia, which is the absence of declarative memory, persists until about the age of 2 ½. But infant researchers can demonstrate that infants remember affective interactions with their caretaker. These memories, however, remain implicit; they are what Bollas called the 'unthought known', p.83 in Kohon, Gregorio, ed., *The Dead Mother: The Work of André Green* (London, 1999)

134 Harris and Oppenheimer: *Into the Arms of Strangers*, p.125.

135 Ruth Marcus Hesse and William Hesse, October 1940, p.14.

136 Ruth Marcus Hesse and William Hesse, Summer 1941, p.8.

137 Ruth Marcus Hesse and William Hesse, Summer 1941, p.8.

138 Ruth Marcus Hesse and William Hesse, October 1940, p.3.

139 Ruth Marcus Hesse and William Hesse, September 1942. Translation courtesy of Helen Hesse Charash.

140 The author in conversation with Manfred Kirchheimer, 12 April 2000.

141 Unpublished, undated letter from Ruth Marcus Hesse to Eva Hesse, courtesy of Helen Hesse Charash.

142 Green, André, 'The dead mother' (1980) first published in André Green, *Narcissisme de vi. Narcissisme de Mort* (1983), translated by Katherine Aubertin and reprinted in André Green, *On Private Madness* (London, 1986).

143 Green: 'The Dead Mother', pp.142 and 149.

144 Winnicot, D. W. *Babies and their Mothers* (Reading Massachusetts, 1987) pp.9 and 20. The holding environment or facilitating environment is the space maintained by the mother that enables the 'natural growth processes and interactions with the environment' thus laying down the foundation of the mental health of the infant.

145 Green: 'The Dead Mother', p.150. Andre Green invokes the sexual notion of impotence and not inadequacy because he reads the secret of the Dead Mother Complex to be the 'fantasy of the primal scene' but I cannot pursue that dimension of his analysis here. See p.158–161.

146 Green: 'The Dead Mother', p.142. In 'The Dead Mother and the Reconstruction of Trauma,' Arnold H. Modell draws a distinction between the dead mother complex and the dead mother syndrome. The syndrome takes the subject within the realm of 'reactive symmetry,' what André Green describes as an unconscious identification with the 'dead mother' from the beginning; 'the only means by which to establish a reunion with the mother – perhaps by way of sympathy.' What then occurs, is not reparation but mimicry 'with the aim of continuing to possess the object (who one can no longer have) by becoming, not like it but, the object itself.' Thus, André Green writes: The ulterior object-relations, the subject, who is prey to the repetition-compulsion, will actively employ the decathexis of an object who is about to bring disappointment, repeating the old defence, but, he will remain totally unconscious of his identification with the dead mother, with whom he reunites henceforth in recathecting the traces of the trauma, p.152.
The dead mother complex, according to Arnold Modell's differentiation, can predispose a child to make a counter-identification with the mother; that is to try to become her opposite. This accounts for instances of hypersensitivity to the inner life of the self and others, or an addiction to thrills or crises that make the subject feel they are alive in contrast to the imago of the dead mother. Modell: 'The dead Mother Syndrome,' pp.84–85).

147 Green: 'The Dead Mother', p.154.

148 Green: 'The Dead Mother', p.151.

149 Kohon: *The Dead Mother*, p.3. Green refers to the 'breast' as a metaphor for the entire experience of the mother. For, 'however, intense the pleasure of sucking linked to the nipple, or the teat, might be, erogenous pleasure has the power to concentrate within itself everything of the mother that is not the breast: her smell, her skin, her look and the thousand other components that 'make up' the mother,' ([1980] 1986), p.148.

150 Modell: 'The dead Mother Syndrome', p.85.

151 Green: 'The Dead Mother', p.142.

152 Green: 'The Dead Mother', p.142.

153 Modell: 'The dead Mother Syndrome', p.77.

154 Edelman: *Motherless Daughters*, p.xix.

155 Edelman: *Motherless Daughters*, p.200.

156 Edelman: *Motherless Daughters*, p.199.

157 Weaving A Woman Artist With-in the Matrixial Encounter-event, unpublished paper given at University of Leeds 4– 5 July 2000, p.1. Originally presented at the Genius conference, ICA, London, June 2000 and to be published in 2003.

158 Zelizer, Barbie, *Remembering to Forget: Holocaust Memory through the Camera's Eye* (University of Chicago Press, Chicago and London, 1998), p.92. This text gives an illuminating account of how the images were produced, culturally and physically framed.

159 Jeffery Shandler notes that the making and viewing of these films had been a transformative experience that, to borrow the words of Robert Abzug, proved to be 'a turning point in Western consciousness', p. 6–10.

160 Shandler: *While America Watches*, p.6–10

161 The author in conversation with Helen Hesse Charash,

162 Edelman: *Motherless Daughters*, p.77.

163 Therese Rando quoted in Edelman: *Motherless Daughters*, p76.

164 Manfred Kirchheimer in conversation with the author, April 12th 2002.

165 Helen Hesse Charash in conversation with the author, April 2000.

166 Edelman: *Motherless Daughters*, p.38.

167 Edelman: *Motherless Daughters*, p.37. These children are 'cognitively and emotionally advanced enough to feel a profound loss, but their resources for managing their emotions haven't yet reached a level of mastery.'

168 Edelman: *Motherless Daughters*, p.39.

169 Edelman: *Motherless Daughters*, p.86.

170 Helen Hesse Charash in conversation with the author, April 2001.

171 Edelman: *Motherless Daughters*, p.42.

172 Edelman: *Motherless Daughters*, p.182.

173 Edelman: *Motherless Daughters*, p.204.

174 Edelman: *Motherless Daughters*, p.272. 'A child who loses her mother in childhood may continue to identify with her earlier stage as a way to maintain a relationship with her mother and deny the finality of death. The result is an adult who retains some characteristics of an earlier developmental time, one who feels as if a piece of her is still? "stuck" in childhood or adolescence. To this daughter, 'growing up' feels like not only a mystery but a practical impossibility: she's still to wedded to her childhood. "Parental loss per se doesn't lead to an arrest in development, but it can happen if circumstances don't support mourning in the interim," Nan Birnbaum explains. "All the girl's other means and interests develop, but some immature aspects are still a part of her. It's like the child of ten coexisting with the woman of twenty. As long as her mourning is incomplete, she feels that there's something she can't quite recapture, and she remains in a state of yearning"', p.42–43.

175 Wagner: *Three Artists*, p.214.

176 Wagner: *Three Artists*, p.216–217.

177 Ettinger, Bracha, 'Weaving a Woman Artist With-in the Matrixial Encounter-Event.' In: *Theory, Culture and Society* (TCS) 21/1, 2004, pp. 69–94.

178 Ettinger, Bracha, 'Transgressing With-In-To the Feminine,' in M. Catherine de Zegher ed., *Inside the Visible: An Elliptical Traverse of 20th Century Art, in, of and from the feminine* (MIT Press, Cambridge, Mass and London, 1995), p.186. Behind 'the mask of womanliness', she is 'either [...] castrated (lifeless, incapable of pleasure) or (as) wishing to castrate', said Joan Rivière [*International Journal of Psychoanalysis*, 1929, 10, p.38]. Rivière's concept of 'masquer-ade' concerns hiding female 'factual' castration and her castrating wishes, and is therefore considered by me as a phallic concept.'

179 Unpublished manuscript, Eva Hesse Papers, Archives of American Art. The 'thick stew of ideas' that were distilled in this essay have already been charted by Anne Wagner, p.216.

180 Ettinger: *Weaving a Woman Artist*, p.71.

181 Ettinger: *Weaving a Woman Artist*, p.69.

182 Eva Hesse's notes from Picasso in Robert Goldwater, Artists on Art, quoted in Wagner: *Three Artists*, p.218.

183 Ettinger: *Weaving a Woman Artist*, p.69–71.

184 For full critique see Ettinger: *Weaving a Woman Artist*

185 Ettinger: *Weaving a Woman Artist*, p.80.

186 Ettinger's focus on subjectivity rather than the journey of the individual eases our departure from the 'Individual personality' as the 'pulsating centre' of biography defined by David E. Nye in the first chapter of this book.

187 Ettinger: *Weaving a Woman Artist*, p.75. 'We can advance in this route of thinking [about feminine difference] if we free ourselves not only from the compulsion to disqualify whatever is beyond the phallic border as mystical or psychotic, but also from perceiving the borderline itself as castration, split and a bounding limit, and if we distinguish between subjectivity and the individual.'

188 Ettinger: *Weaving a Woman Artist*, p.82.

189 Green: 'The Dead Mother', p.156.

Longing, Belonging and Displacement
Eva Hesse's Art-working 1960–1961

1 Ettinger: *The Matrixial Gaze*, p.8.

2 Johnson: 'Eva Hesse,' p.22

3 Wasserman: 'Building A Childhood Memory,' p.123.

4 Wagner: *Three Artist*, pp.262–273.

5 Wagner: *Three Artist*, pp.264–268.

6 Bolt, Barbara, *Art Beyond Representation: The Performative Power of the Image* (I.B.Tauris, 2006), p. 6

7 Bolt: *Art Beyond Representation*, p.10.

8 Bal, Mieke, *Louise Bourgeois Spider: The Architecture of Art Writing* (University of Chicago Press, Chicago, 2001), p.32.

9 Freud, Sigmund, 'Remembering, repeating and working-through,' (1914) in *The Standard Edition of the Complete Psychological Works of Sigmund Freud*, 12 (1911–1913) (Hogarth Press and Institute of Psychoanalysis, London, 1963)

10 Freud, Sigmund: 'Constructions in analysis,' p.259.

11 Freud, Sigmund: 'Constructions in analysis,' p.258.

12 Wagner: *Three Artists*, p.216. She discusses the relation between the work of Eva Hesse and Tom Doyle during their marriage, pp.250–251, and cites Eva Hesse's reference to Picasso's dictum 'A painter paints to unload himself of feelings and visions' p.218, and her appreciation of Claes Oldenberg, p.317, n.20.

13 Pollock: *Differencing the Canon*, p.106.

14 Pollock: *Differencing the Canon*, p.107.

15 Ibid.

16 Karl Marx, *The Eighteenth Brumaire of Louis Napoleon* [1852], in Karl Marx and Frederich Engles, *Selected Works in One Volume* (Lawrence and Wishart, London, 1970) in Pollock: *Differencing the Canon*, p.207.

17 Pollock: *Differencing the Canon*, pp.109–110, 'the work an artist makes is literally *other* because it is a product of the artist's labour and an external object. It is also other because making a painting, for instance, involves participating in the public languages of the culture whose formal protocols, rhetorical conventions and supplied narratives might be said to *structure* the material which presses upon the artist, functioning as the drive, need and desire to produce. In addition to any conscious manipulation of semiotic conventions of the culture in which the artists is trained, disciplined and operative, there is an exchange between the artist's as yet unformulated materials for discourse and the articulation made possible by its enunciation through the discourse of the other: culture's given sign systems and stories.'

18 Hesse, 8 August 1960 cited by Cooper: *Eva Hesse: A Retrospective*, p.22.

19 Rosenberg, Harold, 'Tenth Street: the geography of modern art,' *Art News*, 1954, reprinted in *Discovering the Present: Three Decades in Art, Culture and Politics* (University of Chicago Press, Chicago, 1973), pp.101–102.

20 Victor Moscoso in conversation with the author 2 August 2002.

21 Weber, Nicholas Fox, *Josef Albers* (South Bank Centre, London, 1994), p.53.

22 I am indebted to Barry Rosen who first suggested I look at the work of Rico Lebrun in connection with the drawings of Eva Hesse.

23 Victor Moscoso in conversation with the author 2 August 2002.

24 Secunda, Arthur, 'An interview with Rico Lebrun,' *Artforum*, 1/11, May 1964, p.34.

25 EH-CNemser transcript: biography section unpaginated.

26 Lippard: *Eva Hesse*, p.14.

27 Ibid.

28 The author in conversation with Katherine Crone, 6 June 2002.

29 Eva Hesse, undated diary extract in February 1960 quoted and edited in Cooper: *Eva Hesse: A Retrospective*, p.22.

30 Judd, Donald, *Donald Judd Complete Writings 1959–1975* (Nova Scotia College of Art and Design, Halifax, New York University Press, New York, 1975), p.37. *Drawings: Three Young Americans*, held at the John Heller Gallery (later the Amel Gallery) between 11 April and 2 May 1961, signalled Hesse's entry into the New York art scene. *Drawings: Three Young Americans* was reviewed in *Arts Magazine* by Donald Judd, in *The New York Times* by Brian O'Doherty, and in *ArtNews* by Mark Roskill.

31 Petzinger, Renate, 'Thoughts on Hesse's early work, 1959–1965' in Elisabeth Sussman Ed. *Eva Hesse* (San Francisco Museum of Modern Art and Yale University Press, San Francisco, New Haven and London, 2002), p.43.

32 Petzinger: 'Thoughts on Hesse's early work', p.44.

33 Ibid. Eva Hesse undated diary extract circa 1960.

34 Ettinger: *The Matrixial Gaze*, p.8.

35 Freud: 'Beyond the pleasure principle', p.290.

36 Raverty, Dennis, 'Critical perspectives on the *New Images of Man* exhibition,' *Art Journal,* Winter, 1994. Raverty's article critiques Selz and Tillich's reductivist interpretation of abstract art.

37 In *Louise Bourgeois Spider* Mieke Bal, tells us that 'iconographic analysis is often a search for antecedent works of art, other images in which motifs, poses, compositional schemata, conceptualizations, or allegories were already used, so that the later work is affiliated with visual predecessors. In other cases, iconographical analysis explains pictorial elements with reference to textual sources' p.32.

38 Lebrun, Rico, *Rico Lebrun Drawings* (University of California Press, Berkley and Los Angeles, 1961), p.11.

39 Lebrun: *Rico Lebrun*, p.30.

40 Johnson: 'Eva Hesse,' p.10.

41 Bolt, Barbara, 'A non standard deviation: handlability, praxical knowledge and practice led research' http://www.speculation2005.qut.edu.au/papers/Bolt.pdf

42 Victor Moscoso in conversation with the author 2 August 2002.

43 Freud: 'Mourning and melancholia', p.265.

44 Freud: 'Inhibitions, symptoms and anxiety,' p.242.

45 Freud: 'Inhibitions, symtoms and anxiety,' pp.302–303. Freud states that the relation between symptom and anxiety is therefore not as close as first supposed (anxiety as a symptom of neurosis or symptoms are formed to avoid anxiety by binding psychical energy) 'for we have inserted the factor of the danger situation between them.'

46 Kofman, Sarah, *The Childhood of Art: An Interpretation of Freud's Aesthetics*, translated by Winifred Woodhull (New York, 1988), p.55. She writes: 'Every text is lacunary, full of holes – the holes that it covers with its tissue in order to hide them. Yet the tissue that masks reveals at the same time by perfectly adopting the contours of what it veils. Continuity bespeaks discontinuity, just as meaning does the lack of meaning. And, conversely, discontinuity – disruption of meaning in the details – bespeaks meaning and a deeper continuity. It is in its very veiling that the text displays what it is hiding...The text is a compromise between Eros and the death drive as well, for every disruption of meaning implies that the death drive is at work in the shadows, while every link implies the work of Eros.'

47 Freud: 'Screen Memories', pp.307–308.

48 Schor, Naomi, *Reading in Detail: Aesthetics and the Feminine* (Methuen, New York and London, 1987), p.71.

49 Freud: 'Beyond the pleasure principle' pp.284–285. In *Freud's Women*, Appignanesi and Forrester elucidate the role of Sophie Halberstadt in the discovery of the significance of 'fort-da'. Freud had 'collaborated with Sophie, as they tried to ascertain the meaning of the game of *fort/da*. The grandfather, through his daughter, gained access to the grandchild's game, grandfather shifting easily in to the shoes of his grandchild, his daughter becoming mother. Through the child he replayed the loss of the mother' p.60.

50 In 'Traumatic wit(h)ness-thing and matrixial co/in-habit(u)ating,' *Parallax*, 1999, 5/1, pp.89–98, Ettinger employs the writing of Fedida to think through the possibility of the movement involved in the repetition as the mother.

51 Freud: 'Beyond the pleasure principle', p.311.

52 Freud: 'Mourning and melancholia', p.267.

53 In *Reading in Detail*, Naomi Schor points out that the essay on screen memories identifies three types of displacement. Each is the product of "'the *chronological* relation between the screen memory and the content which is screened off by it": "*retrogressive*," "*displaced forward*," and "contemporary or *contiguous*.'" p.71. Naomi Schor's text takes on board the work of Tzvetan Todorov. He critiques Jakobson and Lacan who 'assimilate displacement and metonymy,' and, Naomi Schor tells us, states that 'this assimilation is improper: "displacement is not a metonymy, is not a trope, for it is not a substitution of meaning, but a linking up of two equally present meanings. But this ambiguity is, admittedly, in the Freudian text itself."' Naomi Schor concludes that 'metonymic' displacement only takes place in the case of the so-called contemporary or 'contiguous screen-memory': "the case, that is, where the essential elements of the experience are represented in memory by the inessential elements of the same experience..." pp.71–72. Little Ernst we know, was Ernst Halberstadt, the grandson of Sigmund Freud, who lived with his mother, Freud's second daughter Sophie. The metonymic properties of the substitution of the cotton reel for the mother in the fort/da scenario are thus dependent upon contiguity. The unconscious processes that brought about the window motif in the artwork of Eva Hesse, therefore, cannot be ascribed to the process of metonymy.

54 Kofman : *The Childhood of Art*, p.56.

55 Ettinger, Bracha, 'Some-thing, some-event', p.61.

56 Kofman : *The Childhood of Art*, p.57.

57 Ettinger: 'Some-thing, some-event', p.61.

58 Ibid.

59 Ettinger, Bracha, 'Art as a transport-station of trauma,' in *Ettinger : Artworking 1985–1999* (Brussels, and Ludion, Ghent-Amsterdam, 2000), p.93. 'The foreclusion of the feminine is vital for the phallic subject because it stands for the split from death drive in many intricate ways. The idea of death is closely connected to the feminine in western culture and is very strongly embedded in Freudian psychoanalysis in general and in the Lacanian theory in particular, where the feminine is closely assimilated to fusion, undifferentiation, autism and psychosis, all manifestation of deep regression and the activity of the death drive.'

60 Ettinger: 'Matrix and metramorphosis', p.178. 'In the beginning of the Oedipal situation (which, in Lacan's theory, is mainly structural rather than developmental), the desire to be the Phallus is repressed. This primal repression sets the chain of signifiers into action. This brings us to yet another description of the Phallus: every signifier and every signifying act is a substitution. They are successive conversions of the Phallus, which forever remains the first signifier. We might say that every signifier is equivalent in value to the Phallus, which is the signifier of the lost unity between the mother and the child, and is related to the lost or impossible object of desire. *Each time we evoke a symbol, we also evoke the Phallus. The Phallus is, then, an abstract value inherited from one signifier to another along the chain of signifiers.* Every act of language is both a conversion of the phallus and a *failure* of this conversion. The Phallus is not only the unique term for distinguishing the function of the signifier, but it is also the signifier of that which is lacking in the chain of signifiers. It is also the symbol of a function that is only *signifiant*, a signifier which has no signified. (Seminar XX 31). I can present the Phallus from yet another angle and say that it is the code chosen to signify that

which enables the child to separate from the mother's body. This separation takes place during each passage from the real to the Symbolic. According to Lacan, this passage corresponds to each reception of messages from the Other by the subject. We can now see why the Phallus, for Lacan, signifies all the possible relations between the subject and the whole universe of signifiers. He therefore calls it 'the signifier of signifiers, the only one that deserves the name Symbol." Since the father is the imaginary and the symbolic carrier of the Phallus, since he is supposed to have what the woman lacks and desires, the paternal function has a structural advantage in the Oedipal complex and more generally in our culture. it regulates the relationships between mother and child through what Lacan calls the "Name of the Father," a metaphor for all unconscious laws of metaphor and metonymy. These laws are intrinsically phallic, since they reduce chaos to one symbol at a time.' p.189–190.

61 Ettinger: 'Some-thing, some-event', p.61.

62 It is for this reason that I do not pursue Julia Kristeva's theorisation of the pre-symbolic register of the Chora expounded in *Revolution in Poetic Language* (Toril Moi, *The Kristeva Reader*, London, 1986). Significant as her theories are for a radical feminist theorisation of the processes of signification, as Griselda Pollock writes in 'Inscriptions in the Feminine,' the rhythms of Kristeva's poetic language are confined to the 'pre' of the symbolic. Thus the means by which it can disrupt and intervene in the Symbolic via the cut of language is only partial (De Zegher: *Inside the Visible*, p.77). For Kristeva 'the organising principles of the Chora are on the path of destruction, aggressivity and death' (Moi: *Kristeva*, p.95). Thus the pre-symbolic for Kristeva is marked by the logic of the Symbolic, as such its potential as a theoretical tool with which to reveal and read Hesse's drawings for the imprint of pre-oedipal experience, as the return of the repressed for the subject-in-process, and encounter with the post-oedipal mother as speaking subject would still be, however, underpinned by pathology. Only Ettinger's theorisation of the matrix as that which is sub-symbolic, that is beside the symbolic, made present in the weave of the Real, Symbolic and the Imaginary beyond the cut of metaphor and metonymy can support my reading.

63 Clark, T J., 'Painting in the Year Two,' in *Representations*, no.47, Summer 1994. 'And that fact,' he continues 'is bound up, no doubt, with the fiction of address to "contemporary masses"', p.37.

64 Clark: 'Painting in the year two', p.44.

65 Clark: 'Painting in the year two', p.44.

66 Lebrun: *Rico Lebrun*, 1961, p.10.

67 Clark: 'Painting in the year two', p.52.

68 With specific reference to children who loose their mothers between the ages of six and twelve years old Hope Edelman tells us that 'stuck between change and adaptation these children often try to ward off their sad feelings forcefully. As the psychologist Judith Mishne writes: "[they] will skirt the mention of the lost parent, engross themselves in play and suggest "let's change the subject." The avoidance of the finality of the loss is supported by fantasies of the parent's return. While such expectation persists, there is also an acknowledgement of the fact that the parent had died. These two trends of acknowledgement and denial coexist without being mutually confronted' p.38. Mishne, Judith, 'Parental Abandonment: A Unique Form of Loss and Narcissistic Injury,' *Clinical Social Work Journal* 7 (Autumn 1979), p.17

69 Edelman: *Motherless Daughters*, p.38.

70 Freud: 'Screen memories', p.318.

71 Rowley: 'An introduction' p.85.

72 Ibid.

73 Ettinger: *The Matrixial Gaze*, p.42.

74 Ettinger: 'Traumatic wit(h)ness-thing', p.90.

75 Ettinger: 'Traumatic wit(h)ness-thing', p.91.

76 Rowley: 'An introduction', p.85.

77 Ettinger: 'Some-thing, some-event', p.66.

78 Ettinger: 'Some-thing, some-event', p.71.

79 Rowley: 'An introduction', p.85.

80 Rowley: 'An introduction', p.85 Rowley notes that Ettinger speaks of individuals in order to insist that 'the phallic and Matrixial psychic strata exist together.'

81 Ettinger: 'Some-thing, some-event', p.71.

82 Ettinger: 'Some-thing, some-event', p.61.

83 Ettinger: 'Some-thing, some-event', p.74.

84 Evans, Dylan, *An Introductory Dictionary of Lacanian Psychoanalysis* (Routledge, London, 1996), pp.188–190.

85 Kristeva, Julia, 'Revolution in poetic language,' in Moi, Toril, ed., *The Kristeva Reader* (London, 1986), p.122.

86 Kristeva: 'Revolution in Poetic Language,' p.95.

87 Ettinger: 'Some-thing, some-event', p.65 citing Jacques Lacan, *Les non-dupes errent*, unpublished seminar, 23 April and 12 February 1974.

88 Ettinger: 'Some-thing, some-event', p.65.

89 Ibid. For Lacan the Phallus is the only signifier of sexual difference. This asymmetry of the Symbolic order, therefore, dictates that there can be 'no sexual rapport' thus a 'woman is a sinthôme for every man' and, because the sinthôme is characterised by 'non-equivalence,' Lacan writes 'another name needs to be found for what becomes of a man for a woman. For Lacan, "when there is equivalence, it is by this very fact that there is no (sexual rapport)."

90 Ettinger: 'Some-thing, some-event', pp.65–66.

91 Ettinger: 'Some-thing, some-event', p.66.

92 Ettinger: 'Some-thing, some-event', p.67.

93 Ettinger: 'Some-thing, some-event', p.61.

94 Ibid

95 Ettinger: 'Some-thing, some-event', p.67.

96 Ibid. 'Art may be a site from which some light may be shed on this [archaic] "woman."'

97 Ettinger: 'Some-thing, some-event' (2000), p.69.

98 Ibid.

99 Merleau-Ponty, Maurice, *Phenomenology of Perception* (Routledge and Kegan Paul, 1962, 1978), p.139.

100 Freud: 'Beyond the pleasure principle,' pp.311.

101 Ettinger: 'Some-thing, some-event', p.75.

102 Levitt, Laura, *Jews and Feminism: The Ambivalent Search For Home* (Routledge, London and New York, 1997), p.3.

103 The author in conversation with Victor Moscoso.

104 Kaplan: *Between Dignity and Despair*, p.4. Holocaust literature she argues has emphasised 'killers, on Nazi Policies towards the Jews, and, to a lesser extent, on Jewish organizational responses.' See also Anderson: *Hitler's Exiles*.

105 Frank, Anne, *The Diary of A Young Girl*, edited by Otto H. Frank and Mirjam Pressler (New York and London, 1997), p.7

106 Frank: *Diary of A Young Girl*, p.8.

107 Doneson: *The Holocaust*, p.83.

108 Doneson: *The Holocaust*, pp.75-76. She also draws attention to the role of McCarthyism in the shaping what was politically possible for this film.

109 Doneson: *The Holocaust*, p.79. My italics.

110 Doneson: *The Holocaust*, p.79.

111 In *Jews and Feminism* Levitt draws on the writing of Gayatri Spivak and Homi K Bhabha to offer a critique of the American 'Liberal/Colonial project' p.6.

112 Kirchheimer and Kirchheimer: *We Were So Beloved*, p.127.

113 Zinn, Howard, *Postwar America: 1945–1971* (Indianapolis and New York, 1973), p.124. The gradual implementation of the new law, however, meant that in 1965 'more than 75 percent of the school districts in the South were still segregated.

114 *Life Magazine*, 49/22, November 28, 1960, p.38.

115 Zinn: *Postwar America*, p.125.

116 Levitt: *Jews and Feminism,* p.22.

117 Layton, Azza Salama, *International Politics and Civil Rights Policies in the United States 1941–1960* (Cambridge University Press, Cambridge, 2000), p.143.

118 Clarke, Comer, *Eichmann The Man and His Crimes* (New York, 1960), p.81.

119 *Life Magazine*, 49/22, November 28, 1960, p.2.

120 Eichmann, Adolf, 'I transported them… to the butcher,' *Life Magazine*, 49/22, November 28, 1960, p.101.

121 Eichmann: 'I transported them', p.102

122 Ibid.

123 Ibid

124 Eichmann: 'I transported them', p.108.

125 Eichmann: 'I transported them', p.112.

126 Freud: 'Beyond the pleasure principle', p.282.

127 Cooper: *Eva Hesse: A Retrospective*, pp.23–24. Helen Cooper situates the trauma and anxiety Eva Hesse feels as a symptom of Victor Moscoso's marriage. It was, however, Hesse, Helen Hesse Charash states, who had ended her relationship with Victor Moscoso but they remained friends and still corresponded in 1961. I would suggest that the impact from which Hesse seems to be reeling in December 1960, may only be partly explained by his marriage.

128 Levitt: *Jews and Feminism*, p.152.

129 Ettinger: 'Some-thing, some-event', p.67.

130 Lebrun discusses the significance of the colour black in both his interview in *Artforum* and in *Rico Lebrun Drawings*. In conversation it is interesting to note that Rico Lebrun contrasts black 'that contains all colour' with his 'dislike' for 'painted things which are sky-colour, flesh-colour, candy-colour.' This 'anti-decoration' stance finds a significant echo in Eva Hesse's interview with Cindy Nemser in which she too declares her dislike for 'pretty' art. EH-CN Transcript: biography section unpaginated.

131 Lebrun: *Rico Lebrun*, p.34.

132 Ettinger: 'Some-thing, some-event', p.61.

133 Wagner: *Three Artists*, p.230. Wagner describes Eva Hesse's journals as an 'index of purposefulness.'

134 Eva Hesse, undated diary extract in February 1960 quoted and edited in Cooper: *Eva Hesse: A Retrospective*, p.22.

135 All the above quotations reproduced from Cooper: *Eva Hesse: A Retrospective*, pp.22–23.

136 EH– CN transcript: Side B. p.23

137 Kirchheimer and Kirchheimer: *We Were So Beloved*, p.89. In *Eva Hesse* Lippard cites an anonymous friend of the artist who recalls the connection Eva Hesse drew between her life in Washington Heights and art practice. Hesse, writes Lippard: Is quoted as saying that she feels 'growing up with people who went through the ordeal of those Nazi Years makes [her] look very closely – very seriously – beneath the surface of things…"For me being an artist means to see, to observe, to investigate…I paint what I see and feel to express life in all its reality and movement."' Lippard: *Eva Hesse*, p.8.

138 Lifton, Robert Jay, *The Broken Connection: On Death and the Continuity of Life* (Basic Books, Inc., New York, 1979, 1983), p.17.

139 Lifton: *The Broken Connection*, p.18. The other three modes of immortality are the 'theological,' the 'natural,' and the 'special mode of experiential transcendence.'

140 Lifton: *The Broken Connection*, p.19.

141 Wagner: *Three Artists*, p.216.

142 Lifton: *The Broken Connection*, p.21.

143 Merleau–Ponty: 'Eye and mind', p.124.

144 Bolt: *Art Beyond Representation*, p.1.

145 Levitt: *Jews and Feminism*, p.1.

146 Unpublished manuscript, Eva Hesse Papers, Archives of American Art.

147 Bochner, Mel., 'Remembering Eva Hesse' in *In the lineage of Eva Hesse* (Ridgefield, Connecticut, 1994) p.28.

148 Merleau–Ponty: *'Eye and mind'*, p.125.

149 In *Eva Hesse* Lucy Lippard quotes unnamed friends of the artist who stated that Eva Hesse's 'emotional soil was not of the present' while 'another remembers that they never went to Hesse's house "without a memento from the past being brought out…she fed off that material; its physical presence maybe filled some of the voids in her life', p.6.

150 Ettinger: 'Some-thing, some-event', p.71.

In Place of a Conclusion

1 Stamelman, Richard 'The Graven Silence of Writing,' in Jabès, Edmond. *From the Book to the Book: An Edmond Jabès Reader*, trans by Waldrop, Rosmarie (Hanover and London, 1991), p.xiii

2 Jabès, Edmond., *A Foreigner Carrying in the Crook of his Arm a Tiny Book* (Hanover and London, 1993), p.12

3 Jabès: *A Foreigner*, p.27

BIBLIOGRAPHY

Aberbach, David, 'Creativity and the survivor: the struggle for mastery,' *International Review of Psychoanalysis*, 16, (1989)

Alphen, Ernst van, *Caught by History Holocaust Effects in Contemporary Art, Literature and Theory*, (Stanford University Press, Stanford, California, 1997)

—— 'Salomon's work,' *Journal of Narrative and Life History*, 3/2 &3, (1993), p.239–253.

Anderson ed., Mark M., *Hitler's Exiles: Personal Stories of the Flight from Nazi Germany to America*, (The New Press, New York, 1998)

Anfam, David, *Franz Klein: Black and White 1950–1961* (The Menil Collection, Houston, 1994)

Appignanesi, Lisa, and Forrester, John, *Freud's Women*, (Virago, London, 1993)

Appignanesi, Lisa, *Losing the Dead*, (Chatto and Windus, London, 1999)

Arad, Yitzhak, ed., *The Pictorial History of the Holocaust*, (Yad Vashem, Jerusalem, Macmillan Publishing Company, New York, 1990)

Bal, Mieke, *Louise Bourgeois' Spider: the architecture of art–writing*, (University of Chicago Press, Chicago, 2001)

—— 'Reading art,' p.25–41 in Griselda Pollock ed. *Generations and Geographies in the Visual Arts: Feminist Readings*, (Routlege, London, 1996)

Bammer, Angelika, ed., *Displacements: Cultural Identities in Question*, (Indiana University Press, Bloomington and Indianapolis, 1994)

Barrette, Bill, *Eva Hesse Sculpture*, (Timken Publishers, New York, 1989)

Torton Beck, Evelyn, 'The politics of Jewish invisibility,' *NWSA Journal*, 1/1, 1988

Belinfante, Judith C. E. et al., *Charlotte Salomon: Life? or Theatre?*, (Waanders Publishers, Zwolle, Royal Academy of Arts, London, 1998)

Benjamin, Walter, *Illuminations*, (Collins & Fontana Books, London, 1973, 1940)

Bering, Dietz, *The Stigma of Names: AntiSemitism in German Daily Life, 1821–1933*, trans., Neville Plaice, (Polity Press, Cambridge, 1992) first published as *Der Name als Stigma*, (Ernst Klett Verlage, 1987).

Bochner, Mel, 'Remembering Eva Hesse,' in Elizabeth Hess and Mel Bochner, *In the Lineage of Eva Hesse*, (Aldrich Museum of Contemporary Art, Ridgefield, Connecticut, 1994)

—— 'Serial art, systems, solipsism', *Arts Magazine*, Summer 1967, reprinted in Gregory Battock, *Minimal Art: A Critical Anthology*, (E P Dutton & Co., New York, 1968)

Bollas, Christopher, 'Dead Mother, Dead Child,' in Gregorio Kohon ed., *The Dead Mother: The Work of André Green*, (Routledge and the Institute of Psycho–analysis, London, 1999)

Barb, Bolt, *Art Beyond Representation: The Performative Power of the Image*, (I B Tauris, London, 2004)

Bolt, Barb and Barrett, Estelle, *Practice as Research: Approaches to Creative Arts Enquiry,* (I B Tauris, London, 2007)

Burns, Sarah, *Inventing the Modern Artist: Art and Culture in Gilded Age America*, (Yale University Press, New Haven and London,1996)

Bywater, William G., *Clive Bell's Eye*, (Wayne State University Press, Detroit, 1975)

Caruth, Cathy, ed., *Trauma: Explorations in Memory*, (John Hopkins University Press, Baltimore and London, 1995)

—— *Unclaimed Experience: Trauma, Narrative, and History*,(John Hopkins University Press, Baltimore and London,1996)

Chave, Anna C. 'Eva Hesse: "A girl being a sculpture,' in Helen A. Cooper et al, *Eva Hesse: A Retrospective*, (Yale University Press, New Haven, 1992), p.99–117.

Christie, J.R.R. & Orton, Fred, 'Writing on a text of a life,' in F. Orton and G. Pollock, *Avant–Gardes and Partisans Re–Viewed*, (Manchester University Press, 1996)

Cixous, Hélène, 'La rire de la méduse', (*L'arc*, 1975), p.36–54. Translated and reprinted as 'The laugh of the medusa,' in Elaine Marks & Isabelle de Courtivron ed., *New French feminisms : an anthology* (Harvester Press, Brighton, 1981)

Clarke, Comer, *Eichmann The Man and His Crimes,* (Ballantine Books, New York, 1960).

Clarke, T. J, 'Painting in the year two,' in *Representations*, no.47, Summer 1994, p.13–63.

Cooper, Helen A., et al, *Eva Hesse: A Retrospective*, (Yale University Press, New Haven, 1992)

Dawidowicz, Lucy, *The Holocaust and the Historians*, (Harvard University Press, Cambridge Mass., and London, 1981)

Derrida, Jacques, *Of Grammotology*, trans. Gayatri Chakravorty Spivak, (The John Hopkins University Press, Baltimore and London, 1974)

—— *Writing and Difference*, (Chicago University Press, 1978)

Doneson, Judith E., *The Holocaust in American Film*, (The Jewish Publication Society, Philadelphia, New York, Jerusalem, 1987)

Edelman, Hope, *Motherless Daughters: The Legacy of Loss,* (Hodder and Stoughton, London, 1988, 1994)

Eichmann, Adolf, 'I transported them... to the butcher,' *Life Magazine*, 49/22, November 28, 1960

—— 'To sum it all up, I regret nothing,' *Life Magazine*, 49/23, December 5, 1960

Evans, Dylan, *An Introductory Dictionary of Lacanian Psychoanalysis*, (Routledge, London, 1996)

Felman, Shoshana, *What Does A Woman Want? Reading And Sexual Difference*, (John Hopkins University Press, Baltimore and London, 1993)

Felman, Shoshana and Laub, Dori *Testimony: Crises of Witnessing in Literature, Psychoanalysis, and History*, (Routledge, New York and London, 1992)

Lowenthal Feltsiner, Mary, *To Paint Her Life: Charlotte Salomon in the Nazi Era*, (Harper Collins, London and New York, 1994)

Fer, Briony *On Abstract Art,* (New Haven and London, Yale University Press, 1997)

Frank, Anne, *The Diary of A Young Girl*, edited by Otto H. Frank and Mirjam Pressler (Bantam Books, New York and London, 1997)

Anne Frank Foundation, *Anne Frank in the World 1929–1945*, (Amsterdam, 1985)

Frank, Elizabeth, *Eva Hesse: Gouaches 1960–1961*, (Robert Miller Gallery, Xenos Rippas Gallery, New York, Paris, 1991)

Friedan, Betty, *The Feminine Mystique*, (Dell Publishing, New York, 1964)

Freud, Anna, *Selected Writings by Anna Freud*, Eds., Richard Ekins and Ruth Freeman, (Penguin, London, 1998)

Freud, Sigmund, 'Beyond the pleasure principle,' in *On Mertapsychology: The Theory of Psychoanalysis*, Penguin Freud Library, no.11, (Penguin, London, 1991)

—— 'Constructions in analysis,' (1937) in *The Standard Edition of the Complete Psychological Works of Sigmund Freud*, 23, (Hogarth Press and the Institute of Psycho–analysis, London, 1964).

—— 'The dissolution of the Oedipus Complex' (1924), in Sigmund Freud, *On Sexuality: Three Essays on the Theory of Sexuality and Other Works*, Penguin Freud Library 7, (Penguin, London, 1977, 1991)

—— 'The ego and the id', (1923), *On Metapsychology: The Theory of Psychoanalysis*, Penguin Freud Library 11, (Penguin, London, 1991)

—— 'Femininity,' in Sigmund Freud, *New Introductory Lectures on Psychoanalysis*, Penguin Freud Library 2, (Penguin London, 1973, 1991)

—— 'Fragment of an analysis of a case of hysteria ('Dora'), (1905 [1901]), in *Case Histories I 'Dora' and 'Little Hans,'* Penguin Freud Library 8, (Penguin, London, 1990)

—— 'Inhibitions, symptoms and anxiety,' (1926[1925]) in *On Psychopathology: Inhibitions, Symptoms and Anxiety and Other Works*, Penguin Freud Library 10, (Penguin, London, 1993)

—— *The Interpretation of Dreams*, Penguin Freud Library, 4, (Penguin, London, 1991, 1900)

—— 'Moses and monothesism,' (1939 [1934–1938]) in *The Standard Edition of the Complete Psychological Works of Sigmund Freud*, 23, (Hogarth Press and the Institute of Psycho–analysis, London, 1964).

—— 'Mourning and melancholia, (1917[1915]) in Sigmund Freud, *On Metapsychology: The Theory of Psychoanalysis*, Penguin Freud Library 11, (Penguin, London, 1991)

—— 'On narcissism: an introduction,' (1914) in Sigmund Freud, *On Metapsychology: The Theory of Psychoanalysis*, Penguin Freud Library 11, (Penguin, London, 1991)

—— 'Project for a scientific psychology,' (1950[1895]) in *The Standard Edition of the Complete Psychological Works of Sigmund Freud*, 1 (1886–1899), (Hogarth Press and the Institute of Psycho–analysis, London, 1966).

—— 'Remembering, repeating and working–through,' (1914) in *The Standard Edition of the Complete Psychological Works of Sigmund Freud*, 12, (1911–1913), (Hogarth Press and Institute of Psychoanalysis, London, 1958,)

—— 'Repression,' (1915) in Sigmund Freud, *On Metapsychology: The Theory of Psychoanalysis,* Penguin Freud Library 11, (Penguin, London, 1991)

—— 'Screen memories,' (1899) in *The Standard Edition of the Complete Psychological Works of Sigmund Freud*, 3, (1893–1899), (Hogarth Press and Institute of Psychoanalysis, London, 1962,)

—— 'Some psychical consequences of the anatomical distinction between the sexes', (1925), in Sigmund Freud, *On Sexuality: Three Essays on the Theory of Sexuality and Other Works*, Penguin Freud Library 7, (Penguin, London, 1977, 1991)

—— 'The unconscious,' (1915) in Sigmund Freud, *On Metapsychology: The Theory of Psychoanalysis,* Penguin Freud Library 11, (Penguin, London, 1991)

Gaskell, Elizabeth, *Wives and Daughters*, (Penguin, London, 2000, 1866)

Gilbert, Martin *The Holocaust: A Jewish Tragedy*, (Fontana, London, 1986)

Godfrey, Mark, 'Keeping watch over absent meaning: Morris Louis's *Charred Journal* series and the Holocaust,' *The Jewish Quarterly*, Autumn 1999, p.17–22.

Goldhagen, Daniel Jonah, *Hitler's Willing Executioners: Ordinary Germans and the Holocaust*, (Abacus, London, 1996)

Goldstein, Carl, 'Teaching modernism: what Albers learned at the Bauhaus and taught to Rauschenberg, Noland and Hesse', *Art in America*, liv/4, December 1979.

Goldwater, Robert, and Treves, Marco, *Artists On Art: from the XIV to the XX Century*, (Pantheon, New York, 1945)

Green, André, *On Private Madness*, (Hogarth Press, London, 1986)

Greenberg, Clement, *The Collected Essays and Criticism: Affirmations and Refusals, 1950–1956*, 3, ed., John O'Brian, (University of Chicago Press, Chicago and London, 1993)

Hamburg Senat, The *Gedenkbuch fur die judischen opfer des nationalsozial–ismus im Hamburg*, (Hamburg, 1965)

Harris, Mark Jonathan and Oppenheimer, Deborah, *Into the Arms of Strangers: Stories of the Kindertransport*, (Bloomsbury, New York and London, 2000)

Heath, Stephen, 'Difference' *Screen*, Autumn 1978, 19/3, p.51–112.

Heifetz, Julie, *Too Young To Remember*, (Wayne State University Press, Detroit, 1989)

Hoffman, Eva, *Lost in Translation*, (Vintage, London, 1998)

Hopps, Walter, and Printz, Neil, et al., *Andy Warhol: Death and Disasters*, (the Menil Collcetion, Houston Fine Art Press, Houston, 1989)

Hyman, Paula, and Dash Moore, Deborah, *Jewish Women in America: A Historical Encyclopaedia*, (Routledge, New York and London, 1997)

Jabès, Edmond, *A Foreigner Carrying in the Crook of his Arm a Tiny Book* (Wesleyan University Press, Hanover and London, 1993)

—— *From the Book to the Book: An Edmond Jabès Reader*, translated by Rosmarie Waldrop (Wesleyan University Press, Hanover and London, 1991)

Jabès, Edmond and Lichtenberg Ettinger, Bracha, *A Threshold Where We Are Afraid*, (Museum of Modern Art Oxford, Oxford, 1990)

Johnson, Ellen H, *Eva Hesse: A Retrospective of the Drawings* (Allen Memorial Art Gallery, Oberlin College, Oberlin, Ohio, 1982)

Judd, Donald, *Donald Judd Complete Writings 1959 – 1975*, (Nova Scotia College of Art and Design, Halifax, New York University Press, New York, 1975)

Kaplan, Alice Yaeger, 'On language memoir,' in *Displacements: Cultural Identities in Question*, Angelika Bammer ed., (Indiana University Press, Bloomington and Indianapolis, 1994)

Kaplan, Marion A., *Between Dignity and Despair: Jewish Life in Nazi Germany*, (Oxford University Press, Oxford and New York, 1998)

Karpf, Anne, *The War After: Living with the Holocaust*, (Heinman, London, 1996)

Kirchheimer, Gloria DeVidas, and Kirchheimer, Manfred, *We Were So Beloved: Autobiography of a German Jewish Community*, (University of Pittsburgh Press, 1997)

Kleeblatt, Norman, ed., *Too Jewish? Challenging Traditional Identities* (Jewish Museum and Rutgers University Press, New York 1996)

Klein, Melanie *Love, Guilt and Reparation: And other works 1921–1945*, (Vintage, London, 1998)

Klemperer, Victor, *I Will Bear Witness: 1933 – 1941 A Diary of the Nazi Years*, (The Modern Library, New York, 1999)

Kofman, Sarah, *The Childhood of Art: An Interpretation of Freud's Aesthetics*, translated by Winifred Woodhull, (Columbia University Press, New York, 1988)

Kohon, Gregorio, ed., *The Dead Mother: The Work of André Green*, (Routledge and the Institute of Psycho–analysis, London, 1999)

Kolk, Bessel A. van der, *Psychological Trauma*, (American Psychiatric Press, Washington D.C, 1987)

Krauss, Rosalind, *Bachelors*, (MIT Press, Massachusetts, 1999)

LaCapra, Dominick, *Representing the Holocaust: History, Theory, Trauma*, (Cornell University Press, Ithaca and London, 1994)

Laplanche, J., and Pontails, J–B, *The Language of Psychoanalysis*, (Karnac Books, London, 1973, 1988)

Laplanche, J., *Life and Death in Psychoanalysis*, translated by Jeffery Mehlman, (John Hopkins University Press, 1976), first published as *Vie et mort en psychanalyse*, (Flammarion, Paris, 1970)

Layton, Azza Salama, *International Politics and Civil Rights Policies in the United States, 1941–1960*, (Cambridge University Press, Cambridge, 2000)

Lebrun, Rico, *Rico Lebrun Drawings*, (University of California Press, Berkley and Los Angeles, 1961)

Lederer, Zdenek, *Ghetto Theresienstadt*, (Edward Goldston & Son, London, 1953)

Levitt, Laura, *Jews and Feminism: The Ambivalent Search For Home*, (Routledge, London and New York, 1997)

Leys, Ruth, *Trauma: A Genealogy*, (The University of Chicago Press, Chicago and London, 2000)

Lichtenberg Ettinger, Bracha et al., *Artworking 1985–1999*, (Ludion, Ghent–Amsterdam, Palais Des Beaux–Arts, Brussels, 2000)

Lichtenberg Ettinger, Bracha, *Matrix Halal(a) -Lapsus: Notes On Painting*, (Museum of Modern Art Oxford, Oxford, 1993)

—— 'Matrix and metramorphosis,'p.176–208 in *Differences: A Journal of Feminist Cultural Studies*, 4/3, 1992

—— *The Matrixial Gaze*, (Feminist Arts and Histories Network, University of Leeds, Leeds, 1995)

—— 'Some–thing, some-event and some-encounter between sinthôme and symptom,' in M. Catherine De Zegher ed., *The Drawing Centre's Drawing Papers 7. The Prinzhorn Collection: Traces Upon the Wunderblock*, (The Drawing Centre, University of California Los Angeles, 2000)

—— 'Transgressing with-in-to the feminine,' in M. Catherine de Zegher ed., *Inside the Visible: An Elliptical Traverse of 20th Century Art, in, of and from the feminine*, (MIT Press, Cambridge, Mass & London, 1995)

—— 'Traumatic wit(h)ness-thing and matrixial co/in-habituating,' in *Parallax*, 5/1, 1999

—— *Weaving A Woman Artist With-in the Matrixial Encounter-event*, unpublished paper given at University of Leeds 4th– 5th July 2000. Originally presented at the *Genius* conference, ICA, London, June 2000 and to be published in 2003.

Life Magazine, 'Eichmann and the duty of man,' anon editorial, *Life Magazine*, 49/23, December 5, 1960

Lifton, Robert Jay, *The Broken Connection: On Death and the Continuity of Life*, (Basic Books, Inc., New York, 1979, 1983)

Linden, R. Ruth, *Making Stories, Making Selves: Feminist Reflections on the Holocaust*, (Ohio State University Press, Columbus, 1993)

Lippard, Lucy, *Eva Hesse*, (DaCapo Press, New York, [1973]1976)

—— *From the Center: Feminist Essays on Art*, (Clarke, Irwin & Co, 1976)

Lowenstein, Steven M., *Frankfurt on the Hudson: the German Jewish Community of Washington Heights, 1933–1983*, (Wayne State University Press, Detroit, 1989)

Marks, Jane, *The Hidden Children: Secret Survivors of the Holocaust*, (Piatkus Publishers, London, 1994)

Martin, Biddy, and Mohanty, Chandra Talpade, 'Feminist politics: what's home got to do with it?' in Teresa De Lauretis *Feminist Studies/ Critical Studies*, (Macmillan, London, 1986)

Marx, Karl, 'Preface to a contribution to the critique of a political economy,' Karl Marx and Frederick Engels, *Selected Works, Volume One*, (Progress Publishers, Moscow 1969)

Massumi, Brian, 'Painting: The Voice of the Grain,' in *Bracha Lichtenberg Ettinger: Artworking 1985–1999*, (Palais des Beaux–Arts, Brussels, and Ludion, Ghent–Amsterdam, 2000)

Miller, Judith, *One, by One, by One*, (Touchstone, New York, 1990)

Mitchell, Juliet, *Psychoanalysis and Feminism: A Radical Reassessment of Freudian Psychoanalysis*, (Penguin Books, London, 1990, 1974)

Modell, Arnold H., 'The dead mother syndrome and the reconstruction of trauma,' in Gregorio Kohon ed., *The Dead Mother: The Work of André Green*, (Routledge and the Institute of Psycho–analysis, London, 1999)

Mulvey, Laura, *Visual Pleasure and Narrative Cinema*, (Macmillan, London, 1989)

Nemser, Cindy, 'An Interview with Eva Hesse,' *Artforum*, May, 1970
—— *Art Talk*, (Harper Collins, New York and London, 1975, 1995)

Nye, David E., *The Invented Self: An Anti–biography, from documents of Thomas Edison*, (Odense University Press, 1983)

Novick, Peter, *The Holocaust in American Life*, (Houghton Mifflin Company, Boston, New York, 1999, 2000)

Orton, Fred, 'Action, revolution, and painting', *The Oxford Art Journal*, 14/2, 1991

Pajaczkowska, Claire, 'Art as a symptom of not dying,' *New Formations: Psychoanalysis and Culture*, no.26, Autumn 1995

Pollock, Griselda, *Differencing the Canon: Feminist Desire and The Writing of Arts Histories*, (Routledge, London, 1999)
—— ed., *Generations and Geographies in the Visual Arts: Feminist Readings*, (Routledge, London, 1996)
—— 'Inscriptions in the feminine,' in M. Catherine de Zegher ed., *Inside the Visible: An Elliptical Traverse of 20th Century Art, in, of and from the feminine*, (MIT Press, Cambridge, Mass & London, 1996)

Merleau–Ponty, Maurice, 'Eye and mind', originally published as 'L'Oeil and L'Espirt,' *Art de France* 1, no.1 (January 1961), Reprinted in Galen A. Johnson ed., *The Merleau–Ponty Aesthetics Reader: Philosophy and Painting*, (Northwestern University Press, Evanston, Illinois, 1993)

Merleau–Ponty, Maurice, *Phenomenology of Perception*, (Routledge & Kegan Paul, 1962, 1978)

Robinson, Hilary, 'Border crossings: womanliness, body, representation,' in Katy Deepwell, ed., *New Feminist Art Criticism*, (Manchester University Press, Manchester, 1995).

Rose, Gilbert J., *Trauma and Mastery in Life and Art*, (International Universities Press, INC., Madison, Connecticut, 1996)

Rose, Jacqueline, *The Haunting of Sylvia Plath*, (Virago, London, 1991)

Rosenberg, Barry A., *In the Lineage of Eva Hesse*, (Aldrich Museum of Contemporary Art, Aldrich Conn., 1994)

Rosenberg, Harold, *Act and The Actor: Making the Self*, (World Publishing Group, New York, 1972)
—— *Discovering the Present: Three Decades in Art, Culture and Politics*, (University of Chicago Press, Chicago, 1973)
—— *The Tradition of the New*, (Da Capo Press, New York, 1994)

Rosenthal, Norman, et al., *Charlotte Salomon Life? or Theatre?*, (Royal Academy, London, 1998)

Rowley, Alison, 'An introduction to Bracha Lichtenberg Ettinger's "Traumatic wit(h)ness–thing and matrixial co/in–habit(u)ating,' in *Parallax*, 1999, 5/1

—— *Helen Frankenthaler, Painting History, Writing Painting*, (I B Tauris, London, 2007)

Irving Sandler, *The New York School: The Painters and Sculptors of the Fifties*, (Harper and Row, New York, 1978)

Santner, Eric L., 'History beyond the pleasure principle: some thoughts on the representation of trauma', in *Probing the Limits of Representation*, Saul Friedländer ed., (Massachusetts, London, Harvard University Press, 1992)

Schor, Naomi, *Reading In Detail: Aesthetics and the Feminine*, (Methuen, London and New York, 1987)

Secunda, Arthur, 'An interview with Rico Lebrun,' *ArtForum*, 1/11, May 1963.

Seldis, Henry, *Rico Lebrun (1900–1964)*, (Los Angeles County Museum, Los Angeles, 1968)

Shapiro, Edward S., *A Time for Healing: American Jewry since World War II*, (John Hopkins University Press, Baltimore and London, 1992)

Shandler, Jeffrey, *While America Watches: Televising the Holocaust*, (Oxford University Press, New York and Oxford, 1999)

Soussloff, Catherine M., ed., *Jewish Identity in Modern Art History*, (University of California Press, Berkley, Los Angeles and London, 1999)

Sussman, Elisabeth, Ed. *Eva Hesse*, (San Francisco Museum of Modern Art and Yale University Press, San Francisco, New Haven and London, 2002).

——, *Lippard's Project*, a paper presented at the Eva Hesse Symposium, Museum Wiesbaden, 1 September 2002.

Sussman, Elisabeth, and Wasserman, Fred, Eds. *Eva Hesse*, Yale University Press, 2006)

Tickner, Lisa, 'The body politic: female sexuality and women artists since 1970', in *Art History*, June 1978, 1/2 pp.236–49, reprinted in Rozsika Parker and Griselda Pollock, *Framing Feminism: Art and the Women's Movement 1970–1985*, (London, Pandora Press, 1987)

Wagner, Anne M., 'Another Hesse,' *October 69*, Summer 1994, pp.49–84.

——, *Three Artists (three women): Modernism and the Art of Hesse, Krasner and O'Keeffe*, (California University Press, Berkley, 1996)

Wardi, Dina, *Memorial Candles: Children of the Holocaust*, (Tavistock/Routledge, London and New York, 1992)

Weber, Nicholas Fox, *Josef Albers*, (South Bank Centre, London, 1994)

Winnicot, D. W., *Babies and their Mothers*, (Addison–Wesley Publishing company, INC., Reading Massachusetts, 1987)

—— *The Child and the Outside World*, (Tavistock Publications, London, 1957)

Whiteman, Dorit Bader, *The Uprooted: A Hitler Legacy, Voices of those Who Escaped the "Final Solution,"* (Insight Books, Plenum Press, New York and London, 1993)

Wyman, David S, ed., *The World Reacts To The Holocaust*, (The John Hopkins University Press, Baltimore and London, 1996)

De Zegher, M. Catherine, ed., *The Drawing Centre's Drawing Papers 7. The Prinzhorn Collection: Traces Upon the Wunderblock*, (The Drawing Centre, University of California Los Angeles, 2000)

—— ed., *Eva Hesse Drawing*, (The Drawing Centre and Yale University Press, New York, 2006)

——— ed., *Inside the Visible: An Elliptical Traverse of 20th Century Art, in, of and from the feminine*, (MIT Press, Cambridge, Mass & London, 1995)

Zelizer, Barbie, *Remembering to Forget: Holocaust Memory through the Camera's Eye*, (University of Chicago Press, Chicago and London, 1998)

Zinn, Howard, *Postwar America: 1945–1971*, (Bobbs–Merrill Company, Inc., Indianapolis and New York, 1973)

Films

Eva Hesse in her studio, (1968/1969), Dorothy Levitt Beskind

The Diary of Anne Frank, Directed by George Stevens, 1959, Twen.

Into the Arms of Strangers: Stories of the Kindertransports, (2000), Mark Jonathan Harris and Deborah Oppenheimer

My Knees Were Jumping: Remembering the Kindertransports, (1997), Melissa Hacker

We Were So Beloved: The German Jews of Washington Heights, *(1985), Manfred Kirchheimer*

Web Sources

Hamburg University, History of Jews in Hamburg, http://www.rrz.uni–hamburg.de

The Royal College of Psychiatrists, http://www.rcpsych.ac.uk/info/help/pndep

http://sorrel.humboldt.edu/~rescuers/book/Pinkhof/yaari/sophie1.html

Primary Sources

Walter Erlebacher Interview conducted by Anne Hunter for the Archives of American Art Philadelphia Project, 19 January 1991. Courtesy of the Archives of American Art, Smithsonian Institute, Washington DC.

Eva Hesse Papers Courtesy of Archives of American Art, Smithsonian Institute, Washington DC. and the Estate of Eva Hesse

Ruth Marcus Hesse and William Hesse Tagebuchs written for Eva Hesse and Helen Hesse (1936–1943), unpublished, courtesy of Helen Hesse Charash

Ruth Marcus Hesse, William Hesse and Eva Nathanson Hesse letters to Eva Hesse, unpublished, courtesy of Helen Hesse Charash

Cindy Nemser transcript of 'An Interview With Eva Hesse,' courtesy of Archives of American Art, Smithsonian Institute, Washington DC.

Rico Lebrun Papers Courtesy of the Archives of American Art, Smithsonian Institute, Washington DC.

Edith Robinson Wyle interview conducted by Sharon K. Emanuelli at her home in Los Angeles, March 9, 1993 for the Oral History Program of the Archives of American Art. Courtesy of the Archives of American Art, Smithsonian Institute, Washington DC.

INDEX